Quilt
of Belonging

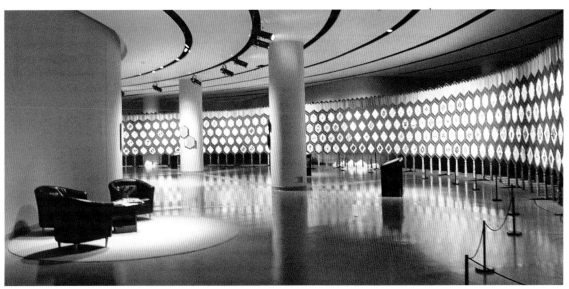

Invitation: The Quilt of Belonging on display at the
Canadian Museum of Civilization/Musée Canadien des Civilisations.

Dedicated to

The families we came from,
The families we are creating and
The family we can become

Quilt
of Belonging

The Invitation Project

ESTHER BRYAN
and Friends

The BOSTON
MILLS PRESS

A Boston Mills Press Book

Library and Archives Canada Cataloguing in Publication

Bryan, Esther,
Quilt of belonging : the Invitation Project / Esther Bryan and friends.

Includes bibliographical references and index.

ISBN 1-55046-435-3

1. Quilts--Canada. 2. Invitation, the Quilt of Belonging (Organization)
3. Immigrants--Canada. I. Title.

NK9113.A1B79 2005 746.46'0971
C2004-906958-6

Publisher Cataloging-in-Publication Data (U.S.)

Quilt of Belonging : the Invitation Project / edited by Esther Bryan.—1st ed.

[304] p. : photos. (chiefly col.) ; cm.

Includes bibliographical references and index.

Summary: A giant quilt -- the Quilt of Belonging -- created for the Invitation Project,
a collaborative community-based project celebrating the cultural diversity of Canada,
with a square representing every immigrant group and 71 distinct Inuit and First
Nations peoples. This is the story of the quilt and the quiltmakers.

ISBN 1-55046-435-3

1. Quilts, Canadian -- Exhibitions. 2. Quilts -- Canada -- History -- 20th century --
Exhibitions. I. Invitation Project (Ontario, CA) II. Bryan, Esther Joy, 1952-. III. Title.

746.460971 22 NK9113.2.Q54 2005

Published by Boston Mills Press, 2005
132 Main Street, Erin, Ontario N0B 1T0
Tel: 519-833-2407 Fax: 519-833-2195
e-mail: books@bostonmillspress.com
www.bostonmillspress.com

In Canada:
 Distributed by Firefly Books Ltd.
 66 Leek Crescent
 Richmond Hill, Ontario, Canada L4B 1H1

In the United States:
 Distributed by Firefly Books (U.S.) Inc.
 P.O. Box 1338, Ellicott Station
 Buffalo, New York 14205

The publisher acknowledges for their financial support of our publishing program,
the Canada Council, the Ontario Arts Council and the Government of Canada
through the Book Publishing Industry Development Program (BPIDP).

Writers: Esther Bryan, Isabella Carello, Andrea Veerman,
 Helen Sloan, Chelsea Stelmach, Debra Fieguth, Lorri Benedik,
 Lori Andrews-Christiansen, Vera Arajs, Nancy Douglas, Meredith Royds

Editors: Ginette Cotnoir, Meredith Royds, Andrea Veerman

Designer: Linda Norton-McLaren

Photographer: Ken McLaren

Printed in China

CONTENTS

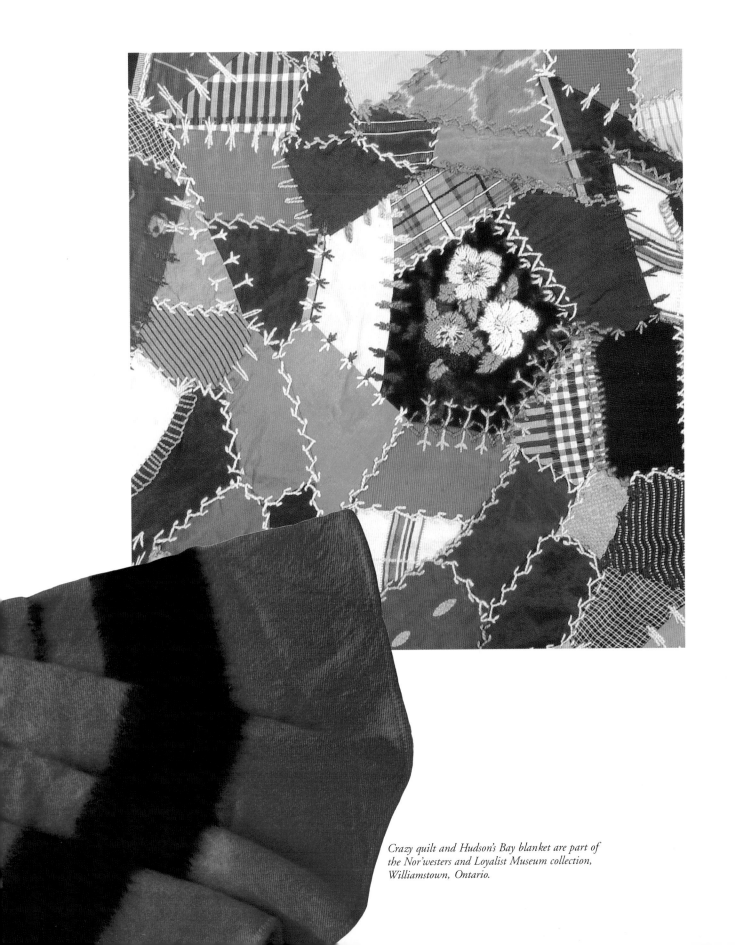

*Crazy quilt and Hudson's Bay blanket are part of
the Nor'westers and Loyalist Museum collection,
Williamstown, Ontario.*

Foreword

For over 330 years Hudson's Bay Company has understood the power, comfort and value of textiles. Blankets were among the earliest trade products exchanged between European merchants and Aboriginal people during the fur-trade era.

The shipping manifest for *The Nonsuch* lists blankets among the trade products carried on board when Radisson and des Groseilliers made their famous 1668 voyage that resulted in the founding of Rupert's Land and Hudson's Bay Company. Point blankets have been used for centuries to solidify agreements, comfort those in need, and clothe even the hardiest adventurers during fierce Canadian winters.

Over time blankets began to be cut and sewn into garments such as stockings, mittens and "capotes" or voyageur coats. The capote is an enduring product that represents the merging of Aboriginal and European traditions and became the main garment for the Métis. It reflects a change in people's way of looking at things, a merging of two cultures, the taking of what works in one culture and creating something new for a new nation.

Like a blanket, a quilt can bring comfort, warmth and a sense of belonging. It can also tell a story, or many stories, one for each of its component blocks. And, like the blanket-capote, it can be a tribute to the renewal of the many materials used to execute the artist's design. An added feature of a quilt, however, is that frequently many hands participate in its creation. Thus a quilt also becomes a collaborative work of art that celebrates the talents of its makers.

Today it brings me great pleasure to once again be part of a partnership which is woven into the images and textures of a cloth that reflects Canada's diverse legacy. The *Quilt of Belonging* tells the story of Canada and its people, from the First Nations through to our newest members of society. Many of the fabrics used in the Invitation Project arrived in Canada in the luggage of those filled with hope for a new life. The *Quilt of Belonging* is also an ambassador of Canada's cultural mosaic, telling a new story and sharing dialogue among the many pieces that make up the whole.

The complexity, dedication and skill with which each square has been fashioned are the same characteristics the adventurers possessed as they participated in weaving a nation out of the wilderness. The *Quilt of Belonging* has captured the heart and soul of all Canadians and provides future generations with a new story told through the enduring tradition of textiles.

On behalf of Hudson's Bay Company I congratulate the thousands of participants who made this monumental emblem of unity and understanding. It is fitting that Canada continues to acknowledge its tradition of creating a work of art out of many separate and varied parts.

George Heller
President and CEO,
Hudson's Bay Company

Grandfather Gazdik

Introduction

THE INVITATION PROJECT

Invitation: The Quilt of Belonging began with the dream of one artist, Esther Bryan, grew to include hundreds of volunteers and continues to reach thousands.

From a small seed in a tiny village, one of the largest and most inclusive works of art in Canada has been fashioned. The journey has touched many lives, but above all, it has changed our hearts and minds.

Stary Dom

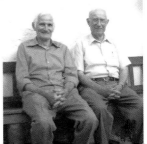

Brothers Milan and Jan Gazdik

THE BIRTH OF A DREAM

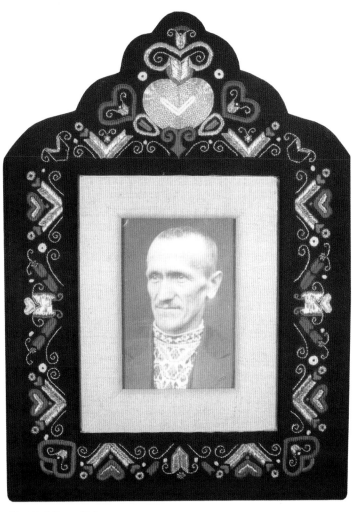

The Guilding of Memory
from Esther Bryan's exhibition Return

The journey of making *Invitation: The Quilt of Belonging* began unexpectedly in the summer of 1994. At age 42, the course of my life as a mother, wife, daughter, pianist, volunteer, but especially as an artist, was radically changed by a single event — travelling to Slovakia with my father. Until then I had been working alone as an artist in my own studio. Whether painting, drawing or playing the piano, I strove to communicate what I understood of the universe around me. But this trip refashioned my understanding of people, how I saw life, and even how I worked — a new part of my heart opened up.

The Iron Curtain had fallen and my father was able to return to his homeland to reunite with his family after nearly half a century of separation. I was confident I knew my father well. Yet he had never told me about his family in Slovakia, not even about his brothers and sisters. The relatives I met were complete strangers to me. In a few short days, I acquired a family whose identity and language had been previously unknown to me. These individuals had lived completely different lives from ours.

Uncle Milan, who lives in Slovakia, conserves the past. Raised in an orphanage during World War II, he returned as an adult to his father's village, Banská Belá, never to live elsewhere again. His father's bed still sits in the corner of the now uninhabited *stary dom* (old house), across from the ceramic stove that heats the tiny house that once sheltered an entire family and their farm animals as well. Surrounding the old house and Milan's newer house, where he lives with his wife and daughter, terraced gardens provide both food and beauty. Life under communism was harsh, money was scarce, and Milan's work in the mines, grueling. Theirs is an old life, without television or computers, which follows the rhythm of the seasons. Each Christmas, Milan, a renowned woodcarver, sets up an extensive, carved nativity scene in his home and visitors make an annual trek to see his "Bethlehem." Shaped by suffering, love, art and nature, all wrapped in a strong Christian faith, Milan's life is complete within this valley. He has no desire to leave. My father, Jan Gazdik, fled Slovakia at the end of WWII, the only member of his family to escape before communism took over. He has always sought new adventures, challenges, and lived his life in many countries. The first of six children, I was born in France, where he and my mother, an American, served as missionaries in the post-war years. His concerns

as a pastor were for the present and the future. He taught our family that life was for reaching out, for helping others. Armed with his unshakeable faith, but few material resources, nothing was impossible. He embraced his new family, new home and new dreams. His past was distant — a collection of painful memories better left undisturbed. He saw no value in wasting time or energy looking back when God had so much work for him to do each day.

When communism in Europe collapsed, Dad was ready to reclaim his history, and he embarked on a quest to revisit the past. I went with him. We tried to retrace every step of his former life. We looked for every dwelling he had occupied. Through fields, forests and mountains, villages and towns, we searched for the missing pieces. His joy was tinged with grief when he was reunited with surviving family members and saw the terrible scars left by years of oppression. The unspoken pain of his past resurfaced along with treasured memories of childhood. While some parts of his Slovakia were as beautiful as he remembered, others were in ruins. Suddenly, a long-suppressed part of my father emerged. He had a desperate longing to have those he loved share his past. He wanted us to understand how his past had shaped him, as if it were a key to loving and accepting him in the present. For the first time I saw how all the elements of our past, good and bad, need to be faced before we can step confidently into the future.

During the emotional rollercoaster of those days, every time I could steal time alone, I tramped up to a knoll my family affectionately nicknamed *Esterkin kopec* (Esther's hill). This solitary peak became my favourite place to think, for I could see the world unfolding around me in a full 360-degree panorama. The mining village of Banská Belá is tucked into the valley below and around it the mountains rise like folds in a cloth, layer upon layer on every side, receding into the distance. I had so many questions to sort out. Why did I feel like part of me was coming home when Slovakia and these relatives had never been part of my life before? I had lived in many places, but most of my adult life was spent in Canada with my large, loving family. Why was my heart so engaged by this new land and these new family members? Would this have been my life if Dad had stayed behind? How can people so far apart in place and experience still be alike in so many ways? I wondered how to fit these two completely opposite worlds into my own life.

Everywhere we went, we hungrily gathered fragments of our lost past. I scribbled down family stories, sketched the village, the fields, the *stary dom*, collected photographs, stones, textiles, crafts, dishes — anything I could bring back in suitcases, objects to hold onto when we were separated once more. Back in Canada, making art became my way of trying to make sense of all these scattered pieces. I incorporated the fragments into paintings, handmade books, textiles, photographs, and poetry. And as I worked over the next two years I asked more questions. What are the basic needs of human beings and what value does God place on each life? How do we all fit together? My artwork from this period was shown in a one-woman exhibition entitled *Return*. When it opened to the public, I was stunned by the response. Many wept or laughed and told me their own stories and struggles, sometimes bringing their treasured heirlooms for me to see and touch. Often they concluded with a phrase I couldn't forget: "You're so lucky you're an artist, you can talk about it." I saw the need of each person to be included, to be seen and to be heard.

Although I've been an artist all my life, I had struggled with the direction my work should take. Why make art? Who is it for? The current Western art scene so often deifies the artist and treats art as a commodity. Artists enter a cycle of building a reputation and selling art to allow them to make more art, to sell more art. So much work for so little gain. The needs expressed by the viewers at my exhibition *Return* led me in a new direction. What of making art, not for money, not for one person, not limited by one mind, one personality, one version of beauty, one reality, one past? I felt compelled to make art that would include all who needed to belong, artist or not. All my life, I had struggled to answer the question of where I belonged, and I realized that this was a fundamental human need. Children and adults alike crave acceptance at home, at school, at work, in communities, and in houses of worship. Every person needs to know that regardless of colour, gender, age, abilities, physical attributes or temperament, his or her life is an equally valued part of the tapestry of life. This then would be the invitation. All would be invited to participate, to belong. *Invitation: The Quilt of Belonging* was born!

Textile Treasures

On my trips to Slovakia, I collected and was given textiles by my new family and friends. The country prides itself on its distinctive regional embroidery styles, and textiles are especially treasured in Slovak homes and history. The hand-embroidered pieces placed in my hands spoke to me. Incredibly, through years of difficult circumstances, extensive embroidery work had been continued. The simplest articles became works of art: pockets to hold combs, costumes, tablecloths, bedding and even work clothes for farmers. The fabrics could be coarse homespun or fine linen, but the need to embellish, to produce beauty and identity even in harsh times spoke to me of the indomitable human spirit.

My reflections led me to choose textile as the medium of choice for this work of art made as a community. Throughout history, humankind has created beauty even with pragmatic articles for daily living. Clothing, like food, is an essential part of survival. We need it for warmth and comfort but also to communicate our individual and corporate identities. Silently mirrored in textiles are time, place and character. They tell our story and transmit our cultural heritage and values. *Quilt of Belonging* became an invitation to make a textile mosaic, to piece together a non-traditional quilt in which each participant told his or her story by selecting both fabrics and designs.

The history of textiles is rich and far-reaching. Fabrics reflect physical geography, the climate, and the natural resources of the land. The settlement and development of Canada was shaped by the fur trade between Europeans and Native people. International trade of textiles has influenced world history for centuries, rising and falling with the latest fashions in silks, cottons or wools.

Textiles proclaim social rank and political structure. The wealthy could afford shimmering satins, soft silks and thick brocades, while cotton, denim and gingham were for the poor. Clothing also involves intricate gender issues, including cultural notions of privacy and morality, whether *burkhas* or bikinis, mini-skirts or robes. Textiles become important markers that provide a visual timeline of significant rituals, ceremonies, and life's major events.

Identity is a powerful aspect of textile selection and use. Human beings everywhere share the need to express their individual and collective uniqueness. Many communities have a textile that is

identifiable as a unique cultural fingerprint. In some European villages, changes in patterns and colour combinations identify territorial boundaries, even familial boundaries. The Saami people in Africa use a distinct border to mark their political identity as separate from that of neighbouring tribes. In business and institutions, uniforms establish corporate identity.

Artistic traditions in textiles delight the senses. As with other visual-art mediums, textiles are part of a local community's aesthetic development and richness. Carpets, quilts, complex lace patterns, or intricate beading designs, all reflect artistic and societal sensibilities while providing outlets for creativity. Colour, line and texture choices reflect individual personality and temperament in home furnishings and clothing.

The face of humanity has been recorded in our textiles, tracing the global family tree since the beginning of time. The *Quilt's* design visually reveals the kind of society we want in the future. I feel that we desperately need a positive image of what the world should be, of how it can be. Too often, what we see of our world hardens us. Bombarded on every side by horrific news of war and misery, we become frustrated by our inability to effect change. It often seems safer to withdraw into ourselves and look after our own interests. Like Abel in the Bible, we ask, "Am I my brother's keeper?"

Who is my brother, who is my sister? The family tree in Canada begins with the Aboriginal peoples, so these groups form the foundational row of the tapestry: Inuit, First Nations and Métis, one block for each main cultural group living within Canada. The next three rows, moving up, include one for each nation of the world. Mirrored on each side of the Canada block at the centre of the top border is a full-colour spectrum pieced from thousands of fabrics that create a harmonious new design, an expansive ribbon, like our country, extending from sea to sea.

Invitation: The Quilt of Belonging was designed to visually remind us that there are still options for the way we choose to live, for the kind of world we want to build. In this powerful, vibrant work of art, the blocks are hexagons, the same shape as the elemental pieces that form every living organism — carbon molecules. Each block is framed with cording in its own visual space, and by the same strands it is

also connected to its neighbours. In our time, we continue to struggle with the age-old challenge of balancing our individual identity and a communal one. We need to understand our responsibilities as members of a society in which we are connected to one another and where every action or inaction affects someone else. We also need to affirm and respect our individuality, our privileges, and our rights.

The *Quilt* reveals a jeweled spectrum of humanity, a horizontal mosaic where each hue is rich, each fabric, design, tradition unique — a framework within which each person can express his or her own story. It is not meant to express ethnic divisions, but to visually symbolize the value of each individual, of each cultural identity, each past history, and the limitless possibilities of each future.

CREATING ART IN COMMUNITY

Chloe Fox, Gillian Legroulx

RéJeanne DesRosiers, Heljä Thomson

> "If faith has been the pivotal ingredient, the volunteers, hundreds of ordinary people working together, have been the magical factor."
>
> *Esther Bryan*

Although fabrics and design were important elements in making the *Quilt*, they were not the foundation. The critical elements and the strongest components by far have been the intangible ones. Without faith, this journey would never have been started or completed. Just months before I began the project, a fellow artist shared her favourite quote from science-fiction writer Ray Bradbury. It became a leitmotif: "If the task at hand gives you fear, walk off the cliff and build your wings as you fall."

When I first thought of starting the project, in the fall of 1998, I was afraid. I talked to a number of friends and family members about my ideas. The obstacles seemed insurmountable at first. I had no money, no workspace, no fabric, not even a table or a sewing machine. I didn't own or use a computer. Making a business plan or writing grant applications seemed as impossible as flying to Mars. I gradually came to understand that this would have to be a walk of faith. I had experienced God's provision for my family and I believed that nothing was impossible for Him. This project involved counting on God to build my wings by providing people with the necessary skills and resources. Despite lingering doubts and fears, I stepped "off the cliff" and began.

The needs were not met all at once, but solutions came little by little as things advanced. Faith seems so simple, but walking without seeing the path ahead is never easy. A friend worked on a business plan with me. Other people became involved and endorsed the project. I live in Williamstown, a small eastern Ontario village with a population of only 250 people and little commercial real estate. But several months before I started, the Township building was vacated because the township amalgamated with others. Armed with the business plan, I asked the Town Council if we could have the whole building to start the project in — rent-free. Amazingly, they agreed, as long as we paid the utilities. It was a bitterly cold February morning when we first stepped into that chilly, empty building. I was terrified! But only for a little while. Overlooking the Raisin River, the building has 3,000 square feet of space with large windows that

flood the rooms with wonderful northern light, perfect for artists' work. Gradually, the rooms began to fill up with supplies. Everything was donated by friends and volunteers, from furniture, fabrics and computers, to dishes and the indispensable teapot in the kitchen.

Funding has always been a challenge. In the first years, grants and corporate sponsors were virtually impossible to get as we hadn't operated long enough to produce annual financial reports, or have charitable status. We decided to fund the project in the same way as the quilt was being sewn, by individuals and small groups. In recent years, as it became clear the *Quilt of Belonging* would be completed and have a powerful impact, we were able to benefit from the help of wonderful corporate sponsors and grants to achieve special goals. However, the project has been sustained by the thousands of gifts from individuals that have had faith in the project.

If faith has been the pivotal ingredient, the volunteers, hundreds of ordinary people working together, have been the magical factor. From the outset we knew that many hands and talents would be required for this colossal task: directors for the board, researchers, accountants, web designers, administrators, writers, fundraisers, all in addition to the artists and sewers. The list seemed enormous, but we made a conscious commitment to make our "Invitation" an open one. We were determined to have the process mirror the message reflected in the *Quilt*, to find a place for each individual who wanted to participate regardless of their age, gender or abilities, even if they couldn't sew a stitch. The volunteer family has included school-children and octogenarians, educated professionals and the mentally challenged, new immigrants who don't speak English or French, as well as ambassadors. The challenge has been to find what each can contribute. Beyond the talent they shared, we've come to appreciate the unique spirit of each person. For example, a blind volunteer was terrific at transcribing interviews for this book. Watching his courage in the face of daily challenges and hearing his infectious laughter encouraged all of us who came into contact with him to be thankful for what we have. The sympathetic ear given to another while working is more precious than the finest stitch or the best-worded letter. I can't imagine completing this journey without those who, through the difficult times, week after week, year after year, gave their unwavering support, doggedly working through the toughest challenges.

The Invitation project began as a small nucleus of dreamers in eastern Ontario, but developed to include people from every corner of the globe, and is still growing. Our vision was to have representation from every country of the world included in the Canadian cultural mosaic, as well as the founding Aboriginal nations. The size of the country or the number of people from that country were not to be deciding factors. The search to locate people from each nation and have them involved took six years, the time it took to make the *Quilt* itself. First, extensive research in Canada's immigration records revealed that at least one person from every country of the world was in Canada. We used the *Stateman's Yearbook* and the United Nations listing to determine the name of each country as of the first day of the new millennium, January 1, 2000. Then the hunt was on! Finding associations, embassies and willing individuals from the larger groups was not always easy, but finding people who have come from small places like San Marino, Kiribati, São Tomé or Tuvalu was like finding the proverbial needle in a haystack. The task was accomplished after thousands of phone calls, word-of-mouth, magazine and newspaper articles, television appearances, travels to major cities and isolated communities, and in some cases just plain miracles.

Including our own Aboriginal peoples was possibly the single biggest challenge we encountered. It was impossible to include more than 640 First Nation bands plus Métis and Inuit groups. It took the Assembly of First Nations, the Department of Indian Affairs, the Canadian Museum of Civilization, band chiefs, Royal Commission reports and masses of research to compile a suitable list of major groupings. For many Aboriginal peoples, their history was largely oral until recently and is only now being collected and written. There were many complicating factors, such as name changes, but trust was also an issue for many who are still wary of betrayal and abuse. As the names and stories have emerged, we, and the thousands of visitors who see the *Quilt*, have been stunned to realize how little we know about the rich history and traditions of the Native people with whom we have lived for hundreds of years. Working with each group was a valuable experience that brought fresh insight and new lessons.

Esther Bryan, Linda Norton, Susan Towndrow, Ken Mclaren

Vera Arajs, Andrea Veerman, Isabella Carello, Meredith Royds, Ginette Cotnoir

From some we learned the value of freedom. Many risked their lives for the chance to live safely in Canada. I well remember the African man who appreciates that he is no longer afraid to go outside, and the refugees trying to grasp the concept that a policeman is a friend rather than a foe. How does one grow a heart big enough to forgive one's persecutors, as did the Central African woman? And there was the Cambodian pastor whose wife was starved to death in front of him. What about some of the South American blockmakers? What of the courage to carry on with daily life when one's family is left behind, trapped by civil war, like Mary Turay from Sierra Leone, Hawal from Iraq, or Justin from Sudan? From many African Canadians I learned about community life and a deep caring for neighbours and even strangers that has been mostly lost in our modern society. In many cultures, profound respect and caring for the elderly are highly held values. For so many, the family unit is paramount and they struggle against the tidal wave of Western culture that threatens to erode those ties. I saw stunning examples of generosity as people with very little gave freely to others. The sacred tenets of Western free enterprise were often challenged as those who were exploited under those systems told their stories of child labour and grinding poverty in third-world countries. A great number of people taught lessons of tolerance regarding religion, race, and noble values. Each time, as lives were discussed, food shared and stories exchanged, new friendships were forged. These human connections have made this journey successful and worth all the years of hard work. While listening to each other's stories, we've grown in our understanding of one another.

The *Quilt of Belonging* was nearly finished and most of this book was written when I returned to Slovakia with my parents in 2004, ten years after the first visit that so changed my life. Once again, I revisited my hill to think and pray. Masses of tiny field flowers provided a soft, colourful patchwork to rest on. A soft breeze wafted the fragrance of summer pastures and grasses freshly scythed. Each sound from the village below reverberated through the hills then faded gradually away into perfect stillness. The land, viewed from my perch, still seemed timeless, as if once God fashioned it, no human hands had touched it. I thought about how I have been seeing the whole world these last years from my own vantage point in tiny Williamstown. Human hearts have touched me and I have been changed.

Elizabeth Krol,
Reina Cross,
Greta Le Corney,
Susan Robertson,
Lydia Bryan,
Mary Morber,
Bridget Grice

Many of the questions I struggled with on my first trip have been answered, but new questions have taken their place. How can we touch the human heart? Once our hearts are open, then what? How and when do we help? Do we settle for a feeling of empathy or do we engage our feet, our hands, our money, our time? How do we help without removing pride, self-worth, without intruding or destroying? Are people best left to solve their own problems or is there a critical time when an outstretched hand makes a critical difference? There have been questions since time began, but we must not stop asking them. It's when we presume that we have all the answers for ourselves and for others that we are at greatest risk of making mistakes.

This I do know. I understand that we are each part of a complex design that is being woven. There are billions of threads that wind in and out in ways that cannot always be seen, whose source cannot always be traced. But each coloured thread affects the overall pattern, each is part of the whole. Every strand is important. It is unfinished, a work-in-progress, and the complete tapestry will be revealed someday by the Master Weaver. No one can see the total effect now. Yet, I can see that we each have choices to make regarding design and colour in working our own allotted threads. The question is what will we make, what will we add? Will it contribute beauty, inspiration or encouragement for others? Or will it become something shameful to be hidden, reviled or regretted? Francis Schaeffer, the great 20th-century philosopher, posed the question we must each answer for ourselves, simply "How shall we then live?"

Esther Gazdik Bryan
Artist and Project Co-ordinator

Daphne Howells, Claudette Voët, Carol White

" How shall we then live? "
Francis Schaeffer

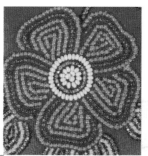

Stitches and Stories

The vision of *Invitation: The Quilt of Belonging* has been to create a collaborative work of art that recognizes the diversity of Canada and the world, while celebrating our common humanity and promoting harmony and compassion.

As each block was stitched, each story written, the makers shared their experiences. When glimpses of their lives emerged we came to understand that everyone has been shaped by past experiences. We learned that each human is unique and that the variety of points of view enriches our world, yet we have so much in common that we can live as one family, caring for one another.

Mi'gmaq

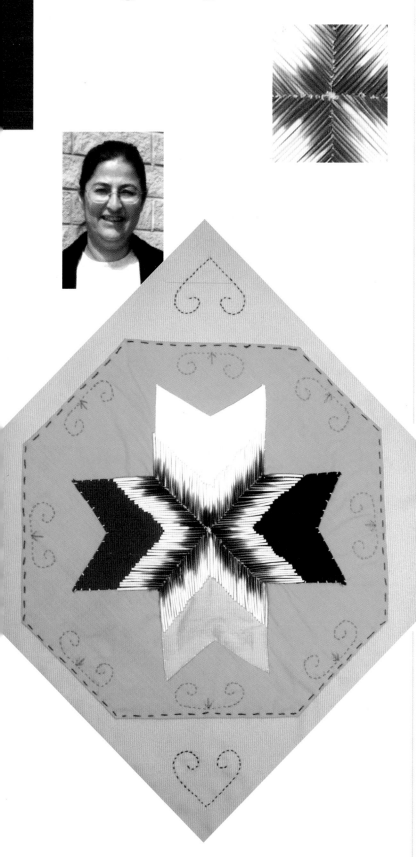

The great mystery

"Crafts are my passion. I love to sew and create things with my hands," says Carol Caplin of Listuguj (Restigouche), Québec. Carol has been doing crafts since she was very young and learned to do beadwork at age fourteen. Throughout her nearly thirty years of marriage, she has continued to learn new handicrafts.

As the focus of the Mi'gmaq block, Carol chose the eight-pointed star, an important symbol in her culture that signifies unity. The points of the star show the four compass directions, and the number four speaks of the balance in the four directions and within a person. Doubled to eight points, the design implies that all one sees is not necessarily all that is perceptible — a recurring theme known as "The Great Mystery" in Mi'gmaq cosmology. Elders also explain the eight-pointed star as representing the original seven Mi'gmaq districts plus the 1752 agreement with the British crown that made them inseparable from one another.

Carol, a mother of four, used embroidery, appliqué and porcupine quillwork to create the block. Even the colours of the star are symbolic, she explains. A blue cotton sky surrounds the four groups of people: the red, the white, the black and the yellow. Each was sent in a different direction to accomplish a mission. In the corners, stitched double curves, or two-dimensional spirals, represent the positive and negative forces of nature's spiral-like movements, such as those of the wind and ocean currents.

The Mi'gmaq ranged from southern Gaspé Peninsula through the Maritime Provinces, up into Newfoundland and down into Maine. They were among the first Aboriginal peoples to meet and trade with the European explorers and settlers. Mi'gmaq were original members of the Wabanaki Confederacy (along with the Abenaki, Penobscot, Maliseet and Passamaquoddy), and they sided with the French against the British and their Iroquois allies during the wars in the mid-1700s. The British tried unsuccessfully to convert the Mi'gmaq to farming in the 1760s, but they remained primarily nomadic hunters, trappers and fishermen. The Mi'gmaq also made distinctive birchbark canoes and toboggans, giving us the word "toboggan" from their language. They also introduced maple syrup as a sweetener and foodstuff, and are masters of fine porcupine quillwork. It traditionally decorated their clothing, moccasins and baskets.

The Mi'gmaq believe that all things of the land are alive and in the existence of an all-powerful entity. They created powerful petroglyphs (rock drawings) that can still be seen at McGowan Lake and Fairy Bay in Kejimikujic Park, Nova Scotia. Through the imagery of her block, Carol has created a different testimony to her people. She says, "I am a Mi'gmaq and very proud of my heritage and my community."

The moccasin man

When Harrison Red Crow of the Kainai Blood Reserve in Stand Off, Alberta, recalls making his first pair of moccasins, his composed features crumple into laughter. "They looked like clown shoes," he roars. But Harrison, a fourth generation descendant of Chief Red Crow, the man who led the Blackfoot nation through the peace processes in the late 1800s, wasn't about to shelve his creative aspirations. He was determined to teach himself the art. It took a while, but he mastered it.

Next, he decided to try his hand at beadwork. "I had no idea you needed to use two needles," he says, smiling again, as he describes loose beads literally hanging by threads from his beautifully made moccasins. Any one of his six sisters could have given him some instruction or artistic direction. But he didn't ask. In fact, he never told anyone he was trying to learn. His urge to create traditional art was strong, but slightly ahead of the artistic landscape of the time — moccasin making and beadwork were still strictly the province of women. Men occasionally *repaired* their moccasins, Harrison explains, but that was the extent of their involvement. This is no longer true, as evidenced by the growing numbers of male artists mastering the art. At that time, however, Harrison was determined to teach himself. He doesn't fully understand what compelled him, "It was just something I wanted to do."

Harrison's a traditionalist who doesn't apologize for remaining true to the old cultural forms and colours. What he remembers most about his parents, who have both passed on, is the importance they placed on their cultural roots. It seems fitting that Harrison dedicates himself to creating traditional art and teaching the Blackfoot culture and language through the Aboriginal Healing Foundation, a part of the Human Resources Department of the Blood Tribe. He says most students between sixteen and twenty, feel proud of their history. Sadly he adds, "Some wonder how learning the language and culture fits into their present reality." Harrison believes peer role modeling is especially important to remedy this mindset.

Harrison's design for the quilt block is a beaded version of an old style of quillwork, in a checkerboard design that was widely used among all four divisions of the Blackfoot Confederacy. Harrison has made remarkable progress since his neophyte beginnings. Today he is known as "the Moccasin Man" by some of his clients in Montana. He's also gained the reputation of being one of the best beadwork artists around. He's proud of the work he's contributed to the Canadian Museum of Civilization. Not bad for someone who began not knowing one end of the needle from the other.

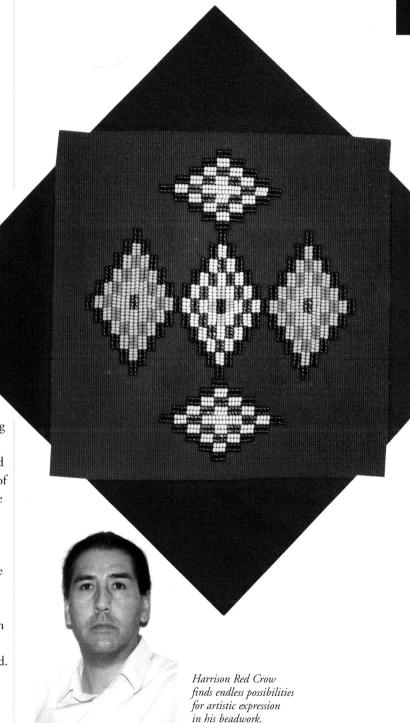

Harrison Red Crow finds endless possibilities for artistic expression in his beadwork.

Thompson

Nlaka'pamux

The Nicola eagle, one of the rock pictographs, was commonly used as a motif for decorating articles of clothing.

A curious mind

Sharon Dick has an exciting idiosyncratic streak of curiosity. When she finds something interesting, like an example of beautiful beadwork, her reaction is to fearlessly attempt it herself. "I just picked it up on my own. I got some beads and just started doing it." But she didn't stop there. Beading led to sewing traditional regalia, glass etching and even basketry. Recently, soapstone and cedar carving have captivated her artistic imagination. She often travels to exhibit her work at craft shows.

Her husband, Arthur, is chief of the Lower Nicola Band near Merritt in the southern interior of British Columbia. He is used to Sharon's quirky flights of fancy and loves watching her artistic expression continually evolve into new and traditional forms. Her hands are rarely idle. Sharon admits, "I don't watch TV much. I keep busy making art."

Sharon is well aware of the difficulties the younger generation faces in terms of maintaining a career and their cultural ties. Lack of job opportunities on the reserve have led many educated people to seek employment elsewhere. "I find in our communities many are told they are either overqualified or underqualified. It's sad to see the band educate them and then not have a place for them to work back at home," laments Sharon.

For centuries, the Stein Valley has been the reliquary of ancient rock paintings depicting the dreams and visions of the people of past generations. The Nicola eagle, one of the rock pictographs, was commonly used as a motif for decorating articles of clothing. The clothing of the Nlaka'pamux was an artistic expression of their deep love for their land. The depictions communicated their position in society, relationships within the tribe and their place in the universe. Originally clothing was either woven from hemp or bark, or made from hide. The arrival of white traders brought changes in fashion and decoration, but the skills involved in making traditional clothing were not lost.

The Nicola eagle represents strength and carries the prayers of the people to the Great Spirit. For generations people of the Nlaka'pamux Nation would stand at a place called Asking Rock in Stein Valley for a moment of quiet contemplation — feeling the rhythm of the land ebb and flow in their souls. Their prayers requesting permission to travel and hunt safely in the valley can still be heard whispering on the wind through the trees. This energy surrounds Sharon and guides her hands as she constantly finds new ways to express the culture of her people.

The eternal circle

Archaeological evidence suggests the Heiltsuk (formerly known as the Bella Bella) have occupied land on the central coast of British Columbia above Vancouver Island for at least 10,000 years. They believe in the Chief Above, the Creator of the Sun, and hold great respect for the *Bukwus*, spirit-men who live in the forest.

The spirit of art, too, is inextricably connected to the Heiltsuk culture. Ironically, there is no word for "art" in the Hailhzaqvla language, part of the Wakashan linguistic family. Both historical and contemporary artists are known for their traditional button blankets, which are still worn on ceremonial occasions. These garments are adorned with designs created by sewing dentalium and abalone shells onto red stroud material and appliquéing the material onto dark wool blankets.

Artist Bernard Windsor designed the striking Heiltsuk block and it was appliquéd by his sister, Mavis Windsor, also an artist. Both participated in a major display of Heiltsuk art at the Royal Ontario Museum in Toronto in 2000. "The block design represents the four main tribes of our nation," explains Mavis. "The Raven (with the straight beak), the Killer Whale, the Wolf, and the Eagle (with the curved beak), are joined together in an eternal circle." Created in the well-recognized red and black colours of coastal native groups, the block combines contemporary fabrics and Bernard's pattern inspired by tradition.

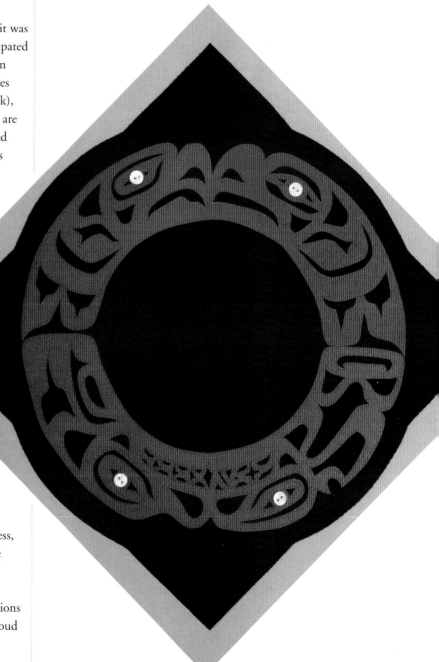

In the Windsor family, art is a family affair. "I work with my sister, Frances Brown (who is a Heiltsuk-language teacher), to design ceremonial regalia," says Bernard, "and my wife, Marie, often consults and sews it." He also carves and paints paddles, ceremonial masks and wooden spoons. Heiltsuk artists are noted for their intricate woodcarvings and for beautifully etched silver bracelets. Mavis became interested in making memorial potlatch regalia while working with her grandmother, Qixaqs (Maggie Windsor), and later studied with Mia Hunt to make vests, blankets and aprons.

In the 20th century, the Heiltsuk were pressured by missionaries and government officials to abandon their traditional beliefs and practices in an attempt to assimilate them into Euro-Canadian society. The potlatch, a traditional gathering with feasting, socializing and the public witnessing of tribal business, was outlawed by the federal government until 1951. Despite these adversities, the spirit of the Heiltsuk prevailed. Today members of the community are working to preserve their lands, language and vitality of their culture. "I am very proud of my culture, my traditions and, of course, my people," asserts Mavis. "And, I am also very proud of my brother's artistic talent."

Cyprus

The Hanging Gardens

Following Vrissiis Mavrou-Paidoussis around Montréal for a week would leave anyone in a tailspin. For starters, she's been secretary-general of the Hellenic-Canadian Solidarity Committee for Cyprus since 1974 and spends a lot of time promoting her country. Apart from her work at the TD bank, two times a week she volunteers at a seniors' residence. Being married to Michael, a mechanical engineering professor at McGill University who's also Honorary Consul of Cyprus, adds to her social commitments. "You have to have a lot of things to do," she says, pausing to catch her breath before adding that her one-hundred-year-old mother-in-law and eighty-six-year-old mother are also part of her busy days.

Vrissiis was born in the province of Kyrenia, now in the Turkish-occupied half of Cyprus, an island in the eastern Mediterranean near Turkey. It is evident this diminutive but vibrant Cypriot is passionate about — pretty much *everything*. "I love gardening. Yes, I love flowers!" she shares. If ever there was an understatement, this is it. Housed on her bowling-lane-size rooftop, hundreds of window boxes, individual pots and large wooden planters overflow with hundreds and hundreds of flowering plants nurtured by Vrissiis' hand. It's a huge production that requires careful planning and budgeting. By the time each spring rolls around, her apartment rooftop is transformed into "The Hanging Gardens", so dubbed by her bemused friends. Her contagious laughter spills out across the expanse where she also likes to do a lot of summer entertaining. "I'm crazy for cooking," she says. She's no slouch in the pastry department either, and at Easter can be seen whipping up *flaounna*, a traditional bread stuffed with seven kinds of cheese.

Just then, all the rocks, stones and seashells initially obscured by the flowers come into focus. The first thought is: *She's been collecting for a while.* "Since I was a baby," she says, spraying water over the stones in one container. "To bring out the colours," she explains. Looking at the rainbow play of glistening stones, Vrissiis announces there are more inside. And there are — along with hundreds of elephants in all sizes, shapes and materials, and Vrissiis's collection of vintage textiles. A particularly beautiful 300-year-old sample of Tsevres embroidery commands closer scrutiny. Skilled at needlepoint, Vrissiis finds time to stitch onboard airplanes en route to various destinations.

The sample of Phitiotika weaving Vrissiis provided for the Cyprus block represents the country's rich and varied weaving history. One time while visiting Phiti, the village that developed this weaving style, Vrissiis watched elderly women working with handlooms. Their deftness and speed, and the fact they didn't use patterns, amazed her. Today only limited amounts of *Phitiotika* are made. Vrissiis, whose appreciation for beauty is limitless, shakes her head, "It would be a pity to see it lost."

A tale of survival

The Austria block bears witness to the strength and perseverance of Lydia Glover. Lydia has expressed the beauty of her heritage in delicately stitched flowers belying her recent personal tragedies. Lydia was working on her block in 1999 when her husband, Joe, still very active on the family's berry farm, died at the age of ninety. Valiantly, Lydia, her family and a few friends worked all that fall at the prickly and difficult task of pruning six acres of raspberry canes. Despite a promising outlook in the spring of 2000, disaster struck when a fungus spread rapidly through the fields and caused all the raspberry plants to shrivel up and die. Unable to face the financial outlay or the years of labour needed to replace the canes, Lydia regretfully decided to close the berry farm. More challenges followed when Lydia was involved in a serious car accident. She developed blood clots in both her lungs and her right leg and nearly died. Adding insult to injury, her farmhouse was robbed in her absence. As these things conspired to defeat Lydia's spirit, she was extremely thankful for the support of her friends, who rallied to help her in many ways.

Young men used to climb the high Alps to gather wildflowers as tokens of love for their sweethearts.

Lydia worked to finish the centre of her block while recuperating at home. It features an embroidered nosegay of yellow arnica, red alpine rose *(Alpenrose)*, blue enzian and the beloved *edelweiss*, all reminders of the rugged Alps where young men used to climb the high and often dangerous rocks to gather these flowers as tokens of love for their sweethearts. Lydia had already sent to the Invitation Project headquarters the other elements she had assembled for the block: the fine cotton dirndl fabrics familiar in Austrian dress, the felt used for embroidered vests and hats, as well as a substantial array of pewter clasps and buttons that customarily fasten both men's and women's garments.

Then one freezing winter night in 2001, fire broke out and the heritage home that she and Joe had restored over many years burned to the ground. Devastated, the family spent days painstakingly salvaging what they could from the rubble. Amazingly, among the debris, they found Lydia's embroidery of delicate Austrian flowers. Although badly stained with smoke and water, it had survived intact. Lydia was thoroughly disheartened because she felt she could not present her work in such poor condition. However, Invitation volunteers gently washed the soiled piece of linen, added the missing stitches and fitted the pristine patch into the centre of the block. There it remains as a testament to survival through many struggles, a witness to the support of friends, and an homage to Lydia's faith, courage and resilience as she rebuilds her home and her life.

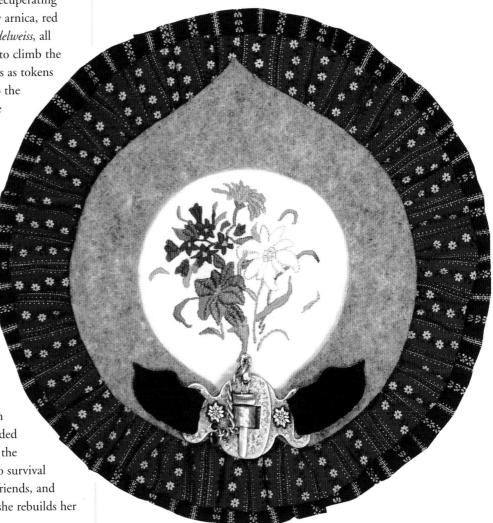

Pakistan

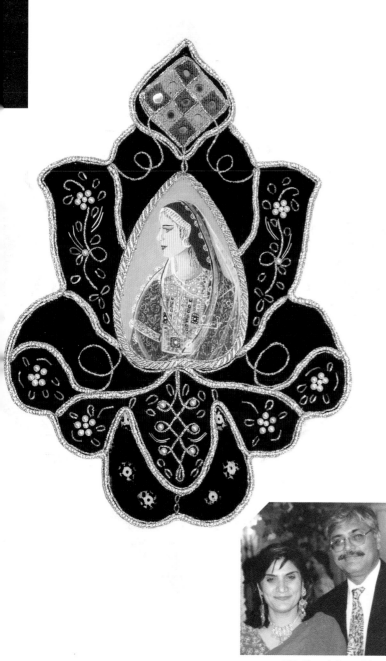

Tehzib and Omer Morad

Tehzib's miniature painting Ladies Night.

The colours of two cultures

Tehzib Morad throws open the door of her modern split-level home to welcome guests with her warm smile and laughter. She ushers them into her enchanting world of family and art, an imaginative blend of Pakistani culture and Canadian traditions. Her heritage and creativity fill the house, each room crammed with carved furniture, brightly embroidered textiles, ceramics, richly patterned carpets and Tehzib's colourful paintings.

Tehzib was born an artist. Even as a young child, she explored all kinds of arts and crafts. She earned a Master of Fine Arts degree at Lahore University in Pakistan before immigrating to Canada shortly after her marriage.

Her mother and mother-in-law (who are sisters) live with Tehzib, her husband and their three children, creating a lively multi-generational household. In keeping with Pakistani custom, Tehzib's marriage was arranged (by the mothers). "My husband is my first cousin, a fact that surprises Canadians, but he was almost a stranger to me," she explains. "I am so grateful…because had I had the opportunity to know him better beforehand, I would have fallen in love with him anyway. He is a very caring person." Omer, a financial manager, supports Tehzib in whatever she chooses to try, encouraging her in each new artistic venture.

When Tehzib first moved to Canada in 1978, clothing and articles from Pakistan were rarely found in shops. She longed to own pieces of her past, so she collected saris and crafts each time she returned to Pakistan. Tehzib is pleased to see elements of her culture becoming popular in the West: foods, fabrics, henna tattoos on hands, nose pins and wearing saris to parties.

As a child, Tehzib was fascinated with the dominant style of Indian paintings, miniatures that evolved from 11th-century illustrations on palm leaf manuscripts less than 3 inches wide. It wasn't until her children were at school that Tehzib started to paint scenes to reflect her heritage as well as her Québec surroundings. She creates intricate miniatures, using vivid colours to make cards for traditional Pakistani events, or she handpaints saris. She is equally likely to produce delightful Canadian-winter scenes featuring snow that could be red, turquoise or bright yellow, to "give it warmth," Tehzib explains.

The central miniature portrait Tehzib painted for her block depicts a Pakistani woman in traditional garb. It is surrounded by examples of various styles of needlework associated with different areas of the country. Silks and cottons are decorated with smooth and wire gold purl, couching, beadwork, gold and silver cording, and an example of mirrored *shishadar*. It is the work of an artist whose imagination is always finding new ways to express her creativity, which overflows with the colours of her two cultures.

Transformation

On Vancouver Island's rugged west coast, Josie Watts of the
Nuu'chah'nulth First Nation had the ocean, the temperate rainforest,
the little fishing village of Tofino, and her home at the Hesquiat
Reserve as the setting for her first eleven years, until she moved away.
Her ancient coastal society, dating back 10,000 years, hunted whales
and sea otter, and fished herring, salmon and steelhead. Sustained by
traditions and abundant natural resources, they flourished. When
Josie's father, a past-chief of the Hesquiat Nation, was a young man,
however, there were government bans against many traditions,
including the potlatch. "We weren't allowed to be who we are," Josie
says. Raising a large family, her parents held to some traditions, while
others slipped away. So the real question is: How did Josie become
such a passionate advocate of her community and her culture?

Only Josie and one sister learned the traditional dances and songs,
although there are ten girls in her family. Before that cultural
transformation occurred, Josie, "skinny and odd-looking," had her
own identity crisis to overcome. Her appearance, like a magnet, drew
the meanest slurs from classmates. One day, the name-calling broke
her spirit and she ran home, sobbing and vowing to her mother she
was finished with school *forever.* "That's when my mom read me
The Ugly Duckling," she says. Their family crest, depicted on the
Nuu'chah'nulth block, shows the transformation of a bear into
a whale, but in this little girl's heart, it was the emerging
swan that restored her hopes. Josie danced into her
teens and came to believe not only in the beauty
of her own transformation, but also in the beauty
of her heritage.

Today, after thirty years as a professional
homemaker in Port Alberni, Josie
recently retired. But the wall-to-wall
swan population inside her house has not.
Her collection continues to grow, outpacing
time and space. Luckily, besides her husband,
only the youngest of four children is still at home.
"People don't have any trouble buying me things," she
says, referring to the bevy of swans. "They know what makes
me happy." This grandmother of six also is happiest contributing
her time and energy to community celebrations and occasions.
Traditional dancing and singing are regular, planned events that
take place even when a hall can't be booked, she says. "People just
come to my house instead."

Work on the Nuu'chah'nulth block coincided with preparations for
a Memorial Potlatch, but Josie wasn't daunted. Her son, Tobias (Bear)
Watts, an artist and carver, designed the bear and whale. Josie stitched
and beaded. "We worked through the night to finish it," she says.
No one, least of all Josie, would have expected anything less.

Nuu'chah'nulth

" We weren't allowed
to be who we are. "

Josie Watts

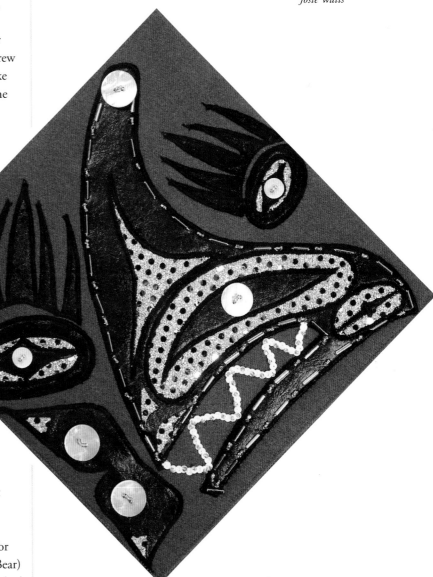

Switzerland

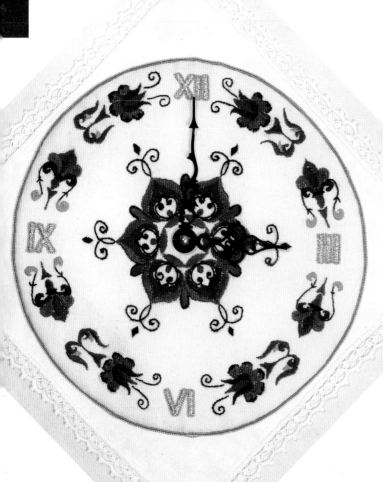

The essence of time

Faced with myriad options, the Swiss design team met nine times before choosing a theme for their block. It was difficult to forego the famous mountains, harder still to dismiss mouth-watering cheeses and chocolates. But out they went, along with the famous banking institutions, vintage castles, quaint villages, and hundreds of cultural events and museums. Likewise, thoughts of a mountain yodeler and the fictional ghost of Heidi evaporated into the ether.

Finally, the eight members agreed on the one sure thing, the singular, ruling pulse of the nation: keeping time. In Switzerland, trains and people are always on time. The block is adorned with an example of a spectacular floral clock. These creations that marry precision with horticultural beauty adorn countless Swiss cities and towns. The embroidered clock is designed in a floral pattern typical of the colourful folk art *Bauernmalerei*, which graces houses throughout the country. Swiss watch- and clock-making are world renowned and synonymous with a people whose small country thrives through careful time and resource management.

When the women of the group gather in Dora Bill's elegantly appointed home, the air resonates with camaraderie and animated conversation as childhood memories surface. Easy banter and spirited laughter peals like the church bells everyone remembers so well, particularly Heidi who, on a recent visit home, couldn't hold back the tears when her senses were inundated by the familiar sounds. Another shared memory is the mandatory elementary classes that featured the ABC's of sewing, knitting, darning and creative needlework. Ruth Lewis has brought her school journal, school pinafore, and the wool sock she meticulously knitted as a child. These items turn back the years with poignant clarity. They well recall the sock: knitting it, cutting it strategically, and then darning it invisibly. Students were encouraged to bring mending from home, to the delight of busy mothers.

Each woman put a little of herself into the block. Ursula created the design. Dora incorporated vintage linen that belonged to her grandmother. Ruth made a lace-edged hanky, of the type traditionally given as gifts, to surround the clock-face. Vreni, Theres, Klara, Heidi, and Anne-Marie completed the group that worked through the creative process by consensus, a reminder that the Swiss people are noted for their integrity, skills and punctuality. When asked if punctuality is an inherited trait or just a myth, Dora shyly admits that it is her one "weak spot." Everyone breaks into laughter. "But I'm working on it," she says, a little chagrined. Later, the essence of time — managed or otherwise — is quickly forgotten when Dora shares her heavenly Swiss chocolate cake with her friends.

Heidi Oeggerli,
Ursula Gut, Ruth Lewis,
Vreni Uhr, Klara Mülebach,
Anne-Marie Vogel, Dora Bill
missing: Theres Speck

Paradise lost

If heaven on earth existed, it would be Afghanistan, according to Ghulam Ferotan. The fertile land grows many kinds of fruit, the people are hospitable and the scenery spectacular. "In Kabul you can see seven layers of mountains," says Ghulam. "I miss it a lot." But even paradise — at least the earthly kind — has its problems. Conflict with Russia and an oppressive regime made it difficult to stay there. In 1988, after completing a Ph.D. in business management in India, Ghulam immigrated to Canada. His wife, Gul, and their three children followed a year later.

Because of warfare in their homeland, Gul lived in Pakistan while Ghulam studied in India. The couple were apart for nine years. During that time, Gul eked out a living by embroidering curtains, tablecloths, and even bed sheets, using skills she had learned as a child. Ghulam had immediately liked the young Gul when his father, a teacher, had introduced them. They were married in 1973 and were blessed with ten children; sadly a son died in infancy and a daughter, by the hand of her own husband.

Through joy and sorrow, war and separation, and life in a new country, Gul and Ghulam have remained devoted to each other and to their children, creating the bonds of a traditional Afghani family. In Canada they feel safe and secure. They are free to practise their religion and to wear traditional clothes, and they have access to education and health care like nowhere else. However, they do miss their families and the spectacular scenery and warm hospitality of the land of their birth. Yet Ghulam likes to put things in perspective. Smart people, he says, "keep the good from Afghanistan, take the good from here, and blend it."

His philosophy is like the array of handmade Afghani carpets that cover the Ferotan's living room: it increases in value with the passing years, welcoming family, friends and strangers. A miniature handwoven carpet, with *guls* or flowers in each corner, forms the centre of the Afghan block. Gul created the wide cross-stitch border that echos the rug's colours and pattern, while remembering the many hours spent stitching when she was alone. The family share their meals in the traditional manner, seated upon one of these famous carpets, where hospitality reigns and conversations both serious and light take place. These rugs reflect the sweet memories of Afghanistan and a life that becomes richer each year anchored in the freedom of Canada.

Afghanistan

" Keep the good from Afghanistan, take the good from here, and blend it. "

Ghulam Ferotan

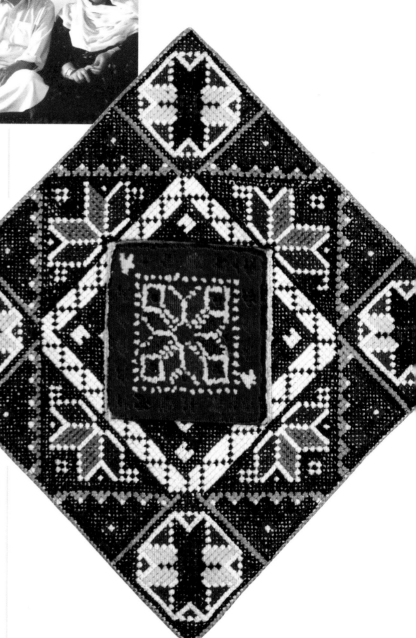

Brazil

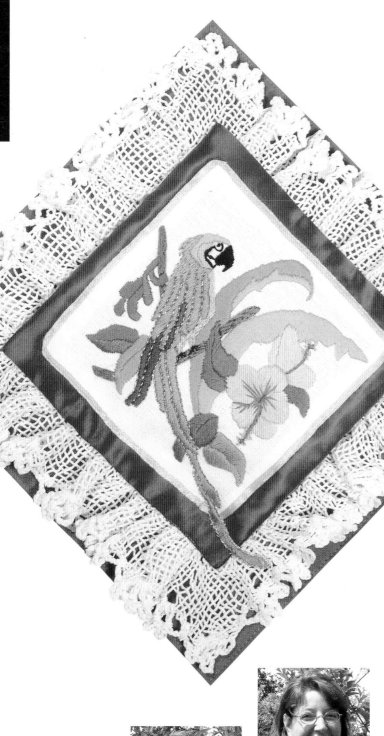

Brazilian hearts

A world of contrasts challenges the senses in Brazil, the largest tropical country in the world. Everything seems bigger than life — the Amazon jungles, the purple mountains, the legendary soccer players, the exhilarating Samba music, the famous coffee and tasty cuisine, exotic blooms and birds, miles of Atlantic coastline, the eye-popping splendour of their carnivals. What can compete with so much variety and beauty?

Blockmakers Saica Hincke and Jeannette Schaak have a strong contender to propose: the Brazilian people. "The people are more beautiful than the country," says Saica, who discovered this firsthand when she accompanied her Brazilian-born mother on her first trip home in forty years. Saica felt an "immediate welcome and acceptance" from everyone, not just family and friends.

This open-armed unconditional acceptance was also Jeannette's experience. To be sure, the country's spectacular beauty bewitched her as thoroughly as it bewitched her husband, Norman, when they first went to live there. But years later, their teary goodbyes were more for the people than the country. Jeannette had come full circle. She'd arrived fearful and uncertain, but when she left, she felt that a piece of her heart remained behind, basking in the warmth of the "Brazilian heart."

"Once they befriend you," Jeannette explains, "it's for life." Like something organic, their relationships grew and expanded to encompass the family and friends of their friends. As the Schaaks tell it, children and grandchildren are readily "adopted," as are mothers and grandmothers. Laughing, Norman shrugs helplessly, his eyes bright with fond memories. "There's no breaking away from Brazil," he says. "We're tied by generations now."

Inevitably, these strong Brazilian ties found their way to the quilt block. The blue macaw and hibiscus bloom, beautifully embroidered by Saica, pay tribute to Brazil's rainbow beauty. A pink satin backdrop celebrates the country's love of carnivals — its "*joie de vivre* soul." The work is bordered with exquisite filet lace, a traditional art form that traces its creative yet humble beginnings to tiny fishing villages.

Jeannette calls her Brazilian experience "life changing." For Saica, it was a cultural awakening with an unexpected gift — a chance to see her mother reflected through the lens of her own people and country. Observing her in this translucent light, listening to family exchanges and life stories, Saica discovered new dimensions of her mother's Brazilian heart.

Jeannette Schaak calls her Brazilian experience "life changing."

Saica Hincke says Brazil was a cultural awakening with an unexpected gift.

Sinews that bind

Dogrib
Tli Cho

The artistic nature and cultural identity of the Dogrib are manifest in their beautifully beaded clothing made of hide and a thick wool fabric called stroud. The Dogrib, who live in the Northwest Territories between Great Slave Lake and Great Bear Lake, are part of the Dene people of the North. Celine Mackenzie Vukson is particularly proud of the resourceful nature of her people. They waste nothing. For instance, caribou leg bones are used to scrape hides, and durable, tangle-free thread is made from sinew.

Celine records not only the story of the Dogrib in her block, but her own as well. She included some precious sinew thread made more than three decades ago by her deceased paternal grandmother, Marie Mackenzie. It serves as a reminder to keep alive her heritage, language and roots. The caribou hide remnants honour all the local Dogrib women who, while they ran their households and cared for large families, would sit for hours huddled in cold, drafty places scraping, stretching and tanning hides.

From a pair of mukluks beaded on navy stroud, Celine has recycled the leg portion and the "uppers" from the feet. The mukluks represent the Dene way of life and their ability to survive an extremely cold climate. A trace of "Dene Ink," a paste combination of flour and water, peeks out from behind the heart-shaped petals of the popular wild rose design. Dogrib women are encouraged to draw new designs for every project. This lets them express themselves individually, confirming their belief that the creator's design and choice are in the mind and heart.

A "pinked" edge on the caribou hide demonstrates the hand method of folding the material together and cutting out small pieces with a sharp scissor blade. Celine remembers her mother squinting as she leaned close to the hides to complete just such a decorative edge. Years ago, Celine bought a special gift of pinking shears for her mother, thinking it would make her work easier. But the shears stayed in the trunk, as her mother preferred her old ways. The pink and burgundy twisted yarn exemplifies Celine's mother's perseverance. Unable to learn all the necessary sewing skills from her mother because she married soon after returning from a residential school, Celine's mother did not know how to make the long string needed for her husband's hunting mitts. Too embarrassed to ask for help, she remained alone for hours taking apart and putting together an old cord. With only five inches of the string left intact, she copied the sample inch by inch until she was satisfied that hers matched the original. Only then did she join the family waiting downstairs.

For Celine, memories of family and community, of persistence and resourcefulness, are recalled through these pieces of her past, and provide comfort for her when challenges arise.

Dene women rarely keep patterns, in the belief that creativity and originality are hindered.

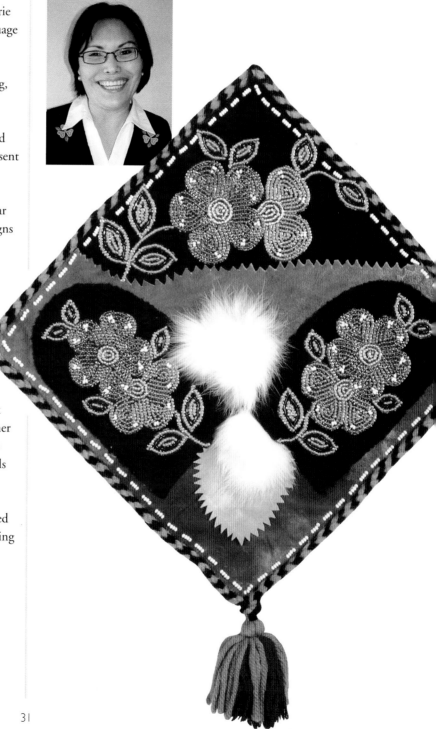

Venezuela

> "Every time I see her dance, I say 'Dance for me, dance for me!'"
>
> *Ana Gil*

Born to dance

Joropo, gaita, tamunangue, zapateado …exotic names for dances that Venezuelans learn from an early age. Ana Gil, merry eyes twinkling, feet tapping, describes the Venezuelan passion for music and dance. "It's a fever that we're born with," she says earnestly. "I have to have my music, and I am very sad without it."

Ana is animated as she explains the *joropo* (pronounced hó-ró-pó), the national dance of Venezuela. "It is Spanish in origin, but Venezuelan in feeling." This folk dance is a series of fast-paced, foot-stamping steps usually done by couples, accompanied by complicated rhythms supplied by relatively simple instruments: the *cuatro*, a small four-string guitar, provides harmony and rhythm; a diatonic harp supplies melody and rhythm; and maracas impart percussion. "Where there is *joropo*, there is a party," laughs Ana, who made the dancer for the block.

Ana's fascination with folk dances began when she was a small child, but her dream of a dancing career came to an abrupt end in her teens. A promising dancer, she was a member of a large troupe from the age of eleven. But when the group was asked to perform in public, her mother adamantly refused to let her participate for fear that the dramatic movements in costume might be improper for a young lady.

Years later when she had a baby girl, Ana whispered a promise to her infant daughter: if she wanted to dance, she would do everything in her power to make it possible. In time, her daughter Raquel discovered she loved to dance! Raquel studied everything from classical ballet to contemporary movement. She has danced with a Venezuelan folk-dance group in Ottawa, performed in festivals, at special events, and has won prizes in national competitions.

Once Ana learned to thread a needle, sewing became another great passion and a way of earning a living. While her daughter danced, Ana sewed. She created costumes for Raquel's dance troupe, as well as her ballet and jazz outfits. She altered wedding dresses, made winter clothing and upholstered furniture. She did whatever it took to pay for her daughter's lessons. Ana laughs heartily as she tells of sewing in private homes. To get to these jobs without a car, she would load her sewing machine into a grocery cart — and travel to appointments by city bus!

Today Raquel attends Ryerson University on a dance scholarship and Ana, now retired, spends most of her days in her tiny apartment at her sewing machine. And the music is always on. She works happily, surrounded by lace, crinolines and metres of fabric to create elaborate costumes for a small Venezuelan dance troupe and for her daughter's performances. Ana's eyes glow with pride as she recounts watching Raquel dance in Toronto. She confesses, "Every time I see her dance, I say 'Dance for me, dance for me!'"

A culture of carpets

From the time he was a boy, Slavik Kazakov loved hockey. Living in Ashgabat, Turkmenistan, he absorbed European and World hockey on television, and he knew about the National Hockey League in faraway North America. He even picked a favourite team: the Toronto Maple Leafs.

Energy-rich Turkmenistan, renowned for the Akhalteke breed of horse (ridden by Alexander the Great), is far removed from hockey country. It is surrounded by Iran, Afghanistan, Uzbekistan and Kazakhstan, but its influences come from even farther — India, China, Turkey and Russia. "It's in the middle," says Slavik's wife, Carol Ritchie, who taught English in the former Soviet republic in 1996. "The cultural influences meet in Turkmenistan. You hear it in the music and see it in the dance." The women wear imported headscarves that indicate their marital status: a woman with two braids and a small headscarf is unmarried, while a single braid and a large scarf say she is married. Head jewellery made of pewter and coins, and distinctive carpets featuring symbols representing the country's four tribes, are traded at bustling markets. Turkmen women wear long velvet dresses in rich, solid tones trimmed with burgundy, plum, green, coppery brown, cream and black — the same colours dominant in their handwoven rugs.

"For Turkmen, carpet making has the same importance as the pyramids do for Egypt," say Turkmenistan Embassy officials in Washington, D.C. "Fifteen factories employ about 10,000 people and put out 41,000 handmade, square metres of carpets a year." Appropriately, the Turkmenistan block honours the centuries-old tradition with an authentic sample of carpeting supplied by Carol.

More than seventy nationalities live side-by-side with Russians in Turkmenistan. The groups mingle and use Russian as a common language but cultural identities remain distinct. The differences are both small and large matters: Russians serve their meals at the table, while the traditionally nomadic Turkmen sit on floor-rugs to eat; the Russians are mostly Christian Orthodox, while the Turkmen are Sunni Muslims.

In this atmosphere of east-meets-west and north-meets-south, Carol met and fell in love with Slavik, a flight attendant attending her English class. The two were married several months later, and the following year, Slavik came to live in the Canadian city that hosts his favourite NHL team. He was disappointed when the 2004 hockey season was put on hold because of a dispute between players and owners. "I live in Canada and there's no hockey!" he says in disbelief. Canada is his home now, hockey or no hockey, but Slavik and Carol are reminded of the warmth of his native land when they feel underfoot the rich wool of the Turkmen carpets that grace their home in Toronto.

> " Water is a Turkmen's life,
> a horse is his wings,
> and a carpet is his soul. "
>
> *Turkmenistan saying*

India

"The glow of a lamp represents life itself, something that goes beyond all religions."

Shilpa Mehta

Lamp of life

Indians throughout the world celebrate Diwali (or Deepawali), the Festival of Light, near the end of October and into November. For five days, oil lamps burn to banish the darkness of death, evil, injustice and ignorance. The creators of the India block chose the central image of an oil lamp to represent what Indians share — a connection that transcends myriad differences and barriers. An oil lamp is a common item used in celebrations of every kind. The glow of a lamp represents life itself, something that goes beyond all religions, explains Shilpa Mehta, one the blockmakers. In the warmth of this glow, family and community bonds are nurtured and strengthened.

India overflows with luxurious and colourful textile art. A kaleidoscope of regions, religions and castes inspires the many different styles and patterns of Indian embroidery. Each style is as intricately nuanced as the thousand-year-old rhythms of India's long-necked stringed instrument, the *sitar*. Sixth-century records document the long tradition of embroidery in India. More elaborate forms, such as metalwork using gold and silver wire, whitework and delicate *tambouring*, remain primarily a male skill, even today. Interestingly, the needle is pulled *away* from the worker in Indian embroidery.

Pieces of finely woven cloth, from the collection of Delores Chew, are layered so the textures and rich colours complement each other for dramatic impact. Among them, fine cotton muslin is superimposed onto a section of fuchsia silk from a *sari*. The cottons are embellished with a variety of stitches and gold-purl work, in addition to *shishadar*, a technique in which small pieces of glass or mica are secured to the material with the *shisha*, a buttonhole-like stitch. The many layers are an apt metaphor for the complex web of humanity in this country of more than a billion people.

Indian celebrations and special occasions are feasts for the eye. Weddings are usually extravagant affairs with many guests, providing a perfect opportunity to display exquisitely embroidered garments. Hindu brides wear two elaborately decorated *saris* during a marriage ceremony. The bride arrives wearing a white *sari* from her mother's family. When she goes "around the fire," a red *sari* given to her by her in-laws is draped over the first, so that half of each coloured top is showing. "It's so heavily embroidered that you can't even carry yourself," Shilpa testifies.

Even though Shilpa was born and raised in Africa, her Indian heritage is something she lives and breathes. For her, as for other Indians who have settled around the world, it is not about *where* she is, but about the everyday things, the rituals and celebrations in which she participates — and the beauty she creates through her exquisite embroidery.

Precious beadwork

When Towanna Miller found herself standing in the midst of the 140-acre campus of the Institute of American Indian Arts (IAIA) in Santa Fe, New Mexico, she was a long way from home — and loving every minute of it! Growing up on the Kahnawake Reserve in Québec, she had been encouraged to follow her artistic nature. Towanna learned Mohawk beadwork from her mother "around age twelve" and rapidly developed a respect for the ancient ways of her Iroquoian people. At IAIA, Towanna studied painting, dance, theatre, photography and grew to love traditional beadwork.

Now "back home," mother of three and a full-time beadwork artist, Towanna carefully researched Seneca patterns, wanting "to stay true to the Seneca heritage." She searched the collection housed at the Kahnawake Cultural Centre, a resource for information on the Six Nations. The Seneca were the largest of the original five members of the Haudenosaunee (or Iroquois) Confederacy, along with the Cayuga, Mohawk, Onondaga, and Oneida. In 1722, the Tuscarora took a seat in the League of the Iroquois Council to create the Six Nations. In the Confederacy, the Seneca are known as the Elder Brothers and the Keepers of the West Door; their Native-language name translates as "people of the great hill."

The Seneca managed to keep many of their old ceremonies and traditions alive, even taking them "underground" to avoid pressure from the "black robes," Catholic priests trying to convert the Native population. Towanna was able to reproduce some of that history in her choice of design for the Seneca block. It is a simple, yet very effective outline, worked in white beads on rich burgundy velvet, in a shape reminiscent of the caps many Woodlands people wore that were based on the Scottish "Glengarry" hats.

Each part of this 18th century design that Towanna reproduced is significant. She explains, "The border represents unity; we are all connected with the 'four corners' — North, East, South, and West." Domes are common in Iroquoian art, and these three stand for "the past, present and future of our world," she says. "The design in the centre dome is the ever-lasting life cycle, everything growing in our world." The Iroquois people came from the celestial world represented by the large top dome, where the "celestial tree provided the Sky Woman with seeds to bring to our world, where Turtle Island (North America) originated."

Towanna Miller reproduced this 18th-century hat worn by Chief Joseph Brant on one of his visits to King George III of England. Brant led the Iroquois nations loyal to the British during the American Revolutionary War.

Towanna, whose native name is *Kiaiatanoron* (meaning "precious"), loves researching and recreating beadwork art from old photos, "making them three-dimensional again." She has even replicated a Victorian-era Iroquoian wedding outfit and 17th-century pouch. "I make them 'reality' once more."

Tadjikistan

Rosa Abramov's son plays with one of the "treasured" pots.

Pots (and pans) of gold

Rosa Abramov came to Canada in 1990 from Tadjikistan — part of the Soviet Union until its 1991 break-up — when rising tensions and increasing turmoil made it unsafe for her and her family to stay. She brought with her only the few belongings she could manage and memories of a land that has undergone dramatic changes in the few short years since her departure. She speaks fondly of her hometown, Dushanbe, explaining that the meaning of its name, "Monday," refers to the huge market displays held there on that day of the week. She recalls with pride the perpetually snow-capped Pamir Mountains, known as the "Roof of the World," and the abundant flowers and greenery of springtime.

Adjusting to life here has not been easy. Language barriers made it impossible for Rosa to continue in her chosen profession as an electrical engineer, a vocation she worked laboriously to attain. As a young adult, Rosa, like other students who wished to further their education, harvested cotton from seven o'clock in the morning until eight o'clock in the evening, struggling to meet the 20 kilograms per day quota that was a condition of attending university. It was backbreaking labour, but as Rosa says, "We were young." She now has a career in a Russian travel agency, and although it is an occupation far removed from her previous life, it is one that helps her stay connected to her heritage.

Rosa stays connected in other ways as well: through her music and a few household items brought from home. These include articles of clothing such as the elaborately embroidered hat she has owned for more than twenty-five years that became the model for the Tadjikistan block. Her treasured pots and pans (which many times become a source of boisterous entertainment for her youngest, a Canadian-born boy) are her "must have" items, for without them she admits, "I can't cook my food."

Special recipes, such as her favourite *pilaf,* prepared in these familiar cooking vessels are a comfort to Rosa and her immediate family, who are alone here in Canada. She misses her native Tadjikistan for many reasons, most of all because it was the land of her childhood and of her two older children. She knows the experiences of her youngest child will be so very different from her own and those of his siblings. However, Rosa also knows that by sharing her music, her memories and her lovingly prepared home-style cooking, she is giving him the best of both worlds.

The power of words

Chloe Fox was born to a Christian mother but from the age of three was raised by a Jewish father who practised no formal religion. Among her earliest memories are times spent sitting on his lap singing Christmas carols. Her father's enjoyment of the holiday only added to Chloe's confusion and uncertainty concerning her identity.

She was twelve when her father remarried and relocated the family to Europe. Crossing the ocean led to much more than a new home — for Chloe, it also became a life-changing journey of self-discovery. On board the ship, she came across *Exodus*, a novel by Leon Uris that deals with the struggle to establish and defend the state of Israel. Chloe says, "I dove into it without coming up for air all the way by train from Naples to Geneva." Through pages and pages of powerful words, Chloe found at last the "connection to a part of me that was familiar but was not really identified till then."

Later, during a vacation in Israel, she felt "drawn to the whole idealistic concept of the Jews returning after 2,000 years and countless instances of oppression, to the land they had lived in as described in the Bible." A second visit, during which Chloe spent several weeks with people her own age, confirmed her feelings. "I was totally hooked and saw the whole lifestyle as being so full of purpose…and I wanted to be a part of it." One week later, Israel became Chloe's new home, and in time she converted to Judaism because "I identified heavily with a spirit and way of looking at life that seemed very basic, strong and life-affirming."

Later in life, Chloe's journey brought her full circle, back to Canada. Even so, like millions of Jews throughout the world, she maintains a strong connection to the land of Israel. Her block is rich in symbolism and depicts God's promise of a flourishing and prosperous Israel, despite years of difficulties. Fruits of the land are embroidered around a central parchment created by Jamie Shear, a Sofer StaM, a ritual scribe trained in calligraphy. The plants, known as the "Seven Species," are staple foods that have symbolized the abundance of the land since ancient times. They are still widely cultivated today and maintain their symbolic importance in modern-day Israel. Gold-work, traditional embroidery found on ceremonial fabrics, encircles the plants. The blue velvet background is typical of material used for *kipas* (skull-caps), for bags to carry *tallits* (prayer shawls), and for covering the *Torah*. The many hours Chloe spent creating this piece was a way for her to express the beauty of a land and a people that have helped her find her true identity.

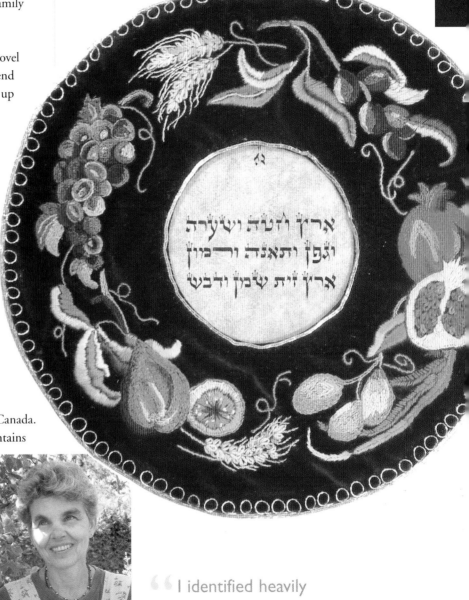

> " I identified heavily with a spirit and way of looking at life that seemed very basic, strong and life-affirming. "
>
> *Chloe Fox*

37

Colombia

> "My country is sunshine and coffee and people who are so lovely."
>
> *Aida Ramirez-Mesa*

Under the Colombian sun

A three-dimensional *Cattleya* orchid, with its luscious pink and violet silk petals, beckons from the centre of the Colombia block. "Look at me," it seems to say. "I am beautiful and worthy of your love." Its designer, Aida Ramirez-Mesa explains, "My country is sunshine and coffee and people who are so lovely. But to most, what comes to mind is the ugliness of the drug trade. In truth, only a tiny percentage of Colombians are involved in criminal activity. This is not who we are."

Aida came to Canada in 1987 to learn English for a job with a Canadian company in Colombia. Studying in Toronto, she met her future husband, Pablo, a Colombian who had been in Canada since he was nine years old. At first she wasn't interested in him. He was younger than her and, to a great extent, had adopted the Canadian way of life. But he persisted, brought her flowers at school, and in time, she fell for his charm.

Like Colombia's image, their marriage has endured many challenges. Within one month of their wedding, Pablo had an accident and couldn't work for eleven months. He returned to work for a few years only to be laid off. Later, he survived cancer thanks to a bone marrow transplant. Aida is devoted to caring for her husband and adolescent sons, Camilo and Felipe. She has raised them with the values revered in her country: respect for elders, politeness and courtesy. They celebrate Christmas in the Colombian way. Starting on December 16, they spend time each day singing around a Nativity scene and then festivities culminate at midnight on the 24th, when Little Jesus brings gifts. Aida is very proud that both her sons are fluent in Spanish. They love to eat *tamale* prepared by their grandmother, and cannot live without their daily *arepas*, cornbread freshly baked on top of the stove.

In the Colombia block, the national flower sits atop two layers of bright yellow sunshine, finely appliquéd and edged with tiny blanket-stitches. Beneath it are several layers of reverse appliqué known as *mola*. The name refers to the technique and to the blouses on which it frequently appears. This traditional work done by the Kuna Indians features boldly coloured, superimposed fabrics. Bits are cut away and stitched to expose the beauty hidden in layers beneath. Aida chose colours that represent her country: green for the mountains where coffee beans ripen, blue for the Pacific and Caribbean oceans that border Colombia, and yellow for the warmth of her people. The artistry of her block and of *mola* encourage the viewer to look underneath, to see the different layers, just as Aida encourages others to take a second look and see the people of Colombia for who they truly are.

A purposeful life

Just as her ancestors have since time immemorial, Hilda George, of the Carrier Nation, roams the mountainous interior of British Columbia where Takla Landing lies nestled between the Rocky Mountains and the Coastal Range. Surrounded by heavily forested mountains, cool lakes and tributaries rushing to meet the upper Skeena and Fraser Rivers, Hilda is in her element. The teachings passed on to Hilda, down a long line of foremothers, foster a sense of peace and appreciation for the abundant natural resources and her own strong Dakelh roots.

Deep within her heart, Hilda hears the call to teach her people, keeping the "old ways" alive. Young people eager to learn the traditions often accompany her on hunting expeditions to Moose Valley. "They stand around watching me skin, scrape, clean, smoke and tan moose hides," she explains. She also conducts workshops within the community to pass on the Dakelh language, which is Athapaskan in origin, as well as methods of making and beading traditional clothing. "I love to teach," Hilda says enthusiastically. There could be no higher purpose for her life.

Her nine children experienced a similar education while growing up. Her daughter Kathaleigh honed the skills learned from her mother, putting them to artistic endeavours such as making jewellery and moose-hide dresses. Hilda also sews and beads moccasins, vests and jackets for sale in Prince George. An example of her work, taken from a pair of moccasins in moose hide, tanned and smoked by her own hands, is featured on the Carrier block. The beading is done in a pattern made more beautiful because of its simplicity.

The Carrier call themselves Dakelh-ne, meaning "people who go upon the water." They earned the name "carrier" from English traders (and *porteurs* from the French) because of a curious custom among the easternmost bands. When a Dakelh man died, his body was cremated; out of respect, his wife would carry the ashes and bones on her back for a period of mourning. Cremation was only abandoned in favour of burial in the 1830s, under pressure from white men. Today, setting up a headstone over a grave is a special occasion attended by everyone in the community. Together the people honour the deceased with songs and dances.

Hilda George feels compelled to pass on her heritage to Dakelh children. Many of today's mothers and fathers were not taught the ways of their people and are unable to teach their own children. The rewards of her work are felt deeply every time she hears a child speak their Native language or takes pride in creating traditional clothing and art. She is on a mission and loving every minute of it.

Carrier

Dakelh-ne

Heirloom Carrier bag provides floral motif for reproduction in the Carrier block.

Tuvalu

Eight standing together

In the middle of the sparkling South Pacific Ocean rests a tiny nation of atolls, small islands formed by coral and volcanic rock. Though small in size, Tuvalu possesses an enormously rich heritage, as deep and fascinating as the ocean that surrounds it.

While Tuvalu's name means "eight standing together," there are actually nine islands, though one has very little land above water and is uninhabited. For hundreds of years, Tuvalu was isolated from other countries and largely untouched by foreign influence. The atolls provoked little interest until the 1800s, when whalers, slave traders and British colonizers turned their attention to the islands. Missionaries brought Christianity to Tuvalu, and today most islanders remain devoted Christians, as reflected in Tuvalu's motto: "Tuvalu for the Almighty." Christian beliefs have been woven into the historic traditions of deep respect for family, community and the environment. Their lifestyle is an example to the international community, as Tuvalu is the only nation in the world above reproach for human rights violations in recent years.

Manuila Tausi came to Canada from Tuvalu to pursue higher education in 1997. The materials he contributed to the block are dear to him and linked to his own warm memories of his island home. "The dancing skirt is worn by men and women during the *fatele*, or traditional dance. A group of men in the centre of a circle drum on wooden boxes or metal containers, and the rest of the group sing and clap. In the olden days, people wore these skirts made from *pandanus* leaves in their everyday life." Pieces of the grass skirt are featured in the block, arranged in a geometric pattern.

While the ocean provides many of Tuvalu's needs, it also threatens Tuvalu's future. Rising sea levels caused by global warming may eventually endanger the country's existence. Since they live in such a dependent relationship to the sea, seashells hold special significance for Tuvaluans. Manuila recalls, "The seashells remind me of the central role the ocean plays in Tuvalu's livelihood. They can be worn as jewellery during the *fatele*, but today they are mostly given as farewell gifts to people who are leaving for a long time." Manuila has said farewell to his life in Tuvalu, but will always carry his memories of the "eight standing together" into his future, simply by singing his national anthem:

"We build on a sure foundation, when we trust in God's great law; Tuvalu for the Almighty, be our song for evermore!"

Manuila Tausi relaxes with his wife and son.

Love letters

The most densely populated country in Central America, El Salvador's volcanic soil provides the perfect climate for it primary cash crop: coffee beans. Nearly ninety-five percent of the government's revenue comes from this popular commodity. Coffee cultivation also accounts for the vast disparity between the wealthy and the dirt-poor *Mestizos* who harvest the ripened red beans. El Salvador (which is Spanish for "the saviour") has a violent political past as well. Fighting throughout its history has cost countless lives, but never more so than in the 1980s when the military junta, guerrilla forces and roaming "death squads" caused the deaths of thousands in a civil war. Around 75,000 people were killed during the twelve years of war; more than 300,000 fled or emigrated.

Against this backdrop, social activists such as blockmakers Martha Viscarra and her sister, Vilma Palacios, worked with the poor. University-trained social workers, they are also women of faith who believe strongly in social justice. They taught poor women how to market their embroidery and other crafts to help sustain their families. Their work letting Salvadorans know they had "human rights" was not appreciated by the government, and in 1987 Martha was captured, imprisoned and tortured.

She was freed unexpectedly after two weeks of interrogation. Martha says it was "miraculous," but did not understand. Her torturers kept repeating something about "letters." Who had written them? Who were her connections, particularly abroad? Martha knew nothing of these letters. After her release, however, she was contacted by an Anglican pastor from Montréal she had met once. His church members had sent eighty-four telegrams to the authorities in San Salvador on her behalf. He invited her to Montréal, where the congregation that had prayed for her welcomed her warmly. Overwhelmed, she wept openly. "Don't ever think that writing a letter isn't worth it. A letter can save a life!" she told them.

Martha had wanted to stay in El Salvador but chose to emigrate because her family members were in danger if she continued her work. She chose Canada because it was on the same continent. Her family "thought I could walk there if I wanted," she recalls.

Poor health prevents her from working in her profession now, but Martha often sends money to El Salvador, scraped together by selling cast-off items she refurbishes. "Even ten dollars a month can buy a lot of beans and corn at home," she reminds us. With very fine wools and handwoven fabric that she imported from El Salvador, Martha and her sister embroidered a brightly coloured, sunny village of whitewashed houses. A stylized dove of peace flies above a *guanacaste* tree representing equilibrium, sacred creation, stability — the very qualities that the sisters, with their unbroken spirits, portray.

El Salvador

" A letter can save a life! "
Martha Viscarra

Oman

In full colour

In many ways, Oman, one of the first nations in the Middle East to embrace Islam, in A.D. 630, remains the most traditional country in the Gulf region. Yet, in just as many ways, it has become the most progressive. A once-prosperous seafaring nation with a 5,000-year history, the country was in economic trouble by 1970, when present-day Sultan Qaboos bin Said seized power from his father in a bloodless palace coup. Many of its wealthy citizens had escaped to other countries, leaving a conflict-ridden, "backward" nation of Arabs, Asians, Africans and Baluchi.

By 2000, Sultan Qaboos and his people had cause to celebrate. In just thirty years, Oman had been transformed into "a prosperous and stable, modern state." Considering the country's comparatively modest oil reserves, profits from which quickly went into the building of roads, schools and hospitals, the recovery has been a remarkable achievement. The country's semi-feudal economy has been modernized; its oppressive social restrictions from the previous rule repealed. Oman's appointment of a female ministerial under-secretary was a first for a Gulf nation, but not the last for Oman.

In rural hamlets and coastal villages, however, daily life has changed little in centuries. Here, men are often seen garbed in bright blue, loose-fitting, floor-length shirt-dresses called *dishdashas.* Curved, silver-sheathed *khanjar* knives often dangle from their waists. Along with other silver handicrafts, Oman is renowned for these ceremonial knives. Here, too, women's dress is more colourful than the heavy black robes common in much of the Gulf region. Bright printed dresses are wrapped with even brighter shawls and veils.

These brilliantly colourful traditional fabrics are often hand-embellished with sequins, silver threads and embroidery for special occasions. Women take pride in their apparel, says our blockmaker, Christa Ohlmann. "Why dress up for strangers," she asks, "when we should present our best to the ones we know and care for most?" Christa, a young mother of three married to a Montréal physician, donated the elegant fabrics that form the Oman quilt block. She modeled some of her rainbow-hued garments with enthusiasm for her Canadian female visitors. Respectful of her Muslim upbringing, Christa explains that such a display is "for women's eyes only," or for the men in their immediate families. So, too, are the photos Christa was happy to share of a fashion-show presented by some friends back home in Oman. Turning the pages of the photo album, a sisterhood of laughing, smiling faces revealed the fun and excitement generated from sharing a common love of new fashions, fabric and glorious, glamorous colour, and from spending time together. Then, it was time for Christa to dress for her husband's return home.

Three grandmothers

"I had a vision from the Creator to do a wampum belt," relates Shirley Baker, a long-time quilter, grandmother and a member of the Lenni Lenape (Delaware) Nation, Moravian of the Thames band. Shirley consulted an historian, who confirmed that wampum belts are tangible evidence of agreements between nations and a way to document special events. From the first moment she heard of the Invitation Quilt Project, Shirley recalls, "I felt I was meant to be part of it." Even though she travels a great deal as a program officer for Revenue Canada, Shirley took the time to locate two artists, members of the same band, to help her. "They create art, not craft," says Shirley of her imaginative colleagues, Marilyn Tobias and Mary C. Whiteye. Together the three women planned their block and incorporated wampum into the design.

Darryl Stonefish, a local librarian and the author of several books on the history of the Nation, provided much insight. He explains that the three clans of the Lenni Lenape — Wolf, Turtle and Turkey — are depicted in the block. There is a wampum belt at the top and a clothing art pattern showing a Thunderbird in one corner. Part of a "Delaware land belt" has been reproduced in purple and white wampum beads.

Mary C. Whiteye, well known as an award-winning powwow dancer and dance teacher, created the traditional ribbon-work on the border. Accomplished in ribbon- and bead-work, Mary appreciates the old ways but likes to experiment with new textiles and procedures. She enjoys learning. "It enhances appreciation of your community and is an active way to bring history forward into the future," explains this busy grandmother who recently completed a diploma in marketing.

Beading, leatherwork and quilling are Marilyn Tobias' interests. She clothed the wolf with fur and beading, and says she loves to make mitts best of all. "Mitts are special because they are big and warm and I love working with deer hide and moose hide," she says. Marilyn misses her friend Elder Betty Pedonaquotte, who is now in a nursing home. Marilyn credits Betty with teaching her many things including how to find medicinal plants in the bush. Participating in the Invitation Project was just what Marilyn needed to get her involved again. "Maybe all I need is a new pal because I stopped when Betty was no longer able to visit," she reasons. Occupied as a community health representative for the reserve, Marilyn confides, "Crafting is a nice break when all worries are put aside."

Made in deer hide, embellished with beads, birchbark, turkey feathers, fur and satin ribbon, this special block embodies the nurturing love of three grandmothers. Mary says, "The block is done for the next generations, our children and grandchildren."

Delaware

Lenni Lenape

> " They create art, not craft. "
>
> *Shirley Baker*

Marilyn Tobias, Shirley Baker and Mary C. Whiteye

Samoa

Treasures in heaven

Francine Duckworth knows about rain and humidity. Former missionaries, she and her husband Larry were appointed to American Somoa and Samoa (formerly Western Samoa) from 1977 to 1997. "When it isn't raining," she says, " it's ninety-nine-percent humidity." In Samoa, cloth eventually mildews, metal rusts and wood falls prey to termites. Archaeologists suspect this is one reason few cultural artefacts made from plant material have survived. Laughing, Francine says: "It makes you a big believer in the Biblical verse: *Put your treasures in heaven where moss and rust do not corrupt.*"

In 1977, Francine and Larry, along with their four young children, began preparing for their new life abroad. First, they had to consult an atlas: Where exactly was Samoa? Pinpointing it in the south-central Pacific Ocean, halfway between Australia and Hawaii, they saw it was nine islands. Only four of them are inhabited — Upolu, Savai'i, Apolima and Manomo. For the next twenty years, the family lived and worked among communities of ethnic Samoans, Euronesians (European and Polynesian ancestry), and a small population of Europeans.

Everyone adapted well, particularly the children, who quickly absorbed the language. No one was more surprised than Francine however, when her daughter came home from school with an A in Samoan and a B in English. While Francine was still working through language studies, the children were carrying on conversations with their Samoan friends and neighbours. The real evolution was felt after a few years when a visitor from the States asked if the children missed *home.* While all the things Francine missed careened through her head, the children looked at each other and said: "*Home?* Samoa's our home!"

In the early years of working in small, rural communities in a third-world country, the law of supply and demand could stretch to a three-month wait. On her first furlough home, Francine, with her irrepressible sense of humour, told people: "After four years on the *rock*, I'm ready for freeways, fast food and friends." In reality, she was far from ready! "I walked into a store and there were rows of jumpers, skirts and dresses. It was too much." She fled. Later, fearing she would look "too much like a missionary," unable to blend in, she dispatched her mother to select outfits in fashionable styles and fabrics.

In Samoa, making *siapo* fabric exclusively from bark of the paper mulberry tree is one of the oldest cultural art forms. The cloth, similar to tapa, is used for both functional and ceremonial purposes. Elizabeth Ferguson sewed a modern interpretation for the Samoa block. This nearly extinct art form is represented using traditional colours of red, black and brown, in leaf motifs appliquéd on a cotton background.

The land of the Thunder Dragon

A mysterious little jewel of a country, Bhutan, or Druk Yul in the national language of Dzongkha, is tucked into the lofty Himalayas between China and India. English has become an official working language as well, with Bhutanese students being trained at institutions such as the University of New Brunswick to teach it in Bhutan. Their king is intent on preserving all that is sacred and valuable from their past, while moving cautiously into the 21st century. Already some incongruities exist: soccer-mania is overtaking the national sport of archery, and the sounds of loud video games echo in the streets of the capital, Thimpu.

The nation remains greatly influenced by the values of Tantric Mahayana Buddhism. It is the only country to retain this form of Buddhism. *Stupas*, or receptacles for offerings, line the roadsides along the routes the high lamas may have taken. Most Bhutanese are farmers, raising herds of yak, sheep or cattle at the higher altitudes and crops of rice, chilies, and other vegetables at the lower ones. About twenty percent of the country's land mass, including almost three-quarters of its forests, has been set aside in ten reserves to protect fragile ecosystems. This is the land of rarities: blue poppies and blue sheep, snow leopards, and the takin — the national animal, whose nearest relative is the Arctic musk ox. There are also orchids and tigers in the tropical forests and about forty species of rhododendron in the temperate forests.

But even more vividly than the spectacular surroundings, Jamie Zeppa remembers the hospitality of the Bhutanese people. "I was there to teach, but the people had to teach me everything," she says. "I remember when I was lost, people would drop everything to make me a meal, invite me in to eat, and then apologize that they had no gift to give me!" She was, in fact, so enchanted with the generosity of the Bhutanese spirit that she converted to Buddhism, married a Bhutanese man, with whom she has a son, and wrote a book about her experiences in Bhutan called *Beyond the Sky and the Earth*, a traditional expression in Bhutan.

Jamie provided the embroidered, coarsely woven woollen fabric comprising the Bhutan block commonly used for creating saddlebags, wall hangings and floor runners. Finely woven cotton or silk is used most often for the mandatory style of national dress. Men wear the kimono-like *gho* and women, the ankle-length *kira*. Weaving is an art form, especially in the eastern high mountain region, where women weave in the open air on portable back-strap looms. It takes up to a year to complete the cloth for one *kira*. It is small wonder that they are considered part of a family's wealth and are sometimes used as a form of currency!

England

In an English country garden

Sally is a passionate needlewoman and a fervent gardener who wouldn't consider picking up needle and thread until the last spade is put away for the season, lest there be a speck of dirt lingering under her fingernails.

A longstanding member of the local Green Thumb Society, Williamstown's Sally Blacker has artfully demonstrated her love of abundant floral designs in the eloquent "needle-painted" block she made to represent her English heritage. The swatch of linen she brought "from home" thirty-five years ago was deemed the only suitable canvas for Sally's enviable collection of imported embroidery threads. The subject of excited discussion, the eventual design — English wildflowers spilling from a gilded, bone-china heirloom teapot — is a subtle and clever allusion to England's beloved teatime. Writer C.S. Lewis would have approved, since he probably spoke for the entire British Commonwealth when he sagely declared: "You can't get a cup of tea large enough to suit me."

Sally's real challenge lay in narrowing her selection of flowers to evoke visions of English woodlands, fields, hedgerows and gardens. She found it tricky to choose just one wild rose, the universal "Queen of Flowers" and progenitor of over 30,000 species. White with a pink edge seemed a good compromise between the white Yorkshire rose and the red Lancashire rose. A Tudor rose, perhaps? "But I'm not absolutely sure," she admits.

England's blooming countryside has inspired some of the greatest writers, painters and composers, and it could do no less for Sally. She called on childhood memories to work out the design. Brilliant carpets of bluebells beckoned from green woodlands. Wild poppies were the "most fun." She remembers them growing everywhere, especially in farmers' fields, where they bloomed among the wheat, barley and oats. Trailing ivy conjured images of the venerable schools, castles, churches, country cottages and old stone walls scattered throughout the country. Foxgloves, ox-eyed daisies, buttercups and bitter vetch fell gracefully into place. A fluttering butterfly represents the "bug" often found tucked into English floral needlework.

Sally is as passionate about colour in her English country gardens as she is in her embroidery. Coaxing nature's resplendent riot of colour and variety into bloom didn't happen overnight. Given to meticulous planning and hard work, she views her stitched contribution as a "challenging labour of love." And embroidery is indeed a "true love" for Sally. Other than when she was a new mother raising two sons, needlework has always been a passion for her. "When everyone was going out with boys," she says, laughing, "I was learning embroidery from a little old lady."

Keepers of the wampum

The Onondaga, or "people of the hills," were one of the League of Five Nations, later joined by the Tuscarora to form the Six Nations or Iroquois Confederacy, along with the Mohawk, Oneida, Seneca and Cayuga. The alliance is known also as the Haudenosaunee (or "people of the longhouse") Confederacy. The league itself was symbolized by the longhouse, the type of homes they built, with the Mohawk guarding the east door, the Onondaga tending the central hearth, and the Seneca guarding the west door. Flanking the Onondaga were the Cayuga on the south wall and the Oneida on the north.

Traditionally, the original five nations had warred with one another, but legend says when the Peacemaker came to them, he carried with him the "great law of peace" that included the principles of peace, equality, respect, love and justice. Members of the Confederacy agreed to protect the peace, the natural world, and the generations to come, while retaining sovereignty over their own nations. As a guiding principle, the effect any action will have on seven generations must be taken into consideration. The Onondaga, who now live in southwestern Ontario, have the white pine tree as their symbol. It represents the Tree of Peace that was planted when the Confederacy was founded. All articles of war were buried beneath the Tree.

Known as the Elder Brothers, Fire Keepers, and the Keepers of the Wampum within the Confederacy, the Onondaga used wampum as a medium of exchange (wherein different lengths of beads were given values) and to record treaties. The word "wampum" comes from the Narragansett word for "white shell beads." Wampum beads are made in two colors: white beads (*wompam*) from the Whelk shell, and purple-black beads (*suckáuhock*) from the Quahog. The seashells were threaded on sinew or woven into belts and sashes, often with symbolic meaning. The historic Two-Row Wampum belt of the Iroquois symbolizes mutual respect and peace between the Iroquois and the European newcomers, establishing the agreement that neither group will force their laws, customs or language on the other.

When the Six Nations Women's Singing Society made the Onondaga block, they worked in three sizes of iridescent white beads set on a background of deep purple velvet, because those are the colours of wampum. They used a raised style of beadwork characteristic of the Woodlands nations. Twenty domes embroidered in white cotton floss create an inward-facing border that frame the simple but dramatic piece.

Nicaragua

The masked
El Güegüense
symbolizes aspects
of the strong, defiant
Nicaraguan spirit.

*Happy Howells Mireault,
César Gaitán, Anneli Tolvanen*

El Güegüense

A desire to make a difference in the lives of others drew Finnish-Canadian Anneli Tolvanen to Nicaragua to coordinate Casa Canadiense in Managua. The centre focuses on establishing links between Canadian and Nicaraguan communities. There she met César Gaitán, who lent his support to the work of the centre. Together they worked on a storybook library project for children from impoverished families.

Along the way, their common goals and growing love for each other led to marriage. In 2000, Anneli returned to Canada, where she met Happy Howells Mireault, who manages an international partnership between the YMCA of Northumberland, Ontario, and the YMCA of Nicaragua. Only in 2003 was César finally able to immigrate to Canada to join Anneli.

It seemed inevitable the three should work together to create the Nicaragua block. Although the country is one of the poorest nations in Central America, Anneli sees the people as "open and hopeful." This is particularly true of the youth, she says. With pride and hope the children embrace national heroes like baseball's Dennis Martinez (El Presidente). Even the poorest children learn to play the game, improvising with a stick for a bat and a rolled-up sock for a ball. In this "nation of poets," Rubén Dario (the "Prince of Spanish-American literature") is as venerated as their sports heroes.

While Anneli and César hone their fit into Canadian society, they invariably miss some elements of Nicaragua. For César, it's the thrum of street life, the constantly changing sights and sounds that mimic live theatre. Years of dictatorship, wars, natural disasters and a depressed economy have, nonetheless, given way to periods of hope and creativity. Being a poor country is difficult enough, but they also straddle an active volcanic and earthquake zone. People are in a constant state of "unpredictability…living on the edge," says Anneli. In light of this uncertainty, the country's artists and athletes are a reflection of their hopes — bigger than life, proudly rising above it all.

Pride is an appropriate theme for the quilt block, which was designed, handpainted, and embroidered by Happy. With its emphasis on El Güegüense. This 300-year-old piece of traditional theatre and dance depicts the strained relationship between the conquistador and indigenous Nicaraguans. It also symbolizes the strong, defiant Nicaraguan spirit. In Managua's main festival, Toro Guaco, masked folkloric figures reveal their public and private faces. El Güegüense, wearing a black horse mask, and other indigenous characters taunt the pale-masked Spanish conquistador. From historical battles up to present-day conflicts, fought increasingly at the ballot box, it is the unpredictable and confounding trickster character of El Güegüense that often still wins the day.

The collector

Growing up in Serbia and Montenegro, then part of Yugoslavia, Dragica Bogdanovic was surrounded by beautiful pieces of embroidery collected and created by her mother's aunt and her paternal grandmother. Her parents came from two very different regions, one influenced by Turkish traditions, the other by Austro-Hungarian customs. From an early age Dragica was exposed to these two cultures and their textile traditions. "Everything was mixed," she says, and it was not long before the "handwork bug" bit her too. "I was always interested in all the things that my mum taught me, and I learned also in school. I always loved to work with my hands — knitting or crochet, or embroidery."

Now Dragica is an avid collector and creator, enchanted by the magic of transforming fabric into beautiful works of art with the help of thread and skilful hands. Her prized collection, started by her mother's aunt, overflows with handmade lace, embroidery and fine crochet work. "I even have my sampler that I did when I was nine," she reveals. She had her favourite shops in Serbia, and now in Canada she continues to scour the shelves for handmade heirlooms. On her last visit home, she bought some old-style pieces of needlework made by women in refugee camps. "You can't find that anymore, and I simply can't resist the stuff." Dragica is somewhat disheartened to think that the traditional embroidery she treasures is a dying craft.

Dragica spent hours searching for just the right themes for her block. She settled on a rich floral pattern featuring one of the favourite flowers in Serbian embroidery, stylized peonies, to surround Serbia's national symbol. Strongly influenced by Oriental and Byzantine styles, the elements in Serbian embroidery are frequently outlined in black.

In 1988, Dragica and her husband came to Canada with their young son. It was thirteen years before she returned to Serbia for a visit. "It was a great shock," she admits. "When I went, things had changed [after the break up of the country]. I enjoyed my stay there, but it was different."

Her elderly parents have now come to live with Dragica in Canada, and their belongings are crammed into her already crowded townhouse. They brought furniture, trunks and even more pieces of beautiful embroidery. Among their treasured possessions is family correspondence from the 1800s. "It's a good thing I am sentimental about the past, and I am someone who loves junk," she says with a hearty laugh.

Serbia and Montenegro

> " It's a good thing I am sentimental about the past. "
>
> *Dragica Bogdanovic*

Kenya

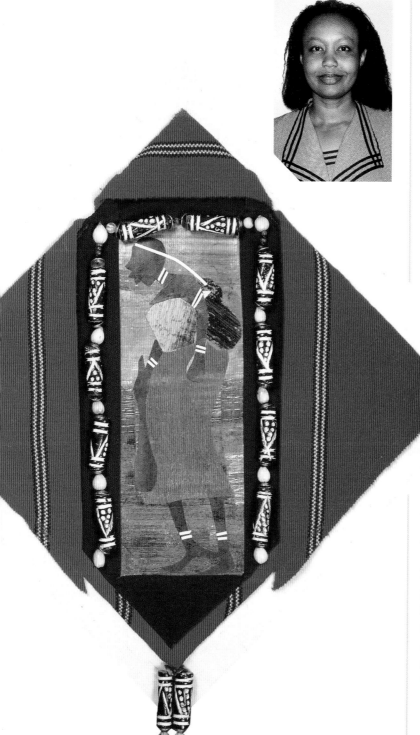

Citizen of the world

Jacqueline Nduta Mochai was almost thirty when she left Kenya to pursue studies in Montréal. Unexpectedly, the first challenge she encountered was the language; her French was different from the Canadian version. She struggled to fully comprehend her professors. In addition, she was alone for the first time, having always lived with her family. Each day she moved through the cultural mosaic of her new city wondering where and how she would fit in. At night, these worries prodded her loneliness and brought tears.

After about a month, in a moment of weakness, she told her father she was "ready to pack her bags." Her father, whom she says exemplifies the Kenyans' enterprising work ethic, remained calm. He said a lot of reassuring, logical things, but only four words resonated: "Things will get better." Eventually her ears became attuned to the different speech inflections. With renewed determination, she focused on obtaining an MBA with a specialization in international business and human resources. On difficult days, missing her family remained her heaviest burden.

At one point, she shared these feelings with a fellow student. "I went on and on about *my* troubles," she recalls, her dark, intelligent eyes lost in the memory. "Don't you miss your family?" she finally asked him. He nodded, and then told her they had all perished in the war-torn country he had fled. At that moment, she realized she had lost sight of the suffering of others while nursing her small sorrows.

Presently, Jacqueline is a human resources consultant with the federal government in Ottawa. Her time in Canada has been marked by personal growth and success — in her work, her diverse friendships and in the community organizations she has joined. The African Spiritual Fellowship, one of these organizations, connected Jacqueline and her sister, Janice Wanjiku Mochai, to the Kenya block. It features a nomadic Masai woman, created with banana leaves, carrying her possessions in a handwoven sisal basket (called a *kiondo*). Framing her are beads carved from bone, tiny mineral stones, wood and seeds. Handwoven cloth in bright red is draped to resemble the hooded-blankets worn by the Masai males, for whom the striped pattern is reserved.

Packed boxes stacked in Jacqueline's small kitchen hold her possessions. Her face is radiant as she talks about the home she has purchased. She likes Ottawa but shrugs at the idea that it will remain a permanent address. She excitedly lists all the things that could precipitate change. The woman who once cried herself to sleep is gone, replaced by a citizen of the world. Smiling, she says, "Who knows what the future holds?"

The language of her love

The town of Maniwaki lies in the Outaouais region, home to Pauline Decontie and one of the nine bands of the Algonquin Nation in Québec. The natural beauty of the forests, lakes and rivers traversed by her Algonquin ancestors surrounds her. Roaming the Ottawa Valley as semi-nomadic hunter-gatherers and travelling great distances in birchbark canoes, they called themselves Anishinabeg, meaning "the people."

For the past fourteen years, Pauline has taught the Algonquian language through the Kitigan Zibi Education Council on her reservation. Inspired by the spiritual presence of her ancestors, Pauline's passion for the work is compelling. "I love being with the children. The language is disappearing and teaching it gives me satisfaction," she says. To her delight, the interest in language revival among the Anishinàbe has increased steadily over the years. The Algonquian language family is the largest Native-language group in North America, with many related languages and dialects. However, not all speakers of Algonquian languages are necessarily Algonquin. Many place-names in the Ottawa region are evidence of the impact of the language.

Working with children fills Pauline's heart with gratitude for the opportunity to share Algonquin culture through language. It reminds her of something her grandmother used to say, "Be thankful for what you receive around you." As a child, Pauline would tag along on her grandmother's berry-picking excursions. Whenever they finished picking, her grandmother would take a coin from her pocket and set it on the ground. Not brought up in the traditional ways, Pauline was curious and questioned her grandmother. "You have to put something down to show your appreciation to the Creator," grandmother responded patiently. "This way the berries will always be there." It became a lesson that Pauline lives by.

Pauline hopes for better understanding of the Anishinàbe people and their way of life. The Algonquin block was the perfect opportunity for her to proudly represent her people. The design was a gift from an elder whose grandmother used it. The typically simple beaded and embroidered star pattern would have decorated moccasins, using naturally dyed porcupine quills and moose hair. The star is repeated four times around a four-direction symbol. This symbol and the number four are prominent themes among the Anishinàbe people. Algonquin oral culture talks about the four races — white, yellow, red and black — and the need for cooperation by everyone to save and protect Mother Earth. In making the Algonquin block, Pauline has joined many others in a profound effort to encourage harmony among the four races living in Canada.

Algonquin
Mamiwinini

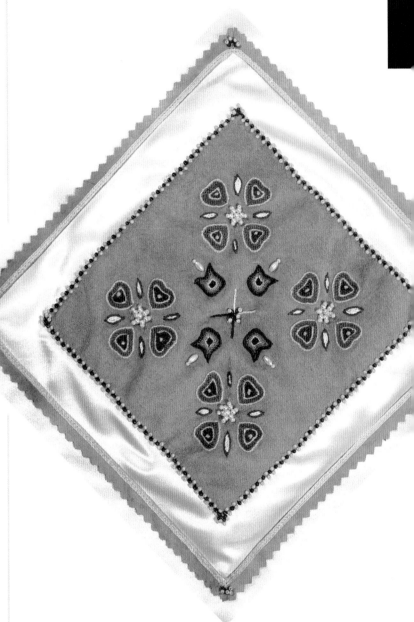

" Be thankful for what you receive around you. "
Pauline Decontie

Estonia

Soul sisters

Helle Arro, Maaja Matsoo and Ellen Leivat were just infants in 1944 when their families fled to Sweden to escape Soviet rule in Estonia. There, Helle's and Maaja's parents became friends. In the years that followed, both families immigrated to Canada. The two families even shared a home at first, and the two girls became as close as sisters. Ellen's family also came to Canada some years later, and she eventually married Helle's second cousin. Decades afterwards, while looking through old photographs, they discovered that Helle's husband, Ellen's husband and Ellen had all attended the same Estonian nursery school together in Sweden.

Now all three women live in Toronto and remain great friends. Helle, a librarian, Maaja, an early childhood education teacher, and Ellen, a social worker, are all members of a sorority called Amicitia, which means "friendship." This organization was revived after Estonia regained its independence in 1991 and gives the three women another means of maintaining their friendship.

In bygone days, Estonian girls started very early to knit, weave and embroider items for their wedding trousseaux. Traditionally, brides also made a small gift, such as a pair of mittens or socks, for each wedding guest. When Ellen's daughter announced her engagement, the trio decided to make a quilt for her wedding gift. Soon, the project expanded to six quilts — one for each of their children. The masterpieces piled up as the women waited for each child to marry. Then, in keeping with the times, they changed the rules. A quilt would be presented on each child's wedding day or fortieth birthday — whichever came first!

The women and their families participate in many cultural activities, such as choirs and numerous festivals celebrated in the large Estonian community in Toronto. They feel strongly about keeping alive the traditions of their heritage, which were severely affected by Estonia's fifty-year occupation. Much of the country's national literature was destroyed, but despite a scarcity of materials, the techniques of a rich textile history were discreetly passed on from mother to daughter. Much of the oral traditions of song, verse and runic chant (which dates back to the first millennium B.C.) also endure.

As blockmakers, the three friends proudly proclaim the survival of their textile culture. Estonians appreciate natural fabrics, such as linens and woollens used in their national costumes. Many feature an intricately embroidered blouse and a distinctive woven belt called the *vöö*. The loveliness of the embroidered flowers and exquisite woven block border, reminiscent of the *vöö*, are indications of the profound love Estonians have for their homeland. The block bears witness to the strength of a proud, hardworking people and to an enduring friendship characterized by generosity and mutual caring.

In bygone days, girls started very early to knit, weave and embroider items for their wedding trousseaux.

Maaja Matsoo, Ellen Leivat, Helle Arro

Bittersweet lace

The Portuguese island of Madeira has been called the "Pearl of the Atlantic," and from this pearl come some of the most sought-after delicacies and desirables in the world. Among them is Madeira cutwork embroidery, a renowned and highly valued symbol of Portugal's finest commodities. Yet the history behind this craft reveals a bittersweet reality.

> 66 Music makes my heart sing; it keeps me active and alive! 99
> *Olivia Abreu*

Olivia Abreu was only seven years of age when she began learning the delicate and difficult art of Madeira cutwork embroidery from her older sisters. Being naturally talented and inclined to the craft, she learned how to create many different styles and was able to sell her work to help support the family financially. By the age of eleven, she had finished her basic schooling and was working full-time embroidering at a highly skilled and professional level. There was no time to play. Free time was dedicated to chores. The women found time to socialize by working at their craft in groups. Mothers would sing, tell stories and teach the children new stitches as they created their intricate patterns.

"Sometimes," Olivia recalls with a gentle sadness in her voice, "we had to work all night to meet the deadlines." Perfectly stitched, unique Madeira pieces were worth thousands of dollars in the world market, but even the most talented embroiderers were paid very little for their diligent efforts. Most women, including Olivia, lost part of their childhood as well as a chance at a formal education because of their involvement in the embroidery industry. Yet, despite these hardships, Olivia enjoyed the camaraderie of working and sharing her days with the other girls in the village. Today, she maintains that same strong work ethic and generous nature. At her home in Toronto, she continues the tradition of offering guests Madeira wine and honey cake on special occasions.

Since coming to Canada with her husband, Olivia has kept her culture close to her heart and is very proud of her homeland. She invests much of her time and energy in a folkloric group that promotes the rich costumes, embroidery and cuisine of Portugal in public displays and shows. Music and dance play an essential role in Portuguese culture, and in Olivia's own life. "Music makes my heart sing; it keeps me active and alive!" she says in her lyrical Portuguese-accented English. Centred in the lacework she created, Olivia has depicted a folk musician and a dancer in traditional costumes. Just like the *fado*, a tragic serenade likely played by the guitarist, the history behind Olivia's beautiful Madeira embroidery is a bittersweet melody.

Slovenia

Ann-Marie Šemen lovingly created the Slovenia block to honour her father and those who came before.

Honour thy father

Ann-Marie Šemen loves to stitch. Bits and pieces of "works in progress" linger in her car, at her workplace and at home in Oshawa, Ontario. While on vacation a few years ago, Ann-Marie visited the Invitation Project in Williamstown, at the urging of her bed-and-breakfast host. She left with an armload of reading material and the knowledge that the Slovenia block did not yet have a creator.

At first Ann-Marie chased away thoughts of becoming involved, as her plate was already full running her own hair salon. However, on the way back home, with traffic at a standstill on Highway 401, she leafed through the brochures and began to feel excited. Her enthusiasm grew further when her father, who generally did not fully appreciate Ann-Marie's needlework, seemed moved by the notion that she could apply her favourite pastime to recognize the legacy of Slovenia, a homeland he had left behind decades ago.

Steve Šemen was barely eighteen when he concluded that Slovenia offered him few opportunities for the future while under communist rule. Both his parents had passed away and one of his brothers had already settled in the United States. In January 1952, alone, he courageously swam across a river to Austria, where he stayed temporarily in a refugee camp. He applied to several countries, but Canada was the first to open its doors to him. Steve settled in Oshawa, where he landed a job with General Motors. In 1957, he served as best man for a good friend, also a Slovenian immigrant. One year later, in 1958, Steve married the bride's maid-of-honour. Ann-Marie's most cherished childhood memories are of Sundays spent at the Holiday Gardens, a Slovenian country club, where she recalls hearing accordion music, laughter and the comforting sounds of her parents speaking their native language.

"We are a very practical people," says Ann-Marie. "For the block, I chose linen fabric and simple cross-stitch, commonly seen in our tablecloths. I designed what appear to be two superimposed doilies, but it is actually all one piece." To achieve this illusion, Ann-Marie meticulously attached each thread of fringe individually. She chose symbols instantly recognizable by other Slovenians: the coat-of-arms with three six-sided stars above three mountain peaks, and blue water beneath. Both the inner and outer squares are awash with red carnations, the national flower.

Ann-Marie Šemen is a humble woman with a great talent. She has lovingly created the Slovenia block to honour her father and those who came before, but also as a reminder to those of her heritage who will follow.

Rush hour

Qikiqtani is one of the three regions comprising the newest Canadian territory, Nunavut, created on April 1, 1999. Centred in Qiqiktaaluk (Baffin Island), this challenging environment of mostly tundra is the home of the Qikiqtani Inuit. Once nomadic hunters who followed the annual migration of the caribou, they now live in small communities that depend on trapping and hunting for their livelihood.

Monica Ell, a Qikiqtani and creator of the block representing her people, started sewing at the age of eleven when her aunt gave her a used sewing machine. Monica was hooked. "There were no longer paper clothes for my dolls after that," she laughs. From knitted slippers in elementary school to sealskin crafts as an adult artisan, she has always had a deep appreciation of her environment and a passion for interpreting the material it provides in a practical, yet artistic sense. For nine years, Monica operated a shop called Arctic Creations in Iqaluit, specializing in leather and sealskins, fabric and notions, and craft items. She sold finished sealskin products that she and other Nunavut home-sewers made. In 1996, she received a Business of the Year award from the Baffin Region Chamber of Commerce for successfully promoting indigenous crafts and artists.

The block Monica designed and stitched shows a Qikiqtani mother rushing across the frozen tundra. The woman is clad in an *amauti*, the traditional parka made solely from sealskin. Her baby is held close on her back, under her coat, attached by a wide sash to keep the child safe, warm and comfortable. According to Monica, "The woman is rushing somewhere and her *amauti* tail is sort of blown by the wind. This depicts most Inuit women; they are the ones rushing to do things and always taking care of their children and family." The figure is made from scraped, tanned sealskin appliquéd onto heavy, icy-grey fabric embellished to represent the snowy expanse surrounding her. The golden, undulating inner border represents the arctic sun, present only a few precious hours a day during the winter months.

In addition to her artistic side, Monica has been deeply involved in community affairs, serving as vice-president of the National Inuit Women's Association (Pauktutiit). She worked on biodiversity issues and promoted indigenous property rights during her term. For eighteen years, Monica was employed with CBC North, Iqaluit, as a journalist and announcer-operator, and where she also trained new journalists.

Monica says she enjoys learning new things, especially new computer software. But it is her ongoing love of sewing in sealskin and leather and her affection for her snow-covered homeland that are readily apparent in the beautiful piece she created to reflect the simple adventures of everyday life in the North.

Thailand

Beloved king

Suree Murphy arrived in Canada a year ago, and though there is much that is new and exciting, she misses loved ones back home in Thailand. Fortunately, they're only a phone call or letter away. But what if one of the people she misses just as much happens to be the king?

Well, in singing his praises she can help the rest of the world understand why the predominantly rural, ethnic Thai population, is so devoted to the world's longest-serving monarch. What qualities does King Bhumibol Adulyadej have that make him such a beloved king? For Suree, the qualities are gift-wrapped in one certainty. "He helps his people," she says. In these troubled times, including Thailand's own recent political struggles, the words ring with faith and trust. For it is religion and monarchy that make up the core of Thai culture.

When Suree needs to immerse herself in all things Thai, she goes on-line to read Thai news and listen to Thai music. She thinks of the king, the spectacular celebrations at the Grand Palace, immortalized in the Thai block in an outline of gold-couched thread. Famous for its spectacular art and architecture, ornate costumes, silk fabric weaving, and locally mined gems and precious stones, Thailand's bounty is mirrored in the shimmer of multi-coloured Thai silk.

During the king's fifty-four-year rule, Thailand has maintained its united, independent and prosperous history. While tourism remains one of the largest economic sectors, the country is also the world's leading exporter of rice and potash. Their fishing fleet is ranked third in the world. Fluent in English and French, and an accomplished musician and composer, the king was also a gold medalist yachtsman at the Asian Games. This king likes to meet and talk with his people. To that end, he travels across the seventy-three provinces, hearing their stories and concerns, first hand.

He might hear stories like Suree's. Her parents were rice farmers with little education. "We were very poor," she says. It was a compelling reason to leave home at fourteen, and find work as a nanny in nearby Bangkok, and later Hong Kong. Thailand encourages and supports cottage industries, so it's no surprise that since arriving in Canada, Suree has seized the opportunity to build a small business. Each Saturday, in the pre-dawn hours, the activity level in her kitchen heats up as she busily prepares a variety of special pungent and spicy Thai dishes, all bound for the Vankleek Hill Farmer's Market in eastern Ontario. "I want to have my own catering business," she says. "And learn how to drive," she adds, smiling.

Life to the fullest

Gregarious, ebullient, and affable are but a few adjectives that describe Alicia Hausman. What this petite woman lacks in physical stature, she more than makes up for in personality. Full of energy and ready for whatever comes her way, Uruguayan-born Alicia epitomizes the amiable and exuberant nature of her fellow South Americans. A people-person, she chose a career as an obstetrical nurse and later as a journalist, writing articles for several of Toronto's Spanish-, Italian-, and English-language newspapers. Alicia fairly bubbles over with enthusiasm as she recalls the many people she has met while working as a journalist, including famous personalities such as Anthony Quinn and Placido Domingo. "I'm still in love with Placido," she confesses. "The jacket I was wearing when I met him, when he embraced me…I never wore it again!"

" Here comes the sunshine! "

Life has not always been kind to Alicia. As a teenage bride, she settled into her role as a wife and, in time, as a mother. All too soon, however, Alicia became a young widow faced with the overwhelming task of raising three small children on her own. But as is her way, Alicia bravely faced the challenge and made the best of a terrible situation. She opted to immigrate to Canada to provide a better future for her children.

Alicia explains that her homeland has become a highly urbanized nation. She is proud of Uruguay's large cattle- and sheep-ranching industries from which many of the country's crafts stem. Uruguayans excel in making handcrafted leather goods and use the material extensively in home furnishings, wall hangings, mats and clothing. Alicia wanted to represent this side of Uruguay, so she cut a piece of cowhide from her own table covering to make the block. The crocheted rising sun in the middle, a symbol of independence, is a prominent emblem on Uruguay's coat of arms. Without question, it is also a trait easily attributed to Alicia.

Although she experiences occasional homesickness, Alicia enjoys a full and satisfying life in Canada. She is an active member of her community and is an enthusiastic volunteer involved in a wide range of cultural organizations, such as Lions International and Celebración Cultural del Idioma Español. Ontario's Lieutenant Governor recognized Alicia's hard work and commitment when he presented her with an outstanding community service award at Queen's Park in 1997. What does the future hold for this spirited woman? That remains to be seen, but surely Alicia's passion and enthusiasm for life will carry her through whatever comes her way.

Iran

He who is indifferent to the sufferings of others is a traitor to that which is truly human.

Sa'adi, Iranian poet

Hossain and Audrey Honarvar celebrate fifty years of marriage.

A celebration of life

Hossain and Audrey Honarvar's story is no different from that of other couples who fall in love, marry and raise a family. Except that Hossain is Iranian and Audrey is English. Like the exquisite carpets for which Iran is famous, their family life has become a rich and colourful tapestry woven from two cultures. Early in their marriage, they lived in Iran for eleven years with their son and two daughters. They kept in touch with Audrey's heritage through occasional trips to Britain. Iran was once part of the Persian Empire, which dates back 2,500 years. When the Honarvar family said goodbye to this ancient land, they didn't shed their primary culture, they simply added another one to their mosaic.

In over fifty years of marriage, Hossain and Audrey have developed a deep sense of family unity and a profound attachment to the Iranian culture. This moved Hossain to invite family and friends to participate in the design of the block. Audrey and her daughter, Jeanette Honarvar Craig, both skilled at embroidery, applied their creative talents to craft the needlework embellishments, gold work and the teardrop shape forming the central motif, known as a *boteh*. It represents the "Tree of Life," significant for providing food, drink, clothing and shelter.

Careful research resulted in Hossain's hand-inked Persian calligraphy framing the central design. These lines by Sa'adi, a well-known 12th century Iranian poet, mean: "The children of Adam are limbs of one another, having been created by one essence. When the calamity of time affects one limb, the other limbs cannot remain at rest. He who is indifferent to the sufferings of others is a traitor to that which is truly human."

Indeed, these words function as the family credo, influencing how the Honarvars interact at home, in the community and in the world at large. Reflecting on the project, Hossain is filled with admiration and joy. "It's been a wonderful thing," he says with quiet pride. "I've often thought our daughter Jeanette, being born in Iran, and my wife, Audrey, having been immersed in Persian culture, are more Iranian than I am, and in drawing the design and choosing the colours…it was very satisfying to work on the piece together."

Even though they have lived in Ottawa for thirty-six years, Iranian traditions remain an integral part of their lives. One of particular importance is No Ruz, Iran's national new year, celebrated on March 21, the first day of spring. Hossain explains that this 2,500-year-old occasion is a joyful celebration of life for all Iranians. "The good part is that everybody feels close, everybody celebrates together."

In the spirit of cooperation

Tahltan people share a close spiritual bond with their land, which lies along the banks of the Stikine River in northern British Columbia. It is an ancient symbiotic relationship that began when the land provided food, shelter and medicine for their first ancestors. Through keen observation of the natural environment, the ancestors developed a vital collective memory of practical knowledge and skills that was passed on. The lay of the land was indelibly etched upon their minds and descriptions of specific landmarks aided navigation. The Tahltan understood the untamed wilds of their country, the habits of the animals and the useful qualities of different plants. They met the challenge of survival head on by working together. The Tahltan block is evidence that a strong spirit of cooperation remains the heartbeat of this First Nations people.

Making the block was a coordinated effort involving many members of the Telegraph Creek community. On a red stroud background, the Tahltan Wolf and Crow clans are represented in black flat-form designs typical of West Coast Native art. Such clan crests have always appeared on ceremonial regalia and other artefacts of daily relevance. Well-known artists of the Crow clan, Nancy McGhee and her son Shane McGhee cut and appliquéd the symbols. Nancy and Shane have been at the forefront of a cultural revival, teaching the next generation traditional songs, dances and drumming.

Lorraine Henyu's grandson was one of the McGhees' dance students. Her rounded abstract designs balance the block, top and bottom. Lorraine created the images, based on a drawing by local carver Edgar Frank, using beads and porcupine quills stitched to stroud. This woven woollen cloth is similar to the blue blankets obtained from trade ships off the coast that were used to make traditional button blankets. These blankets are highly valued, particularly when decorated with clan crests. In the true spirit of inclusion, each elder in the village participated in the Invitation project by sewing a small faux-pearl button onto the inner border to complete the block, adding even greater meaning to the piece.

Each one of the village elders sewed on a faux-pearl button to frame the flat-form designs of the clan crests.

Since the "first women" of the Wolf and Crow clans, Tahltan people have belonged to the land and the land belongs to them. They learned to respect themselves, others, and the land by looking to the Crow, Tsesk'iya Cho, as a model for behaviour. The art and craftwork of Tahltan artists like Nancy, Shane, Lorraine and Edgar serve to remind both young and old of their rightful place in this land and their responsibility to it.

Greece

The olive branch carries the message of peace, while philotimo *is about respect and generosity of spirit.*

Philotimo

About twenty years ago, when her children were little, Helen Catevatis of Vancouver took on the sewing project to end all sewing projects. She courageously volunteered to design and sew all the period costumes for a Greek play her husband Nick was co-producing for the Vancouver Hellenic Community Theatre. It became a perilous journey into uncharted territory. Helen persevered despite some terrorizing moments of uncertainty. She did some research and then, mysteriously, assistance arrived from unknown sources. "While I was working, I felt like I had a kind of intuition," she explains, "sort of how to go about it." Her voice is hushed, recalling the memory. "It was a goose-bump experience," she says.

Helen, an early childhood educator, came to Canada from the island of Crete in 1965. Few Greeks immigrated to Canada before 1900; the numbers rose gradually in the first part of the century and reached a peak in the decades after World War II. Today there are an estimated 200,000 Greek-Canadians. They have been quite successful in maintaining their language and culture with the help of the Greek Orthodox Church and cultural organizations. Formerly a member of the Hellenic Choir, Helen says that in each Greek community, volunteers make folk costumes for special events, sing in choirs, and keep traditions alive.

The block representing Greece was a collaborative effort by three women: Evie Katevatis, Helen's niece, created the overall design; Antigoni Pitsos embroidered the Ionic column and two olive branches, symbols of renowned Greek architecture and of peace; and Helen deftly cross-stitched the "Greek Key" border, which reflects eternity.

The olive tree carries both economic and symbolic significance. In some ways, the message of the olive branch extended as a peace offering parallels *philotimo*, the cultural virtue most valued by the Greeks. Helen says *philotimo* is all about being human and honest, respectful of family and others. No matter where Greeks live across the globe, the core of this cultural virtue is hospitality and generosity of spirit. Instilling the culture and the virtue of *philotimo* is a long process that begins when children are young. It involves teaching the Greek language and folk dances. "You also talk to the children about the country," Helen says, and those who can afford it take them back to experience it for themselves.

This is what Helen and Nick did with their sons, Apollo, Aries and Hermes, all named after mythological gods. After years of talking about Greece, the family finally made the trip. Standing along the ocean's edge, arms outstretched, embracing the beautiful environment, Helen's oldest son turned to her and smiled. Greece was as spectacular as she had described it.

Good things come in small packages

"The Most Serene Republic of San Marino," as it is officially known, is the world's oldest surviving republic. This postage-stamp-sized nation, the third smallest country in the world, has a total area of only 60.5 square kilometres. It was founded in A.D. 301 by Marinus, a Christian stonecutter who sought refuge from religious persecution in its rugged peaks. Though completely surrounded by Italy, San Marino has stubbornly clung to its three hills and three castles, retaining its identity and independence. Resplendent in medieval costumes, the citizens regularly re-enact history in a rich pageant that includes an elaborate flag-tossing competition, crossbow archery contests, parades and the music of a military band. San Marino is credited with having the world's first national anthem, a moving wordless melody based on a tenth-century monastic chorale.

For centuries, quarrying stone out of caves was a major occupation in San Marino, and fittingly, all the buildings are made of stone. The Sammarinese have survived by making wine and a special anise-flavoured liqueur, cheese, pottery and ceramics. Perhaps most innovatively, San Marino produces beautiful postage stamps for sale to eager philatelists around the world. Sewn into the stamp-shaped block is a triangular sample of one of these unique postal beauties.

After World War II, there was very little work available and many citizens of San Marino, including Giuseppe Colonna, set off to seek their fortunes elsewhere. Giuseppe arrived in Canada in 1956. At first, he laboured as a steelworker building the St. Lawrence Seaway. Later, he continued this demanding work in Toronto, where he had the privilege of driving the first steel rod into the ground to build Toronto's Skydome before he retired. Now he and his wife, Rose, tend their delightful European-style vegetable garden and enjoy their extended family of five children, their spouses and many grandchildren.

Periodically, family members visit relatives still living in the stone houses of San Marino. The country has changed as tourism has brought some economic security. Very few of its inhabitants emigrate now. In fact, many are returning. The government of San Marino invites the children of emigrants, between the ages of eighteen and twenty-five, to study Sammarinese history and culture during the summer months. The offer includes living free of charge for two months. Giuseppe's youngest daughter, Diana, spent two summers there. She has kept many treasured mementoes of her visits, which warms her dad's heart. "We are unique, one in a million," extols Giuseppe with pride. He reminisces about the lessons learned in his tiny homeland, a nation that values independence and self-reliance, perhaps little realizing how much he mirrors his birthplace's virtues.

San Marino

San Marino is the world's oldest surviving republic.

Guiseppe Colonna and his daughter Carolyn

Botswana

In a land known for the scorching heat of the Kalahari Desert, rain, or pula, is considered the greatest blessing that you can have.

Pula! Pula! Pula!

Most brides don't want rain on their wedding day, but for Sarah Trevor, the opposite was true. "When my husband and I were married in Botswana, it was terribly hot. The sweat was dripping off my nose in the church! We had our little party in my parents-in-law's garden. The heavens just opened and everybody shouted, 'Pula! Pula! Pula!' because it is considered the greatest blessing that you can have, to have it rain on your wedding."

In Botswana, a land known for the scorching heat of the Kalahari Desert, rain is a miraculous gift of life. Rainwater, or *pula* in the Setswana language, is so important that the same word is used for currency. *Pula* is also the national motto, and can be expressed as a greeting or farewell. It literally means, "Let there be rain."

In Sarah's batik print created for the Botswana block, fresh puddles surround the central motif, the *kgotla* or ceremonial council chair, acknowledging the importance of water. This chair represents the traditional form of democratic government of the Batswana people. The meaning of the *kgotla* is summed up in a well-known saying: Aggression is better expressed with argument than with a spear. "People have said it is actually closest to the Athenian form of democracy; always, people had the right to have their say," says Sarah. The chair folds up and can be transported to neighbouring villages if decisions affect them as well. This style of government goes hand-in-hand with the character of the Batswana people themselves, who are known for their generous nature, good humour and deep respect for the value of natural blessings, like water, that so many other nations take for granted. The block is bordered by *ngami*, a common basket weaver's pattern, honouring the decorative and utilitarian tradition of basket-making in the country.

Although they are geographically isolated, the people of the Kalahari have a remarkable aesthetic sense, which Sarah absorbed during her time in some of the more remote areas of the country. While in Botswana, Sarah's interest in biology led to her fascination with art, wherein she discovered a relationship between humanity and textiles. "I work with fabric because I can feel the connection with women and with Africa. Fabric is, in a way, a woman's journey; the fabric she wears on her body is always her statement of individuality and femininity."

The Alaskan high kick

At the shore by Kitigaryuit, a large base camp in Inuvialuit, hunters stand at the ready. At the signal from their leader, they paddle *qudjuts* (kayaks) in a fan-like formation toward a group of beluga whales while slapping the water with wooden paddles. In a blind panic, the whales beach themselves on a mud bar, becoming easy targets for the hunters' harpoons. Hunting stories describing such scenes have been passed down for generations among the nomadic Inuvialuit, or "real people." Sharply honed hunting skills ensured their survival in the harsh environment above the Arctic Circle, where their travels extended from the Alaskan border, along the edge of the Yukon and into the Northwest Territories.

Every winter, when the land was cloaked in darkness, the Inuvialuit came together to share stories and information about the best hunting locations. They would trade goods, sing and dance, enjoy good food and each other's company. Among the highlights of the gathering were the competitive games meant to build and test the hunters' strengths. Today this gathering has become known as the Arctic Winter Games.

One of the most difficult, yet traditional, competitions is the Alaskan high kick. It is a dramatic display of agility, balance and control. With one hand planted on the floor, the athlete kicks at a stuffed sealskin suspended from above while holding the non-kicking foot in the free hand. Participants at the Games demonstrate not only strength and stamina, but also the values of diligence, honesty and respect for others. The Games celebrate the vitality of Inuvialuit heritage while promoting a stronger, more harmonious community.

Artist Agnes Kuptana designed and made the Inuvialuit block by ingeniously trimming grey-and-white pieced sealskin fur to define details that reveal an Alaskan high kick athlete. The sheen and supple texture of her creation incite the urge to caress the block. Agnes' female family members began her training in traditional sewing skills at a young age. In earlier days, Inuvialuit women spent hours perfecting the art of sewing in an attempt to impress young men. As an adult, Agnes takes pride in her many creations, which include parkas, kamiks, wall hangings, beadwork and embroidery. Her work is well appreciated, and she is pleased when customers want something she made for their own.

As Beaufort regional director of the Native Women's Association of the Northwest Territories, Agnes takes great pride in her people. She works with others to further the economic, social and political equality of Inuvialuit women through education and training. The association runs programs in everything from literacy to developing leadership skills and operates the Yellowknife Victim Services Program, a referral service dedicated to helping women who have experienced violence.

Solomon Islands

> "Whenever you see
> birds out on the ocean,
> you know land is near by."
>
> *Ake Lianga*

An artistic experience

Since childhood, twenty-nine-year-old Ake Lianga of Victoria, British Columbia, has expressed himself through his art. Born into a large family on the island of Guadalcanal in the Solomon Islands, he has been inspired by people and their environments. Art classes were not part of his village schooling, but this did not hinder Ake's artistic growth. His ancestors were carvers and weavers, and he feels that connection each time he creates art.

Despite concerns that pursuing an art career would be an unreliable livelihood, his close-knit family encouraged him. "They always supported me by telling me stories, explaining the cultural importance of our heritage," Ake says. These stories are retold in the quilt block, an abstract interpretation of life in his South Pacific archipelago. Three figures represent the indigenous population — largely Melanesian with smaller groups of Polynesians and Micronesians. The fish are the ocean's sustaining harvest, while birds are important to fishermen lost at sea. "Whenever you see birds out on the ocean, you know land is nearby," says Ake. Tropical sunshine and blue sky blend with the dazzling white of cowrie shells, once used as currency. Quiltmaker Marilyn Vance has reproduced the balanced lines and curves of Ake's original painting in flowing cotton appliqué work and colourful embroidery. "I had to make it," she says. "It 'spoke' to me!"

After high school, Ake worked producing screen prints and painting signs. Completing a two-year apprenticeship, he freelanced as a mural artist and sign-painter, travelling extensively throughout the Oceanic region. He won a South Pacific Continental Art Competition and participated in two group exhibitions in Australia. Then a Commonwealth Arts and Crafts scholarship allowed him to study in Canada. He wanted a "unique artistic experience" and felt that Canada, with its diverse cultures and contrasting artistic environment, would challenge his ability "to survive." He explains, "This is part of 'the experience' of being an artist."

A major hurdle came when he discovered his scholarship would not cover all his required courses, and his student-visa status prevented him from working. Shocked, he faced defeat. But even before this reality set in, the same island-community spirit he'd grown up with reached out to enfold him in B.C. Through the efforts of fellow students, sponsorship donations poured in from across the province. Not about to let anyone down, Ake went on to graduate from Fine Arts with honours. He taught printmaking at North Island College and has put together three solo exhibitions.

Ake has volunteered his time with the Pacific Peoples Partnership in Victoria, but he wants to do more. Of that extraordinary generosity that enabled him to complete his studies, he says: "It was an overwhelming surprise. In my culture, that is something I have to repay — by contributing to the community."

A fine balance

In Diana Tsertsvadze-Smirnoff's home in Kanata, a bowl of seedless grapes, chocolate-nut cookies and freshly brewed coffee are hospitality icebreakers, except there really isn't any ice to break. Once the introductions are over, Diana's contagious laughter and warm welcome make her seem like a long-time acquaintance.

At the edge of the foyer, Diana's five-year-old son, Dato (David), shyly introduces his one-and-a-half-year-old brother, Daniel, who is curious but unwilling to come out from behind his big brother. Eventually, he flashes a wobbly smile and everyone is settled. Before talk of Georgia can get underway, Diana leaves the room, returning with a very large book. "It was my grandmother's," she offers, smiling. The book is a pictorial of Georgia, Diana's homeland, and throughout the visit, it becomes a convenient reference source.

Diana grew up in Sukhumi, a city on the Black Sea coast. Her memories are of a "beautiful and happy country," a description that is reflected in the photos in the book. She admits that Georgia, with its 2,500-year history, is poor economically. "We didn't have riches, but we had everything we needed," she says, her voice lifting with pride. Georgia is culturally rich: literature and arts, music and dance, their distinctive architecture, and much more. Political conflict changed everything, however. Diana was the first of her family to leave, followed by her parents. "They went to Israel because of me," she says. Israel is where she met her husband, Alex, a computer programmer, and where Dato was born. It then became another place to leave when the three immigrated to Canada in 2001.

Canada's distinct changes of seasons have become a new source of pleasure for Diana. It is a land where future opportunities are no less important than peaceful days without fear. The family has returned to Israel for extended visits, but Diana has not returned to Georgia, where many members of her family, including her grandmother, still live. "It is very hard for them," she says, her voice breaking slightly as she talks of Georgians displaced from homes and communities. Diana, though, is hopeful that with a new president in power peace will be restored.

Peace and prosperity are the themes she chose to represent Georgia. A church atop the Abkhasia Mountains reflects their status as one of the oldest Christian nations. A cross-stitched frame of squares in wine, tan, black and cobalt replicates a typical Georgian pattern. The country's spirit, says Diana, is somewhat of a paradox. "Georgians can be loud, strong-willed and impulsively hot-blooded." But she adds, "They can also be quiet, intelligently thoughtful and logical, striking a fine balance."

Georgia

"We didn't have riches, but we had everything we needed."

Diana Tsertsvadze-Smirnoff

Yemen

> **"** Prayer, passion and patience are the ingredients of peace. **"**
>
> *Heyam Qirbi*

The miniature dagger, carved by Elspeth Greer elegant in its embroidered sheath, graces the Yemeni weaving.

A life worth living

The struggle for justice, freedom and peace has defined Heyam Qirbi's life since she was fourteen. "It was a voice inside my head," she explains. "The woman is the foreman in this world; she is the mother first, the sister, the daughter, the mate…the friend." Heyam, a women's rights activist, pours her energies into the efforts of such groups as the Muslim Women's Organization, Arab Canadian Women's Association, Circle of Canadians and Mothers Juggling Cultures. The dynamic energy generated when people join forces is powerful, she says simply: "There are a lot of us."

Yemen is a starkly beautiful country, rich in ancient architecture and colourful traditional arts. Heyam sees a new era emerging for her country, one that will gradually challenge some of the old ways. People are slowly embracing modern economic opportunities and fresh social ideas. In urban cities such as cosmopolitan Aden, influenced by education and the outside world, Yemeni women have moved into the work force and beyond. Yet, in most places the vast majority of women are still enshrouded in black — they have never held jobs, never driven a vehicle and never been seen by men outside their families.

There's a subtle shift in Heyam's voice as she recalls Yemen's 1962 student revolution. She first saw her future husband there during a student demonstration. "That was the beginning of our love story," she says. Strong and independent, she married without her family's approval. "It was going against the culture — quite an unusual thing," she recalls. Later, her strength was deemed a hindrance and the relationship saw unsettled times.

Her voice is soft and thoughtful as she shares her experiences. "I had two children and I thought I owned them; and when my youngest one, Sami, took his own life, I felt I had nothing in this world." Finding strength in hardship, she started a support group for other mothers who had lost children in this devastating manner. Her other son, Waleed, battled a debilitating brain tumour in 1998. Together, they fought against its ravages and grew stronger in the process. With his recovery, Heyam and her son enjoy a close bond.

Although Heyam has seen some very dark times in her personal life, she is not battle weary. She sees her struggles as universal, not exclusive. Her voice, though gentle, is edged with steely conviction: "I think about the hardest parts of my life as going up a mountain. When I get up there, I feel okay. Prayer, passion and patience are the ingredients of peace." She doesn't deny the journey's cost. Her laughter is spontaneous, a welcome sound, welling up from somewhere deep. "You can't expect things to happen without a cost," she says. "A life worth changing is a life worth living."

Beauty and balance

An adult first-year Arts and Science student, Melanie Dreaver breathes a sigh of contentment as the early morning sun glimmers through the windshield of her car as she drives to the University of Saskatchewan. The endless northern plains that flash past, stretching into the distance, are the tribal lands of her people, the Plains Cree. On her car radio, music for a Round Dance, or Moving Slowly Dance, soothes Melanie's spirit as she greets the new day, completely at peace with nature. In her own words, "It's as simple as being grateful for life and all of creation, for the sun coming up and the changing colours of the leaves."

As a middle child of sixteen, with eleven sisters and four brothers, Melanie set herself apart at an early age by displaying a strong independence and indomitable spirit. At the age of five, Melanie decided she wanted to be like her mother. She watched with avid interest as her mother sewed and beaded clothing, committing the techniques to memory. She practised with an enthusiasm and determination rare in one so young. "Instead of playing I guess I sewed," she reminisces, laughing. As her level of skill increased, so did her pleasure in the art. Beading was much more than a simple pastime for Melanie. "It made me feel connected to my culture and gave me peace of mind," she explains.

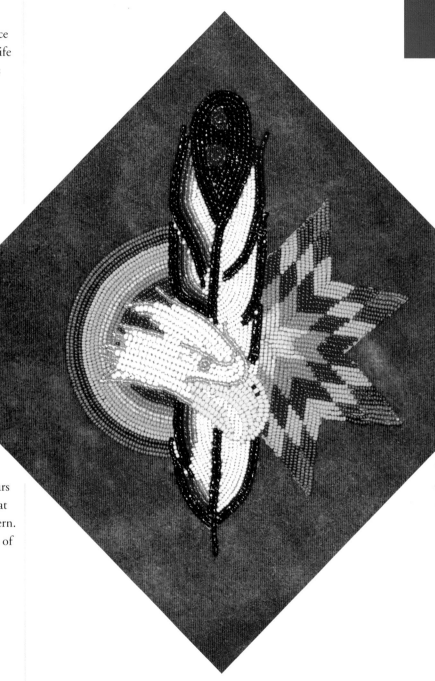

Melanie was honoured to use her long-held talent to bead a design she created to represent her people. In the foreground on a square of tanned hide, Melanie prominently placed the head of an eagle, a potent and sacred symbol of power throughout Plains Cree beliefs. Courageous and swift, the eagle facilitated communication between men and spirits. A feather from this magnificent bird was highly treasured as a badge of honour. On the block, the four colours of man (black, white, red and yellow) highlight a beaded feather that divides a rainbow and a starburst reminiscent of a star-blanket pattern. The overall composition of the block draws the beauty and balance of life together in a symphony of peace and harmony.

The atmosphere within her own close-knit family when Melanie was a child was one of love, caring and support. The people in her community showed respect for one another and exchanged greetings with hugs and kisses. Melanie hopes to combine her lifetime learning and understanding with her new knowledge from university to help others lead holistically healthy lives and to rediscover "their true paths."

Spain

The fan embodies
the mysterious
and exotic spirit
of Spain.

Virginia Winn and Susan Garin

The fans of romance

Susan Garin met Alberto, a Spaniard from Barcelona, at a YMCA summer camp north of Montréal in 1966. She smiles as she recalls their courtship. "One of my sisters had met him first. Because I had studied Spanish, she thought that he would be an interesting person for me to meet, and I could practise my Spanish. So that's what we did, we practised Spanish and things evolved from there. My Spanish improved greatly!"

Their children, who hold Canadian and Spanish citizenship, speak both languages at home, and now their grandson is learning Spanish also. They have maintained ties to Spain in other ways, with a shared fondness for typical Spanish dishes such as *paella*, the taste of olive oil and robust red wines, and a passion for the game of football — or soccer, as it is known in Canada. The family often spends vacations in Spain, where they immerse themselves in their love for family, friends, food, culture and climate. It is a way of life shaped by the Carthaginians, Romans and Greeks, who followed Celtic and Phoenician settlers to this geographically diverse land. Christianity followed centuries of Moorish influence, and all the various and diverse cultures left their mark on modern Spain.

Over the years, Alberto has given Susan a treasured collection of striking fans from Spain. The folding hand-fan, developed in medieval Japan, was introduced to Europe around 1600 by way of China. Blades of ivory, bone, mica, mother-of-pearl, or tortoiseshell were delicately carved, and contemporary artists often decorated the coverings of lace, silk, or parchment with original paintings. The fan embodies the mysterious and exotic spirit of Spain. A black lace fan, for instance, is inextricably connected with the Spanish flamenco dancer and, along with castanets and dance, the fan is an integral element of the *zarzuela*, a form of opera introduced in the 17th century.

Susan and her sister, Virginia Winn, collaborated to create this dramatic block. Virginia stitched the flowers that decorate the graceful fan, inspired by the multi-coloured embroidered carnations and roses that are often seen on Spanish women's deeply fringed shawls. Susan created the distinctive embroidered border in "blackwork." It is a form of counted-thread embroidery usually worked in geometric designs with black silk on even-weave linen. Blackwork had its origins in Northern Africa and arrived in Spain with the conquering Moors early in the 8th century. Spanish princess Catherine of Aragon, who in 1501 became Henry VIII's first queen, is purported to have popularized the craft in England.

Elated with their creation, the sisters were just a little sad to put the final stitch into their beautiful block. Its genesis recalls the Romance language of Spain, and especially the language of romance that brought Susan and Alberto together.

Poto-mitan

One room in Kettly Hamilton's home is her refuge and her tribute to the Caribbean island where she grew up. Framed pictures, tropical plants, souvenirs, bright colours and the ever-present music… all speak of Haiti. "I am at home here in Canada," she says, "but I always keep my Haitian identity close to me."

Kettly reflects her Creole culture through the embroidered scenes of everyday life that are classic needlework themes in Haiti. She explains, "These are significant scenes showing women's work. She leads the burdened donkey to the market, also carrying goods on her head, to exchange for money. She sweeps and tidies around her home, and she crushes pistachios to make food. These are all still typical, rural activities." Through these tiny pictures, she emphasizes the importance of women's labour, their role as *poto-mitan* (literally, the centre post of a temple) within their respective families as well as in their communities.

To further illustrate everyday life, Kettly chose to work on a double background for the Haiti block. A family doily, neatly bound in buttonhole stitches and made in Haiti, is her main canvas for the circle of scenes. Beneath it lies Carabella chambray, a very fine denim-like fabric known affectionately as *le gros bleu* (the big blue). Used in every facet of daily clothing, boy's shirts, country-wear, and items for sale, this fabric is synonymous with Haiti. The chambray is highlighted with a delicate band of red, a popular colour for accessories and clothing. "And it goes well with blue," she laughs.

In recent years Kettly has become involved with Toronto's Haitian community. She first heard of its growing importance through radio announcements on a local cultural station. She participates in various meetings, special events and church gatherings. At home, she speaks French and Creole, and regularly cooks up a storm of flavourful and spicy native dishes. "It is essential to keep that contact with my country."

While still very young, "maybe ten years old," Kettly learned her embroidery skills from her mother, an accomplished needleworker. Even as her mother lay gravely ill, she taught Kettly new stitches, which she has been perfecting ever since. To this day, her needlework provides Kettly with a concrete connection to her mother, whom she misses dearly. "Embroidery is my passion," she says openly. "It sustains me and maintains my spirit."

> "Embroidery is my passion. It sustains me and maintains my spirit."
> *Kettly Hamilton*

69

Iraq

Nawal Hassan models her traditional embroidered Iraqi hachmie.

Faith in peace

Her demeanour is shy, but now and then, like quicksilver, pride reveals itself when Nawal Hassan models a traditional Iraqi tunic-gown called a *hachmie*. This Ottawa mother of five is active in Arabic community organizations such as the Iraqi House of Ottawa. The other women, curious and admiring, reach out to touch the gold embroidery that shimmers against the black gossamer fabric. "It may also be worn like this," she demonstrates, sliding the wide kimono sleeves up and around her head into a draped hood, framing an enigmatic smile.

The gowns are made in different colours, says Nawal, and at weddings a bride may change five times in one night! Enhanced with symbolic motifs, Nawal's own vintage *hachmie* is the inspiration for the Iraq block. Gold-stitched sheaves of wheat and date palms represent the rich soil along the Tigris and Euphrates valley, while the squares symbolize a traditional architecture called *shanashil* — a porch with net-like wooden screens. "Women can look out, but no one can see *them*," Nawal explains. The turquoise ceramic in the centre keeps a constant vigil.

After an absence of twenty-four years, Nawal risked the journey home when her mother was scheduled for heart surgery in 2002. As she said goodbye to her husband and two sons, and set off with her three daughters, fear numbed her heart. While two older daughters stayed behind in Jordan, Nawal and six-year-old Sara Rose, the child she calls an unexpected gift from God, carried on to Iraq.

The reunion was bittersweet, as family members tried to bridge the years in just eight days. "The first time my family saw me, they were laughing and crying," she recalls. With hopes and relations renewed, Nawal returned to Canada. A year later, full-scale war broke out in Iraq, crushing those hopes. All that year, and even today, the ring of the phone is as frightening as its silence. In May of 2004, the calls came, one by one. Her mother, uncle, and cousin, all died within two months of each other.

Eyes shining, Nawal takes a few family photos from her wallet. One is of Sara Rose, her smile a beam of innocent, boundless joy. Nawal fears that grief and worry have left her too soul-weary to keep up with Sara Rose's high spirits and vivid imagination. Yet when the child is away from home, the house feels empty, she says. With the return of Sara Rose, Nawal's faith in peace is once again restored.

Hemp gatherers

Keepers of the Eastern Door, the Tuscarora were the sixth and last to join the Haudenosaunee, or Iroquois Confederacy. They called themselves the Ska-ru-ren, meaning "people of the hemp," "hemp gatherers" or "hemp shirt-wearing people." Tuscarora men also wore a distinctive headpiece like the one depicted on the block, called the *Gahsdo: wa* or *Kustowah*. It was usually a strip of deerskin wrapped around the head like a turban and decorated with fine, small feathers.

Before the arrival of Europeans, it is estimated that 25,000 Tuscarora peoples from several tribes lived in what is now North Carolina. According to educator and writer Shirley Hill-Wilt: "When the white man invaded our country, Tuscarora land extended from near the Atlantic seacoast clear inland to the Appalachian mountains…the hunting lands extended into South Carolina and Virginia, and even sometimes as far as Pennsylvania… There were large and small settlements, made up of long houses and ringed by cornfields. The larger settlements were called 'towns' by the white man when they saw them… [The Tuscarora] welcomed the first English-speaking explorers and settlers… As early as 1650, they are mentioned by the white contacts as being 'very powerful and addicted to trade.'"

From 1711 to 1713, the Tuscarora were displaced from their traditional lands along the Roanoke and Neuse Rivers in a series of clashes with the white settlers called the "Tuscarora Wars." In their search for a new home, they followed the White Roots of Peace extending out from the Great Tree of Peace in the territory of the Five Nations. They went to live near the Oneida and eventually joined their confederacy in 1722. In the American Revolution, most Tuscarora joined the Oneida and supported the Americans against the British.

Today, about 2,000 Tuscarora live on and off the reserves of Glebe Farm and the Six Nations near Brantford, Ontario. There are also smaller groups living on a reservation near Lewiston, New York, and in Pembroke, North Carolina.

Julia Stiles Vernon, who made the Tuscarora block, explains that the green triangle represents the Great Tree of Peace standing above all others; the blue background symbolizes the sky and the lakes; and the Tuscarora man in profile, wearing the *Gahsdo: wa* hat, with his hair tied and braided in the Tuscarora style, represents the Ska-ru-ren. Julia used white glass beads to adorn the *Gahsdo: wa* headpiece on the block, but traditionally whelk shells were used. The purple background fabric represents the quahog shells of the Iroquois wampum belt.

Djibouti

An unexpected reunion

When Hanane Abdallah arrived in Canada from Djibouti in 1998, she was completely unprepared for the extremely cold winter. The temperature in Djibouti, formerly known as French Somaliland, typically hovers around 25 degrees Celsius during the cooler months but peaks at 45 degrees in the hot season. Djibouti, situated in northeastern Africa along the Gulf of Aden and the Red Sea, is one of the hottest, driest countries in the world. Hanane spent her first winter bundled up in bulky sweaters and thick socks. "I was too afraid to go out of my apartment," she admits. She has since adapted to the climate and bravely ventures out into the snow and ice.

In the same year, a woman named Asli Merane arrived in Canada with her five children. Hanane and Asli had been friends while attending the *Lycée* (high school) as children in Djibouti. When Hanane saw Asli at a community centre in Ottawa, she could not believe her eyes! It was a joyous reunion. The two women have since renewed their friendship and support each other in those moments when life becomes overwhelming. But it takes a lot to discourage these two cheerful and lively women. Together, Hanane and Asli are completing an internship with the Catholic School Board, working with disabled children as part of their Social Support Worker diploma program.

The opportunity to design the block was a way for Hanane and Asli to express their love for both Djiboutian culture and their adopted country. Most of the population comprises ethnic Somalians and the nomadic Afars. The bright bands of colour echo the brilliant long skirts, dresses, and gauzy *shalma*, or wrap, worn by women in Djibouti. The beadwork in exuberant colours and the woven raffia piece are examples of the art traditionally produced by nomadic groups and prominent on everyday items. The distinctive sandals, replicated in miniature on the block, carry Djiboutians through their days, whether in the city, in the forests or to work in the newly exploited salt beds.

During the Islamic fast of Ramadan, Hanane is grateful for the stability of her new country. Canada has been a refuge from the disruptions of civil war that have plagued her homeland for years. During the evenings of the month-long Ramadan, family and friends gather in their homes, or in one of the small Djiboutian restaurants that have sprung up in Ottawa, to share a light repast of tasty North African dishes. These are the moments Hanane savours and for which she feels infinitely blessed.

Hanane Abdallah and Asli Merane have renewed their old friendship.

Meant to be together

Baiaa and Dale Teangauba were swept away by a love as powerful as the ocean waves that pound the shores of Baiaa's island nation, Kiribati (pronounced *Keer' ee baus*). Dale had completed her two-year volunteer teaching contract there and was preparing to return to Canada when a friend introduced them. "It was love at first sight!" she says of meeting Baiaa in January 1997. By chance, they met again a week later at a house party. "We talked and opened our hearts as we sat by the ocean under the moonlight," Dale says. "We both knew that night we were meant to be together and that it was no accident we had met. It was part of a plan greater than both of us. We prayed and hoped that the dreams in our hearts would come true."

When she returned home in April 1997, Dale's heart remained in Kiribati. Comprised of thirty-four islands grouped in the south-central Pacific, the nation is a blend of Micronesian and Polynesian influences. Kiribati has survived invasions and unchecked mining, but the cooperative spirit and solidarity of the people have remained the basic building blocks of this society and its traditions. Now global warming threatens Kiribati's inhabitants. Rising sea levels may endanger freshwater lagoons, even if the islands themselves are not submerged. If some of the population is relocated, such resettlement could jeopardize Kiribati's heritage and culture. But in their block design, Baiaa and Dale have captured forever the romance of the islands. A woven coconut-fibre mat supports gentle ocean waves of rippling blue ribbons and a radiant sun made from the sleeve of a smocked blouse or *tibuta*. Cowrie-shell flowers move to the rhythm of the *ruoia*, the national dance.

Baiaa came to Canada a few months before the infamous ice storm that hit the eastern provinces in January 1998. "Having no electricity wasn't an adjustment for me," says Baiaa, "because I grew up with no electricity. But we have 40-degree temperatures year-round. The cold — that was a shock!" Otherwise, the storm didn't affect their lives too much, because later that month Baiaa called Dale's mother to ask permission to marry her daughter. They were wed in March 1998 in Canada.

In July 2000, they returned to Kiribati, where they partied with Baiaa's family and friends for six weeks. His entire village joined in, providing food, handicrafts, singing and dancing to celebrate their union. "The love we have found is very rare in the world today," they agree. "Fate was on our side the day we met, joining two different worlds in a celebration of love!" Indeed, an appropriate sentiment in a country in which love and unity form the basis of culture, society and traditions.

Kiribati

> " Fate was on our side the day we met, joining two different worlds in a celebration of love! "
>
> *Baiaa and Dale Teangauba*

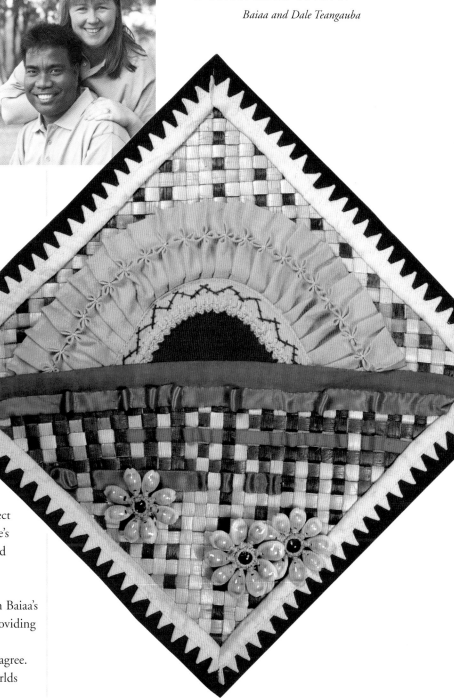

Eritrea

Mulugeta Negash Desta, a young Eritrean art student now living in Ottawa, has taken on the challenge of making himself and his beloved country known through his art.

Cards of friendship

Not many people have heard of Eritrea, a recently independent African country located on the west bank of the Red Sea, cradled by Djibouti, Sudan and Ethiopia. This nation, the size of England, has a history that goes back 5,000 years. It is home to four million people trying to recover from thirty years of war, drought and famine.

Mulugeta Negash Desta, a young Eritrean student now living in Ottawa, has taken on the challenge of making both himself and his beloved country known through his art. Interested in art since his youth, he entered competitions and drew constantly. He often copied the icons and paintings found in churches such as the Orthodox Christian church, which dates back to A.D. 300 and is well established in Eritrea and neighbouring Ethiopia. Mulugeta writes poetry and loves to learn. He also does woodcarving, painting, coil weaving and photography — creating works in as many different media as he can.

To teach others about Eritrea, Mulugeta designed and stitched his block, trying to include as many elements as possible. The beaded yellow sun rising over the Red Sea is a sign of "good hope" for Africa. The embroidered sandy desert, colourful mountains and graceful palm trees form the main topographical elements of the land, while the camel represents a way of life that is still largely rural. Nine cowrie shells from the Red Sea, often used in crafts, correspond to the number of different ethnic groups represented in the population. Tiny "man" and "woman" symbols anchor the shells to indicate Mulugeta's pride in the growing equality of men and women in Eritrea. A richly hued woven border cut from the bottom of a woman's traditional garment frames the scene.

Shortly after his arrival in Ottawa in 1993, Mulugeta's studies were interrupted by a near-fatal car accident that led to long, lonely months of convalescence. In Eritrean society families live together as a community, helping one another through sickness, child rearing and daily challenges. Now he found himself ill, isolated and living alone in a large apartment block.

Mulugeta spent many solitary hours using his art to reach out to his neighbours. Wreaths, doves, candles and poinsettias abounded as he made Christmas cards by hand for the occupants of each unit in his building, signing them with his name and apartment number. This personal greeting prompted erstwhile strangers to begin talking to him, to visit, to get to know one another, and provided Mulugeta with the sense of community for which his heart longed.

L'ours chasseur d'étoiles

Cree artist and printmaker Virginia Pésémapéo Bordeleau often draws her inspiration from the profoundly spiritual relationship her people have with the land and with the animals of the North. In particular, she notes, one of her preferred subjects for paintings and engravings is the bear. "He is often present in my dreams," she explains in French. "He is my personal totem because he was present at my conception and birth." The strongly held belief in the presence and protection of animal spirits is common throughout Aboriginal nations.

In traditional Cree mythology, the bear united with the first human woman sent down from the skies and henceforth became known as "grandfather." This imagery is further emphasized by the "human appearance once his skin is removed," Virginia explains delicately. She has created her tribute to *L'ours chasseur d'étoiles* ("the star-chasing bear") on white-tanned moose-hide. The backdrop is a hand-painted navy sky beaded with planets, moon and stars. They are being liberally tossed into the heavens by the fluidly embroidered bear that has a store of them upon his shoulders. She was pleased to supply "a piece of the artistic puzzle" to represent her people, says Virginia, who lives north of Rouyn–Noranda near the Québec–Ontario border.

The Eastern Cree's region borders eastern James Bay and southeastern Hudson Bay, an area approximately two-thirds the size of France that they call Iiyiyuuschii (land of the people). Their language is one of five Algonquin dialects, a language spoken by more than 45,000 people. They call themselves Ayisiniwok (true men) or Iynu (the people). Once small nomadic groups, the Cree first came into contact with Europeans in 1610, during the explorations of Henry Hudson. Traders sought the highly prized fur pelts the Cree collected, providing a new way for them to earn a living. In modern times, the incursion of mining, forestry and hydroelectric projects (such as the James Bay Project) has drastically affected their way of life. Yet to this day, the territory provides more than thirty percent of the Cree in northern communities with their traditional livelihood from wild game such as moose, caribou, geese and fish.

Virginia has exhibited widely throughout Québec and France, and in Denmark. She is proud that some of her "animal spirit" images have been given as gifts to visiting dignitaries and now hang in collections in Northern Ireland and the United States as well. In keeping with her people's spiritual beliefs, she continues to draw her inspiration from her environment. Although the historical aspect of Cree life as hunter, fisher and trapper has changed, the fundamental respect and honour they feel for their culture and for their Creator have not.

Eastern Cree

Iynu

> "The bear is often present in my dreams."
>
> Virginia Pésémapéo Bordeleau

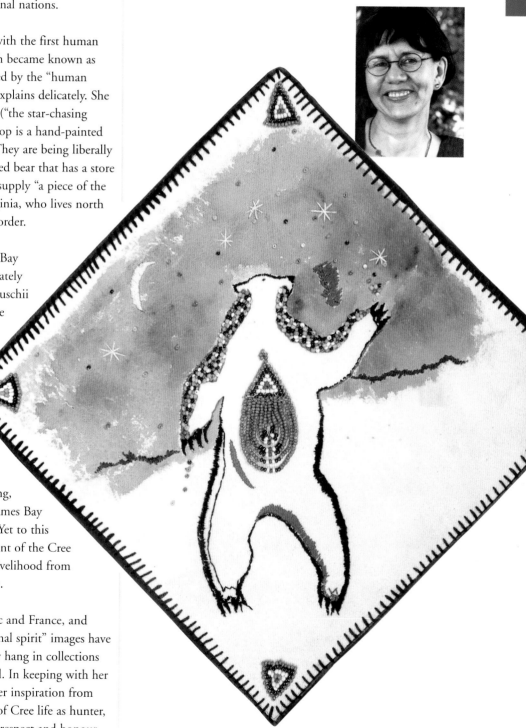

Uzbekistan

> " Textiles are
> my passion,
> my hobby. "
> *Ruslan Takhautdinov*

Honour for the master

Legend claims that long ago a governor ordered the master weavers in the silk-production centre of Marghilan in Uzbekistan to create a textile unlike any other. Many masters fled the city for fear of falling into disgrace or of suffering punishment should they fail. While sitting on the lakeshore pondering his family's future and the fate of his colleagues, one master noticed a fascinating image on the water's surface — rays of the setting sun were pouring the colours of the rainbow into the reflection of a cloud. This inspired him to create a wonderful iridescent fabric with silk threads, which he presented to the governor, who was delighted. He named the master's work "abrband," which can be translated as "cloud's reflection caught in silk." Today this silk production, known as *ikat* in Europe, is called *abrbandi* to honour the master.

Ruslan Takhautdinov has found a new way to honour the masters of his homeland. He often travels back to his country to buy beautiful fabrics from local markets to help struggling artists who have few outlets for their wares. Ruslan displays their work to the world by promoting and selling the crafts of his countrymen on his website. As such, he offers a global awareness of the unique artistic treasures of the ancient Uzbek society.

Weaving and embroidery are highly respected arts in Uzbekistan. Skilled artisans are honoured within their family and community. Because many of Uzbekistan's cities are located along the ancient "Silk Road" trading route that linked China with Western Europe, both the East and the West have influenced the rich textile arts of the country. These traditions also influence the styles of embroidery decorating head coverings and skullcaps. A cap is the central feature of the Uzbekistan block, framed by *ikat* silk weaving, both provided by Ruslan.

In his apartment, Ruslan is surrounded by piles of textiles, including many examples of *suzani*, a type of traditional embroidery used to decorate homes. In a humble way, *suzani* honours a different master, Ruslan explains: "Very often in *suzani* [the embroiderer] leaves white patches or unfinished panels because we believe that only God is perfect and humans are not." He also points out that the intention is for the unfinished parts to be completed by the next generation, so that the skills can continue to be passed along.

"Textiles are my passion, my hobby," Ruslan says with great enthusiasm. "I remember as a child, sitting near my grandmother when she was embroidering. I was very excited about how she could make such beautiful things from small pieces of coloured thread." Eyes sparkling with delight, he says, "From that time, I just loved textiles and kept them in my heart."

Traditional tapa'stry

Lying within the Polynesian Triangle in the heart of the Pacific, the people on the archipelago of Tonga love a good celebration. In the capital city of Nuku'alofa ("the City of Love"), they celebrate King Taufa'ahau Tupou IV's birthday for more than a week. Feasts, parades and beauty pageants, as well as dynamic forms of art, song and dance, play a major role in every festivity. Whole communities perform the *lakalaka*, the national dance. Time-honoured stories and legends are shared with the next generation through complex musical compositions and the graceful choreography of hands and feet.

But the best place to hear the current local news is in the *ngatu* houses. Women gather daily to participate in one of the country's oldest cultural traditions: making tapa cloths (*ngatu*). They share stories of yesterday and today, and dreams for tomorrow. They talk in time to the incessant rhythm of wooden mallets pounding strips of inner bark from the paper mulberry tree. Later, the softened lengths of tapa are beaten together to form the desired size of cloth. Repeated designs are printed onto the material using natural dye to create eye-catching patterns, emphasized with black and brown outlines.

Tapa cloths are a vital component of island social culture. They are used in homes for placemats, wall hangings and tablecloths, and are also a customary gift between new friends. Highly prized longer lengths of tapa are given at weddings, royal ceremonies and even funerals. A strong sense of community permeates Tongan society. Within the extended family, food, goods and wealth are shared equally. Children are brought up by everyone and often call several places "home." Tongans respect traditional values and customs, which are strongly influenced by Christianity and the old ways, called *Anga Fakatonga*. This ingrained practice of sharing is the reason Captain James Cook, on his first visit in 1773, dubbed Tonga "the Friendly Islands."

Penny Fraser, a graduate of the Ryerson School of Fashion, and Penny Kobrynovich, an experienced creative quilter, were excited by the opportunity to design the Tonga block. The project allowed them to share their love and knowledge of textile art. After much research, "the Two Pennys" decided on a stylized representation of the sweet-smelling national flower, a small red flower called the heilala. Throughout the process of printing and painting the design on imported handmade tapa cloth, they followed traditional methods and incorporated authentic motifs to honour the few hundred Tongans who make Canada their home.

Women gather daily to exchange news and participate in one of Tonga's oldest cultural traditions, the making of tapa cloth.

Guyana

Habits of home

When the Guyanese sit down to eat, ethnic differences vanish at the table. Chances are the food they consume is the cuisine of the person beside them. And Joan daSilva agrees: the Guyanese love good food. "Food is important, but we were also brought up to accept everybody," she says, recalling Sunday mornings after church, many years ago. "You would see a multitude of different colours — a rainbow collection of people — all sitting, drinking and eating and having a good time."

After all these years in Canada, the cuisine of Guyana remains an important cultural link for both Joan and her husband, Paul. What they serve at their table often reflects their country's ethnic diversity: a mix of Amerindian, African, East Indian, Chinese and European. Paul says Pepper Pot, one of the dishes he used to love to eat, is a traditional South American Indian stew made with bitter cassava juice, fish or meat, and hot peppers. Laughing, Paul admits the last time he tried this spicy dish, he was "on fire."

The daSilvas, with their five children, were the last members of their respective families to emigrate. "We didn't want to leave," says Paul, who describes a comfortable lifestyle in a country they both loved. Guyana, with its abundant rivers and Kaieteur Falls, one of the world's natural wonders, its picturesque towns and tropical forests, is a country they miss for its beauty. But political unrest and its impact on everyone, particularly the children, hastened their resolve to leave. Beyond their initial struggle to get established, Joan says, "Life has been good to us in Canada."

For her quilt block, Joan and Paul chose their national flower, the Victoria Regia Lily. Named after Queen Victoria, this giant lily has round, flat leaves that can grow to more than eight feet across and can support the weight of a five-year-old child. The nocturnal flower is more than one foot across when the petals open. Three of these giant beauties have come to life with Linda Norton McLaren's skilful fabric painting and delicate surface embroidery.

The daSilvas miss the habit of impromptu get-togethers with friends and family, an important aspect of Guyanese culture. Discussions can cover everything from politics to family problems and every topic in between. Faster paced Canadian lifestyles forced certain changes, says Paul. "We can't just arrive on someone's doorstep. We have to call first." However, Joan has noted similarities between the Guyanese and French Canadians. "They show up and the next thing you know, there's food and drinks on the table and you're having a good time. And that is life, spring, summer, winter, fall. That is exactly how we live in Guyana."

> " Life has been good to us in Canada. "
>
> *Joan and Paul daSilva*

Salmon-rich

The salmon-filled streams, the thick forests, abundant wild berries, game and plentiful fur-bearing animals from the Pacific coast and inland in northern British Columbia provided well for the Tlingit people who settled there ages ago. Unlike many of the first peoples in the interior, the Tlingit could spend less of their time in search of hunting grounds and gathering food for basic survival. They used their time to become exceptional crafts people and traders. Salmon provided them with food and an economy when, in the 1800s, fish canneries were established.

Wood from the forest was used for building houses and canoes, and for dishes, utensils or other daily items. The Tlingit are well known for their carved totem poles that include sculpted figures of people and animals depicting a clan's history. The Tlingit Nation is divided into five clans: Eagle, Frog, Beaver, Raven Child, and Wolf. The last two symbols are stitched by Marion C. Horne onto the block in the black and red flat-form design typical of West Coast nations, using a button-blanket style on wool stroud. The Tlingit are known, too, for their Chilkat blankets, named after one of the bands but made by other bands as well. They were woven from cedar-bark fibre and mountain goat hair or mountain sheep wool. Each blanket could take several months to complete. Traditionally, women wove abstract and animal forms into the blankets and finished them with long fringes at the bottom and sides.

The Tlingit were also skilled navigators, paddling great distances in their seaworthy canoes, which were carved and sophisticatedly decorated. They were the first of the coastal people to introduce Russian goods to the southern Yukon, and developed an extensive trading network. White European influence came in the late 19th century, bolstered by a Presbyterian mission established at Dei shu ("the end of the trail"). Then the Yukon Gold Rush brought many more outsiders into the area. As the English language took hold, the Tlingit language faded and has become highly endangered; today only about one hundred fluent Tlingit speakers remain in Canada.

The Tlingit believe in the spirituality of all things and that animals have spirits with the same basic nature as humans, which allows the animals to communicate with humans and to help them. In recent years, their traditional clan system set the stage for Teslin Tlingit legislative self-government. Two decades of negotiation with the governments of Canada and the Yukon led to self-government agreements enshrined in legislation in 1995. Marian Horne, executive elders coordinator, says, "We are fiercely proud of the Tlingit heritage and culture. We want to preserve and develop the social, economic, political and cultural well-being of our people, while conserving the wildlife habitat and traditional territory for the well-being of future generations."

Suriname

A fashion transformed

Joyce Ford has pleasant memories of her childhood in Suriname. She recalls, "I grew up on a sugar plantation where my father was the manager, and it was lovely. We just roamed around the plantation all day long. It was quite safe. Everybody knew everybody, and it was like one big family." But during the days of slavery, plantations in the Dutch colony were not such pleasant places. On the Suriname block, the doll is wearing a bulky and heavy costume called a *koto*, typically stuffed with straw and worn by female slaves. There are two sides to the origin of the *koto*. One claims the wives of plantation owners designed it to prevent their husbands from being attracted to the female slaves. Another version says the slaves themselves developed it to hide their figures from the unwanted attention of their masters.

The *koto* is made of bright plaid or floral fabrics and worn with a headscarf called an *anjisa*. It was meant to be a symbol of oppression, but in time the slaves' resourcefulness and patience transformed the burden into a means of communication and celebration. They developed a "head language" of secret messages. "The head tie is something like a messenger; the men and women were not supposed to meet, so they transmitted messages to each other by the way they tied their head tie," Joyce explains, in her gentle Creole accent. Joyce remembers seeing older women wearing the *koto* when she was growing up. She even has a portrait of herself and her sisters wearing them when she was a child. Slowly times changed, and the Surinamese proverb "Patience is a bitter tree, but the fruit is sweet…" now rings true. Today, the dress style is modernised, transformed into a celebration of perseverance and freedom.

In Canada, Joyce keeps a huge jar of fermented fruit in her cupboard and bakes rum cakes to share with friends as reminders of her homeland. "It is a party place. Oh my, the Surinamese love partying and all kinds of get-togethers," Joyce says. She enjoys the laughter and chatter of her weekly stitching group, which includes her daughters, and the monthly reunions with other family members, but she still misses her friends in Suriname. She tries to visit both Holland and Suriname whenever she can. She picks up the celebration and communication right where she left off. "When I go back to Suriname, it's as if I never left."

Wearing the koto was part of life on the sugar plantation for Joyce Ford and her sisters when they were young.

The colours of home

The important elements in this embroidered story are the "colours of home," physically, emotionally and culturally. Women prepare food together, share homemade beer and welcome a stranger to the village. Small houses with straw roofs made from banana leaves are clustered behind a wooden fence, typical of traditional villages in Burundi. Known as the Switzerland of Africa because it has a thousand hills, this republic close to the equator is one of the continent's smallest nations.

Mathilde Nduwimana, who crafted this peaceful scene, emphasizes that sharing and solidarity are crucial to her people. "Burundians may lack material wealth," she says, "but we are rich in caring and morality, even to feeding and housing strangers. People are always coming and going." Time is elastic there. "But that only works in a society without telephones," she remarks wistfully.

A relaxed sense of time does not transfer well to the Western lifestyle where days are apportioned in measured time periods. Transplanted from a life of communal living to a bedroom-community where people are busy with their own concerns, Mathilde often struggles with a gnawing sense of isolation. In modern society's climate of rampant individualism, she questions when and how one can find time to care for others.

In her carefully stitched village portrait, Mathilde recalls the tranquil lifestyle of Burundi that was disrupted by a terrifying civil war that caused many to flee. She tries to include some of the happier elements of her homeland in her new life in Canada. Weekly, she prepares special Burundian meals, and almost every visit to her home becomes an instant celebration. Friends and strangers, African and other, often come bringing food and drink, to share laughter and dancing. To add Burundian colour to her new Canadian house, she carefully chose floor tiles in colours and textures to mimic those of the mud or baked clay floors of her old country. Now, says Mathilde, when she comes in her door she takes off her shoes and socks to feel the cool tiles beneath her bare feet. Then she has indeed arrived home.

Burundi

> " Burundians may lack material wealth, but we are rich in caring and morality. "
>
> *Mathilde Nduwimana*

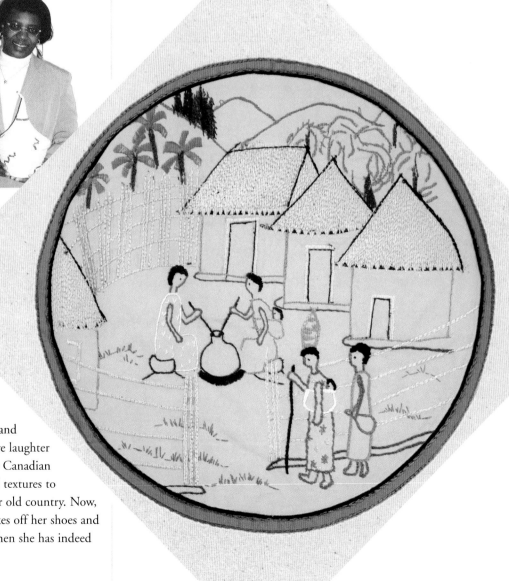

Taiwan

In the secret pocket

Unusually, the lotus flower blooms when its fruit is ripe, not before, as with most other plants. This is an attribute that Buddhists believe means the lotus can reveal the past, present and future all at once. The lotus is also now bringing prosperity to Taiwan. Commercial lotus ponds have replaced many rice fields. For the Taiwan block, Ming-Chan Su has beautifully embroidered a lotus flower on a fine handkerchief to symbolize her past, present and future while simultaneously representing her homeland's multifaceted culture.

After coming to Canada in 1967, Ming-Chan faced many difficulties when she had to re-learn obstetrical nursing in a new language. As she integrated into Canadian daily life, she continued to pursue and honour her background. "Today, I go to Taiwanese school twice a week to sing songs and to learn traditional crafts such as flower drying and arranging," she says. "Also, we do exercises such as *tai-chi*; in Taiwan, people do it early in the morning in the parks." Taiwan's culture has been described as "a true cultural banquet." The people have a history of passionately celebrating holidays, temple festivals, and the Chinese New Year. The "terraced bay" (the meaning of Taiwan's Chinese name) has many unique art forms, including giant folk-art puppets representing dragons or lions that perform dances.

Ming-Chan's grandparents played a formative role in establishing her Taiwanese identity. "My grandfather gave us our names. In the Chinese tradition, we have two words for our first name. My grandfather said my name should be 'Ming' which means bright or smart, and 'Chan' which means bird," she explains quietly.

From Ming-Chan's grandmother came the silk and brocade centrepiece of the block. It is a small pocket from an apron her grandmother wore like a bib underneath her clothing. Tucked into the outer opening is the embroidered handkerchief, while under the flap is a hidden pocket usually reserved for special treasures. Ming-Chan fondly remembers her grandmother used to buy candies and other treats for them with the pocket money she carried there.

According to tradition, Ming-Chan's future would be revealed in the legacy left to her children, the family heirlooms and traditions she would pass down to the next generation. Having no daughters to whom she could pass on her grandmother's apron piece, she has generously contributed a pocketful of memories from the past to the *Quilt of Belonging*, passing on her inheritance and embroidering her future into the fabric of Canada.

Full potential

Olive Itsi discovered early in life that she had a deep reserve of inner strength. At the tender age of fifteen, Olive was catapulted into the role of caretaker to her younger brothers and sisters when their mother died unexpectedly. She missed the companionship of her friends when she had to quit school to manage their home. The vast lands of the Northwest Territories, home of the Gwich'in or "People of the Caribou," and the long, cold winters only intensified Olive's feelings of isolation. Watching her dream of an education slip by was frustrating, but there was nothing that could be done about the situation. Instead she used the time at home to teach herself how to sew.

She honed her skills and began making parkas, mukluks and gloves. She used caribou and moose hide to make the parkas, trimming the body, front or sleeves with traditional "Delta braid." This braid is created by tightly sewing together narrow overlapping strips of colourful fabrics. By using pieces of contrasting colours, the artist develops secondary and tertiary geometric designs. Olive made the Gwich'in block in the Delta braid style, using fifty-five layers of fabric. The effect is a mesmerizing blend of shapes and colours. For most people this would have been a time-consuming project, but Olive's practised hand created her design in a breathtaking three hours. "The layering of fabrics makes the finished piece strong, each colour giving the next a life of its own," she says. This could be a metaphor for Olive's own life. Every major event, whether joyful or sad, has reinforced her personal strength.

The suicide-death of her son was a cataclysmic event in Olive's life. She attended a local program designed to help families deal with such difficult situations. The counsellors, recognizing Olive's potential to help others, encouraged her to take a one-year counsellor-training program. Today, Olive works as a drug and alcohol counsellor at the Tloondih Healing Centre. Helping others has been the antidote to her grief. She finds the work fulfilling: "It makes you feel so good to help even one other person."

Olive brings a special understanding and compassion to her work. Daily she witnesses first-hand the devastating effects that abuse of drugs and alcohol have on her community. She hopes that the work done by both counsellors and clients at the Centre will inspire "everyone to work together to build a better community." She believes education is the key to developing a supportive and vibrant community. She wants to see First Nations youth stay in school, acquire a strong sense of themselves, and realize their own full potential. Olive is living proof that it can be done.

> " The layering of fabrics makes the finished piece strong, each colour giving the next a life of its own. "
>
> *Olive Itsi*

New Zealand

*Clockwise from top:
a star-shaped clematis,
the fiery-red kakabeak,
a golden kowhai, and
a scarlet pohutukawa.
On either side, silver ferns
float beneath the clematis.*

Colours at play

Like many New Zealanders, Del Roulston is a passionate gardener who loves to "play" in her garden. A temperate climate and the rich horticultural legacy of its British settlers have combined to give New Zealand its well-deserved reputation for luxuriant gardens. Del laughs as she remarks, "I find great joy now in seeing that plants usually grown indoors in Canada are ones we used to grow easily outside in New Zealand." However, she adds that the variety of Canada's dramatic seasonal changes has enriched her life.

"I don't think I appreciated the beauty of New Zealand until I went back and explored it with a fresh eye," Del acknowledges. As often happens, she took for granted the familiar scenes, traditions and idiosyncrasies of her home country. She fondly recalls the influences of the Maori culture, like the unusual shapes of animals and plants in Maori designs, whether woven or carved in wood. When Del trained as an occupational therapist in New Zealand, she learned to do the intricate Maori *taaniko* finger-weaving to work with Maori patients. Now when she travels home, these are the types of crafts she collects to bring to Canada.

"A very special part of who I am, here in Canada today, comes from a maiden aunt who stayed with my family a great deal and taught me to do a lot of hand crafts: tatting, crochet and embroidery," explains Del.

For her block, Del worked on an ecru linen background using tones that reflect the New Zealand landscape and Maori traditions. Front and centre is the small, nocturnal kiwi, the protected national bird from which New Zealanders get their nickname. The bird is surrounded by a selection of unique flowers finely worked in cross- and long-stitch embroidery. She honours the Maori with two borders: the inner one of stylized ferns and the outer border in the form of a geometric *taaniko* design in traditional black and red.

Del grew up in a conservative society where tablecloths were often woven in dark colours and older widows dressed sombrely, frequently in deep purple. But both Del and New Zealand have changed. New Zealand updated its image for the international World Cup sailing event it hosted a few years ago, incorporating more colour into everyday life. Likewise, Del has found freedom with colour and design. She loves to experiment. She enjoys following the advice that "every colour goes with everything." "Like flowers…you can mix everything. They go together," says Del enthusiastically. "I now take pleasure in picking tablecloths that are wild and fun." The colours of her personality have emerged. She has learned to appreciate creativity in others, as well as in herself, to take chances…to explore new possibilities.

The perfect plan

"God had a plan for me," says Rose Marie Chiu from her comfortable home in Mississauga. Born in Belize City, Rose Marie, her brother and sister spent a happy childhood surrounded by a close-knit family. Known as British Honduras until 1973, Belize is a Central American country of ancient Mayan ruins, old colonial-style houses, rainforests, and beautiful black orchids. It boasts one of the most spectacular coral reefs in the world. Although it is relatively poor economically, its people are rich in friendships and freedom, living without the sting of discrimination so rampant in other countries, notes Rose Marie. "Belize has always been a stable, free and democratic nation with no internal conflicts," she states.

Rose Marie's Catholic-school education included learning English smocking and cross-stitching, for which Belize is well known. Smocked throw pillows were very popular, Rose Marie recalls. In the Belize block, the national bird, a Keel-billed Toucan, perches in stitched splendour surrounded by bright embroidered flowers atop a sunny yellow circle smocked by Mona Kerr Street.

In 1980, when Rose Marie and her husband were dealing with the heartbreak of Rose Marie's fifth miscarriage, God's plan for them began to unfold. Rose Marie met a Canadian volunteer who assured her she could find the medical help she needed in Canada. With this person's help, they were able to immigrate in June of the same year. Two years later, after treatment, the Chius became the proud parents of Elizabeth, and in 1984, of Christine. "To me, this was an answer to my prayers," says Rose Marie happily.

While Rose Marie continues to work as a legal assistant, as she has done for more than twenty years, she spends much of her free time volunteering through her church. Now an "empty nester," she delights in helping others. "I get so much joy in meeting people's needs," she says. Content with her townhouse and its minuscule garden, she uses her resources to help others.

When her daughters ask if they plan to retire to Belize, Rose Marie responds, "No, this is where I'll be, with my grandchildren." Although they live far from their homeland, the Chius have kept their traditions alive so their children will know their roots. Her husband enjoys cooking Belize's delicacies for family dinners — ox-tail stew, pig tails, rice and beans cooked in coconut oil, and Spanish *tamales* made from corn and sauce and wrapped in coconut leaves. The girls even call home for recipes to make the Belize-style dishes for themselves now. When the whole family gets together around one of these feasts, Rose Marie looks around the table at her precious daughters and silently gives thanks. God's plan was good!

> " I get so much joy in meeting people's needs. "
> *Rose Marie Chiu*

Fiji

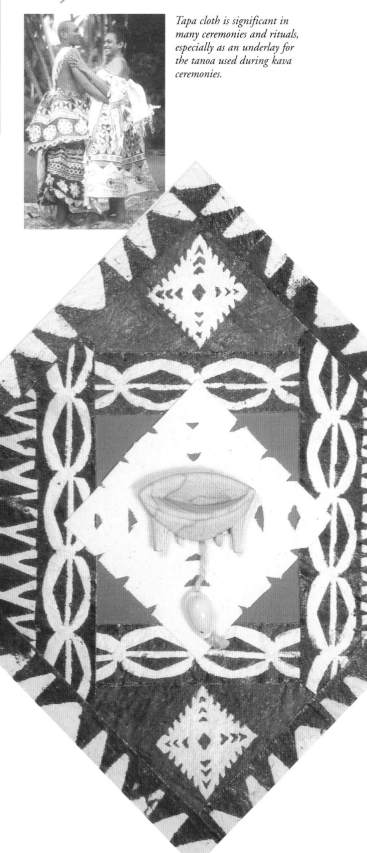

Tapa cloth is significant in many ceremonies and rituals, especially as an underlay for the tanoa used during kava ceremonies.

Good mana

With its sun-drenched white sand beaches surrounded by an incredibly blue-green ocean, Fiji is a natural paradise. However, its true beauty is found in its kind and generous people, who bring together a fascinating blend of cultures from over 300 islands scattered in the South Pacific. Despite the more than 5,800-mile distance, over 30,000 Fijians have chosen to immigrate to Canada. Their warm, friendly nature ensures they make new friendships easily, and the Fiji Canada Association helps them maintain connections and provides camaraderie.

When he first arrived in Vancouver in early 1965, Bimal Parmeshwar's first impression was that "Canada was a very wet country!" After a few days of solid rain, the outlook brightened and he moved east to establish himself in a teaching position that drew on his experience in aviation. His life here has been full and good to him. Yet, he says, "A man may leave his country, but the country will never leave him."

Two of his country's traditions are represented on the Fiji block. Central is a *tanoa*, a wooden bowl carved in miniature, by Roy Hiscock, used to serve *yagona*. Also known as *kava, yagona* is prepared from a type of pepper plant and is important in the Fijian ceremonial culture. Originally exclusive to chiefs and priests, it is now used to welcome visitors, for storytelling sessions or merely as a pastime. A cord of natural fibre with a white cowrie shell attached traditionally designates the guest of honour.

The background fabric is hand-printed tapa cloth, made from the inner bark of the paper mulberry tree. Using ancestral patterns that tell stories of early times, designs are applied by dipping leaves, brushes or bamboo stamps in natural pigments. Strips of tapa are pieced together with plant-resin glue to make sheets of fabric for clothing and home decorations. Tapa cloth is significant in many ceremonies and rituals as well, especially as an underlay for the *tanoa* used during *kava* ceremonies. It is often offered as a gift to a bride and groom. The good *mana* of the women who create the tapa is believed to infuse each cloth and provide good luck for the recipient.

"Our ways were rather simple and unsophisticated, but we listened to others, we paid lots of attention to what parents expected of us," says Indu Bhalla, who came to Canada thirty years ago. "I feel nostalgia for the Fiji I grew up in, but I do not relate to it the same way now. Fijian society has been changing, and changing fast!" She cannot separate her life in Canada from her youth in Fiji. "They are two integral parts of my life and I could not be one without the other."

The Ktunaxa mystery

A certain amount of mystery surrounds the origins of the Ktunaxa First Nation. The Ktunaxa (pronounced *tuna-ha*) teach each generation that they have inhabited their Aboriginal lands since time began. Others say the Blackfoot pushed the Ktunaxa west, where they settled along the banks of the Columbia and Kootenay Rivers. Nobody claims to know for sure. Their traditional territory straddles the Canada–United States border, extending northward into British Columbia and southward into Montana and Idaho. Today five of seven bands of the Ktunaxa Nation live in Canada, with complex relationships that tie them to the Secwepemc (Shuswap) and other Salish nations.

Yet the Kitunahan language of the Ktunaxa is entirely distinct. If the language is related to any other native language, linguists say it is so distant that any evidence is unconvincing. Even the origin of Ktunaxa is not clear, though it is thought it may be based on the Blackfoot pronunciation of the name they called themselves, or on the Siksika word meaning "slim people." Ktunaxa relatives in Montana call themselves Ksanka, meaning "People of the Standing Arrow." The Ktunaxa were formerly called Kootenay (spelling variations include Kootenai, Kutenai, Cootanie), with various translations given as "water people" or "deer robes."

There is no argument, however, the Ktunaxa are a unique people inhabiting one of the most richly beautiful places in Canada. Until relatively recently, they were semi-nomadic hunters and gatherers, and largely dependent on fish stocks of the Columbian Basin system of lakes and rivers. Their distinctive sturgeon-nosed canoe, used for fishing and travel, was designed with a reversed prow specifically for travel through bulrushes. Made from the bark of various types of trees, this canoe was lightweight, fast and manoeuvrable in turbulent waters. Everyday wear was plain and typically made of buckskin, but for special ceremonies, clothing would be elaborately beaded. Traditional geometric beadwork patterns evolved into intricate floral designs under the influence of Catholic missionaries.

The Ktunaxa block made by Alice Olsen Williams, is an embroidered and appliquéd rendering of a traditional breastplate. A renowned Anishinaabe quilt artist living in Curve Lake, Ontario, Alice reproduced this piece of ceremonial regalia from period photographs Ktunaxa Nation representatives provided to her. A front-piece like this "bib," large enough to completely cover the wearer's chest, traditionally would have been made entirely with seed beads, making it very heavy.

The Ktunaxa block made by Alice Olsen Williams is an embroidered and appliquéd rendering of a traditional breastplate.

In keeping with their cultural beliefs, ecotourism has become a growing enterprise among today's Ktunaxa people. Ecotourism allows the community to benefit financially without sacrificing their cultural mandate to respect the environment. They continue to be self-reliant and maintain their distinct language, traditions and customs.

Malaŵi

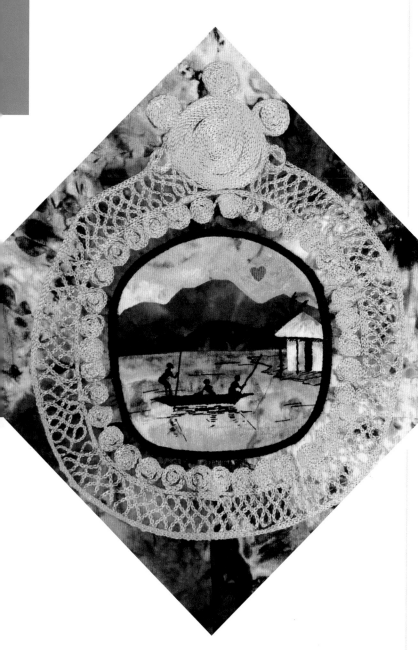

Warm heart of Africa

A peaceful country south of the Equator, with an untouched, beautiful environment, Malaŵi is home in the heart of Neps Ng'ong'ola. Its bustling towns, picturesque villages and friendly, welcoming people have earned this landlocked nation the reputation of being "the warm heart of Africa."

Neps hadn't realized just how much he loved his homeland until he found himself willing to literally give the shirt off his back to Invitation for the Malaŵi block. Neps' shirt was Malaŵian from start to finish. Native grown cotton was processed at the country's main cotton mill and weaving factory, then the fabric went back to a village to be tie-dyed, embroidered and made into a shirt by an itinerant tailor. Malaŵians are proud of the cottons, yarns, fabrics and African prints produced in their country, which have won international recognition at trade shows for their quality. Thus, Neps thought it fitting that his shirt be transformed into textile art.

The neck of the shirt, with its typical circlet of heavy chain-stitched embroidery, frames a tranquil landscape. A painting, provided by Malaŵi's Deputy High Commissioner in Ottawa, Henry Chirwa, served as a guide for the scene re-created in appliqué. Colourful sections were cut and pieced together from Neps' shirt and touches of black embroidery added. The finished work shows a scene of rugged mountains, azure sky, and in honour of Malaŵi's nickname, a blazing heart-shaped sun. On the colour-dappled surface, three silhouetted fishermen pole their dugout canoe through the calm waters of Lake Malaŵi, a reminder of the importance of the country's fishing industry, and the many Malaŵians who depend on the lake for their primary source of food. Henry Chirwa waxed poetically about the virtues of the lake that covers almost a fifth of the country and is home to more than 500 species of fresh-water tropical fish.

However, Henry Chirwa's enthusiasm bubbled over when he recounted the legacy and influence of the beloved Scottish missionary-explorer David Livingstone. The country's largest city, located in the Shire Highlands was founded by Livingstone and a fellow missionary in 1876, and was named Blantyre after David Livingstone's birthplace in Scotland. In Malaŵi, Livingstone's birthday is still celebrated — a convincing example of long-lasting respect and the warm hearts of Malaŵians.

Hope springs eternal

"It is a small country, yet unique and full of diversity," says Ximena Clavijo of her native Ecuador. As blockmakers, sisters Ximena and Monica sought to represent the incredible variety of the people, history, topography and wildlife unique to their South American homeland. These noble elements, which foster creativity and development, co-exist with the country's deeply rooted problems, its cycles of poverty and the frequent changes in government that have brought instability to Ecuador. At present, these difficulties are diminishing and the future looks brighter.

> ❝ We wanted to represent eternal spring. ❞
>
> *Ximena Clavijo*

For Canadian-Ecuadorians like Monica and Ximena, family ties are an important and essential foundation, especially in a society where relationships are increasingly fragmented. "We are very family-oriented, continually looking out for each other, sharing contentment and sorrow; we have a wonderful relationship in our family," says Monica. The sisters celebrate traditions with their parents, brother and respective families, teaching their children about their background and language. Together they are living out their commitment to their families.

Unfortunately, Ecuador's exceptional geography and fragile environment have been damaged by industrial development. Parts of the Amazon rainforest, the Andes Mountains, the Pacific coastline and the famous Galapagos Islands have been adversely affected. Yet, Monica and Ximena, like most Ecuadorians, believe that there is reason to hope for harmony and balance. Mount Chimborazo, featured in the block, is one of the biggest active volcanoes in the world and is the point on earth that gets closest to the sun. Tradition says that nearness creates a special environment of spiritual enlightenment. Ecuadorian beliefs also emphasize harmony with nature, while the prevalent faith teaches the parallel message of "the Golden Rule." These values, along with the relaxed nature of the society as a whole, provide hope for improvements in the social, political and cultural realms of Ecuador.

"We wanted to represent eternal spring," says Ximena, referring to the sun shining over their block and the use of the vibrant colours of the Andes. "You can feel spring all year round in Ecuador; the sun is always shining." Spring is the season of new beginnings, and hope does indeed spring eternal in the hearts of Ximena and Monica.

Ethiopia

> " Materially we are poor, but we are rich in culture. "
>
> *Mebrathu Mogus*

Free to grow

Anilem Tebeje came to Canada as a student twenty years ago. "We were all running for our lives," she remembers, running from "daily persecution" in a country torn by war. Mebrathu Mogus's memories reflect the same painful flight to freedom. Both left families behind and searched for their place in a new country. Eventually they established a new life in Canada, but if "home is where the heart is," their voices betray that it still beats for their homeland as they speak of Ethiopia.

Mr. Mogus has great faith in Ethiopia's spirit, its strength and its pride. "Materially we are poor," he says, "but we are rich in culture." The Great Rift Valley of his homeland is considered the cradle of civilization and the great legends of his people ring with tales of King Solomon and the Queen of Sheba. Pride in this cultural heritage led Ethiopia to fiercely defend its independence, making it the only African country to have escaped European colonial rule.

In the Ethiopia block, Anilem pays tribute to the extraordinary women who helped shape the country's long and rich fabric-making history. Cotton played an integral role, becoming "a home industry," she says. "It literally begins and ends at the fingertips of women: from growing and picking the cotton to spinning, weaving, sewing and embellishing the garment." Decorations often include the Agadez cross motifs adorning the handwoven cotton in the quilt block. The crosses reflect both the four corners of the world and the country's ancient Christian influence.

When "Lucy" is mentioned in conversation, Mr. Mogus laughs with delight. The world-famous 3.5 million-year-old female skeleton housed at the Ethiopian National Museum is a subject of pride for the nation. To Ethiopians, Lucy is known as Dinkenesh, an Ethiopian word that means "thou art wonderful." He pronounces the word phonetically in a singsong cadence and then smiles approvingly when his visitor repeats it almost perfectly.

Anilem sees the Invitation Project as a picture of the Canadian family in its broadest sense. "Maybe it's God's blessing that we can come from different cultures and live in such harmony — so it's a very beautiful symbol of society." What Mr. Mogus sees echoes his own life: someone from another country who was free "to grow and become strong." In his Ottawa restaurant, Horn of Africa, surrounded by native handwoven baskets and artwork, he talks of new beginnings. He pursued the business to earn a living and watched as the restaurant evolved into a cultural meeting place. These days he's busy with a second restaurant but explains that Horn of Africa still attracts a cross-section of cultures tempted by Ethiopian dishes like *wat*, a spicy stew served with *injera*, the country's traditional bread. All of these blessings make him feel so happy, so safe.

Stitches of discovery

Tracy Paul lived on the Woodstock First Nation reserve in New Brunswick until the age of nine or ten. When she returned as an adult in the position of community planner, she began to reconnect with her past. Her work allowed her access to many sites normally off limits, including the sacred burial mounds believed to be more than 10,000 years old. She felt awed and deeply touched while visiting this revered place, prompting her to research her own history.

She became acutely aware that members of her generation and younger people are losing their culture. The reserve has no on-site school to teach Maliseet traditions, and the language is in danger of becoming extinct. Tracy is now learning her native tongue, an eastern dialect of Algonquin close to Passamaquoddy, which uses a different writing system. "My father speaks it fluently," says Tracy, "so I am learning it — a word, a sentence at a time — from him and other elders."

When she was invited to make the Maliseet block, Tracy delved into many aspects of the culture and conducted research on design and techniques. She sought guidance from the elders, and from anyone she thought could advise her. Tracy had taught herself traditional beadwork, but for the block she wanted to draw upon other skills. "I've always done sewing," reports Tracy, "and from early on, I could make anything with a sewing machine and I did a lot of hand work."

Tracy felt that the ribbon work found on traditional Maliseet ribbon dresses now mostly worn on formal occasions was a good choice. But since she didn't know this technique, once again she began to teach herself. She also asked for, and received, spiritual guidance as she made each decision about how to proceed. Tracy laughs as she recounts the various directions she tried before settling on the dramatic black velvet and striking green satin for her block. Tracy was absent-mindedly coiling a piece of ribbon when the idea for the fiddlehead struck… and stuck. Fiddlehead greens, known as *Mahsusiyil* in the Maliseet language, remain a traditional springtime delicacy, growing in great numbers along the banks of the *Wolastoq*, the Maliseet name for the St. John River.

Tracy says the rest of the block "just came together as I went along." She adds, "I worked at the stitching and beading with the piece pressed against my knee. I didn't know it would have been so much easier if I had used a hoop!" Tracy's return home to the Woodstock reserve continues to be a journey of self-discovery and an opportunity to share the important traditions of the Maliseet with others.

Maliseet

Wolastoqiyik

Tracy Paul taught herself beading and the ribbon-work technique she used to honour the Maliseet.

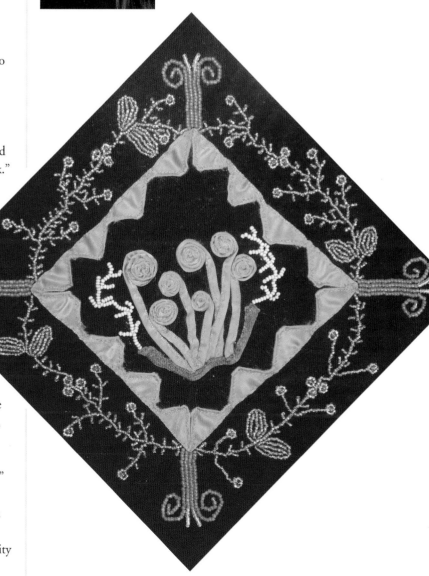

Antigua and Barbuda

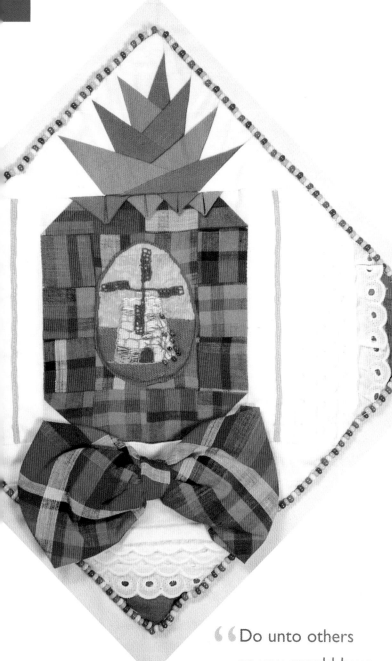

> "Do unto others
> as you would have
> others do unto you
> is the motto we
> strive to live by."
>
> *Geri-Anne Seaforth*

All dressed up

Geri-Anne Seaforth came to Canada nineteen years ago but never misses an opportunity to visit her homeland in the Lesser Antilles. This independent three-island paradise, comprising Antigua, Barbuda and uninhabited Redonda, is surrounded by coral reefs and "an enormous number of sunken ships." Like many islanders, Geri-Anne loves to celebrate and displays an exuberant, full-of-life nature. "There are many occasions to enjoy, and so much food," she says happily. "On Good Friday we eat salt fish and *doucanna*, a sweet potato flavoured with cinnamon and wrapped in banana leaves. At Christmas the whole island is decorated and there's plenty of food and drink." In Toronto, Geri-Anne often uses her "coal pots" to cook up island recipes. "The food tastes different, sweeter," she explains, "all with a wonderful smoky flavour."

The people of Antigua and Barbuda celebrate Independence Day with much pomp and planning. "In the last ten years, national dress has become very important and everyone proudly wears it on November 1," Geri-Anne stresses. "The islands wanted a distinct identity. Now we have week-long festivities. All the islands are decorated in bunting, bows and fans made of the national green, gold and red madras — even the buildings."

The colourful national costumes also feature the same madras, a plaid lightweight cotton fabric named for its origins in India. Women's outfits are topped with elaborate eyelet lace aprons threaded with ribbons, accompanied by bright beads and a madras head-tie knotted to suit individual tastes. "My grandmother always wore hers tied," Geri-Anne recalls. "Often women would twist their shopping money into the head scarf," adds Evelyn Burns, who demonstrates the technique. Men add colour to black pants and a white shirt with a madras-trimmed straw hat and waistcoat. Antiguans love to dress up and party to the music of steel bands, calypso or reggae for any occasion.

Jody Savard Willie's block design, framed with eyelet lace and beads, features an Antigua black pineapple, the national fruit, and a matching bow fashioned from madras. The embroidered sugar mill centred on the fruit represents one of more than 114 sugar cane mills still standing today, a historical reminder of what was once Antigua's main industry.

Christopher Columbus landed on Antigua in 1493 and named it after a church in Spain. "The people of Antigua and Barbuda have strong faith, go to church, and look after each other," Geri-Anne confides. "'Do unto others as you would have others do unto you is the motto we strive to live by," she continues. Whether playing cricket or having a picnic on one of 365 white sand beaches, Antiguans believe it is essential to be polite and respectful. Most important of all, though, is to celebrate life!

Afternoon tea at the yurt

One summer day in Kyrgyzstan, Ed Cook was on his way to town when he spotted a yurt, an igloo-shaped tent, with a colourful red doorway. He asked his Kyrgyz colleague, who worked with him in a local gold mine, if he could take a picture. "No problem," was the reply, but when Ed pointed his camera, an old woman standing in the doorway began waving her arms. Ed looked quizzically at his co-worker, thinking he had offended the woman. "No, she just wants to invite us in for tea!" his colleague explained.

Afternoon tea at the yurt gave Ed a glimpse into Kyrgyz life. The visitors sat on colourful traditional rugs covering a dirt floor and sipped tea accompanied by fermented mare's milk. People are very gracious and friendly, says Ed, and happy to entertain strangers passing by. Kyrgyzstan is a mountainous country. Its inhabitants are traditionally nomadic and famous for their horsemanship. The Kyrgyz dwell in the valleys during the winter and in summer take their sheep and horses to feed in the alpine meadows, where they live in yurts.

Ed's adventure began in 1996 when he accepted a position in the environmental department of a Canadian company establishing a gold mine in Kyrgyzstan. He spent six years commuting long-distance — one month in Kyrgyzstan, one month in Canada. When he first arrived in Bishkek, the capital city, with a population of about a million people, he noticed that the collapse of the Soviet Union several years earlier had left the country poor. Without subsidies, few streetlights functioned, and central heating was intermittent.

The economy has improved, but salaries are low. Many people supplement their income by selling rugs, wall hangings and carvings. The sheep that cover the countryside and wander along the roads provide the wool for rugs, often dyed in vibrant colours such as orange, red, blue and green, and woven into geometric patterns. Wool is also used to make felt, which is dyed different colours and fashioned into wall hangings and hats.

Ed's assignment ended in 2002. The fully operational gold mine was gradually turned over to Kyrgyz staff. He's now back in Saskatoon, where he has a collection of rugs and wall hangings to remind him of his time in the mountains of Kyrgyzstan, sometimes called the Switzerland of Central Asia. The block is fashioned from a tapestry he brought back with him. The vibrantly coloured felted wool is pieced in a traditional design, projecting the warmth and liveliness of the Kyrgyz people.

Jordan

A welcoming oasis

Almost entirely landlocked, Jordan is surrounded by Syria, Iraq, Saudi Arabia and Israel. It became a welcoming oasis for Taghreed Sandouka's Palestinian family when Israel occupied the West Bank during the 1967 Six-Day War. "My story is like eighty percent of Palestinians who live in Jordan because they were outside the country during the occupation and couldn't go back," says Taghreed. Jordan is like a second home, she says, "a place where people were reunited."

Now living in Cornwall, Ontario, Taghreed says the connection to Jordan "is a nice feeling." Her parents will eventually retire there, but until then, Jordan remains a central meeting place where family members living in the Gulf region gather at least once a year. "The kids really enjoy it," she says, but the adults appreciate its other qualities. Jordan has an excellent health-care system that includes free clinics, and dental and eye care for those without medical insurance. It is also the only Arab country that has ended the practice of compulsory military service for young men. Yet, unlike other Middle Eastern countries, Jordan has no oil.

Run as a constitutional monarchy, the country gained independence in 1946. American-born Queen Noor al-Hussein, widow of the former king, converted to Islam when they married in 1978. About ninety percent of the Jordanian population is Sunni Muslim. Special religious holidays are plentiful — weddings, births and harvests are cause for parties and great enjoyment. Festivals celebrate various sports and culture. The popular Jerash Festival for Culture and Arts features singing and dancing, painting, poetry and plays, as well as handicrafts. A rich heritage and colourful past are reflected in the traditional crafts, such as gold and silver work, rug-making using goat hair and sheep's wool, and embroidery.

In the past, every young Jordanian girl was expected to embroider her own wedding dress, and to make the clothes she would need as a married woman. The Jordan block Taghreed made shows detailed patterns cross-stitched on black cotton. Bright tones of red, green and yellow reveal traditional Cyprus tree motifs, while four triangles form a square in the centre. Tassels, an important decorative touch in Jordan, dangle from each side. They are attached, yet separate — much like Taghreed's connection to Jordan.

Hands that always move

Rugged Mount Rocher de Boule and the Seven Sisters Mountain Range have stood like sentinels of the Gitxsan as their culture evolved along the Skeena and Bulkley Rivers in northwestern British Columbia. Since the time of remembering, from the peaks several hundred miles inland, to the seas, the mountains have shed their burden of snow in early spring. While the mighty Skeena River swells to clean its banks, Gitxsan people in villages along the river await the arrival of the first spring salmon.

As the river recedes, the Salmon People (a race of people from the sea) begin their journey upriver to spawn. As they traverse each Gitxsan village, the ritual of the First Salmon is performed. Welcome dances, feasting and the return of complete salmon bones to the river are traditions that guarantee an abundance of salmon for generations to come.

Blockmaker Valerie Morgan, whose Gitxsan-language name is *Stem gem gi pikxw*, was too busy to accept the invitation to make the Gitxsan block when first asked. Unbeknownst to Valerie, her aunt took on the task, but illness prevented her from completing it. When the block returned to Valerie, she then believed she was destined to do this for her people.

Valerie's childhood experience with a nest of hatching snakes led her grandmother to predict that her hands would always move, that energy flowing through them would join visuals from her mind in an artistic expression of her culture. Self-taught, Valerie moved to Saskatoon to obtain academic qualifications after her fashion designs took off like wildfire. Later Valerie developed her natural ability to carve by attending the Northwest Coast Indian School of Art at Ksan. A wolf transformation mask carved for Walt Disney's *White Fang 2* is one of her important works. Her husband, Ken Mowatt, a carving instructor at Ksan, continues coaching Valerie at home.

Valerie also works with youth and young mothers, teaching them life options. She instructs Native culture, and traditions are strong in her family. Her children are talented in fashion and woodcarving, and assist in producing family art and clothing lines.

A respected Native artist and carver, Ken assisted in designing the Gitxsan block, using "methods, colours and materials passed down from the grandparents." Backed with navy cashmere wool, a Welcome Dancer with Raven headdress and Frog cape is appliquéd in tan moose hide. Turquoise leather strips depict water and a red spring salmon is outlined in white buttons symbolizing fish eggs. Treasured heirloom dentallium shells decorate the headdress, while twelve fringes on the cape include matte teal beads, iridescent teardrop beads, and copper bugles that represent the historic shields of Gitxsan warriors.

Welcome dances, feasting and the return of complete salmon bones to the river are traditions that guarantee an abundance of salmon for generations to come.

95

Luxembourg

A coq siffleur *is a reminder of courting rites and childhood in the tiny but feisty Grand Duchy.*

Le coq siffleur

Field-flower bouquets of white daisies, blue cornflowers and red poppies filled the homes of Luxembourg during World War II as a subtle show of resistance, since the three colours signified the country's flag. Represented in embroidered stitch-work on the Luxembourg block, they are reminders of a nation's courage and unity under adversity. Alain Dupont believes this courage came from innate stubbornness — a firm refusal to give in. "We had to resist in any way possible," he says.

Yet, according to Alain, Luxembourgers also have a whimsical side, and he describes some of their traditions as proof. For example, when a man wants to propose to his beloved, about four weeks before Easter, he will send her an almond-studded sweet-dough pretzel — up to two feet long! If she sends back a basketful of coloured eggs, he can begin the wedding plans. Sweethearts might also present each other with a small, clay *coq siffleur*, or whistling rooster. "This clay bird is such a remembrance of my childhood," Alain says fondly, because they were also customary Easter gifts for children. At the centre of the block, one such *Pëckervillercher*, or *coq siffleur*, is reproduced in fabric and nestled in the pocket made of a decorated linen napkin. Woven from flax grown in Luxembourg, the napkin is a tribute to Alain's father's family, who were producers of linen and woollen textiles for more than half a century.

Canada received over 2,000 Luxembourgers in the 1950s, but only some 200 now remain here. "Most are elderly. They are the ones who stayed here and married," he explains. He speaks of his country's long history with a mixture of pride and amazement. He points out that his small country has not just survived but has thrived. "Luxembourg has one of the highest per capita incomes in the world," he says. One advantage is the educational system's language curriculum. When Alain decided to emigrate, his fluency in four languages eased the way considerably.

In Canada, Alain has kept his country's traditions alive throughout his twenty-five-year association with the Canadian Luxembourg Society. His work in the travel industry allows him regular visits to Europe and his family ties in his native land help him keep ex-patriots current on all things Luxembourgish. He unabashedly admits he brings back a little *coq siffleur* made from the clay soil of Luxembourg on each trip, adding it to his growing collection in his Montréal home. "I guess I'm sentimental," he sighs. "It is like bringing a little piece of the country home with me."

Family roots

Loupu "Sugar" Orogie couldn't know that shortly after returning to Liberia in 1987, following a family visit to Canada, her parents would send her back to attend boarding school. It proved a timely blessing when civil war erupted into a systematic, grand-scale destruction of their country less than two years later. As conflicts intensified, thousands of Liberians fled, while tens of thousands who remained perished in ethnic massacres.

In 1990, her parents came to Canada for temporary refuge. Now fourteen years later, the fighting continues; their one hope is that upcoming elections will restore peace to their country. Sugar's mother, Mary Mamolu, a director at Rainbow Skills Development in Ottawa, mourns the fact she cannot return to Liberia to see her mother and family until the country is more stable. Liberia's population comprises some sixteen ethnic groups, including Americo-Liberians, descendants of freed slaves from America who resettled in Liberia in the late 1800s. Although this group represents only five percent of a largely indigenous population, the economy and governance was under their control for many years.

A trust company customer service representative, Sugar believes her experience has made her stronger and more independent. "I went from a life of privilege to a life where I have to struggle for everything," she says. Despite sending "prayers, money and clothing" to help ease the suffering of fellow Liberians, she laments, "There's only so much we can do." She says, "Liberians back home believe everyone in Canada is wealthy." Like her parents, she despairs when she thinks of the country in which she grew up. Sugar is eager for peace so her children can learn about African culture first-hand. "They need to know their family history and roots," she says. "Everybody needs to know where they started."

The three-dimensional cassava plant Sugar and her mother chose for their block honours its importance as a versatile, enduring food staple also used for cooking in Canada. The striped background is *fanti,* or country cloth, reflecting the strong West African tradition of handwoven strip weaving. Ceremonial clothing, including wedding garments, is created from more vividly patterned fabrics.

With much of their hospitality focused on sharing meals, Sugar continues to make African food and listens to African music — they make her "feel good." She describes Liberians as "gracious hosts, a warm, loving people capable of adapting to any situation." Her own adaptability to Canadian life and her stories of her family and homeland are part of the cloth she weaves for her children so they will know their own story.

> " Everybody needs
> to know where
> they started. "
>
> *Loupu Orogie*

97

Jamaica

Keep smiling

When Marjorie Blake lost her mother at a young age, her great aunt, Floris Flynn, became the guiding force in her life. "She praised me for everything I did," Marjorie explains. This formidable Victorian woman encouraged her to "move ahead, do things, make things, and keep smiling." In many difficult seasons Marjorie did just that: through the anguish of losing twins shortly after birth; during a frustrating seven-year immigration process; through the sad dissolution of her marriage; and the emotional hardships of pursuing a teaching career as a single mother. She faced every challenge with spirit and courage.

Strength of character wasn't the only legacy Marjorie received. Her aunt also taught her the elegant expressions of decorative needlework. Marjorie's drawn-thread work in her block creates a distinctive frame. The narrow inner bands are inspired by the colours of the Jamaican flag: gold represents natural wealth and the beauty of sunshine; the black border stands for hardships faced and surmounted. The national bird is the unusual doctor bird, immortalized in folklore and song. Of the 320 species of humming-birds, this rare iridescent hummingbird, also known as a swallowtail, is found only in Jamaica. It hovers while sipping nectar from a hibiscus bloom, the beautiful flowering shrub that grows throughout the country. The national fruit, from the ornamental ackee tree, completes the presentation. Its botanical name, *Blighia sapida*, honours the notorious Captain William Bligh, who took samples of it to England in 1793.

Marjorie explains that ackee is a special delicacy that involves careful work to extract the yellow fleshy parts of the fruit around the seeds. She has graciously prepared an exotic luncheon that includes salt cod, cooked ackee and fried plantain. The dessert of black fruitcake is more familiar and tastes like English plum pudding. Marjorie is reminded of her compassionate aunt who not only dispatched Christmas meals to shut-ins, but also regularly opened her doors to the less fortunate. "No one ever went away empty-handed," recalls Marjorie. Following the same tradition, she offers a bottle of steeped sorrel and ginger as a keepsake.

Jamaicans, like Canadians, embrace multiculturalism. Their motto reflects this openness: Out of many, one people. They also champion and revere children, considering it a community responsibility to nurture and guide them. For Marjorie, raising her son alone from the age of two was both a joyful and daunting task. She prayed he would become a good person. "That was most important," she says. Today, Marjorie is a Canadian citizen, a proud mother and a grandmother. She is grateful her prayers for her son were answered and now realizes that they were, after all, no different than her great aunt's prayers for her.

66 Move ahead,
do things,
make things;
keep smiling. 99

Marjorie Blake

Born to drum

Blockmaker Lise Mestokosho used traditional embroidery on caribou skin to express the history of her people. "The art tells how the Innu travelled the lands and waterways, by canoe and on foot, by snowshoes and sled, existing upon traditional salmon harpooning," says Lise. "These are the Innu tools of transportation and survival."

The traditional lands of the Innu ranged from southwestern Québec to Labrador. As nomadic woodlands hunter-gatherers, they moved regularly to occupy the best hunting grounds. In summer they lived in villages near the rivers, and in winter they set up hunting camps in the interior. Deer, moose, seal and salmon were staples of the Innu diet, while porcupine meat was considered a delicacy. The southern Innu constructed wigwams with birchbark covers, but their Naskapi relatives followed great migrations of caribou herds and covered their homes with hide.

French explorers who saw them coming out of the Laurentian Mountains called the Innu the *Montagnais*, meaning "mountaineers." They were also called the Kebic tribe, a possible source of the name Québec. The Innu language, *Innu-aimun*, is an Algonquin tongue close to northern Cree. The Innu have used a strong oral tradition of stories, songs and dance to transmit legends from generation to generation.

The Innu once made stone and animal bone tools, crafted wooden utensils, and made clothing and footwear from animal hides. Many items of clothing were decorated with painted or woven designs. Naskapi painted caribou-skin coats are particularly notable and can be found on prominent display in museums throughout the world.

In the centre of the Innu block, Lise has stitched the *Teueikan*. "It is a sacred musical drum that can only be played by those men destined to do so," she explains. Accompanied by the *Teueikan*, the Innu sing of their dreams, their hunts, their history, and they thank the Great Spirit for future good hunting. At the hunting feast after a kill, called *mokushan*, the drumming and songs are dedicated to the animal's spirit. The Innu are a spiritual people whose culture is focused on their relationship to the animals they hunt. To kill an animal is considered an act of respect, as the animals have spiritual power and allow themselves to be killed to gain the hunters' respect. In the crumpled-leather background of the block, one can imagine the shadowy figure of the great master caribou Papakassik. "It is he," says Lise, "who guides all natural and supernatural laws."

Montagnais

Innu

Nigeria

Kofo Dedeke's block is an expression of love for the geography of the homeland she left almost fifty years ago.

The complete suit

As a young woman, Kofo Dedeke became the first female draftsman to work for the Nigerian Survey Department. She spent countless hours as a cartographer mapping her country. Located on the western section of the continent, bordering the Gulf of Guinea, Nigeria is Africa's most populous nation. It is very evident in her block and in her voice that she loves Nigeria's geography.

But Kofo was also in love, engaged to a fiancé who was studying in Manitoba. They had not seen each other for four years, so they decided she should come to Canada to get married. Before leaving home, Kofo bought her first and only "complete suit." In the tradition of the southwestern Yoruba, this includes a lower wrapper (a bedsheet-sized fabric), a *gele* (head covering) and a top wrapper or shawl. This outfit was worn on special occasions and women who could afford one usually had only one. It was 1956 and she was ready to sail for Canada.

In Liverpool, England, Kofo was stopped by Immigration Canada from proceeding. She was labelled a liability, as she was going to marry a man who was not a citizen and not employed. What could she do? Her brief layover stretched to more than six weeks. Her fiancé, Theodosius Dedeke, was also heartbroken. One day, the University principal asked why his fiancé had not arrived. After hearing the story, the principal picked up the telephone and called a former school chum — the Minister of Immigration! Within hours, Kofo was on her way.

In 1957, the newlyweds moved to Montréal so Theodosius could continue his studies. The Dedekes decided to remain in Canada when war broke out in Nigeria. At church, members introduced Kofo to the president of a large company that had refused her employment; she was hired the next day. While working there, she lent her "complete suit" to someone. It came back ruined. Her beautiful, ecru, raw-silk outfit had been machine washed with dark colours! She could not bring herself to get rid of it, but she could never wear it again.

After she retired from work as a civil engineering technician, Kofo served as president of her United Church Women's group, where she learned about the Invitation Project. Kofo, who enjoys new challenges, excitedly volunteered to make the Nigerian block. And she knew exactly where to get her material — her "complete suit"! She carefully dyed the fabric to reflect the colours of the Niger River, adding beaded date palms and fabrics to represent the grazing savannah. Now the ruined suit has turned into an expression of love for the geography of the homeland she left almost fifty years ago.

Fields of flax

Irish eyes, an Irish name and a winsome colleen's smile, combined with a gift for music and skilful hands to stitch delicate needlework are Loralyn Reilly Gazdik's legacies.

Loralyn chose twenty-eight-count Cashel linen to highlight the superior quality of Ireland's world-famous fabric. To her, linen represents a contradiction. It is so very fine and delicate, yet the Irish are known as workers of the land. They are "working class," but their linen is found in the most elegant homes. When Loralyn's grandfather felt homesick he would talk about the vast fields of flax, from which linen is made, abloom with bluish-purple flowers. Loralyn thinks this natural beauty is reflected not only in their linen, but also in Irish music, stories and literature.

The Celtic cross embodies the inherent religious nature of the country. Since wood is scarce in Ireland, crosses are usually carved of stone. Loralyn has cross-stitched a Celtic cross with "woven bars" in rich colours and an abundance of gold thread in the tradition of Celtic art. The circle, embroidered in the distinctive Irish stitch, represents the eternity of God. The three swirls at each end represent the Trinity. The famous shamrock, synonymous with Ireland, is centred in the block.

Crocheted Irish lace, often called "poor man's lace," copies the designs of expensive Venetian and French laces using very fine cotton thread. Women create beautiful intricate patterns with fine picots, leaves and flowers to make bedspreads, doilies, tablecloths and edgings. Often these skills were taught to young women in convents to help them support their families, especially during the potato famine of the 1840s. The desperation of those hard times drove thousands of poverty-stricken Irish to leave their homeland. Many perished aboard over-crowded, disease-infested ships. Some French-speaking Québec families bear Irish surnames, a testament to adopted, orphaned children who were permitted to keep this link to their roots.

The Irish on both sides of the Atlantic treasure their lace, linens and patterns. When Loralyn's grandmother emigrated, she brought along her prized linens and needlework. Loralyn cherishes one of her now-deceased grandmother's Irish-lace shawls. She is learning to replicate this shawl as a way of maintaining a connection with her grandmother and her Irish heritage.

The Reillys, like so many at the time, emigrated from County Armagh for both economic and political reasons. The mammoth scale of Irish immigration to Canada over the last two centuries has had an enormous influence. At the time of Confederation, Canadians of Irish lineage formed the largest ethnic group in the country. Like the fine threads of their linen and their lace, they are intricately woven into all areas of the Canadian fabric.

Mauritius

The prospect of parenting from the distance of the southwest Indian Ocean, left Serge Nina cold, no matter how hot the sun shone.

The price of paradise

Some people when they retire move away to a tropical paradise. Former chief inspector Serge Nina did the opposite. When he retired, he and his wife, Lyldya, left their tropical paradise and moved to a place where snow hangs around from November to April. They did it because their three sons immigrated to Canada, and the prospect of parenting from the distance of the southwest Indian Ocean, left them cold, no matter how hot the sun shone.

Serge's glowing description of Mauritius is not empty sentiment. "I was well off," he says, as he tells of an independent island country with one of Africa's highest incomes per capita. The beautiful coral reefs, stretches of white sand beaches, and the sea are natural bonuses. Serge smiles and tries once more to explain the gravitational pull of familial ties. "Our sons asked us to join them. So, I retired from the police force prematurely." In thirty-six years of service, Serge had moved up the ranks from constable to chief inspector. His natural gift for drawing placed him at crime scenes, sketching suspects from eyewitness descriptions. He loved his work, and if he could love his retirement half as much, he'd be a happy man!

In the end his happiness had nothing to do with retirement. After less than two weeks in Canada he found work as a security officer with an Ottawa firm. That was fifteen years ago. He's seventy-two now, and continues to work full time. Grinning like someone who's outwitted the laws of nature he admits that finding a job so quickly, years ago, was a surprise. "But I'm bilingual," he rationalizes. "And I learned the job quickly."

Formed on an extinct volcanic archipelago, Mauritius includes the islands of Rodrigues, Agalega, St. Brandon and Cargados Carajos — housing a population of Creole, French, Indian, European and Chinese. Sugar cane production once dominated the economy; now it is tourism and textile production that fuel it. Mauritius was once home to dodo birds, extinct since the 17th century. On the block designed by Serge, Bernice Michaud has richly depicted the 50-pound, flightless bird in beautifully detailed textured embroidery stitches. A blend of cottons and specialty fabrics that sparkle in blues and greens, evoking the exotic mystery of land and sea, provide the backdrop.

The Ninas display a book on Mauritius in which each photo is an invitation to paradise. Into the absorbed silence Serge introduces a half-teasing mention of the island's cyclone season that spins out of control between November and April. Laughing again, Serge announces he's taken a particular liking to snow. Everyone is reminded that paradise often comes with a price.

A good journey

Wendy Whitecloud likes to know exactly what she is doing. Even as a young girl learning the art of quilting and embroidery at workshops offered through her church on the Sioux Valley Reserve, she felt most confident following a design's established lines. Now a law professor at the University of Manitoba, she laughs at herself, at the precise creature she's become. "I'm a linear person," she says, laughing again. "I have to follow patterns to the max."

Because she had never done anything quite like it before, Wendy wasn't sure she could coordinate the design and create the Dakota block, with its dominant beadwork. She remembers watching her great-grandmother and aunt working carefully and artistically with beads. It seemed to her that beading was a difficult art, something she could never attempt. Encouraged to think of it as "just another medium," and being the logical and orderly type, Wendy began with research. "This was my first big project," she says in a voice that leaves no doubt as to how thorough she was. "That's why I laboured over it."

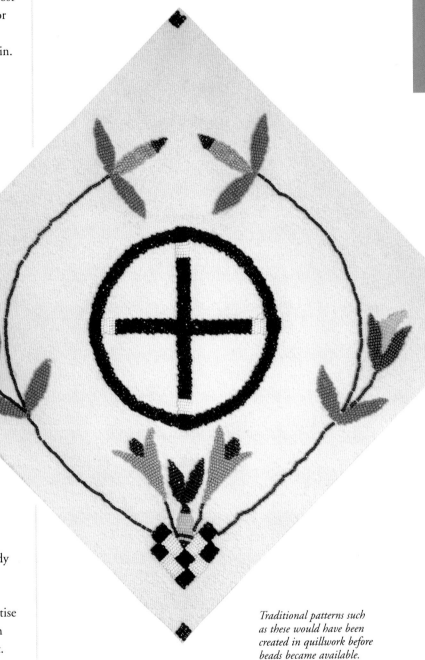

Wendy explains that the design on white deerhide begins with a foundation in black and white beading, showing the duality of life for Dakota people; past and present, male and female. The mandala represents the circle of all life, the four directions of the universe, and Dakota people's fundamental belief that all animate or inanimate forms are their relatives. The stylized flowers are based on typical eastern prairies flora. Traditional patterns such as these would have been created in quillwork before beads became available, says Wendy.

Many southern Manitoba Dakota descended from the nomadic Dakota of the Minnesota area. A member of a large family, Wendy went through her own "nomadic period" in her youth before she returned home, settled down and studied law. Married, with an eighteen-year-old son, she says she always knew she wouldn't practise law, but teach it. Although she says you always have to be "on" in the classroom, working with students is the thing she enjoys most.

Traditional patterns such as these would have been created in quillwork before beads became available.

The block was a labour of love for Wendy, an opportunity for her to explore Dakota beadwork designs and to engage in a different art form. The design is based on an historic Eastern Dakota (Sioux) pipe-bag pattern from the mid-1800s, and was created by her good friend, Rainey Gaywish, who also supplied the beads and materials to make it. Wendy says without the support and encouragement of her two sisters, Bonnie and Lisa, and of Rainey, "I could not have completed the block." But she did. And, she says, "It was a good journey."

São Tomé e Príncipe

The emerald background symbolizes the nation's lush, natural beauty, but also speaks of hopes for a better future.

Awakening hopes

The natural beauty of the country, the warmth and spirit of the people, and close family ties — these images and memories spill out whenever Agapito Mendes Dias talks about his homeland. "We are a unique blend," he says with pride, "an ethnic and cultural mix of African and Portuguese."

Agapito, a soft-spoken man, is one of only a handful of São Toméans living in Canada. The place he speaks of with such feeling is São Tomé e Príncipe, Africa's smallest democratic nation consisting of two islands, straddling an extinct volcanic archipelago in the Atlantic. The Portuguese claimed these islands in the 15th century. Today, following a turbulent history of colonialism and plantation farming, the country retains many elements of its diverse past in its cuisine, customs and dress.

Agapito cares deeply about his country, but is saddened by São Tomé's sharp contrasts. "It's rich in natural resources, but at the same time, the economy is extremely poor," he explains. Since gaining independence from Portugal in 1975, São Tomé has struggled to develop a self-sustaining economy through tourism, light industry and cash crops. Another irony is that São Tomé's main export is some of the best cocoa in the world, but most islanders cannot afford to buy it.

While these issues disturb Agapito, he is not one to merely lament the woes of his country. A background in economics allows him to help in a more concrete, purposeful way. Presently, he is coordinating relations between São Tomé and the World Bank as they work through a structural adjustment program that began in the late 1990s.

With the same sense of purpose, Agapito presented the carefully selected materials he'd brought back to Montréal from a recent trip to São Tomé. He gave much consideration to the design for the block. Against the foil of pleated eyelet lace, typical of women's native dress, the island's exquisite national flower, the *rose de porcelaine*, unfurls its delicate petals. On either side, two red triangles are reminders of the country's historical struggles. The emerald background symbolizes the nation's lush, natural beauty, but also speaks of hopes for a better future. Recent oil explorations taking place in the Gulf of Guinea offer interesting possibilities. Even so, Agapito is the first to admit there is much work ahead for this developing nation. Yet like all São Toméans, he nurtures hopes and dreams for a prosperous future.

The sweet scent of Comoros

Native Comorian, Youssouf Abdourahame, sets a hand-stitched embroidered skullcap on the table, inviting closer inspection. Thousands of pinpoint eyelets swirl out in intricate designs made by repeatedly piercing a needle through the material. Embroidery in matching shades surround each pinpoint. This stunning work of art and labour of love, created for Youssouf's five-year-old son by Youssouf's mother, took eighteen months to complete. This is a modest timeframe according to Youssouf. Depending on a woman's other family responsibilities, "It could even take up to five years," he says.

Men traditionally receive gifts from future wives and in-laws as an expression of welcome. This often takes the form of beautifully embroidered garments. Youssouf displays a long cotton shift, called a *malabary*. The exquisite white-on-white stitching around the neckline is as precise and delicate, and as labour intensive, as his son's skullcap.

Women also receive fine gifts. With great relish, Youssouf produces photos of a weeklong Comorian wedding celebration he attended. One photo shows a table laden with gold jewellery. "For the bride," Youssouf explains. Confused, his guest asks for clarification: *To choose from, right?* "No," says Youssouf, laughing. "That's all of it! And probably, that's half of the picture." He shuffles through the photos to find one of the bride. She is young and beautiful in her richly-textured wedding finery, a perfect foil for an astounding display of gold jewellery.

Comoros Islands, along the Mozambique Channel, are inhabited by a blend of African mainlanders, Malay-Polynesians, Arab traders, Shirazi Persians and Creoles. Traditions are strong in this predominantly Islamic republic. For those who can afford it, traditional "grand marriage" celebrations continue to be eagerly awaited and significant social events enjoyed by entire villages.

Ylang-ylang flowers, featured in the Comoros block, are also part of the lavish nuptial celebrations. They are scattered across the newlyweds' bed. The essence of ylang-ylang, used in making expensive perfumes and soap, along with vanilla, are two of the country's chief exports. On sudden impulse, Youssouf dashes into the kitchen and returns with a crumpled paper bag. He smiles as he opens it. At once, the air in the dining room of his small Ottawa apartment fills with the intoxicating scent of vanilla, the sweet scent of Comoros.

Saint Lucia

Detail of a jacquot, an endangered parrot indigenous to Saint Lucia, beautifully stitched by Reina Cross.

Hearts engaged

Saint Lucia, a tiny island nation in the eastern Caribbean, is home to many stunning sights and sounds. For sisters Avril, Merle and Roslyn Phillip, thoughts of their birthplace stir memories of mountain peaks, brilliantly plumed tropical birds and colourful national dresses. Not surprisingly, these elements became the inspiration for their block.

At the centre are the Pitons — dramatic twin coastal peaks that soar 2,000 feet up from the sea, and a beautifully stitched *jacquot*, an endangered parrot indigenous to Saint Lucia. The design is crowned with a piece of madras tied like a customary *tête en l'air*, the headdress of the national costume. The initiated know that it is more than just a head covering for it reveals the romantic commitment of the woman wearing it. One peak declares "my heart is free," two means "my heart is engaged but you can try," three communicates "my heart is engaged" and four peaks says "anyone who tries is welcome." The sisters chose three peaks for the block's headdress, perhaps one for each of them.

The national dress of Saint Lucia also includes a white blouse, an outer skirt made of madras fabric and worn over a long, white petticoat trimmed with rows of eyelet lace, and a *foulard*, a triangular scarf pinned on the left shoulder with the ends tucked in at the waist. The ensemble is usually completed with hoop earrings, and many chains and bangles. When Avril, Merle and Roslyn first came to Canada, they enthusiastically continued this tradition of donning abundant jewellery, but were dismayed to realize this was not a common practice in their new country. Not wishing to appear to be "showing off," they reluctantly stopped doing so.

Despite wearing less jewellery now, the Phillip sisters have embraced their new lives in Canada while proudly preserving the treasured traditions of their native Saint Lucia. Of course, when asked, they unanimously — and honestly — admit to missing "the climate." Each patiently teaches the Creole language to her children, cooks the foods she remembers so well, and welcomes opportunities like Toronto's annual Caribana Festival to celebrate and share her culture with other Canadians. Their memberships in the St. Joseph's Convent (Saint Lucia) Alumni, an organization that provides scholarships for needy students on the island, is a thread that keeps the sisters connected to Saint Lucia, even as they make a place for themselves within the Canadian fabric.

Caught in the "web of life"

Once part of the Yanktonai Sioux in the United States, the Nakoda (also called Nakota, Assiniboine, and Stoney) broke away from the main group during a civil war and moved northward into Canada sometime during the 1600s. The Nakoda assimilated cultural aspects of the Plains Cree living to the north and the Blackfoot to the south, as they roamed the rolling plains west of Lake Winnipeg. They often travelled as far as the foothills of the magnificent Rocky Mountains, following the migrating buffalo herds that carpeted the plains of Western Canada.

Along the trails, the Nakoda set up camp, unloaded belongings from their travois and put up buffalo hide tepees. Meat and vegetables simmered in birchbark or hide baskets of water ingeniously heated with scalding stones. The Ojibwe-Chippewa word *Assiniboin* means "one who cooks with heated stones." Pemmican, a mixture of dried, shredded buffalo meat, mixed with fat and berries, was an invaluable dietary staple during their rigorous travels. Highly nutritious and easily transported, pemmican required no further preparation, and would keep for long periods. It was often traded for other goods.

With the decimation of the buffalo population by 1880, the Nakoda experienced terrible hardships. They were forced onto government reservations and many died of starvation without access to their traditional food source. For the people of the five Nakoda/Assiniboine reserves in Saskatchewan and Alberta, the loss of the buffalo brought about irrevocable changes to their ancient way of life.

Despite the difficulties, the Nakoda and their culture have survived. In the evening after children have had their fill of stories about Iktomi, the great trickster and teacher of wisdom, they can still sleep beneath the protection of a dream-catcher. It is believed that bad dreams are caught in the spider-web-like weaving of the dream-catchers, while good dreams sift through the central hole and into the mind of the sleeper. The entangled bad dreams wither at the first light of dawn. Another version of the tale says the good dreams and visions stay in the "web of life" to be carried with the dreamer, while the evil in their dreams escapes through the hole. The Wesleys, a family of contemporary Nakoda artists who often work together to complete their pieces, made the unusual heart-shaped dream-catcher with a miniature staff suspended in the centre featured on the block. Although times have changed, the Nakoda are moving forward with new dreams, delicately threaded with elements of the past.

Cape Verde

Under a blazing sun

When Gloria Henck thinks of Cape Verde, she envisages women working at their daily chores on the rocky archipelago off Africa's west coast. Whether it is creating a piece of embroidery, pounding corn, or simply washing the family's laundry, women's chores make up the durable fabric of each community. The quilt block depicts the latter, a delicately embroidered woman, perhaps a mother, washing laundry while seeking refuge from the blazing sun by working under the shade of a large tree. Rising peaks in the distance are beautiful, but speak of a rough, arid terrain. For Gloria, who lived on the island for thirty-seven years, this is one of many familiar images.

Fishing reminds Gloria of tuna and the rich fishing grounds that surround Cape Verde. Considerable investment during the 1990s went into the industry, allowing for construction of new fish-processing facilities and upgrades to the fishing fleet that harvests mostly skipjack, yellow-fin tuna and wahoo. Commercial fishing contributes almost half of the total export earnings for the country. Gloria remembers vividly the men catching "huge tunas" and carrying them home on their shoulders. "But," she adds with a chuckle, "women would carry the tuna on their heads." This was wise since some tunas weigh between 100 and 250 pounds.

Gloria also remembers that many men had to find jobs on board ships, because work on the islands was so scarce. The need to look elsewhere for a livelihood and different lifestyle accounts for the roughly 700,000 Cape Verdean émigrés who live abroad. For well over a century, their remittances to the government of their homeland, currently totaling between $25 and $30 million annually, have been a vital source of national income. More than two-thirds of Cape Verde's inhabitants are Mesticos, a mix of European and African ancestry, and nearly all the remainder are of African descent. Portuguese is the official language although most people speak an informal Creole tongue known as Crioulo.

A general West African influence is evident in much of Cape Verde's culture. They are known for their strong oral tradition of stories and poetry. There has been a spectacular revival of weaving, cloth making and tapestries, as well as wood sculptures, basketry, and ceramics made from red clay, in the city of Mindelo on the island of São Vicente. Music, too, is an essential part of community life and includes the foot-stomping *funana* and the melancholic *morna*. A special, deep-fried dish called *pastel com diablo dentro* (pastry with the devil inside) is made with fresh tuna, onions and tomatoes wrapped inside pastry made from boiled potatoes and corn flour. Gloria says her "favorite local dish" is *cashupa*, a combination of corn and beans cooked together.

Achieving balance

Ann Dawes, a pastry chef and former restaurateur who once worked eighty-hour weeks, rejects the workaholic label. "I'm an overachiever," she says, and then laughs when asked the difference. "Workaholics don't know when to 'pull away,'" she answers.

Seven years ago, cancer pulled her away from her work and from the life she'd built through backbreaking hours. Ann thought she was simply *too busy* to be sick. Diagnosed on a Tuesday, she argued with doctors when they couldn't begin treatment sooner than Thursday. "Excuse me, but I have a restaurant to run," she told them. For years, Ann's hectic pace of life never let up even when she travelled for business and pleasure to the Dominican Republic. Ironically, the tourism motto there is, "Here I can relax." Even her social calendar was busy during her ten-year relationship with a Dominican *merengue* singer, who provided entertainment for many festivities.

Ann underwent a biopsy and evaluation as scheduled, yet she worked all day Friday on a big job. She tried to get her treatment accelerated, but to no avail. Medical complications led to a seventeen-week hospital stay. "Other people had to run my restaurant," she concedes. There was nothing more she could do except concentrate on healing. Forced to slow down, Ann remembered a time when she had enjoyed making crafts. She reawakened to the quiet visual pleasures of creating with fabric and colour. "It became part of my recovery," she says.

Later, stitching the Dominican Republic block provided an extension of her healing process. "Dominicans love colour," she states. She used bright cottons, intricately folded and positioned to create an appliquéd panoramic view of the island with its beaches, mountains and rainforests. Atop the highest peak perches the Monument of the Heroes of the Restoration, a 67-metre, white marble structure housing the murals of Spanish artist, Vele Zanetti. Three-dimensional petals of the *Flor de la Caob,* the island's national flower, are placed in the foreground. "Dominicans love music and dancing as much as their carnivals," says Ann. "If they can come up with an excuse for one, they will." Major-leaguers Sammy Sosa and Tony Hernandez are perhaps the best-known players of the other Dominican passion, *pelota,* or baseball. Their charitable foundations provide free clinics and other help to their impoverished countrymen.

Today, Ann is healthy and works in a small bakery that specializes in products made from natural ingredients. Sometimes, the pace can be hectic. But now she takes a lesson from the Dominicans. "I take time that is just mine," she says with satisfaction.

Dominican Republic

"Dominicans love music and dancing as much as their carnivals."
Ann Dawes

Central African Republic

> " Each fall, butterflies
> fill the sky, as if
> it were snowing. "
>
> *Rosalie Yonaba-Bernier*

On butterfly wings

Rosalie Yonaba-Bernier lives in a small apartment in Hull, Québec surrounded by her family and beloved treasures from the Central African Republic. Her home is a live-in museum, housing an impressive collection of carved ebony figures, engraved calabashes, musical instruments, colourful fabrics and delicate butterfly art. Butterfly wings, cleverly arranged and glued to paper, become birds, animals, geometric patterns or scenes of village life. Rosalie's eyes soften as her mind slips back to her childhood. "It's a phenomenon unique in the world. In the fall, butterflies fill the sky, as if it were snowing. When they die, children gather the coloured gossamer wings. My brother still makes all sorts of things from butterfly wings and he sends me many."

Her dream is to start a museum to showcase Africa's riches. "People always think of Africa as a place of misery and trouble, but there are many who make wonderful things…sculptors everywhere and remarkable clothing designers." Brilliantly patterned cottons are shaped into *boubous, foulards,* and shirts, replacing garments fashioned in raffia cloth made from bark.

"But that was before," laments Rosalie, "when my country was the most beautiful in the world, the most peaceful, welcoming all its neighbours. We were self-sufficient, blessed with so many natural resources. Now all that has been destroyed and poverty reigns." When she was ten years old, Rosalie participated in the investiture of the incoming head of state. In subsequent years, Emperor Bucassa became corrupt, terrorizing and exploiting his people. Still just a schoolgirl, Rosalie led a peaceful student protest against him. But her brother was killed as their placards were met with bullets, one of which is still lodged in Rosalie's leg. The leader was deposed after years of brutality, eventually returning to die in his homeland. Rosalie, who emigrated in 1989, returned to visit in 1995. While there she confronted her former persecutor despite her family's protests. He received her well, allowing her to tape the last interview he gave and answering her piercing questions. They had brokered a remarkable personal truce.

Rosalie has toiled tirelessly for the cause of children and women, starting a special centre for female victims. She greeted the Pope and presented him with butterfly-wings art on behalf of the Republic. Later she worked in the Vatican for two years. In Canada, she has been no less productive, volunteering and establishing a help centre for new immigrants. For the Department of National Defence, she gave cultural training to soldiers deployed to Africa. Upon their return, the soldiers gave her a special gift: a picture of her country's flag made out of bark and butterfly wings. Once again, the delicate wings had found Rosalie, their fragility a contrast and a tribute to her inner strength and courage.

Better than chicken

When one tries to reach Carol Mackenzie on the telephone, any one of a number of people might answer. "Oh, yes," says Carol, her voice bubbling with friendly laughter, "I live with my mother, two brothers, a nephew, an uncle…." Carol, of the Yellowknives Dene First Nation, lives in Ndilo in Yellowknife, capital of the Northwest Territories. "That's the 'Native' area," she adds, giggling once again. The name of both the people and the city is said to derive from a small group of Athabascan Indians who used yellow copper to fashion knives and other tools. The city was founded only in 1935, one year after gold was discovered in the area; however, the Yellowknives and their Dene kin — the Chipewyan, Slavey, and Dogrib — have lived on these lands located 450 kilometres south of the Arctic Circle for thousands of years.

Descendants of the band led by Chief Akaitcho, saved the Franklin Expedition in 1822 and were subsequently awarded a medal from the British Crown for their efforts. The Yellowknives were the largest tribe to sign Treaty Number 8 in 1900. This document became the model for land use and development in the North. Early in the 20th century, church and federal government officials began amalgamating the Yellowknives into the Chipewyans. This continued into the 1960s. A number of further circumstances led to the dispersal of the Yellowknives to various locations across the North. In the 1990s, different groups surfaced with claims to the land rights of the Yellowknives. These claims are still unresolved.

Carol doesn't want to see her culture, language or land lost as she grows older. "My heritage means a lot to me," she says seriously. "We are losing our elders, we are losing so much." Although Carol speaks her native Athapaskan language, she knows few people who do. "Most of the young people, and even the middle-aged ones, speak English to their parents."

Carol also learned the traditional skills such as beadwork and sewing from her mother, "before I was thirteen." She still makes decorated moccasins, mitts and jackets from caribou hide, "But I sew just for myself," she adds. She contributed two pairs of beaded slipper vamps, which have been sewn in the form of a flower to create the Yellowknives block. Set back slightly, the uppers are outlined by cobalt-blue felt, leaving a subtle hint of their original purpose. It is important for Carol to maintain her connection to the "old ways." Her favourite food is still wild game, especially muskrat stew. Asked what that tastes like, she answers enthusiastically, "Oh, it's better than Kentucky Fried Chicken!"

Yellowknives

Tatsanottine

Uganda

Betty Kieran among her African treasures.

Africa's beautiful everyday face

Betty Kieran's son Michael was only nine when he came home from school and announced: "People don't understand Africa." Betty understood. After her arrival in Canada in the 1970s, she had tried telling people about herself and her country. All too soon, she saw that Western perceptions of African countries were filtered through media coverage of natural disasters and political turmoil. She remembers the Uganda of her youth as beautiful and peaceful. "It's still beautiful," she says. And today, it has one of the fastest-growing economies in Africa.

Michael's solution was to present a slide show of the Africa he had experienced. There were a *lot* of photos. The family had lived in Tanzania, where Michael and his brother had gone to school. They had trekked through national parks, gone on safaris, visited grandparents and other members of their large, extended family in Uganda. Satisfied there were enough images to unveil Africa's beautiful everyday face, Michael made a presentation that astounded and delighted his classmates. But what they were really curious about was where Michael had gotten "all those great postcards."

Betty laughs, recounting the story. But for her, it wasn't until the birth of Giraffe, the African Store, that she was presented with an ongoing opportunity to share her country's diverse culture. "It also became a way to keep in touch with my own background," she says, referring to the annual buying trips that always include visits to Uganda. The store was established in 1974 with locations in Ottawa and Montréal. It has since become the largest North American store showcasing African art and crafts.

Giraffe is a journey into the creative heart of Africa. Henna-painted, goatskin lampshades flicker with mysterious lights. Like imperious sentinels, beautifully carved, high-backed chairs stand guard next to display cases filled with exotic silver jewellery, studded with semi-precious stones. Vintage and modern art provide fresh balance and continuity. Masks, spears, soapstone and woodcarvings give way to an astonishing array of traditional musical instruments. And swatches of brightly coloured textiles dazzle the eye.

When Giraffe first opened Betty's Ugandan aunt supplied the store with bark cloth, crafted into blankets. In the quilt block this traditional textile serves as a textured background to Uganda's national bird, the crested crane. From day-to-day use, to special ceremonial functions, bark cloth speaks the language of a people. In Betty's small office, some two-dozen masks peer down from the wall. Betty takes one down and studies it thoughtfully. She says African art is not only about masks, although they too, recall a history. Many items carried in Giraffe are rich in history and culture, she explains. "Each piece tells its own story."

The breadfruit of life

"St. Vincent has the oldest botanical garden in the western hemisphere, established in 1765," explains Cynthia Murray. "In this garden, there is a breadfruit tree that was planted by Captain William Bligh himself in 1793." The captain of the HMS *Bounty*, under orders from King George III, brought the tree from Tahiti to provide nourishment for the African slaves working on plantations in the Caribbean. For its historical role and its place as a dietary staple, Cynthia chose a breadfruit tree to symbolize her country on her block.

St. Vincent is the largest and most northern of about thirty islands, many of them uninhabited, that make up St. Vincent and the Grenadines, a country with only 120,000 inhabitants. The people are descended from South American Caribs, African slaves and European settlers. Fishing and agriculture keep the economy going. In addition to abundant breadfruit, coconut and other tropical fruits, St. Vincent is the world's largest producer of arrowroot.

Raised on this idyllic eastern Caribbean island, whose jewelled waters and lovely beaches attract a strong tourist trade, Cynthia has fond memories of being close to aunts, uncles and cousins. She remembers the annual carnival called Vincy Mas when "you go downtown and you find lots of music and you dance, and it is like a big party, all the way to the next morning." The street parties go on for nine days until the big day comes when dancers don elaborate costumes involving enormous gauze-covered wings and fancy headdresses.

In 1984, Cynthia exchanged island life for the fast pace of a big Canadian city. While studying accounting at Concordia University in Montréal, she met her Iranian-born husband, Vahid. Though her life now in Brampton, Ontario, is much different from what it was in St. Vincent, Cynthia finds ways to keep ties with her culture. She still prepares breadfruit (when cooked, it feels and tastes like fresh bread) that she buys in West Indian specialty markets. In her block, Cynthia put the breadfruit on a background of the same bright colours as the country's flag: blue for the sky and ocean, gold for the warm sunshine and bright spirit of the people, and green for lush vegetation. "The colours I chose are meaningful to me," she says, "because I think no matter where we migrate, we keep our bright, spirited qualities."

Mongolia

On the road again

Mongolia: the name itself conjures up images of 13th century ruler Genghis Khan, herds of Mongolian ponies racing across the steppes, and nomads transporting their conical yurts to their next settlement. Home of the Gobi Desert, Mongolia is bordered by Russia on the north and by China on the southeast and west. With a density of less than two people per square kilometre, its population of two-and-a-half million live mostly in rural areas. Slightly more than one million live in or near urban centres with the capital city, Ulaanbaatar (Ulan Bator), alone housing about 847,000 people.

The nomadic lifestyle of the Mongols has shaped the culture of this country that gained independence from China in 1921. Seventy-five percent of the population speak Khalkha Mongolian, the official language, and over ninety-six percent follow Tibetan Buddhism. Many traditions have remained unchanged for centuries, including their renowned hospitality and a willingness to share what they have — even with strangers. Their habitual dwelling is the *ger*, or yurt, a round, self-supporting, tent-like structure made of felted wool that is always owned by the wife. A popular Mongol adage warns never to have more wives than yurts! This portable home is set up so daylight will enter the roof ring to illuminate the part of the yurt that is in use at various times of the day. For instance, light falls in the kitchen area during evening meal preparation. Mongols believe in a universal cosmology that governs the man and woman's sides of the yurt (the kitchen and the matrimonial bed are on the woman's side).

Both men and women wear traditional dress called *deel*. Sha Ren, a gracious elderly Mongolian woman now living in Ottawa, modelled her heavily embroidered and intricately decorated best dress with pride, clarifying that ceremonial costumes are made in delicate satins and silk while every day clothing are embellished cottons. Over a cup of strong tea, she explained that Mongolian men still tend sheep, goats, horses, camels and yaks. They supply the materials to make hand-spun and felted wool for yurts, wall hangings and clothing such as the *khurim*, a jacket worn for centuries by horsemen to protect them from the fierce winter elements.

The ram's horn design in felt that forms the backdrop of the Mongolia block adorn both yurts and clothing. However, "it is Mongolian ponies that are in my dreams at night," confesses Doreen Stonehouse, who worked to bring to life Sha Ren's ideas of honouring Genghis Khan. The horse he rides is as essential to the nomad as is the yurt. The sturdy body of this 15-hands-tall horse provides transportation, helping the Mongols to move hearth and home, to continue their centuries-old nomadic way of life.

Anything but dull

The Tutchone have "always" lived in the southwestern area of the Yukon, leading a semi-nomadic way of life that included hunting moose, sheep and woodland caribou, as well as fishing the salmon-rich rivers of the region in spring and summer. Both the Northern and Southern Tutchone Nations were affected by the influx of thousands of gold-seekers in the late 1800s and had their lives further disrupted by the building of the Alaska Highway in the 20th century.

Throughout time, the Northern Tutchone have expressed their history and culture through singing, dancing, storytelling and artwork. Beadworker Marlene Drapeau, of the Selkirk First Nation resides in Mayo. Her Northern Tutchone dialect is one of seven Athapaskan languages spoken in the Yukon.

Marlene's grandfather ran a wood camp that supplied the steamships that travelled the Yukon River. Her grandmother introduced Marlene to the skills needed for beadwork, which Marlene perfected while she helped her grandmother create goods for sale to tourists who voyaged on board those ships. Her grandmother's small items of decorative clothing such as hats, slippers and moccasins were very popular. When her grandfather died, the job of supporting the family fell to the creative hands of his wife. She would outline the beadwork designs and Marlene would fill in the shapes. "My grandmother's work is probably all over the world," Marlene says with pride.

Her grandmother was very accomplished in "the old ways" Marlene says. She smoked and tanned her own hides, made her own fishnets and snowshoes. In keeping with the traditional ways she learned, Marlene says she used "dull-coloured beads" to make her floral arrangements on the Tutchone block. "These colours were used before the brighter beads became available," she notes. In the centre are a pair of vermilion flowers, complete with upright yellow stamen and pistils, surrounded by generic blue and white flowers. Buzzing about are two bees essential for pollination. The subtle touches of black and red on white honours Marlene's grandmother's Tlingit heritage. Many Southern Tutchone intermarried with Tlingit over the years, making it difficult at times to trace lineage completely. As if in answer to the unspoken question, Marlene laughs and volunteers, "I'm not sure how I got to be Northern Tutchone, Selkirk First Nation!"

Tutchone

> " My grandmother's beadwork is probably all over the world. "
>
> *Marlene Drapeau*

Andorra

The long, colourful streamers flowing from the black hat on the block stir memories of the village festival in Sant Julià, a parish that carefully preserves its folklore.

Tiny perfection

High in the Pyrenees Mountains between France and Spain, tiny Andorra has preserved a rich architectural heritage through a thousand years of history. Some of its most interesting structures are religious monuments. With over fifty-five of them catalogued in a country of less than 465 square kilometres, nowhere does one find as many Romanesque churches and chapels gathered in such a small area.

Bernice Michaud reproduced the wolf-like beast at the centre of this block in detailed embroidery based on a photo in a book provided by the Embassy of Andorra. For Andorrans, cave paintings such as this one found in La Cortinada's church of Sant Martí — a treasure house of 12th-century Romanesque murals — best reflect their country's heritage. Wavy bands in red, yellow and blue (the national colours) suggest the shape of the three lush valleys that form Andorra, and repeat a prominent symbol found throughout the country. Pat Brittain appliquéd the mountain peaks, numerous and often snow capped, which surround this parliamentary co-principality. International tourism has boomed here since the 1950s, becoming the chief source of income for this increasingly modern country. The few Andorran farmers who remain grow their crops in the lower valleys and on terraces carved into the mountainside.

Centuries-old fêtes and customs are integral to the culture of many Andorran villages. The long, colourful streamers flowing from the black hat on the block stir memories of the village festival in Sant Julià, a parish that carefully preserves its folklore. At the Ball de la Marratxa two men, wearing top hats decorated with ribbons, each dance with three ladies apiece, ribbons flowing and intertwining. Tradition holds that the Ball represents the nation's two original co-princes (one civil, one ecclesiastical) dancing with the six parishes of Andorra.

In an unusual balance of power, France and Spain jointly governed Andorra for more than 700 years. This allowed the nation to remain an autonomous principality until it adopted a democratic constitution in March 1993. Its tax-free system brings millions of tourists each year. Skiers flock to the 9,000-foot peaks and hikers to the hillsides of patchwork green fields rampant with streams, waterfalls and pristine lakes. Whether spending francs or pesetas (both official currency), trying to decipher the intricacies of Catalan (the official language), enjoying the *festes majores* or the quiet hospitality of a warm and welcoming people, Andorra's tiny perfection is not easily forgotten.

The crossroads of the world

"Panamanian people are, as they say, 'warm country, warm folks.' We're kind of noisy too… we like to talk and we're not shy. We like to welcome everyone and care for people," says an exuberant Linda Gomez Robertson. And that's a good thing because Panama's geographical location makes it the bridge between Central and South America. The land is bisected by the famous Panama Canal, which joins the Atlantic and Pacific oceans. The 80-kilometre canal, which opened in 1914, brought many immigrants, sailors, traders and visitors to the country. Linda says, "For us, everybody is the same; it doesn't matter what colour or nationality you are."

Camaraderie developed between Linda and Happy Mireault (who designed and stitched the Panama block) when Happy hired Linda to teach Spanish at the YMCA in Cobourg, Ontario. Now a Canadian, Linda remains strongly attached to her Panamanian identity and her many family members who still live there. She looks forward to seeing them, especially during Christmas and New Year celebrations. She often decorates her home in November and begins celebrating in Canada. Then she continues the festivities in Panama on a month-long visit with her husband and children. "My family would kill me if I didn't bring them along," she says, laughing.

Panama's heritage incorporates both Spanish and aboriginal elements. Happy's design, using the *mola* reverse appliqué technique, is an expression of the proud Panamanian identity. A unique textile tradition, it is the signature craft of the Kuna tribe, one of the nation's seven indigenous groups. In the Kuna's matriarchal society, making *molas* (the Kuna word for cloth) is an important activity. Women draw their themes and images from nature, as well as from dreams and the myths of their storytelling tradition. "The Kuna have a fascination with 'jokey' animals," says Happy, hence the fish complete with fish-bones. Her brightly coloured design is particularly appropriate, since Panama's indigenous name means "abundance of fish." In this style of appliqué-work successive layers of fabric are cut away in a set pattern, revealing the colours beneath and creating an effect similar to a contour map. Happy explains, "The characteristic lozenge-shaped slits are *tastas* and the triangles and dots are *nips* and *pips*." Happy also added typical embellishments in chain-, cross- and straight-stitches.

The special friendship of Happy Howells Mireault and Linda Gomez Robertson.

"If you find a little imperfection or two in the *mola*, that's how you know it's an original," says Linda. "The Kuna always do that to make it their own, creating beautiful work." In the same way, people have little imperfections, yet the combination of unique individuals from diverse cultural backgrounds creates an original multi-layered fabric, both in Panama and in Canada.

Barbados

*Jeanette Goodridge and
Hazel Seale*

The sound of music

Jeanette Goodridge exudes a gentle humour and genuine warmth typical of her fellow Bajans. When she left her native Barbados in 1963 to begin a new life in Canada, good luck (or maybe fate) landed her in the same neighbourhood as Hazel Seale. Married to a Barbadian, Hazel spends a good deal of time on the small Caribbean island so she has an appreciation for, and an understanding of Jeanette's homeland that enhances their enduring friendship.

Many conversations between the two women are fuelled by talk of the island's elaborate festivals, tropical weather, and miles of spectacular beaches lapped by warm turquoise waters. Rhythmic sounds of West Indian music set their toes tapping. A large part of Jeanette's culture is reflected in calypso, the lively and unique song style that chronicles daily life. She feels this music is an important element in Caribbean communities as it tells the stories of "people and the things they do…cutting cane, selling sugar, enjoying family and friends." An integral part of Toronto's major Caribana festival, calypso music is a way of keeping traditional stories alive and connecting Barbadians to their homeland.

Celebrations or family gatherings would not be complete without the songs of the Merrymen, for decades Barbados' most popular calypso group, with whom Jeanette has a special association. "A lot of them I went to school with…for me that is quite a thing. We are among their true, loyal fans." Annual performances by the Merrymen in Toronto bring together many Caribbean people and "occasionally, you see somebody that you have not seen for ten or twenty-five years."

With many family members now living in Canada, Jeanette rarely goes back to Barbados. She misses the ocean and the beaches, but most of all she misses "the friendliness of the people. It's a different type of atmosphere," she explains, "maybe because of the climate…no matter where you are or who you see, they always have time to say 'Hi, how are you?' They don't pass you by on the street, as often happens here."

Jeanette and Hazel worked together on their block. Against a hand-painted sunset an embroidered flying fish soars above the sparkling Caribbean Sea. These relatively small, silvery-blue fish, the national dish and daily staple food for many, are abundant in Barbados, where whole schools of fish can be seen leaping from the water to cover distances as great as 23 metres. In Canada, "if you can get it," flying fish are a delicacy, perhaps best served accompanied by a cool rum punch and infectious calypso music — all the warmth, flavours, rhythms and sounds of home.

Proud heritage, humble heart

"When people first meet Diane, they see a serious-looking woman…until she gives them her mischievous smile. Her heart is so big that it's amazing it fits in one body," says Ronaye (M'konce) Gabriel-Cooper as she describes her close friend. Diane (Msewebek) Nadon Mackenzie's giving spirit is complemented by a strong sense of humility that keeps her grounded.

At thirteen, Diane went to visit her grandparents in rural Ontario. The time spent in the traditional environment of her grandparents' home altered the course of her life. In an attempt to contain Diane's rebellious spirit, her grandmother gave her a piece of beadwork and told her to duplicate it. The exercise awoke her artistic talent and nurtured a sense of pride in her First Nations heritage. From her grandfather, Diane learned to hunt, trap, recognize natural medicines — and how to skin a snake!

Diane gives freely of herself through continuous volunteer work. She is a traditional educator who lives her dream, passing on what she has been taught. Blackfoot traditions are taught orally, and people learn by watching and listening. When Diane teaches beadwork at the Odawa Native Friendship Centre in Ottawa, she reminds her students, "It's okay to make mistakes…because ego has no place in these teachings." She is modest about her own achievements, but her exquisite work speaks for itself. She was commissioned by the Hudson's Bay Company Heritage Department to replicate traditional Native clothing.

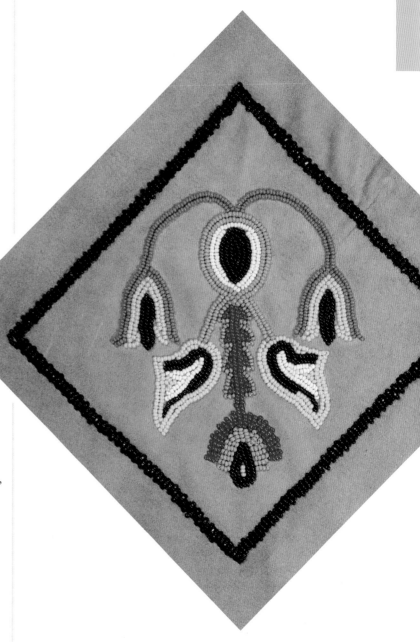

To Diane, beadwork is much more than an art form; it is a personal journey. When she teaches people beading, Diane guides them "in seeing the vision that is always there, that will teach them how to heal, to be creative or to tell a story." The symmetrical floral design on the Blackfoot block was traditionally used to decorate moccasins for special occasions. The beadwork is done on deer hide with glass seed beads, which became popular in the 1840s, spawning more intricate designs. Earlier work was done with naturally dyed porcupine quills, a skill once considered so sacred that women underwent an initiation ceremony before learning the art.

Blackfoot tradition teaches that knowledge is to be shared. Diane teaches the art of beadwork as a way to honour and pass on the traditions of her people. The Seven Grandfather Teachings of honesty, truth, wisdom, love, respect, bravery and humility are told through the designs of her own work. Diane sees teaching as an exchange of knowledge and feels "fortunate to live in an urban, aboriginal community surrounded by various nations — one can learn from so many."

> " It's okay to make mistakes… because ego has no place in these teachings. "
>
> *Diane Nadon Mackenzie*

Korea

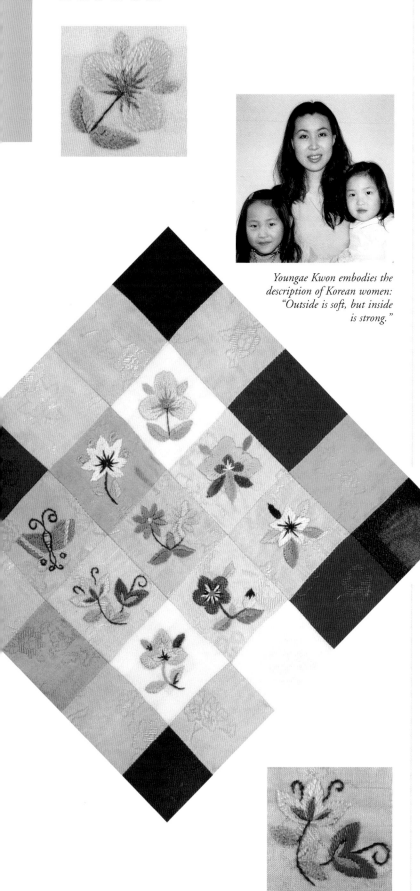

Youngae Kwon embodies the description of Korean women: "Outside is soft, but inside is strong."

Patchwork patience

Youngae Kwon tenderly attends to her two small daughters as she explains that she and her husband came to Canada for the sake of their daughters and their future. Youngae recounts that life in Korea leaves little time for leisure as a family. "Koreans work very hard and many hours." The family's spacious new home, surrounded by trees and meadows, where children have freedom to play, is in sharp contrast to their former crowded housing in Seoul where "there is much pressure on children."

Koreans are taught to obey and respect their elders. Devotion and family loyalty are important values; so living thousands of miles from her mother, sister, and extended family is difficult for Youngae. This is not the first time her family has been apart, however. Her paternal grandparents lived in North Korea when civil war erupted. Her grandfather escaped to the south with his first-born son, but never saw his wife and other children again after the borders between North and South Korea were closed in 1953. Youngae sadly wonders if her grandmother might still be alive.

A lingerie designer in Korea, Youngae learned to embroider at school and later studied quilting, as well as textile art. For her block, she made a fine example of the Korean *pojagi* patchwork called *chogak po*, an ancient style of needlework. Remnants of silk, cotton and linen are neatly cut into geometric shapes and hand sewn to make works of translucent quilt art. Unlike Western quilting that has batting and backing, these quilts form a single, pieced layer. The *pojagi* pieces serve many functions. They can be used as table coverings or to wrap gifts. Wrapping something in a *pojagi* is thought to capture good fortune within.

Enchantingly, Youngae has hung *pojagi* in the windows of her home. The coloured fabrics glow as light filters through and the neat seam outlines are like leading in stained glass. The colours of the different fabrics reflect the stages of life. Bright, lively colours are for the young, white and soft pastels are worn after marriage and all-white clothing is reserved for the elderly.

Embroidery is also a time-honoured art in Korea. On the middle nine patches of her block, Youngae has used *Min-su*, a simple folk-embroidery style of flowers and birds, which differs from *Gung-su,* the royal-court embroidery with special intricate motifs used for screens, coats and official garments. Finely handwoven *Sambe* linen frames the patchwork squares.

Patience is a treasured virtue in Korean women. Youngae reflects this quality in her rendition of an ancient art form that was once believed to mirror the lives of women devoted to their families. As she faces new challenges, Youngae embodies the description of Korean women: "Outside is soft, but inside is strong."

A wedding extraordinaire

Isabel Nzuzi Sebastiao loves to show the videos of her weddings. Yes, that's plural. Isabel and her husband were married two times. The first ceremony was held in 1998 in their homeland of Angola. It was an immensely elaborate affair, one her husband could not even attend! He had already emigrated and the cost of his plane ticket home was used to pay the dowry to his bride's family. In keeping with the Angolan custom of *marriage coutimies,* the groom's brother stood in his place and spoke on his behalf.

A traditional Angolan marriage begins with a meeting at the home of the bride's parents. Seated across from each other, both sets of parents discuss a list of presents to be included in the dowry price. The groom's whole family chips in to buy the gifts, usually various items of clothing, in order to prove that the husband can afford to take care of his wife. A divorce is even more daunting; it includes an intervention that involves all members of both extended families in a discussion of the couple's marital problems!

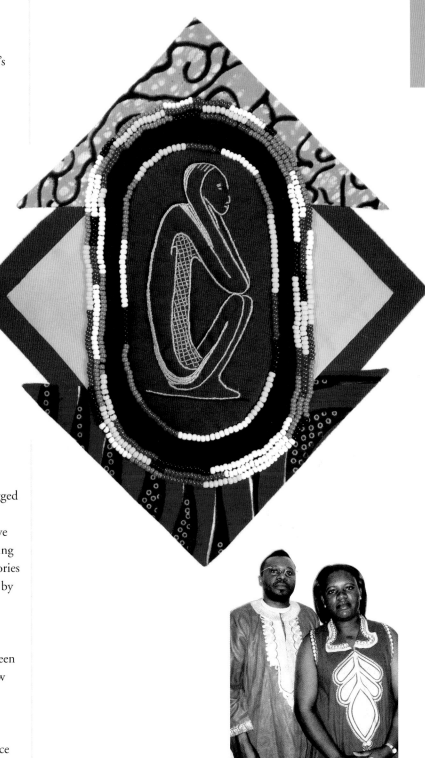

Their second wedding occurred after Isabel arrived in Montréal one shockingly cold day in December 2000. This time it was a much briefer Canadian-style ceremony, complete with the white dress and exchange of rings. Isabel's groom Adelino Artur Quialunda had been in Canada since 1992, but the devastating twenty-five-year Angolan civil war that ended only in 2002 disrupted their plans to be together.

Nothing, however, seems to interrupt *Le penseur* (the Thinker), a well-known Angolan statue of Chokwe origin. The block is an embroidered, quilted rendering of this statue that sits in a cross-legged position with hands to its head. What exactly is going through its mind will forever remain a mystery. Still, it is seen to have a positive energy, protecting the people of the village of Chokwe and conveying a good spirit throughout. Colourful beads, worn as popular accessories in Angola, surround the image of *Le penseur,* which is accentuated by the background of Angolan cloth in much-favoured fabrics and patterns.

Subtle differences in clothing offer insight as to which of the eighteen provinces an individual is from. "It is not the cloth so much as how the style is put together," Isabel explains. The colours and unique patterns of Angolan fabric are easily recognizable by those in the know. In Montréal, where Isabel's husband is president of the Communauté Angolaise de Montréal, Angolans from every province get together on April 4 to celebrate the Day of Peace that marks the end of the civil war. It is a nostalgic and emotional experience for Isabel, a time when she can replace the travails of the past with the brilliant textiles and warmth of her homeland.

Mozambique

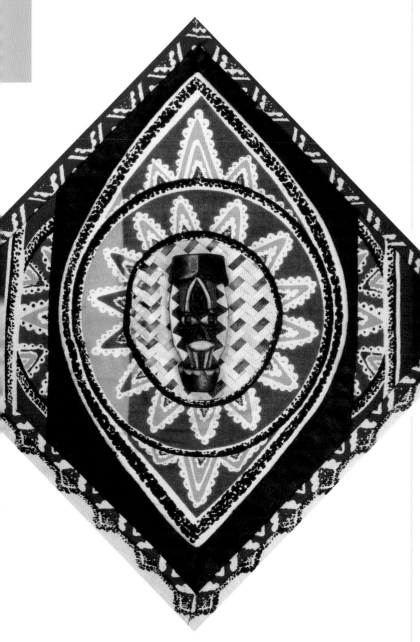

Dancing to the same beat

Chosen from her prized collection of printed cottons from Mozambique, Anneta Chicogo's donation to the block emits both proud and poignant vibrations. Strikingly beautiful, the fabric's design bursts with stylized suns and geometric motifs in national colours. It sings of new beginnings and creative inspiration, despite the country's tremendous suffering. But more precious than the fabric's beauty is the knowledge that the pattern was designed by her mother, the well-known visual artist Maria Senzani.

Though Ukrainian born, Maria married a man from Mozambique and her heart beat for Africa. She was often affectionately referred to as "that Mozambiquan Russian" in her own community in Mozambique. Annetta proudly recalls her mother's art. Maria's work has an important place in the country's history. She channelled her experiences of living in Africa into paintings that reflect the tremendous struggles of the people she so loved. She drew the designs for many of the textiles produced in her country. The highest honour was awarded to her, in fact, when she was chosen to design the first fabric to be produced for Mozambique after their Independence Day, June 26, 1975. Still today, men and women remember that special fabric and the pride they shared in wearing it.

Throughout its struggles, Mozambique's rich artistic traditions haven't missed a beat. Now, as then, the common theme of dynamic and creative cultural expression thrives with a life of its own. Mozambique continues to produce some of Africa's finest art. A tiny carving on a woven mat in the centre of the Mozambique block resembles the wooden sculptures and masks made famous internationally by the Makonde, who have practised the abstract art for 500 years. Each piece is unique and usually carved in ebony, often from a single log.

Anneta considers herself a child of the Mozambiquan revolution and when she thinks of her tremendously gifted mother, who died in Canada in 1995, she becomes emotional. "I'm a proud daughter," she says, recalling her mother's important contributions to Mozambique's cultural history. "My mother lived through the civil war and her art symbolizes the struggles and suffering." Anneta says that growing up in Mozambique's culturally diverse society helped her when she immigrated to Canada.

Mozambique's indigenous ethnic groups have their own musical and dance styles, but when musicians strike the chords of "The Sun Has Up-Risen," the contemporary musical piece celebrating Mozambique's independence, all hearts come together to dance to the same rhythm and Anneta believes that her mother's heart beats on.

Dream weaver

Two Abenaki communities founded in the late 1600s are nestled along the picturesque south shore of the St. Lawrence River, near Trois-Rivières, Québec. The towns of Odanak (meaning "welcome") and Wolinak ("land of the rising sun") shelter about 400 of the 2,000 remaining Abenaki. They are a proud Aboriginal people whose past is interwoven with Canada's history. Strong allies of the French in the early days of the colony, the Abenaki fought against the British in the 1700s, defended Canada against American invasion during the War of 1812, and in the 20th century many bore arms in both World Wars.

In the tranquil village of Wolinak, a little house is tucked into the edge of a forest. Pathways curl around the dwelling and meander into the forest. The property contains surprises — like a small pond, a wigwam, a campfire and woodland gardens. Inside the home diverse visual treats abound. It is decorated with an eclectic blend of bold contemporary design and unabashedly romantic antiques. The art is sometimes modern and experimental, and in other instances, traditionally Aboriginal. The contradictory styles surprise, but this warm home is a true reflection of the woman who created it.

Diminutive yet strong, sensitive yet outspoken, Sylvie Bernard is every ounce an artist and a study in contrasts. While she lives in the Abenaki village of her youth, she is a vocal proponent of the need for Aboriginal people to be fully modern and part of mainstream contemporary society. She is a renowned singer who has shared the stage with Céline Dion. Although she is completely at ease in front of large audiences, she hates leaving the safety of her home. She excitedly describes a singing gig in Africa, yet ponders her life as a semi-recluse.

Her art is not limited to music, gardening and interior design. Sylvie maintains a beading and leatherwork studio where she has neatly arranged materials she has collected since childhood. For four years she taught traditional Native arts in her community, challenging her students to produce "significant articles of high quality." Drawing on traditional elements, Sylvie fashions innovative articles. An example is her block, a bold contemporary abstract design made in the traditional way. "The most spiritual form of Native design comes from dreams. You wanted Native, you got it," she laughs. Sylvie dreamed this design and then executed it with the white hairs from the forehead of a deer using a laborious, hair-tufting technique on soft embossed lambskin.

Always restless, yet content in her romantic hideaway, she believes in honouring the past, but challenges both her Native family and her non-Native friends to move forward and explore all the possibilities life offers now.

Việt Nam

Genuine appreciation

"My grandmother had a concrete bomb shelter in the middle of her living room. Whenever there was shooting, family and friends would all run in, remaining there until the shooting ceased," remembers Oanh Attfield of Greensville, Ontario. Fear was constant while growing up in Việt Nam. In 1980, when Oanh was sixteen, her family travelled to Malaysia and lived in a refugee camp for three months, before being accepted as immigrants to Canada.

"We received transportation to Saskatchewan, an apartment, furnishings, social assistance and English classes," Oanh explains. Even so, it was confusing and frightening to be in a new land. Soon her mother got a job and Oanh went back to school. Vietnamese view education as the key to success, which in turn brings honour and prosperity to the family. "The teachers encouraged me and spent many extra hours helping me catch up with my peers," she acknowledges gratefully. Oanh has always had a strong desire to succeed, and went on to earn an engineering degree from the University of Waterloo.

Việt Nam, sometimes described as a "pole with a basket of rice on each end" because of its topography, is located on the eastern side of the Indo-Chinese peninsula in Southeast Asia. Mangrove swamps and highland forests in the narrow centre divide the northern and southern rice-growing regions. Children are taught respect and honour for their parents, ancestor worship, as well as modesty and humility about their accomplishments. Although Oanh doesn't stay at home like a traditional Vietnamese wife, she does exhibit the four valued virtues: hard work, beauty, refined speech and excellent conduct.

Embroidery is taught to girls in Việt Nam, which has a long history of fine needlework. The embroidered piece Oanh contributed for the Việt Nam block is worked in myriad colours on a silk background, executed in the country's classic style known for its delicate shading and intricate patterns. The block shows a young lady, dressed in a traditional high-necked tunic called an *Aó Dài*, sitting quietly by a river playing a bamboo flute. Soaring high in the background are the Truong Son Mountains, home to many rare plants and animals.

Oanh's mother now lives in Toronto and they celebrate events such as Tét, the lunar New Year, with the Vietnamese community there. "Children receive gifts for three days and we enjoy moon cakes with mung beans and sweet rice," she relates. Oanh regularly serves Vietnamese food to her husband and two sons to connect them to her roots. One day, she would like them to visit Việt Nam to learn about her homeland firsthand. "For now, though, I feel safe and secure in Canada," she says.

Life's a challenge

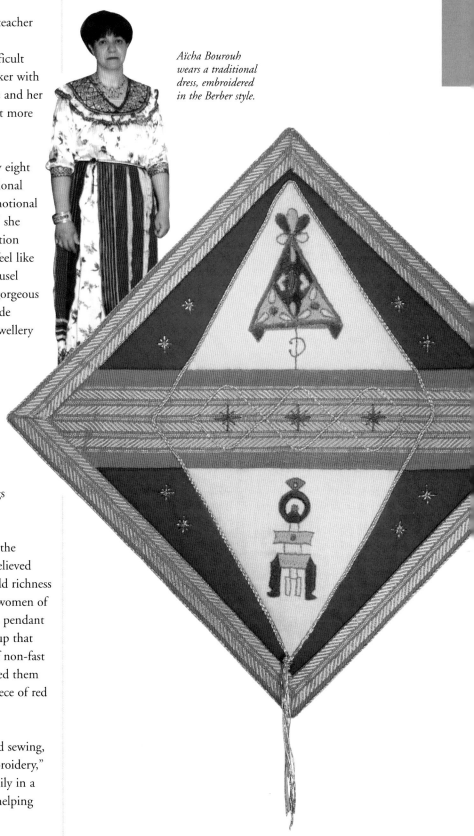

"Canada is the safest place to live," Aïcha Bourouh says with relief, ensconced in her home in Windsor, Ontario. Aïcha, her husband and three children left Algeria in 1996 with only a suitcase in hand. "There was much political unrest and safety was an issue," acknowledges Aïcha. In Algeria, she was a French-language teacher and her husband was a professor. With their credentials not recognized in Canada, permanent employment has been difficult to obtain. Aïcha now assists new immigrants as a social worker with Ontario Public Health. Her understanding of their struggles and her empathy make her a valuable employee. "The children adapt more easily," she says. "They learn English quickly."

Aïcha Bourouh wears a traditional dress, embroidered in the Berber style.

"We miss our families so much, especially my father and my eight siblings," laments Aïcha. In her home, she wears long traditional dresses embroidered in the Berber style. "I wear these for emotional and physical comfort. It makes me feel closer to my family," she reasons. The Bourouhs are members of the Algerian Association in Windsor, along with thirty other families. "It makes me feel like I belong," she says. Once a year, they participate in the Carousel of Nations, incorporating their food, handicrafts and their gorgeous costumes in the festivities. Well-known Algerian crafts include handwoven rugs, camel hair products, earthenware, silver jewellery and pottery.

Aïcha misses her beautiful homeland, too. Although Algeria is the second-largest country on the African continent, the Sahara Desert makes up eighty-five percent of it. Berbers, the indigenous people of North Africa, once ruled it; then the Phoenicians, Romans, and the Arabs conquered it. Consequently, it has diverse architecture with Roman ruins, Arab mosques, Turkish palaces, and European-style buildings gracing the landscape.

For her block, Aïcha used an eight-pointed star (made with the Algerian eye stitch or star stitch), a common motif that is believed to have protective powers. Gold filament and blue thread add richness to the block. At the top is depicted a *fibule* (a pin) used by women of the Kabylia region to fasten their clothing. At the bottom, a pendant of the Hoggar region symbolizes the nomadic Tuareg, a group that still enjoys the age-old pastime of camel racing. Their use of non-fast indigo to dye clothing, which then dyes their skin, has earned them the name Blue Men. From her own clothing, Aïcha cut a piece of red and gold woven cloth to make the border on the block.

Although she still enjoys traditional styles of embroidery and sewing, Aïcha has now learned to quilt. "Quilting is faster than embroidery," she justifies. Through the struggles of reestablishing her family in a new land, Aïcha's discovery of this new national pastime is helping her become "more Canadian."

Zambia

Living values

When Cecilia Mulenga immigrated to Ottawa from Zambia she brought with her a deep faith in God and the mandate to love and care for others. This gentle, tender-hearted lady lives simply, content with little material wealth.

Although she was a city dweller in her homeland, Cecilia chose to embroider memories of village life onto the Zambia block. Its base cloth is a vibrant example of one of Zambia's traditional arts: *chitenges*, lengths of colourful printed cotton. Created in a variety of geometric designs, multi-purpose *chitenges* are typically worn by women as wraparound skirts over their regular clothing, but they are also used as baby carriers, coverings, decorations and gifts. The block displays stitched figures of two women engaged in ritual tasks along a riverbank. One supports a pot of water on her head, while the other, pestle in hand, stands over her mortar pounding dried white maize into a fine meal, used to make *nshima*, the country's staple food. Zambians consider *nshima* a full and complete meal.

Known as Northern Rhodesia until its independence in 1964, Zambia is a landlocked country in south-central Africa. One of seventeen waterfalls in the country, Victoria Falls is considered one of the Seven Wonders of the World. It boasts the "greatest known curtain of water," with plumes spraying so high they can be seen kilometres away. For more daring souls, it is also the site of the world's highest bungee jump. Lake Kariba, one of the largest artificial lakes on Earth, was created by a dam constructed across the Zambezi River in 1960.

There are over seventy ethnic groups that speak many tongues and dialects, but English is the official language of the country. Zambians also communicate through various forms of dance, sometimes recreating historical events. Their strong oral history includes myths, fables and proverbs. Traditional arts, which are increasingly taught to children in schools, include woven baskets, pottery and wood carvings.

Like Cecilia, Zambians are known for their friendliness and courtesy. Gift giving is an important ritual and a sign of honour, friendship, and gratitude. In her private life and in her work as a caregiver, Cecilia lives out the values of her faith, giving of herself to others.

A history of trading

The Odawa people of southern Ontario can stake a claim no other Aboriginal group can: Canada's capital city, Ottawa, takes its name from them. Traditionally, however, the Odawa were known more for their business acumen than their political involvement; their own name comes from the Algonquin word *adawe*, which means "to trade." It originates from their role as traders long before contact with Europeans. Like the Ojibwe, the Odawa usually referred to themselves as Anishnabe or Anishinaabe, meaning "original people."

More than six hundred years ago, the east side of Lake Huron became home to the Odawa, along with the Ojibwe and Potawatomi nations. Instead of moving west they settled primarily along the Bruce Peninsula and on Manitoulin Island, the largest freshwater island in the world. Known as Mnidioo Minssing, meaning "Spirit Island" or "Land of the Great Spirit," the island was a central stop-over on the route between the Great Lakes and the Atlantic coast. The Odawa traders travelled great distances from their ancestral lands in birchbark canoes to trade with other Aboriginal groups and, later, the Europeans.

Together with the Ojibwe and the Potawatomi, the Odawa are members of the Three Fires Confederacy. Within this longstanding alliance, the Odawa are known as the Traders, the Ojibwe as the Faith Keepers and the Potawatomi as the Fire Keepers. The confederacy is based on Manitoulin Island in Wikwemikong, or "bay of the beavers," in the Odawa dialect of their Algonquin language. Oral tradition says it was so named because the beaver originated and spread across Canada from there. Through their trade with Aboriginal peoples to the north and west, the Odawa had access to a large supply of beaver pelts, which were especially popular for winter clothing since the cold weather caused the beaver to grow thicker coats.

Shirley Pitawanakwat is a designer of leather garments and other crafts at Anishnaabe Zhichiganan (a craft store) in the community of Wikwemikong. A mother of four and maker of the Odawa block, Shirley beaded a grouping of small, maroon flowers outlined in dark turquoise beads. A single dark-green bead joins the grouping to a sinuous circlet of similar five-petal flowers and leaves. Although she is a graduate of the contemporary George Brown College with a major in fashion design technology, Shirley chose to work in the traditional style on a supple, cream-coloured hide background.

Oral tradition says that Wikwemikong, or "bay of the beavers," was so named because from this place the beaver originated and spread across Canada.

Togo

Dressing up

Antoinette Hounye remembers that she and her young daughter arrived at Mirabel International Airport to start a new life at precisely 4:30 in the afternoon on May 15, 1996. A refugee from political turmoil in Togo, she had been under the protection of the United Nations in Senegal when she learned that Canada was offering her a permanent home and a new start. Her father died when she was young and her mother, who had been the centre of her world, passed away in 1990. Antoinette trained as a seamstress and also worked as a secretary in Togo, although she admits to disliking secretarial work. All her life she has had a passion for fabrics, for fashion, and for dressing. She confesses, somewhat guiltily, that when an invitation comes her first thought is always "What will I wear?"

When Antoinette arrived in Canada, finding work was difficult so she decided to open her own sewing business, located on Rideau Street in Ottawa. In a section of the capital that has a small collection of African shops, groceries and restaurants, her shining new sign proudly heralds her talents and textiles. Inside the shop customers can find fabrics imported from Togo, Nigeria and other parts of Africa, as well as some from Canada. From these she sews dress outfits for other Africans, "*boubous* and *foulards*, wraps and *chemises*...." She particularly loves to use the special wax prints and lace yardage that come from Africa. Colourful and richly textured, these fabrics are considered valuable assets. Each outfit made from them can be worn for a lifetime, she says, and then they are passed on to friends or the next generation. "There is one drawback to wearing these clothes in Canada," she warns. "One has to change into them at the party, because it is too cold to wear them outside!"

Antoinette's block displays richly textured Togo weaving in blue and white, shot with gold, framed by pieces cut from lace yardage made in Holland for the Togolese market. The latter yard goods often come studded with rhinestones or other embellishments and are popular for creating special evening wear. Elspeth Greer embroidered the famed Akrowa Falls that take centre place along with an African elephant, now found mostly in one of the country's several game preserves.

The many happy changes in her life make Antoinette smile. She now has a new husband, a new business and a new country. Appropriately her store is called Alpha Couture. Alpha means "beginning" — and is a testament to Antoinette's strong desire to make a new start supported by her belief that all things are possible with the help of, and trust in God.

The foundations of a nation

Mali's ambassador to Canada, His Excellency Mamadou Bandiougou Diawara, was well chosen for the position, for he embodies the incredible passion of an entire nation for their way of life and enduring traditions. Mali, formerly French Sudan, has a richly textured history, with great kings who ruled over large empires. For centuries, praise-singers hailing from the Mandingo people, called *griots* (GREE-oh), *djele* or *jelis*, have passed on the histories orally. The tale of Sundiata Keita, first ruler of the Mali Empire in the 13th century, is a story of love, intrigue, jealousy, greed and power. With good triumphing over evil, it is a crowd favourite. Such oral renditions have greater cultural value than any written version.

Landlocked in Western Africa, Mali would seem to be a harsh, unforgiving land with stifling temperatures and ever-encroaching desert terrain. Despite its ethnic diversity, it is a stable country because Malians work together to ensure their livelihood. They are a hardworking people, whether they are the nomadic Tuaregs eking out a desert existence or the Dogon living in typical agricultural villages. Elders choose future village chiefs from among the children of special families. All villagers play a role by scrutinizing closely the behaviour of the eligible children as they grow and mature. The eventual choice ensures a candidate with suitable leadership qualities. One is not likely to become chief until quite elderly, but the position is held until death.

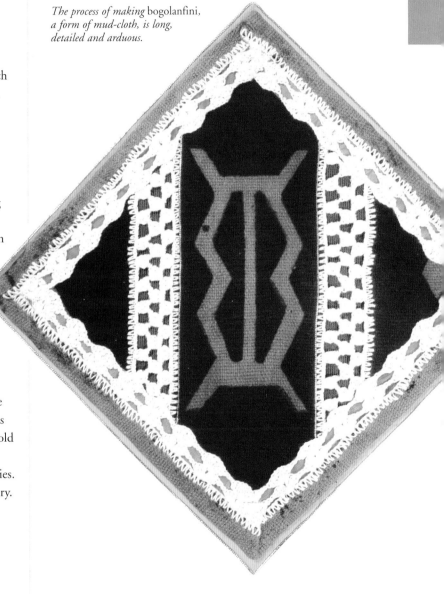

The process of making bogolanfini, *a form of mud-cloth, is long, detailed and arduous.*

The Niger River and the desert trades routes have been the arterial pathways of this country for centuries. Timbuktu became a major cultural centre attracting poets, artists and students to the immense libraries and Islamic universities. Craftspeople traded their creations of distinct leatherwork, stylized woodcarvings, fantastic pieces of gold and silver jewellery and unique textiles. Today seventy percent of Malians, mostly women, remain involved in the handicraft industries. *Bogolanfini*, a form of mud-cloth, is a staple of Mali's textile industry. The process of making *bogolanfini* is long, detailed and arduous. An example of this cloth makes up the Mali block. Framing the *bogolan* cloth, ribbons in the national colours are threaded through crocheted lacework, and surrounded by a thin band of gold cording in recognition of the importance of gold jewellery throughout Malian culture.

His Excellency Diawara feels the intricate layers of his country's cultural traditions are often misunderstood. While he wants to see Mali continue moving toward modernity, he does not want to see it happen at the expense of tradition. His ambassadorial position provides him an ideal opportunity to promote his dream of greater understanding and respect between cultures. "This needs to happen in order for the world to know peace and harmony," he says hopefully.

Chad

Fragile coexistence

It was minus 40-degrees Celsius when Raphael Jimsangar arrived at Dorval International Airport from the torrid heat of Chad. He still calls this first encounter with winter, on January 24, 1987, his most memorable day in Canada. Trained as an agro-economist, Raphael holds advanced degrees from Université Laval in Québec City and the Sorbonne in Paris. He returned to Chad in 1994 hoping to use his knowledge to help his country, but the political climate made that dream impossible. In 2004, he came back to Canada with his young daughter Geneviève to make it their permanent home. Even though he was well educated, it was difficult for Raphael to find employment at first. Now, he proudly uses his expertise working for the Department of Natural Resources.

Immersed in his work, his new home, and his garden, Raphael almost forgets the past. Occasionally, the dormant memories are prodded to life by a chance encounter or a comment. One of Africa's largest cotton producers, Chad is largely agricultural with about twenty percent arable terrain. Raphael remembers a childhood when Chad was not divided over religious issues, even though over 100 distinct groups make it one of the most ethnically diverse nations on the continent. "Everyone went to school together, ate meals together and fished together," he recalls. Fish is part of the daily diet, because stock animals are considered a form of wealth, and are only consumed on very special occasions.

In this matriarchal society, women weave, sew clothing, and "control the food." They also fashion intricately engraved calabashes from gourds for household use. An example of a calabash design is reproduced on the block. The fish represents Lake Chad, the country's namesake and the seventh-largest lake in the world. Moon designs, profoundly significant symbols in the lives of women, also decorate these vessels. People count time and mark special events according to the moons. In Chad, names are important identifiers as well. His family name and the scarification on each of Raphael's cheeks reveal his royal lineage and region of birth. Song, food, dance, crafts and the scars are all pieces of Raphael's past.

Chad has changed and its reality is very different from the past. Its cultural landmarks, including millennia-old cave drawings that show abundant water in the now-Saharan region, are testament to its long history. Discovery of a seven million year-old pre-human skull in Chad's Djourab desert sparked national pride in 2002. Nicknamed Toumai — a Goran-language word meaning "the hope of life" — it may reveal that the evolution of man occurred much earlier than previously believed. Thoughts of Toumai are now added to Raphael's recollections of the past, to the memories of peaceful coexistence he cherishes.

" Everyone went to school together, ate together and fished together. "

Raphael Jimsangar

Community giving

All her life, Elder Mary Thomas has given generously of her cultural knowledge, her time and her spirit to ensure the future of the Shuswap First Nation in and around Salmon Arm, British Columbia. So it was particularly devastating when one day, early in July 2004, her home burned to the ground. "We lost everything," says Mary's daughter, Delores Thomas, who shared the home with several other family members. "All the things my mother used to teach in the schools or at gatherings were lost. Her crafts and her displays…an eighty-seven-year-old woven basket, wildcat, silver fox and otter hides …all smoke-damaged or gone."

A great-grandmother who raised fifteen children, Mary Thomas is an elegant, white-haired lady with spectacles and a warm, welcoming face, who looks like a family matriarch should. Dr. Mary Thomas, holder of two honorary doctorates and the national 2004 Medal for Exceptional Contributions to Early Childhood Development, is also a dynamic activist and environmentalist. She is determined to ensure that the language and the traditions of her people are kept alive by sharing them with both Natives and non-Natives alike through various teaching programs. She could just as easily coach a group of youngsters on how to dig a traditional winter home, a *kekuli*, as pass on her expert knowledge of beadwork, how to make baby moccasins, tan deer hides, make coiled-root and pine-needle baskets, or weave bulrush mats, to name just a few skills. Mary's block represents a bear's paw, made in brown felt with an outline in flattened porcupine quills. The sun peeks between the mountain tops, also in natural quills, all appliquéd onto a cotton background.

Highly regarded for her tireless work, Mary has been involved with the First Nations/Inuit Child Care Initiative on both the provincial and federal levels, and is cited in the B.C. First Nations Health Guide. "I am worried about the children; I want to make people whole again," Mary says. Perhaps her most important national contribution is still underway. Mary and her family have devoted themselves in recent years to funding and establishing the Shuswap Centre *Knucwetwecw*, which means "Working Together." The native cultural and interpretive centre is being raised on land Mary has donated, and is scheduled to open officially in May 2005.

The Neskonlith Band, of which Mary is a member, has been instrumental in promoting the development of the new eco-cultural centre that will focus on the Interior Salish peoples. They also saw another opportunity for their community to repay Mary for her lifetime of giving. Before cold weather set in for the winter of 2004, her fellow band members, family and friends, as well as people from near and far who contributed furnishings, appliances, money and materials, got together and built Mary a new home.

Shuswap

Secwepmec

" In order to move ahead and get on with our lives, we have to know where we came from. "

Mary Thomas, Shuswap elder

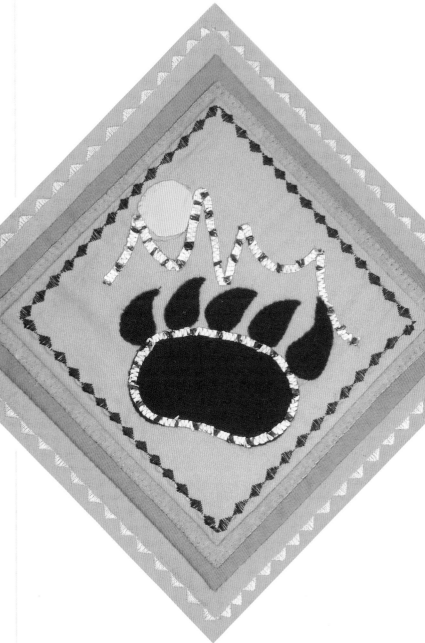

Czech Republic

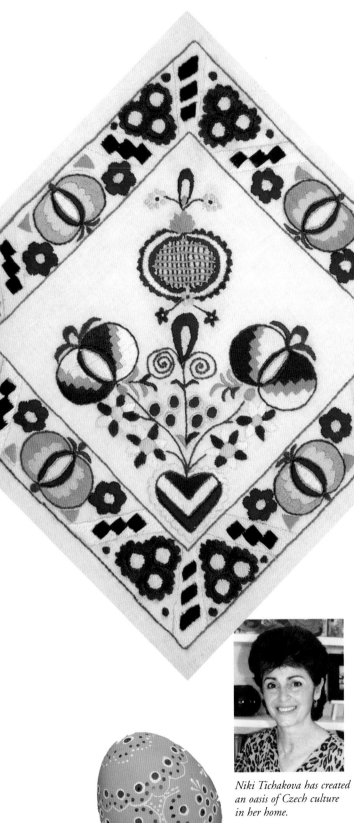

Niki Tichakova has created an oasis of Czech culture in her home.

Czechmate

Niki Tichakova's childhood in the Czech Republic (which peacefully separated from Slovakia in 1993) sounds like a fairytale. She recalls village weddings where everyone brought food, wore traditional costumes adorned with lace and embroidery, and celebrated with music and dance. She remembers castles and churches full of beautiful artwork, gorgeous music, sumptuous baked goods at Christmas, delicately decorated eggs at Easter, houses made of chocolate and gingerbread iced with lacy patterns. There was gingerbread at every celebration. And there was always something to celebrate.

"That's what I miss," says Niki, who has lived in Canada since 1988. She and her husband, Dalibor Tichak, left their homeland because they felt Canada was a cleaner and safer environment for their two children. A forest engineer, Dalibor saw how pollution was affecting his country, a landlocked nation bordered by Poland, Slovakia, Austria and Germany. Statistically, the life expectancy of people in the industrialized regions is five years shorter than in other areas, and three percent of the population die from illnesses caused by air pollution.

But leaving the country wasn't easy. Authorities took away Dalibor's job, as well as the couple's passports. Two and a half years elapsed before their passports were returned and they made their way to Canada, leaving their seventeen-year-old son and fourteen-year-old daughter behind for almost a year.

A cartographer in her homeland, Niki did housekeeping work in Canada for eleven years. In her spare time, she turned her attention to the fine arts and also produced mountains of fancy traditional breads and cakes, and vast amounts of gingerbread. A prolific artist who paints, makes pottery and mosaics, and still practices traditional crafts such as *kraslice* (decorated eggs), Niki exudes an attitude that life itself is something to celebrate.

The block Niki made features embroidery designs taken from a traditional apron created in South Bohemia. It was part of an outfit for special occasions last worn in the 1920s. Densely packed long-stitch embroidery in muted green, orange and burgundy on a white linen background shows the stylised variations of fruit and flowers typical of the decorative work found on clothing, household linens and folk costumes.

Through her generosity, gracious hospitality and her love for beautiful things, Niki has created an oasis of Czech culture in her home and studio in rural Ontario. Whenever guests arrive, it is cause for celebration. She eagerly brings out her fine Czech china to serve rich coffee and, of course, her delicious iced gingerbread.

Connections

Although Céleste Compion was born in South Africa, she created the block for Namibia because her brother Douglas Taylor and his wife, Sarah, live there. "They are people who love the desert and the outdoors," she says. Namibia, on Africa's lower Atlantic coast, can certainly serve up plenty of both. It has three distinct regions: the Kalahari Desert, a mountainous central plateau, and a low-lying coastal belt that includes the Namib Desert, site of the world's largest uranium mine.

While Douglas works as an information technology specialist in the capital city of Windhoek, Sarah started and edits a publication called *The Big Issue*. "It gives unemployed people on the streets an income from selling the periodical," explains Céleste. There are similar initiatives around the world. Training workshops help primarily black Namibians learn skills to make a living. "The hope is to eradicate illiteracy and raise the standard of living," continues Céleste.

The country's many ethnic groups live peacefully together, but they have seen their share of violence in the past. "During South African rule, apartheid laws extended to Namibia," comments Céleste. This barrier was removed as independence approached in 1990. In a land that is one of the driest on the planet, many Namibians still depend on subsistence agriculture and raising livestock. Different ethnic groups make specific and widely varying handcrafts such as ostrich-eggshell necklaces, basketry, wooden masks and stone carvings, glass and metal beadwork, and Victorian dolls. Textiles include weaving, blankets and printed cottons.

Céleste comes from a family of needlewomen. "My grandmother was a dressmaker, my mother is a knitter and my aunts and cousins are all knitters and sewers as well," she explains. The first friends she made after moving to Elora, Ontario, "on the edge of Mennonite country," were through quilting. To create the Namibia block, Céleste quickly put to use the quilting skills she first learned from her grandmother at sixteen. ("It was ten years before I finished my first project," she confesses.) Her patchwork frame of African printed textiles typifies the Victorian style of dress introduced by German missionaries in the 19th century and worn today by Damara, Herero and Nama women. The central figure represents the naturalistic scenes depicted by the Bushman who predate most other ethnic groups in southern Africa. Sister-in-law Sarah gave Céleste the ostrich-eggshell and fish-bone beads to create the bushman's loincloth. Rust-coloured fabric the exact shade of the Namib Desert sand is also symbolic of *otjize*, the red ochre paste with which Himba women decorate their bodies and protect themselves from the sun.

"Working on the block was a connection to my past…and my future," says Céleste. "As an immigrant from a country that focused on what made us different, it was healing to focus on what makes us the same."

Namibia

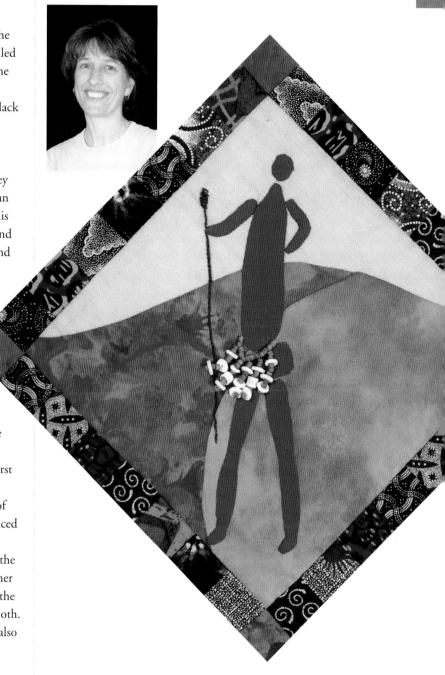

Guinea

> **"To learn the Guinean ways...I want them to see why I raised them the way I did."**
>
> *Soloba Sako*

Guinean ways

Soloba Sako is a mother whose children were born in a country that is not her own. She says it is as natural as breathing that she should want them to experience her homeland. "When they're older," she'd like to see them spend at least a year in Guinea-Conakry on Africa's west coast, to explore its shoreline and coastal plains or the mountainous Fouta Djallon, the savannahs or forested highlands. "To learn the Guinean ways...I want them to see why I raised them the way I did," says Soloba.

In the meantime, she will follow the traditions of her people, the Malinke (or Mandinka), famous for their centuries-old storytelling and musical skills. She, too, will recite the traditional tales, speaking softly in her mother tongue. She will ensure they hear the music. She may tell them that while urban centres have theatres, nightclubs and cinemas, Guineans prefer to make their own entertainment. Often people gather in the streets to dance, sing and play their musical instruments. At the other end of the entertainment spectrum is the world-renowned Les Ballets Africains, a complement to a nation of diverse ethnic groups, including the Fulani and Susu, in addition to the Malinke.

Soloba and design-collaborator Kaba Hawa Diakité chose *Nimba* for the block's central theme. Holding tight to traditions, *Nimba*, the embodiment of the Goddess and of Mother Earth, symbolizes fertility, strength and the joy of living. Soloba says there are also a Mount Nimba, revered Nimba masks, and a sacred Nimba Forest. This Nimba lies against a fabric called *bògòlanfini* or mud cloth, made from Guinean-grown cotton. Using small handlooms, men weave narrow strips that the women sew into garments and then laboriously hand-paint with designs using an aged mud solution. This once obscure, local textile tradition has gained international recognition as a symbol of African style. The circles and cowrie shells at each corner, signify the four geographic regions of Guinea.

Kaba says she misses her country's strong sense of supportive community spirit. It is common, for instance, if there is a death or major family event, for a Guinean to try to be there in person to offer support, no matter the distance. Soloba agrees. Her mother travelled from Guinea to be with her following the birth of her twins, the same children she hopes will journey across the Atlantic to live and learn in her country one day.

The rules of art

There are times when internationally acclaimed Aboriginal artist Rocky Barstad opens his paints and is immediately swept back to the day his father gave him his first paint-by-number set. The smell of paint triggers the memory. He was just a boy then, and looking back he realizes how long he's been at it. "It becomes a part of you," he says, comfortably resigned. After all, creating art is what this Tsuu T'ina does best.

Yet, an art career wasn't something Rocky chose consciously. "It was decided for me," he says, recalling his early absorption in drawing and painting the world around him. In grade three, he won a Poppy Poster contest. The thrill of winning spurred him on. Although it was two years before he won his next award, the pleasure was just as sharp, but life is practical and Rocky, no less so. For over thirty years, before he even began to study art seriously, he was self-employed in the concrete construction business. Today, his artistic works are exhibited across Canada and the United States. He has travelled throughout the world promoting Aboriginal art and the importance of keeping it authentic. He's won numerous awards for his paintings, bronze sculptures, large-scale murals, and artefact replicas that speak of other times.

These artefacts might have existed centuries ago, when the Tsuu T'ina, a relatively small nation of Dene origin, began moving southward from the sub-Arctic region. They travelled by horse, a symbol of freedom and prestige, represented in the block by a sinew-stitched, miniature horse effigy, adorned with brass bells and glass beads. They settled in Kootisaw, meaning "meeting of the waters," the location of present-day Calgary. Here, where the Highwood and Elbow Rivers meet the Bow River, the Tsuu T'ina evolved into an individual and distinct people who have a reputation as peacemakers.

Rocky and his wife Judy live in High River, Alberta, where for the past ten years the Two Feathers Gallery has been a family-run business offering fine Native and western artwork. While Rocky's two sons and daughter, now in their twenties, have not grown up on a reserve, the art gallery has been their introduction to the Native world. "As they get older, they're more interested in their heritage," he observes. "There's more respect."

Respect is an important factor in the painting of buffalo skulls, a privilege granted only through a special ceremony. When Rocky begins this work, the rules of art no longer apply. He listens with his heart. "It's what you feel," he says. "Each skull has its own energy. I try to honour that energy."

Sarcee

Tsuu T'ina

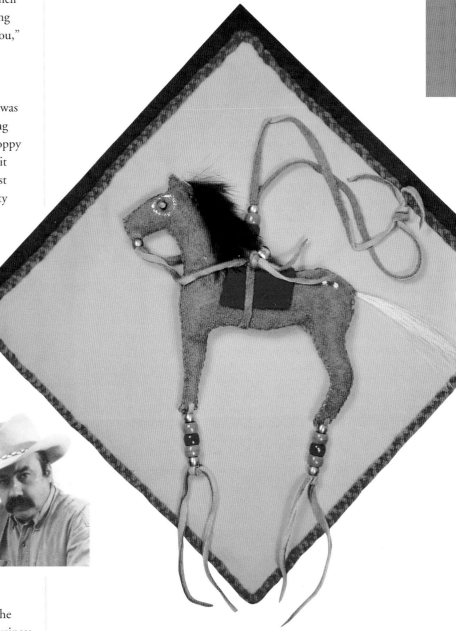

" Each skull has its own energy. I try to honour that energy. "

Rocky Barstad

Guinea-Bissau

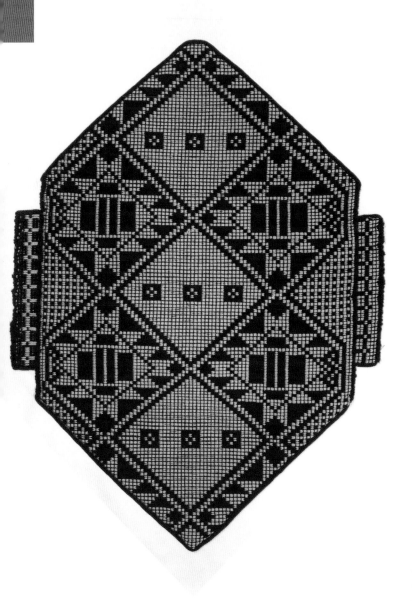

Teacher learns a lesson

When Christa Furst went to Guinea-Bissau as a teaching volunteer in 2001, she loved the country, but doubted she would make a lot of social connections. Within weeks, however, she found herself not only surrounded by friends, but also drawn under the protective wing of a Guinean "mother hen." Each day Fatumata took on the task of caring for Christa with a devotion that defied all resistance, preparing substantial meals for her adopted charge to ensure she ate well. Not wanting to impose, Christa sometimes tried to hide out, skipping meals. Invariably, someone from Fatumata's family would arrive to bring her to the dinner table. Finally, Christa reasoned she *did* need to eat after all, and she allowed herself to enjoy the warmth of a "family."

Remembering this time in her life with a smile, Christa says few are ever really homeless there, because they take care of each other. "Come eat" is the most common invitation. This small, former Portuguese colony on Africa's west coast is a poor nation, but their heartwarming generosity is reflective of the people and their community spirit. Christa came to know the people well during her three years as a teacher trainer. "They have many admirable qualities," she says. "For example, they are very accepting of inter-tribal and inter-faith marriages." After the country declared unilateral independence in 1973 (something Portugal only accepted a year later), periods of political and social unrest followed. "It was strictly military. Tribes don't fight each other, because they could be fighting family members," Christa explains.

In Guinea-Bissau, clapping hands will rouse men and women to dance just as quickly as music. Dressed in colourful woven cottons, reflecting a history of weaving and tie dyeing, their bodies move in a natural rhythm. Men, and the older generation mostly, wear garments with a length of fabric draped over a shoulder, while women make skirts from the cloth. Bold geometric designs are woven into narrow strips and the most intricate designs are used for special ceremonial clothing. The gold and black piece used to create the block was contributed by Molly Kane.

"Come eat" is the most common invitation for the caring people of Guinea-Bissau.

Back in Canada, where people often stay isolated in their homes, Christa truly misses the spirit of inclusiveness that once enveloped her. She says she felt almost a sense of "loneliness" after leaving a community of people who, as a matter of course, constantly acknowledge each other, invite each other to sit and talk, or to share a meal. "Even the few Guineans living in Canada open their homes to you. It is simply what they do," she affirms. "From them, I learned to care and trust."

Parallel lives

The life stories of Lilija Treimanis and Zinta Enzelins parallel one another: Both were young girls — Lilija, thirteen, and Zinta, not quite five — when their families fled Latvia because of the Russian occupation during World War II; both lived in Germany; both came to Canada in their late teens; and both married Latvian-born husbands here. "When I came to Canada, it was paradise," recalls Zinta, who arrived on her own as an eighteen-year-old in 1958. Her family, who followed later, had spent ten years squatting in an abandoned air force base in England. In Canada, she could live in a house.

In Toronto, they sought out other Latvians through folk dancing and craft guilds. They became Canadian citizens within five years of arriving here, but both Lilija and Zinta held onto their native language, speaking Latvian at home and teaching it to their children. The two women met in the early 1970s, through a mutual interest in learning the traditional crafts of their homeland. They have been friends ever since.

Trained as a nurse in Canada, Lilija sang in Latvian choirs and learned to make Latvian national costumes in her spare time. Each differs regionally, but all require a variety of skills such as weaving, pillow-lace making and drawn-thread work. Zinta, a secretary, joined a folk dance group and needed a national costume, so she taught herself how to make one by following instructions in a pamphlet. Since those early days, both women have become highly skilled in the various techniques. They now teach their crafts in Canada, the United States, and even in Latvia.

When they got together to do the Latvia block, they drew their inspiration from the country's iron age, which dates back to the 7th century "when Latvia was the most independent and pure," Zinta explains. Lilija created the card-woven inner border, while Zinta wove the rust-coloured fabric for the outer border and the navy-blue centre with its bronze spirals. The bronze rings are set in the *jumis* symbol, representing two interlocking stems of wheat.

Even though they left their homeland long ago, Lilija and Zinta still hold Latvia close to their hearts. "We never dreamed to leave our country," says Lilija. "We loved it." Since the fall of the Soviet Union, they have been able to go back without restrictions, and that has strengthened their attachment to Latvia. For Zinta, her life in Canada is doubly rich because her cultural roots lie in the Latvia she loves.

Latvia

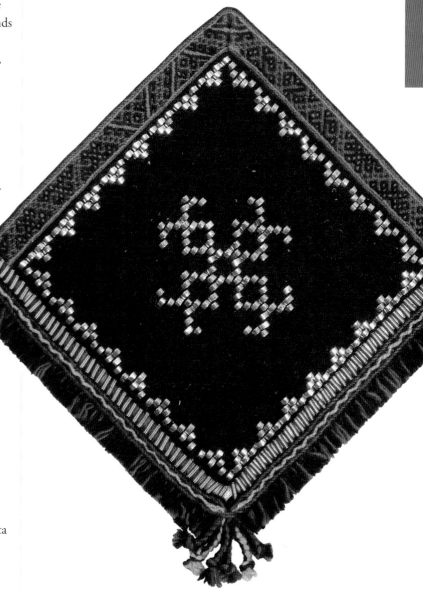

The inspiration for the Latvia block comes from the country's iron age, which dates back to the 7th century.

Sierra Leone

Answered prayers

For one long year, every moment of hope in Mary Turay's life would disappear, plunging her into a dreaded abyss of fear and uncertainty. Throughout 1999, Mary didn't even know if her family in Sierra Leone was dead or alive. Civil war raged in many areas, and at one point all outside communication was severed.

Mary and her husband, Thomas, were completing studies in Toronto in 1998, while their daughters, twelve-year-old twins and a fourteen-year-old stayed in Makeni, Sierra Leone, with their grandparents. As the conflict intensified, Mary's husband flew to Sierra Leone to bring back the girls. Once there, "he became lost in the middle of the war." Meanwhile, to ensure their safety, Mary's parents, Fatu Fornah and Mark Fornah, took the children to their father's rural hometown. "The very week they moved the girls," says Mary, "the rebels invaded Makeni and took hostages."

Back in Canada, Mary waited for news week after week, month after month. "It was a time when I felt so alone," she says, her voice breaking. Mary says the source of her strength to endure came from her faith, and from the support she received from family, friends and community organizations. "There was so much concern for me...it helped a lot," she explains. Although Mary had agreed to make the Sierra Leone block, she set it aside. When her husband finally made contact and she learned everyone was safe, she returned to it with renewed faith and vigour.

Mary assembled the overall design on cotton fabric her mother had tie-dyed to create a spiral pattern. The spiral symbolizes continuity and community inclusion, while the green suggests the fertility of the land. Seeds from the cola-nut, the cultural symbol of peace and sharing, produced the yellowish rust colour. The gold thread border reflects the country's mineral resources, and the women who "save" their gold jewellery as a form of investment and family legacy.

In 2000, Mary was reunited with her family. Although their home and possessions in Sierra Leone were destroyed, just being together was a profound blessing. Today, the family lives in Antigonish, Nova Scotia, a place, says Mary, that has similarities to their African community. Her husband teaches at the university, and Mary, whose lifelong dream is to own her own fashion business, is completing a business degree to complement her studies in fashion design. "The girls are very involved in school and community activities," she says, pleased with their adjustment. When Mary thinks how much they have accomplished after such an unsettled time, she rejoices in the opportunity to rebuild their lives in a safe haven.

Where eagles soar

Songhees knitter and weaver Iona Misheal lives in Sidney, B.C., along the southeast coast of Vancouver Island, a welcoming habitat for many wintering bald eagles. Soaring high, with a wingspan of two to three metres, Canada's largest bird of prey easily commands the sky. A spiritual symbol for many Native people, these magnificent birds have been part of Iona's environment most of her life. And she's never once taken them for granted. Each sighting elicits the same awe and admiration, the same creative inspiration. Her droplet-shaped knit piece showing an eagle's head forms the central focus for the Songhees quilt block. Although she knits other images, she has become focused on the majestic eagle of late. "It's all that I do," she says.

As an adolescent with ten other siblings to consider, Iona didn't ask her parents for pocket change. Iona's mother would gently remind her, "You have to make your own to travel." It was her way of saying if Iona wanted the little extras, she had to earn her own money. Iona considers herself fortunate to have lived in a household where she learned weaving, knitting and other needlework skills from the women in her family. "I grew up knitting," Iona says. And she always began "from scratch," she adds, carefully carding the wool and then spinning it. Over time, Iona also became adept at needlepoint, crochet, embroidery, beadwork and weaving. The latter is a textile tradition of the Coast Salish from which the Songhees descend.

The Songhees Nation, now located around Esquimalt, first built their village along the western shore of Victoria's inner harbour in 1844. Their dwellings were large cedar houses accommodating extended family groups. One resource that remains sacred to this day is the cedar tree. Ancestors of the Songhees used its wood to create shelter, clothing, transportation and art. Its roots and bark were used to weave baskets and capes.

Recently, Iona met the challenge of creating a different kind of cape. "It took me three years to knit," she says of the memorial cape made to honour a chief's passing. Iona used more than a dozen shades of wool to create a spectacular chief's headdress design in needlepoint with cross-stitch on it. And then, for good measure, she added a few eagles.

Iona Misheal always starts her knitting "from scratch," first carding the wool and then spinning it.

Burkina Faso

A rich welcome

Landlocked Burkina Faso shares borders with six other western African nations. Formerly called Upper Volta, the country adopted a new name that means "the country of honourable people" in 1984. A disputed territory amid African ethnic groups and then among colonial powers, it became a French colony in 1896 and remained so for over sixty years. Recent decades have been marked by mass unrest and a long series of political coups.

Moussa Gourané, who came to Canada in 1982 and stayed after his studies, says the most important thing in his culture, above all else, is respect. "We are raised to respect our elders, to ask their advice and value their opinions," he says. "If you respect people, especially strangers, and if you take time to learn about them and their culture, to truly accept them, you cannot have prejudice," states Moussa.

Political upheaval has caused massive poverty, but visitors are deeply touched by the respect and camaraderie Burkinabès show their fellow men. Paul Gazdik, who travelled there with a group of students in 1995, recalls, "We stepped into a very different world." As soon as he arrived, the Burkinabès wanted to know all about his life in Canada. "I was not a curiosity, but rather it was their way of making me feel at home. It told me a lot about how much they value human relationships."

Although French is the official language, tribal languages are spoken by ninty percent of the population. The territory itself is as diverse as the sixty ethnic groups that inhabit the land. Most of central Burkina Faso lies on a savannah plateau scattered with fields, brush and trees. The north is desert, but in the south, lush forests and fruit trees abound. Village life, where round mud huts with thatch roofs are the norm, has remained unchanged over the years, with electricity a rarity away from the capital. "Clean drinking water is a definite concern," remembers Paul. The daily tasks of women are extremely labour intensive. The strip-woven block depicts a woman at work. "They haul water from incredible distances, tend to their families' needs, lend a hand with farming, and also do odd jobs to bring in money or goods."

By North American standards, Burkinabès are very poor. However, they have a sense of community that Paul says the visiting students could not begin to comprehend. Taking time to communicate with people is their way of life. They place a high value on extending hospitality, especially to strangers. Paul recalls, "Even in the poorest of areas, they welcomed us with feasts and dancing."

> "We are raised to respect our elders, to ask their advice and value their opinions."
>
> *Moussa Gourané*

The proudest treasure

Sand dunes sweep across the remnants of four ancient Mauritanian *ksours*, cities that thrummed with the energy of prosperity in the 11th and 12th centuries. Trade routes breathed life into these metropolises, whose ethnic composition mirrored the Mauritanian population of today. Back then, peoples of Moorish, Islamic and African descent intermingled within a complex caste system. The sounds of the *tidinit* (Moorish lute) and *ardin* (a harp) echoed through the streets competing with the cacophony of merchants selling their wares. Lines of caravans meandered across the once lush landscape, camels laden with burdens of gold, dates, wheat, barley and salt. The cities became renowned as centres of Islamic culture and learning. Thousands of priceless manuscripts have been preserved in the interest of posterity housed in libraries and *madrasas* (Koranic schools).

Today the *ksours* are virtually ghost towns, obscured among the sand dunes of the ever encroaching Sahara desert, which already covers two-thirds of Mauritania. UNESCO has listed the four cities as a World Heritage Site because of the integral role they played in the development of Mauritanian culture and tradition. Intricate geometric designs and arabesques decorated the walls of the ancient cities and embellished everyday objects, as well as religious items. Generations of artisans have continued to replicate these designs to this day.

The ancient patterns appear on leather-work, jewellery and even women's hands and feet, explains Mme Mint-Amara, the wife of Mauritania's ambassador to Canada. While offering freshly baked Mauritanian delicacies, she proudly showed her visitors samples of the renowned leather-work and gave each visitor one as a gift. Examples of crafted leather were carefully chosen to grace the Mauritania block. Painted freehand in warm, saturated colours, they are a visual reflection of the cultures and traditions of Mauritania, which still bear the imprints of its various ethnic groups. At the centre of the block hangs an ornament of carved ebony and brass, another sample of Mauritanian craft work. A distinctive tassel of painted and finely twisted leather gives the final exotic touch.

The formality of embassy life melted away as Mme Amara worked on the block. Conversation flowed easily as she shared memories of her family and life in her homeland. Then she brought out her proudest treasure of all, a new baby boy, born in Canada.

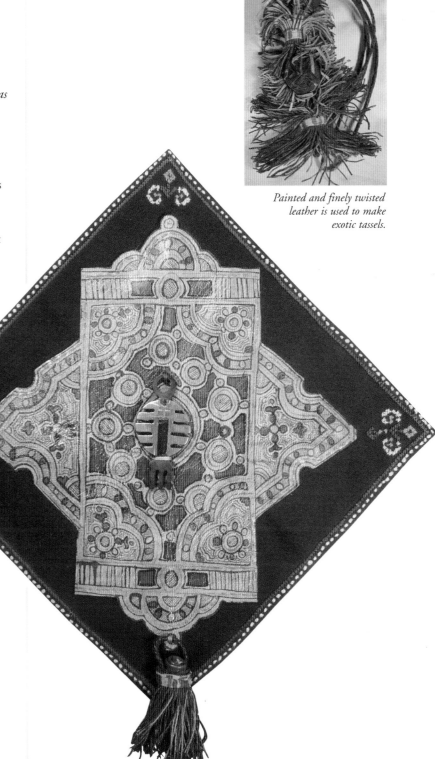

Painted and finely twisted leather is used to make exotic tassels.

Russia

> From time to time, I feel there is some power which will show you the way in your life.
>
> *Tatiana Jouikova*

A guiding power

Tatiana Jouikova's love affair with textiles began before she was old enough to understand its significance. As a small child, she remembers being fascinated with the special garments and embroidery her elderly aunt showed her. "I couldn't imagine what piece of clothing this was, with its hooks, eyelets, lots of strings and very hard parts," she recounts. "Next to this wondrous thing [a bodice!], her beautiful embroidery looked very ordinary!" She began her own needlework lessons in first grade, but found the exercise "too boring." Eventually she overcame her "two left hands," and a fervent passion for Russian embroidery grew. She taught herself many styles of embroidery, textile production and batik by reading books, visiting museums and taking lessons.

Years later, the physical and spiritual aspects of her art merged when she created a deacon's vestment for her nephew. "He brought me an old silk curtain they had found at the back of the church. The colour was still vivid, so I cut and sewed a garment from it. Later, I did other pieces for the church." Now, living in Canada since 1998, Tatiana continues her artistic contributions to her church here, connecting her with the life and work of the Russian Orthodox Church as a whole.

Many times in her art and life, Tatiana says, she has felt a guiding power influencing her. During a trip to Moscow, she visited a museum exhibiting antique priest vestments on a day when an historian was giving a lecture. She couldn't stay to the end of the talk, and all the way home she felt sad, as though she had missed out on an once-in-a-lifetime chance to learn more. "In Moscow, there are about fourteen million people, but the next day I met the historian in the subway train! And he remembered me!" Even in the immigration process, a powerful hand guided her family. Her daughter, Maria, suffers from a life-threatening inability to absorb protein. Canada was the only country that welcomed them, and medical specialists were found to help her. "I bless this country; immigration saved Maria's life!"

Tatiana's warmth and caring are evident when she speaks of teaching textile arts to mentally challenged children. She particularly enjoys creating *batiks* with them. "You can't spoil it because each is so individual, as the silk painting technique is immensely variable," she explains. For Tatiana, a strong spiritual connection also emerges when different generations work together. There is time to listen to each other's stories, dreams and ideas. It is a time to learn from the past and look to the future. "Not only is it good for the family, but for society also."

All creation listens

The culture and legends of the Nisga'a, passed down to each generation, are inextricably linked to their lands. Clan families of the Wolf, Raven, Eagle and Killer Whale have lived along the salmon-rich Nass River basin in the Pacific northwest, since the last great Ice Age. In the *Ayuukh*, Nisga'a ancient oral code of laws, each family owns their legends and myths, dances and songs.

A well-known story is the legend of the volcano. The children of Nisga'a were playing cruel games with the life-giving salmon. Stones placed on their backs were followed with burning sticks. As the fish struggled to swim away the children laughed. Warnings from elders went unheeded, until one day the ground shook and the volcano erupted, spewing burning lava into the Nass Valley, killing 2,000 Nisga'a.

Today, lava flows are special features of the Nisga'a Memorial Lava Bed Park, the first provincial park in British Columbia to combine interpretation of natural features and native culture. It is also the first park jointly managed by a First Nation and British Columbia Parks. The Nass Valley is still a breathtaking place of ancient forests, raging rapids and wild landscapes of volcanic lava and glaciers. There are about 2,500 Nisga'a living in four villages just outside Nisga'a Provincial Park and another 3,500 live across Canada and around the world. Visitors come to explore the park and the Nass Mountain Range. Chance encounters with moose, goat, marmot, bear, and other wildlife quicken the adventurous heart. Once, Nisga'a hearts also quickened at the abundant natural resources allowing them to develop into one of the most powerful, sophisticated cultures in North America. Today, Nisga'a, part of the Tsimshian group, are taking control of their education and health systems, as well as land and tourism resources.

In addition to salmon, oolichan, a tiny, oil-rich fish, was once harvested for food and lucrative trade. Large, one-room, post and beam longhouses were the traditional dwellings. Most cloth was woven using the plain twining method. Other clothing was made from furs, leathers, and mountain goat hair. Wood carvings and painted forms, based on family legends, animals and supernatural beings, are typical of the northwest-coast art style with its flat-form design, using ovoids, form lines and filled spaces.

Recreating this traditional art form in needlepoint, blockmaker Stephanie Crunkhorn designed *Gisk'ahaast*, the Killer Whale, to represent her people. Strong traditional colours in black and red add impact. Having fallen in love with the osprey, the whale spins and leaps out of the water, flying and singing a song so beautiful, "all creation listens."

Nisga'a

In the Ayuukh, Nisga'a ancient oral code of laws, each family owns their legends and myth, dances and songs.

Monaco

For all its dazzling sights and sounds, it is "the wedding" that took place there that holds the most meaning for Daphne.

Through the eyes of love

Daphne Howells' work in diplomatic and library services took her to many scenic corners of the world. But her eyes sparkle when she reminisces about her life in Monaco, the tiny Mediterranean principality ensconced on the French Riviera. For all its dazzling sights and sounds, it is "the wedding" that took place there that holds the most meaning for Daphne. She is not referring to the fairytale wedding of Prince Rainier III and American film-actress Grace Kelly (though Daphne did witness its royal procession from her balcony); she is remembering her very own special day. For it was in Monaco that Daphne married her husband, Jock.

Daphne's meticulous research, treasured mementos and warm memories provided the images for the Monaco block, stitched in the form of a heraldic banner by Suzanne Labrie. Monaco Castle, home of the ruling Grimaldi family since 1297, remains the official residence of Prince Rainier and acts as the central element of the design. Daphne remembers its façade, often bathed in shadows. This look was recreated for the block through a form of black-work. Embroidered rows of lozenges, symbols of honesty, constancy and tokens of noble birth , flank the palace. Historically, this pattern was part of knights' clothing identifying them with the Grimaldi name, today the design is used extensively on heraldic devices, postage stamps, banners, the soccer team's scarves, and at all national events.

Tiny Monaco, with only 1.95 square kilometres of territory, benefits from a choice coastal location on the Mediterranean Sea. Warm breezes, beautiful beaches and mild weather fuel tourism as a mainstay of the economy. Small it may be, but it manages to be crammed with sights and activities, enough to provide a lifetime of memories for Daphne. It is home to Monte Carlo and the world-renowned Grand Prix race and Grand Casino. Its Exotic Garden houses plants from around the world, and the Musée Océanographique is a museum with ninty seawater tanks and a display of living coral showcasing the work of oceanographer, Jacques Cousteau. The Tête de chien mountain range "took my breath away each time I saw it," recalls Daphne. Native Monégasques and tourists alike patronize the Monte Carlo Philharmonic Orchestra and Les Ballets de Monte Carlo, established in 1985 by Princess Caroline in honour of her mother, Princess Grace.

While Daphne has called Canada home for many years, it is evident in her eyes and in her voice that this "magical kingdom — seen through the eyes of love" will always hold a special place in her heart.

From many, one

In the same manner that the United States has always combined cultures and traditions to create one nation — the proverbial "melting pot" — American fibre arts also reflect merged influences. To represent the United States, Hope Brans and Carol Campbell chose two traditional forms that exemplify American textile art, the patchwork quilt and the embroidered sampler. In early-American households, where every scrap of cloth was precious, women perfected the art of patchwork. Designs evolved, combining influences from African, Aboriginal and ancestral sources. Quilting, practised by all classes of people, expressed a new spirit in a new land.

The log cabin design featured in this block reflects not only the early pioneering homestead, with its red centre symbolizing the hearth in the home, but also has become a prominent pattern in American quilting. Whether fashioned from silks, homespun wools or calico cottons, the log cabin design with its hundreds of variations crosses all geographical, social and racial barriers. The pattern is credited with playing an important historical role as well. In the unwritten code of the Underground Railway, which helped thousands of slaves flee to freedom in the north, the colour of the centre and the orientation of the dominant hues gave important directions to fugitives. Red, white and blue prints, some scattered with tiny stars, pay homage to U.S. patriotism. The miniature squares, set in the "barn-raising" pattern, are tied at their centre point in the utilitarian fashion that saved many hours of intensive hand quilting.

The quilt design is cleverly mimicked on all sides with Hope's carefully scaled "sampler" stitching. Traditionally, young girls practiced embroidery stitches on their samplers while at the same time learning numbers and letters. It often included stitched pictures of their home, family, dates and mottos.

Prominent among the lines of varied patterns in this sampler is the motto of the United States, *E pluribus unum*, meaning "From many, one." The words are appropriate for the many immigrants who flock to the United States in search of their "American dream." They are as diverse as those who seek a better life in Canada. For Hope, who holds dual American-Canadian citizenship, her perspective on these two countries gives her a special insight but presents occasional problems. There are times when she doesn't know where to show her allegiance, she says, "I am really torn between the two." Hope has often defended one or the other country on both sides of the border. "I am always stunned at how little people know about their neighbours." Yet, each nation needs the other and shares much in common. Both countries draw strength from their diversity, as well as their friendship.

Denmark

The spirit of Christmas

Denmark is famous for beautifully designed ceramics, silverware, porcelain and modern home furnishings. As world leaders in environmental and human rights issues, Danes take pride in being progressive. Yet traditions remain important and vibrant in their lives.

Christmas, which begins on December 24, is celebrated with food and drink. Stylish Danish tables groan with mouth-watering roast goose, or duck, caramelized potatoes and red cabbage cooked with shredded apple, syrup and apple cider vinegar. The meal is rounded out with delicious cakes and cookies, among the best in the world.

"*Glogg* is a must," says Inge Nielsen, a Glengarry County resident, who served as Montréal's Vice Consul to Denmark for many years. *Glogg* is an adventurous version of mulled wine. Meanwhile, the rice pudding *risengrod* has been cooking all day and will be eaten hot with dollops of whipped cream. "We hide a whole almond in the rice pudding and the person who finds it wins a marzipan as a prize," says Jetta Blair, a self-employed Montréal businesswoman. Later, tree ablaze with lights, families exchange gifts and sing songs, sharing the spirit of Christmas. The next day, explains Inge, most Danes usually go to church in the morning and have a "smaller" Christmas lunch.

Tradition is also evident in the typical Danish village, featured in the block. The scene is fashioned after the stylized patterns on bell pulls and wall hangings found in many Danish homes. These often feature Danish landmarks, history and sometimes the beloved Little Mermaid. Created by Montréal artist Michael Fog, the design was transferred by Jetta into a fine cross-stitch pattern for embroiderers Inge and Rosa Christensen. The corner hearts are worked in *Hedebo*, a form of open embroidery that originated in Denmark. Popular Christmas symbols such as pine trees, elves, cats and bowls of *risengrod* form a lively border, dispelling the notion that Danes are reserved.

At Inge's home, bell pulls share wall space with other works of art, including an entire wall of Royal Copenhagen porcelain plates. Plump pillows on chairs and sofas, soft carpets, well-tended plants and soothing Danish music, nurture the senses. A fire burning in the wood stove brings comfort from the cold November rain outside. As coffee is poured, the feeling of being cozy, snug and safe from the outside world — what the Danes call *Hygge* — pervades the senses.

Detail from one of Inge's traditional bell pulls.

Roses for Kathleen

It was Mother's Day when Gladys Jiixa Vandal, of the Haida Eagle clan, found herself traveling home by overnight ferry. Home is the Queen Charlotte Islands — Haida Gwaii, the Islands of the People. Her ninty-nine-year-old mother, Kathleen, had recently passed away. Gladys' heart was flooded by memories of her mother's loving spirit, embracing life fully despite advancing age and failing vision. In the last years, says Gladys, "She did everything by touch." Kathleen's greatest joy was working alongside her daughter, as she applied herself to the traditional art forms of Haida cedar-bark weaving.

Gladys comes from a family of weavers and carvers. Although she learned the art late in life, her skills are excellent. Using the technique of plaiting and twisting, she creates a variety of traditional and modern forms, using red and yellow cedar bark and spruce roots she has harvested. Her work is popular with private collectors, and she regularly exhibits at art shows, galleries, and at the Haida museum.

Traditional weaving meshes with her role as a "watchman" of ancient villages. Monitoring public access to national historic sites throughout the islands is the responsibility of the Haida Gwaii Watchmen, a committee based in Skidegate. For several weeks each summer, Gladys and other watchmen travel to historic villages such as Windy Bay and Hot Springs where they act as interpretive guides to hundreds of visitors from around the world. Gladys, who describes these historic sites as "peaceful, beautiful places," is proud that her daughter shares the same heritage vision through her work with Parks Canada.

Heritage aside, there's a whimsy in Gladys that pushes her to create new things, such as an intricate mask, or the cowboy hat she "whipped up" for her husband one day. Creative ideas excite her, but she finds the actual weaving process "relaxing and healing." Lately, she's been teaching the Haida language, in addition to Haida weaving. Students, young and old, praise her energy and patience. This same creative energy produced the boldly beautiful quilt block. In appliqué, it highlights the flat-form designs of Eagle and Raven, symbols of the Council of the Haida Nation. They are the main social groups of the Haida, a nation renowned for its boat building and woodcarving. Plaited cedar-bark weaving and abalone-shell buttons frame the work.

Gladys knows her mother would have been proud of her. "I adored her," she says, going back to that night on the ferry. She was seized with the urge to create a tribute to Kathleen. Her mother's love of roses finally inspired her. Setting to work, Gladys carefully wove one cedar bark rose after another. Hours later, tired, but happy, she presented one of her special roses to each mother onboard the ferry.

Haida

Xa'ida

Traditional weaving meshes with Gladys' role as a "watchman" of ancient villages.

Malta

*Madlene Cumbo and her
Maltese knight, Richard.*

Cross my heart

Richard Cumbo readily admits his heart is in two places — Canada
and Malta. The tranquillity of his island homeland provides a perfect
counter-balance to his hectic pace of life in Toronto. A tiny trio of
islands in the middle of the Mediterranean, Malta boasts myth and
history disproportionate to its size. Arabs, Italians, French and British
have all influenced Malta. Known as the bridge between the Arab
world and Europe, its legends are filled with the likes of love-starved
Calypso and captive Ulysses, a shipwrecked Saint Paul who
introduced Christianity there, and Napoleon and his troops who
held the island in 1798 on their way to Egypt. It became a British
colony in 1801 and gained independence in 1964.

The Maltese cross, created on the block with an heirloom
bobbin-lace doily, donated by the Cumbos, is the most famous
emblem of the island nation. Distinguished by eight points said to
represent the Beatitudes, the cross is the symbol of the Sovereign
Order of St. John of Jerusalem, Knights of Malta. They received the
islands as a gift from the King of Spain in 1530, in exchange for a
bird of prey — the now-famous Maltese falcon. The religious order
initially cared for pilgrims, but in time it acquired a military role and
subsequently ruled Malta for 260 years. In a famous battle in
1565, the Knights valiantly fought off attackers who doused
them with a flammable liquid, hence the Maltese cross
became the international symbol of firefighters.

Known for charity and chivalry rather than
for military expertise, Richard was named
a Knight of Malta in 1975, in honour
of his humanitarian work. A former
Ontario government worker and
a freelance journalist, Richard has
been involved in numerous charitable
organizations in a range of areas, including
multiculturalism, hospitals, welfare and the
Catholic church. Although he came to Canada
when he was just two years old, Richard speaks Maltese,
which is rare even in parts of Malta. An unofficial Maltese
ambassador to Canada, he has returned to his homeland more
than two dozen times. Tirelessly serving the Maltese community
in Toronto has helped Richard fill the void he feels living so far
away from the country he loves.

Love of a different kind struck one day in 1974 when Richard looked
through at a friend's photo album. He saw a picture of a beautiful
woman in a red dress. He immediately fell in love with the lady in
red, demanded to know her address in Malta, and began writing to
her. After meeting Richard under the watchful eyes of her parents,
Madlene agreed to come to Canada to be his bride — swept off her
feet by her knight.

Costumes, customs and cadences

A plethora of prizes, awards, newspaper features, and photos with dignitaries testify to Jelena Vrdoljak's years of tireless volunteer work. These souvenirs take pride of place among the abundance of Croatian treasures in her home. In 1968, when her family fled their native Dalmatia on the eastern shores of the Adriatic Sea, they brought as many precious mementos as they could carry. They have been collecting "all things Croatian" ever since. While virtually every room in their residence is a showcase, they also have an actual in-house museum affectionately dubbed "The Croatian Room." From their own extensive collection, they chose the 100-year-old silk embroidery used in the block and its frame of distinctive red and white needle-weaving to give a taste of the immense textile diversity in the costumes and linens of Croatia.

While home provides the emotional heart for this close-knit family, the Vrdoljaks have worked in many areas of community service since their arrival in Canada. Their deepest commitment has been to the Canadian-Croatian Folklore Ensemble, Zrinski-Frankopan. Jelena comes from three generations of classical musicians and she is also a talented costume designer who created the vivid outfits for the troupe's dancers. Her husband, Nikola Vrdoljak, a denturist and dental technologist by day, rehearsed the ensemble evenings and weekends. Trained in Croatia as a professional folk dancer, he shaped a keen group of agile young people, including his own daughter, into a world-class folk-dancing troupe. Resplendent in their colourful attire and accomplished in the complex, highly athletic cadences of Croatian folk dances, they were in great demand. The ensemble toured and performed in many places, from the 1976 Montréal Olympics to Washington's White House.

These activities were only one facet of a busy schedule for the Vrdoljak family. In Croatia, most recently under Yugoslavia's control until 1991, almost every village, town and island has a longstanding tradition of holding an annual fair. The city of Zagreb held fairs for three centuries before it became the capital of Croatia in 1557. Steeped in this Croatian heritage, Jelena, here in Canada, enthusiastically organized and coordinated a dizzying number of displays, large exhibitions, festivals, Easter fêtes, and public events, including a three-month feature of Croatian culture at the Royal Ontario Museum. She prepared many displays in Toronto's annual Christmas Around the World Festival, in which every item on the Croatian tree was handmade, from the gingerbread to the paper *licitar* hearts filled with walnuts and sugar cubes. Generously sharing her heritage and her heart in this way comes naturally. But then, says Jelena, eyes lit with pride, "Everything in Croatia is about the heart."

Nikola and Jelena Vrdoljak

> " Everything in Croatia is about the heart. "
> *Jelena Vrdoljak*

"The generosity of spirit,
people sharing of themselves,
defines Canadians for me."
Meredith Royds

"In Canada,
the people are creative,
open and dynamic."
Andrea Veerman

"Freedom. Though it is not
always visible and often taken
for granted, it is present in the
way we can live our lives and
in the choices we can make."
Esther Bryan

150

Sparkling with diversity

Softly, from the centre of the jewel-toned border of the *Quilt of Belonging*, emerges a simple, yet powerful motif — a single maple leaf.

Like the familiar silhouette left by a leaf on wet pavement, long after the autumn wind has whisked it away, the Canada block subtly outlines our country's emblem. Peacefully it whispers our story, suggesting our nature and history.

It conjures up a kaleidoscope of meanings. In a country that stretches 4,800 kilometres from the Atlantic to the Pacific Ocean and includes an area of approximately 10 million square kilometres, Canadians, like the beads, are clustered in a few urban centres or sprinkled across great distances. Sometimes defined, other times left open, the contours of the leaf speak of unbounded space, freedom and a history that is still young. The future lies open like an exciting work-in-progress, an unfinished canvas.

Tiny glass beads on a velvet background recall the early European trading exchanges with Canada's Aboriginal peoples. Sparkling with diversity, their iridescence reflects a wide range of colors…Canada's people.

> " Canada welcomes all,
> as we are welcomed by all. "
> *Ken McLaren*

> " Le Canada est l'étendue
> de notre ouverture d'esprit
> et l'ampleur de nos paysages. "
> *Claudette Voët*

> " As a country we are a collective
> of all the different peoples of the
> world. That is the wonder and
> richness of our culture. We are
> not homogenous, and that gives
> us endless possibilities. "
> *John Towndrow*

> " Just like a new house becomes a home,
> Canada generously gives us a country
> to call our own.
> Tout comme on fait d'une maison notre chez soi,
> le Canada nous accueille généreusement,
> et puis un jour il nous appartient tout entier. "
> *Catherine MacLaine*

Australia

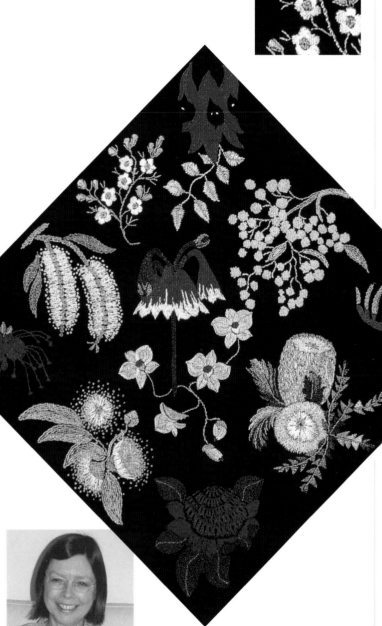

Controlled profusion

Despite its southern Pacific location, Australia is the driest continent in the world. Fittingly, many of its native plants can withstand long droughts. After a hard rainfall, sometimes several years apart, the desert bursts into bloom, its plants of different colours, sizes and textures all springing to life at once. Some shrubs require the heat of bush fires to crack open their pods to release their seeds.

Lyn Prichard's artist's eye, combined with her knowledge of Australia's fine needlework history and bold contemporary art scene, led her to select eleven wildflowers from some 22,000 native species for this block. Inspired by the work of Australian embroiderer Liz Walsh, Lyn's informal arrangement reflects the casual lifestyle favoured Down Under. Using mainly stem stitch, a bit of lazy-daisy stitch and straight stitch enlivened with some French and half-Colonial knots, she flung the distinctive wildflowers on a black wool backdrop, freely adjusting scale to bring order to the overall design. Lyn took a whole year to stitch this piece, which she calls "controlled profusion."

The black, pure wool background is both visually dramatic and significant as Australia produces about seventy percent of the world's wool. Lyn has stylized the wildflowers as in a medieval *mille-fleurs* tapestry. Yet, unlike a medieval tapestry, Lyn used vibrantly hued rayon embroidery floss to simulate the sheen of the hot sun on Australian plants.

Lyn loves bold colours and uses them liberally in her home. She surrounds herself with bright, hot oranges and reds. Lyn says, "In Canada, where the colder weather means we spend so much more time inside our homes, we need lots of colour to create cheerful warmth."

Australia has developed its own distinctive culture as a result of strong Asian and European influences and an interesting ethnic mix; twenty-five percent of the modern population was born elsewhere. The continent's original inhabitants, the Aborigines and Torres Strait Islanders, were joined by some 160,000 British penal colony inmates and their keepers, starting in 1788. Today, close to eighty percent of the population lives in towns or cities, while the harsh conditions of the famed Outback retain those with an especially adventurous spirit.

"Aussies" are widely known for their great sense of adventure, but Lyn says they also have a delightful, ironic sense of humour. "We love to tease everybody and we don't mind if people do it to us — we have a very self-deprecating sense of humour that is difficult for other cultures to recognize." Lyn enjoys looking at life from different angles, questioning ideas, and challenging the norm with a quiet irreverence — and with a mischievous twinkle in her eye.

Clockwise, from 12 o'clock: Sturt's desert pea; wattle; kangaroo paw; banksia and dryandra; waratah; Tasmanian blue gum; grevillea; callistemon or bottle brush; and Geraldton wax flower; with Christmas bells and Cooktown orchids filling the centre.

Children of the fur trade

Who are the Métis? The exact definition is one over which even Métis themselves have disagreed. Their origin as the offspring of European explorers and predominantly Cree and Ojibwe women in the days of the expanding fur trade is undisputed. Even their name comes from the Latin "miscere," to mix. What is most important is that they are defined under the Canadian constitution as "Aboriginal people of Canada," along with Indian and Inuit peoples.

Reverend Kathryn Gorman-Lovelady, an Elder of the Métis Council, is proud to see her people represented in the foundation row of the quilt. "It would have been wrong not to include them, based on the charter," she says. Her complex, three-dimensional voyageur canoe filled with trading goods pays tribute to well over 300,000 Métis across Canada. Kathryn, an interfaith church moderator, shaman and director of the Moonstar Lodge, is also a certified quilting teacher and a textile artist. "Over three hundred combined hours of work went into the block," Kathryn points out. "Robert Newell carved the paddles to scale, and the birchbark-printed fabric was imported from England. Daphne Howells created the woven Métis sash to my specifications, using red to represent the Red River Métis and blue for the Hudson Bay."

Michif and Ojib-Cree are languages still spoken by some Métis, but generally distinctive clothing and identifiers are hard to pinpoint. Physically, most are lighter-skinned than other indigenous people owing to their English, Scottish, French, Irish, German, Scandinavian or other European ancestry. In larger society, one source estimates forty percent of French-Canadians can claim at least one native forebear, as can Dr. Norman Bethune, hockey player Brian Trottier and former Alberta premier Peter Lougheed. Possibly from their Celtic and French ancestors, the Métis "are wonderful fiddle players and clog dancers," Kathryn adds. "The Red River Jig" is perhaps the most renowned of their lively tunes.

Many Métis played a major role in the fur trade as *coureurs de bois* earning their livelihood through trading pelts, bolts of cloth and beads. The Dakota called them "flower beadwork people," because they introduced trade beads to First Nations people and are admired for their beautiful designs. "It is difficult to give documented sources for information because ours is an oral history," reminds Kathryn. Certainly the most common knowledge of Métis history is the hanging death of Louis Riel in 1885, following the uprising he led. Although they have mixed ancestry, Métis see themselves as distinct and separate from both Natives and whites. The best definition of who are the Métis could come from their own 1979 *Declaration of Métis Rights,* in which they stated they are "the true spirit of Canada and…the source of Canadian identity."

The Métis were called "flower beadwork people," because they introduced trade beads to First Nations people.

Poland

Embroidered Polish folk costume vest.

Kaszuby

At Halina Urbanowicz's home on Christmas Eve, the festive table is set for a twelve-course dinner, representing the twelve apostles. "We also set one free plate for an unexpected visitor," Halina explains. It is a tradition her family has kept over the years, one her daughter and son took with them when they left home.

"Leaving home" for Halina herself, however, meant leaving Poland after the World War II and living in France for eight years before immigrating to Canada. "I worked in Montréal for a while, but I missed Europe," she says. Determined to go back, she bought her ticket, only to hit a roadblock in Toronto when she met a man who convinced her to stay in Canada. Laughing at the memories of impassioned youth, Halina says, "That was the end of my going back to Europe." That man she bumped into in Toronto so long ago? He was so convincing, she married him.

Fifty years later, she shares memories from her home in Barry's Bay, Ontario. This region is known to the Polish-Canadian community as Kaszuby, named after the part of northern Poland the first Polish settlers came from in the mid-1800s. Fourteen Kaszub families cleared forests and built homes of rough-hewn logs. They also formed the first parish in the township of Hagarty in 1875, preserving their distinctive character, language and customs.

These first few families were followed by several waves of Polish immigration. Prior to World War I, approximately 110,000 Poles came to Canada, many of them to establish farms on the prairies. Between the World Wars, Poland went through tremendous economic and social turmoil which led to another massive immigration of Poles. Yet a third wave, many of them ex-military men, came in the aftermath of World War II and the establishment of a communist regime in Poland.

The Polish arrivals spread across the country, engaged in every profession and have successfully kept their culture alive. Traditional folk dancing, cuisine and special holiday festivities are marked in Polish-Canadian neighbourhoods, like those in Winnipeg's North End and Toronto's Parkdale district. But when it came to creating the Poland block, the Canadian Polish Congress of Toronto asked Anna Zurakowski, of the Polish Heritage Institute Kaszuby, to find someone from tiny Kaszuby where Polish life in Canada had begun.

Stylized flowers became the theme of the needlework Halina created in collaboration with Anna Zurakowska. The centuries-old flower and leaf motif is a design from the Kaszuby region, and is characteristic of the brilliant needlework that adorns folk dresses worn during ethnic celebrations. A hand-carved wooden brooch with brass inlay, an heirloom donated by Alicia Hodson, provided the perfect finishing touch to this glance back in time.

From breadbasket to granary

It is said that every other Ukrainian is a poet. Their lyrical language, literature, folk art and cultural festivities all communicate the beauty and poetic spirit of the people. For Jeanne Pawluk, being a Ukrainian-Canadian brings a rich sense of heritage and history to her life. Jeanne's maternal ancestors came in 1897, when the Canadian government encouraged immigrants to settle the west. Some 75,000 Ukrainians arrived between 1891 and 1911. Her paternal relatives came in 1945, among the last large wave from Ukraine after World War II.

Jeanne learned the Ukrainian style of embroidery from her mother and "inherited the talent" for needlework from her father, a tailor who created folk-dance costumes. She has stitched traditional blouses, pillows, table runners and special cloths to drape over picture frames. "The embroidery makes me feel connected to my heritage. The elements included in the block are symbolic of our culture," she explains. The trident, the state emblem, generally represents power and unity. Cornflowers and poppies are symbols of fertility and the fragility of beauty and love, while shafts of wheat honour the period when Ukraine was the greatest producer of high quality grains, and was known as the "breadbasket of Europe."

> " The embroidery
> makes me feel
> connected to
> my heritage. "
> *Jeanne Pawluk*

Ukrainians are famous for their delicious and unusual breads, a staple of daily life and ceremonies. *Korovai* is built up to form a tall, cylindrical, wedding bread in lieu of cake; egg bread called *paska* is braided in the shape of a cross for Easter; and *kolach*, made with sour cream and honey, is dipped in salt and honey and given to each household member during the traditional Christmas meal. Hundreds of loaves are baked and sold as a fundraiser at Jeanne's church in St. Catharines, Ontario. "We can't keep up," she reports happily.

Pioneers from Ukraine opened up an estimated forty percent of Canada's wheat land, helping to establish their new homeland as the "Granary of the World." As the fifth largest ethnic group in Canada, numbering over 1,125,000, Ukrainians have contributed to shaping the nation. They introduced the concept of multiculturalism, which has been an official policy and defining characteristic of Canada since 1971. Jeanne also participated in promoting her culture. She recalls, "I was involved with a Ukrainian folk-dancing troupe in the 1970s. We toured throughout Canada, and actually performed for Queen Elizabeth!"

Ukrainian playwright Anton Chekhov wrote, "He who desires nothing, hopes for nothing, and is afraid of nothing, cannot be an artist." For Ukrainian-Canadians, their desires, fears and hopes have created a beautiful and rich artistic culture, which they generously share with all Canadians.

Germany

The support of friends and colleagues convinced Elfriede that, at sixty-five, she could rebuild her block and her life.

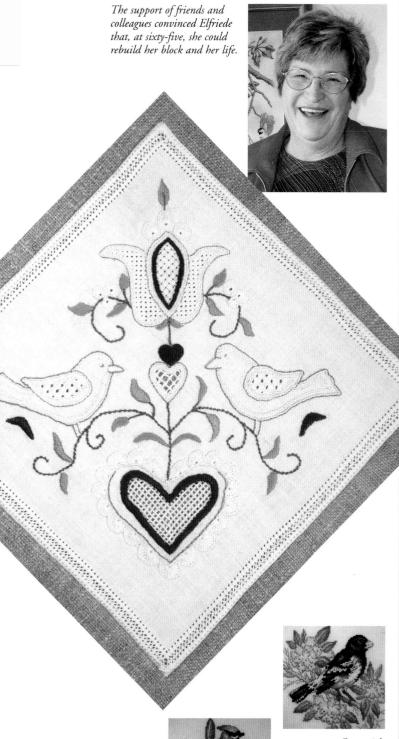

Cross-stich of Elfriede's beloved birds.

Life changes

Elfriede Petric created beautiful works of embroidered art for twenty-five years before she began to see her craft as more than just a relaxing pastime. The change came when Invitation members saw her extraordinary talent and praised her work. "I had literally given away hundreds of embroidered pieces and never realized I was pretty good at it."

Sadly, the block she was creating to represent Germany was accidentally destroyed one evening. Elfriede was disconsolate and felt she could not start over. But members of the animated stitching group that met weekly at the project headquarters encouraged Elfriede to join their ranks, and they asked to see her work. The praise and occasional gasps of wonder came naturally, particularly when she brought in samples embroidered with exquisite flowers and luminescent birds.

And then, more trying days arrived. The end of a long and difficult marriage coincided with the loss of her job. When Elfriede thought she could not go on, the support of friends and colleagues convinced her that at sixty-five, she could rebuild her block, and her life. In the wake of these life challenges, she created a stunning afghan for Invitation's fundraising efforts. This highly coveted prize featured hanging birdhouses and wildlife beautifully executed with such precise stitches, one could barely tell the front from the back. Elfriede's richly coloured canvasses invariably include winged creatures — her favourite subject. And the ones that fly to her birdfeeder? "I spend more on bird food than I do on food for myself," she says, laughing at the absurdity of it.

With her mother's beautiful trousseau of *Schwalm*-embroidered table linens and bedding in mind, Elfriede worked her block white-on-white, introducing colour for visibility. For the base she used linen woven by her great-grandfather who once lived in an area of Germany now part of Poland. For the inner border Kathleen Alguire donated the hand-spun legacy from her German forbears. This linen was woven in the early 1800s from flax grown in southeastern Ontario. Yet, away from the camaraderie of the stitching group, Elfriede admits she doubted her ability to bring the project to completion. Then, little by little, changes in her demeanour became apparent — she regained lightness in her step and a special twinkle of pleasure in her eye.

When Elfriede came to Canada to join her two sisters, she was seventeen, spirited and adventurous. Today, she's reclaimed those qualities. She talks of Germany and the mountains she will always miss. If there hadn't been so many changes, she says she might have moved back. But then the moment passes. Elfriede has come to realize that change is constant. She cannot go back, so she moves forward, into joy and laughter once more.

Spirit of Bella Coola

Lillian Siwallace of the Nuxalk Nation remembers when the rising waters of the Bella Coola River sluiced through her small village in 1938. She was only eight then, yet the images remain strong, part of the history that reshaped her environment. "There were houses and a sidewalk along the riverbank," she says. "I saw cows trying to climb up on the sidewalk…and the river just swept them away, out to the ocean." Chickens. Horses. Everything was lost.

Despite this, the indomitable spirit of the Nuxalkmx ("people of the Bella Coola valley") survived. Distinguished by their masterful carvings and crafts, this nation has thrived along the central coast of British Columbia for thousands of years. It would take more than a flood to wash them away. As people rallied together to save their community-built church, spirits rose. Accompanied by the lively strains of the Nuxalk brass band, villagers cheered as the Emmanuel United Church was barged across the swollen river and placed on higher ground on the south bank, where Bella Coola village sits today.

Lillian has other memories, all set against a background of breathtaking mountains and deep, glittering fjords. Bella Coola has been home through the seasons of her life. She was the eldest of a large family, and then she raised eight children of her own. "Seven boys and one girl," she announces, chuckling at the genetic luck that blessed her with a daughter. Life was busy. Finally, the household was down to three people: Lillian, her thirteen-year-old son and her husband, who was often away on commercial fishing trips. While others her age slowed down, Lillian worried about "sitting at home doing nothing." She enthusiastically embraced a new vocation by earning a certificate as a Nuxalk-language instructor.

Lillian's graduation became a powerful juncture. As one who mourns the "missing generation," those who lost their language and culture through changing times, Lillian proudly contributed to the survival of her culture. For the next seventeen years she transmitted her knowledge and heritage to elementary and secondary school students. Being part of the Nuxalk Nation's efforts to save their language from extinction satisfied her soul. Today, at celebrations such as the potlatch, young people sing and dance, their voices and bodies echoing ancient traditions and stories. Lillian watches and listens, her heart swelling. "It makes you feel good because you're part of teaching them," she says.

It was while watching the young dancers that Lillian thought of the Thunderbird mask for the *Invitation* quilt. Lillian transformed red wool felt, moose hair tufts, cedar braid and abalone shell buttons into the revered Thunderbird, designed by teaching colleague Foster Walkus. Lillian explains, "We have many dances, but the thunder dance is our most powerful and most respected."

> **"We have many dances, but the thunder dance is our most powerful and most respected."**
> *Lillian Siwallace*

China

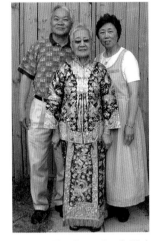

Eric Lam, Angela Yick and Judy Gin

Yet Keen

The Chinese revere age for the wisdom and history it embodies. This is not surprising, given that China's recorded history goes back more than 4,000 years, with unwritten history much longer. More than twenty dynasties have ruled China. The teachings of 5th-century-B.C. philosopher Confucius, and the edicts of Mao Zedong still shape society. Ancient Chinese arts are part of contemporary life, even in the Western world. Chinese medicine has existed for millennia, while *tai chi chuan* and *feng shui* often form an integral part of daily life.

Canada's story is short when compared to that of densely populated China, whose people played an important role in our country's early history. Hundreds of Chinese worked the fields during the Fraser River gold rush of 1858, while thousands of labourers were directly recruited from China for the grueling work of building Canada's transcontinental railroad.

Judy Gin, Eric Lam and Angela Yick, who collaborated to make the China block, are among more than 900,000 Chinese who live in Canada. Each grew up in Hong Kong, a modern city that maintains its roots and culture despite its whirlwind pace. All are dedicated to creating a supportive haven for elderly Chinese, a goal realized in the Yet Keen Seniors' Day Centre in Ottawa, which opened in 1984. Its goal is to help non-English-speaking Chinese seniors access mainline services and socialize. In China seniors are respected for their wisdom and experience. They are cared for by their families or choose to stay in homes "for revered seniors." Emigrants lose their social network. Eric says this was not only true for early Chinese immigrants, but also for newer ones. Many Chinese elders are cocooned within the Chinese community, working long hours with little educational opportunities and minimal contact with the mainstream population. Many grandparents stay at home taking on the role of babysitters.

Judy came to Canada to join her family in 1969. She worked long hours at her brother's restaurant, married and raised two boys. When she was widowed, the Centre became her "second home." In 1988, Angela joined her sons in Canada. She says her fluency in English made all the difference in her interactions with her neighbours and the Chinese community. "Not everyone is so fortunate," Eric observes.

In Chinese culture, dragons are considered the ultimate symbol of good fortune. On their block, a resplendent silk and couched-gold dragon symbolizes longevity and divine protection. Butterflies and lotus flowers (for purity) fill the corners and interior spaces. It is bordered in deep red silk, the colour of traditional wedding dresses, meant to bring good luck. "Those who are lucky," observes Eric, "have to help others to have the best quality of life."

Ready to go anywhere

The two women first met while studying at the University of Vilna in 1938, when that part of Belarus was under Polish control. Even back then, Raisa Zuk-Hryskievic says, Ludovika Bucka's artistic abilities were evident. The two young women became the best of friends during their student days on campus — sharing laughter and dreams for the future.

Raisa's memories of Ludovika span sixty-six years up until her friend's passing at the age of ninety-one in 2002. Raisa's voice is still spirited at age eighty-four; it echoes with love and admiration when she describes her friend's creative genius. During World War II, in which more than 2.5 million Belarusians were killed, the two friends were reunited in a refugee camp. "Ludovika was teaching artistic things — music, dancing and singing," she says. Although it was extremely difficult to get material, by some extraordinary means, Ludovika managed to create "professional-looking costumes" for theatre productions they mounted. Despite dispiriting conditions, numerous activities, organizations and schools sprang to life from the positive efforts of Belarusian refugees in various camps. During the war years, particularly because of the reduced circumstances Belarusians endured, the continuation of culture and education was considered crucial. Today, the country is renowned for its work in advanced science and engineering.

"There was no future in the camps," says Raisa. Belarusians moved "all over the world." Ludovika went to England and from there, to the United States. When Raisa and her sister had the opportunity to emigrate, they didn't hesitate. "It was our last chance," Raisa remembers. "And we were ready to go anywhere."

"Anywhere" turned out to be Canada, where Raisa had to re-certify in dentistry before she could practise here. She is past president of the Belarusian Canadian Coordinating Committee that helps children affected by the Chernobyl nuclear disaster in 1986 receive aid in Canada. Divided by only a short geographical distance, Raisa and Ludovika kept in touch over the years visiting each other often and sharing life's passages. They collaborated to create the Belarus block, a fine sample of Belarusian embroidery featuring complex cross-stitch in a geometric pattern. Ludovika used traditional red and black stitching against a background of white, homespun linen.

Over the years, Raisa received many gifts of Ludovika's beautiful needlework. She cherishes them, for they connect her to memories of Belarus, when she and her friend were young, open to the rich promises and possibilities of life. Raisa laughs with contentment, leaving no doubt the promises were met.

Belarus

Distinctive red-and-black cross-stitch binds old friends across continents and beyond.

Paraguay

Webs we weave

Maria Aguirre has a collector's passion for exquisite antique fabrics, especially table linens and bedspreads. Her appreciation for Paraguay's famous *Ñandutí* lace stems not only from its exquisite, fragile beauty, but also from the important role it plays as one of her country's cultural treasures. Threads are worked solely in white or, as in the block's example, interwoven with brightly coloured threads to highlight the design.

The art of *Ñandutí* lace-making is a blend of 16th century Spanish techniques and Guaraní traditional forms. Similar lace styles, also based on the wheel, are found in Tenerife and Belgium. Paraguay is eager to preserve the tradition, Maria says, but it may be difficult to maintain as women now have opportunities to earn more money working in factories or other businesses. A co-operative in Itagua, the weaving capital of the country, encourages women to use their needlecraft skills to ensure its continuance.

The blend of the indigenous Guaraní and Spanish cultures is reflected in the uniqueness of Paraguay's folklore, literature and arts. Paraguayans are renowned for crafting musical instruments, most notably the harp and the guitar. The skills required to preserve and transmit Paraguay's cultural heritage are carefully woven from one generation into the next. For this reason, Maria felt *Ñandutí*, meaning "spider-web" in the Guaraní language, was the perfect symbol of Paraguay.

A beautiful, subtropical nation, Paraguay is still largely undiscovered by the rest of the world. This unspoiled country attracted a group of Mennonites who left Manitoba in 1926–27 to avoid religious and political persecution. They settled in the Chaco region where they established the city of Menno. Since then, Mennonites have successfully built independent farming and religious communities. They are highly respected as the leading milk producers in the country. Now, after years of remaining apart, Mennonites are increasingly integrating into mainstream society. Today, the flow of immigration is reversed — thousands of descendents of these Mennonites have returned to Canada to form vibrant communities of Paraguayans in Manitoba.

Maria notes that family life is very important to Paraguayans; being away from home is not always easy. But after living in many countries around the world, she says, "I create a family environment in whatever country I live in. I make friends." She continues to visit Paraguay often because her eldest son is studying law there. She also continues to weave her personal story from the central hub of her homeland into an elaborate pattern of friendships reminiscent of her much-admired *Ñandutí* lace.

A vanishing nation

The headwaters of the Yukon River in the southern Yukon Territory remain the home of the dwindling Tagish Nation. The Tagish name itself is an Inland Tlingit place name that means "the spring ice is breaking up." Culturally dominant, the Tlingit influenced the Tagish heavily even before the arrival of non-Natives in the Yukon. Intermarriage with the Tlingit has meant dilution of their own culture and customs over the centuries. "We are a dying nation," says Karen Lepine of Whitehorse. The language of her ancestors is dying, too. Linguistically, Tagish is closely related to Kaska and Tahltan, but is sometimes confused with Tlingit. "I remember my great-grandmother spoke it," recalls Karen but she, herself, does not. Almost no one speaks it fluently now.

One of several quilters who work at the Skookum Jim Friendship Centre, Karen volunteered to make the Tagish quilt block. "I learned sewing from my mother," she explains, "but my mother-in-law got me into quilting about ten years ago." She admits she wasn't too interested when she thought quilting was "cutting up and sewing together little pieces" but enjoys the freedom of the more modern techniques. She particularly likes making baby quilts, because "I can see faster results and I have the patience for that!" She makes them for "all the special children in my life."

The special block Karen created ties in to her heritage and to the Centre where she has worked for over nine years and is now director of finance. In the button-blanket style of the West Coast, Karen reproduced the Killer Whale *(Dakl'aweidi)* clan crest of Keish, a Tagish Kwan man, also known as "Skookum Jim" Mason. He and fellow guide "Dawson Charlie" were co-discoverers of gold in 1898, setting off the Klondike Gold Rush. The familiar flat-form design in red and black stroud is embellished with abalone shell buttons, true to tradition.

"We have the best weather up here," Karen says of the Yukon, where she was born and raised. "We may have snow in the mountains, but we have dry heat and dry cold…not that bone-chilling dampness you get elsewhere." She loves the mountains, too. "Everywhere you look, you can see a mountain," she says enthusiastically. "I can't believe my friend in Manitoba has never seen one!" Another thing Karen delights in relates to her unique environment and the extended hours of daylight in summertime. "We hosted a conference for other friendship centres and the participants were amazed to be walking about in the light at two a.m.…tired, but amazed!" she laughs. The centres are non-profit organizations committed to bettering the well being of First Nations people. One of their goals is to strengthen the increasing emphasis on Aboriginal cultural distinctiveness, important in a time when some cultures — such as the Tagish — are disappearing rapidly.

Tagish
Ta:giizi dene

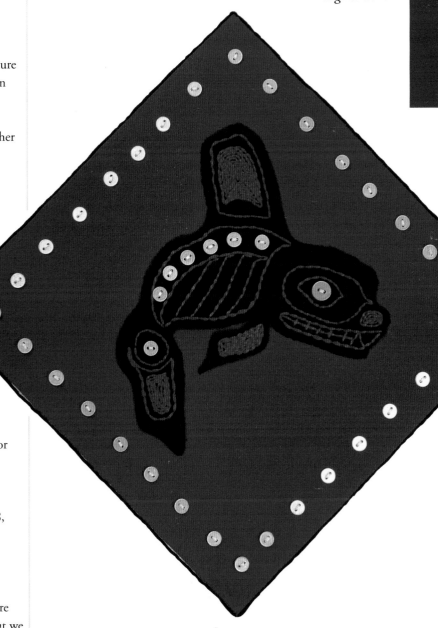

" Everywhere you look, you can see a mountain. I can't believe my friend in Manitoba has never seen one. "

Karen Lepine

Hungary

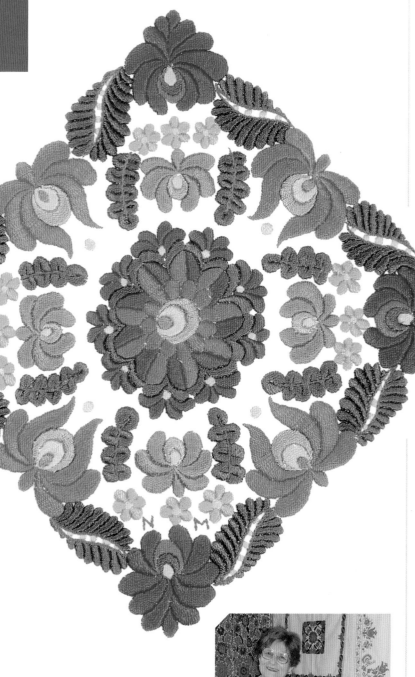

Each region has its own unique embroidery traditions, passed down from generation to generation.

Matyó mania

Sometimes, when Monika Nemeth is designing a new piece of embroidery, she can hardly sleep. During the weeks of planning, she finds herself waking up in the middle of the night with flashes of inspiration that demand to be written down or drawn right away. "It is so exciting to make your own designs," says this devoted embroiderer who always has multiple projects on the go.

Monika's love for embroidery is strongly tied to her Hungarian heritage. In her culture, embroidered fabrics were at one time very important in marriage and family life. Young women began preparing for marriage long before their weddings. All the women in the family would work steadily for years to create every piece of household linen a bride would need. Each piece was meticulously embroidered with local patterns. But today, Monika explains, things are changing. "Even on the farms, everyone is modern, everyone buys from the store…. The young people now only use embroidery for special occasions."

Monika has an intense desire to see Hungarian traditions and arts transmitted to the next generation, so she teaches embroidery to children. While passing along the skills of the craft, she also wants the children to learn about the suffering of the past and the hope for the future of Hungary. "Village life was very hard," she says. "We did not have much money for rich materials."

Despite material poverty, Hungarian embroidery is rich in history. Each region has its own distinct motifs and unique embroidery traditions, which have been faithfully passed down from generation to generation. Monika grew up near Matyó, an area that developed one of the most famous types of folk art in the country. When viewing her work, one senses the atmosphere of Monika's homeland: the deep orange-red evokes the scent of paprika, the national spice; the intense greens are much like the *puszta*, the great Hungarian plains; the concentrated blues hint at the waters of Lake Balaton, Europe's largest warm-water lake and the thousand thermal springs that well up throughout the countryside. Joyful colours of celebration, pink, purple and yellow, often decorate the beribboned headdresses of folk dancers spinning in a *csárdás* to the thrilling sound of racing violins.

When she first came to Canada, Monika greatly missed her homeland. Even now when the homesickness grows too heavy, the patterns and vivid colours of her extensive embroidery collection surround her, bringing comfort. Still her greatest joy comes in losing herself in the designs of Hungarian heirlooms yet to be stitched.

More than a church

From the beginning, the Norwegian Seamen's Church on Dorchester Street in Montréal was more than just a Lutheran church. It provided a common meeting ground for Scandinavians near and far. "It was the first place sailors went when their boat docked," says Grete Grzegorek, a member of the Norwegian Church Association of Montréal. Grete joined creative forces with four *Kirkeringen* church auxiliary members to fashion the Norwegian block. After much consideration, a layered design was chosen. Ellen Styker's finely painted wooden floral *Rosemaling* rests in the centre of an intricate sample of *Hardangersöm* embroidery. This style of needlework is often used to embellish church cloths, household linens and clothing. Wool background fabrics, typically used in folk costumes, add a soft beauty.

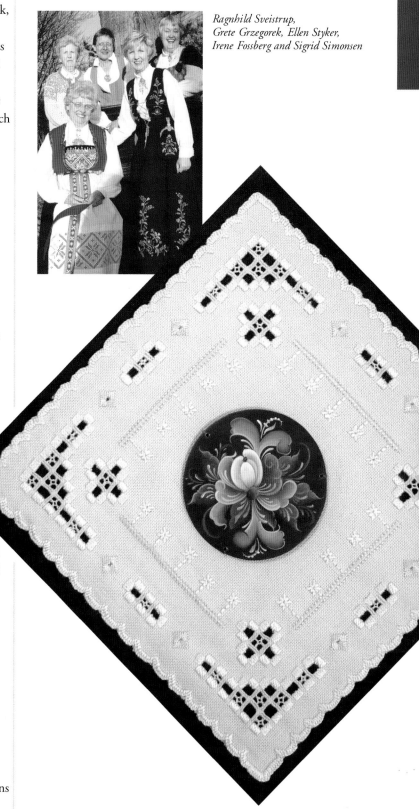

Ragnhild Sveistrup, Grete Grzegorek, Ellen Styker, Irene Fossberg and Sigrid Simonsen

The Seamen's Church was a cosy, welcoming place with comfortable sofas, easy chairs, a regular supply of Norwegian newspapers and a pool table. Even King Olav stopped in to say hello in 1987. Long-time members have fond memories of many festivities, including the famous Christmas sale, a seasonal highlight, with its imported foods, handmade textiles and knitwear. The gatherings were exciting too, say the women, with Cupid drawing bows on future husbands and wives. Sigrid Simonsen remembers it as "a safe haven for everyone," including the children who played there. When her son visited another church and reported that it wasn't a "real church" because it didn't have a crocodile or a pool table, she had to tell him their church was a little different. The pool table and an old, stuffed crocodile left behind by a sailor, had become such familiar fixtures for the children that they thought no house of God was complete without them.

Of course, regular services were also important, uniting members in prayer. But patriotism presented its own agenda. During the speed skating competitions at the Lillehammer Olympics, services were delayed until the races were run. When the announcement came that Norway had captured three gold medals, services resumed on a tidal wave of jubilation and thanksgiving prayers. Ragnhild Sveistrup describes the church as all encompassing, taking members through "everything from birth to death." For Ellen Styker, whose father was its pastor for many years, it was a home away from home. She remembers her parents "dedicating their entire lives to serving the spiritual and social needs of the community and compatriots abroad."

When the church closed in 1994, it might have marked the end of an era. But bent on preserving a legacy that spanned sixty-five years, a committed group of Norwegians went out and bought another building in Lachine. Fitted with all the furniture brought from the old church, this new gathering place welcomes Scandinavians from all over. It thrives with a strong pulse that continues to beat in the heart of the Norwegian community.

Bangladesh

Natural rhythms

A well-known Bangladeshi embroidery artist, Ilora Awal brought her considerable talents to Canada, and more specifically, to the Invitation Project. In 1998, she left the capital city of Dhaka to reunite with her husband Monir Hossain, a computer program analyst who had been in Montréal since 1991 completing university studies. The couple worked together to create the Bangladesh block, along with Ilora's younger brother, who is also an artist. They considered many images to reveal the cultural identity of close to 39 million people living in multi-faceted Bangladesh. Predominantly Bengali, the culturally distinct tribal groups that inhabit the country's hilly regions make up one million of the population.

Their hometown of Dhaka, once a significant Mogul trading-centre, straddles the north bank of the teeming Buriganga River, where the panorama of life is as varied as it is constant. Waterfront, baroque-style palaces, historic forts, and architecturally stunning mosques are just some of the splendours. There are also over 300,000 colourfully painted rickshaws, ready to roll. In Paharpur there is the 27-acre archaeological site of Somapuri Vihaar, an eighth-century Buddhist monastery, and at the Sundarbans National Park, about 400 royal Bengal tigers roam the wildlife sanctuary. The park also has the longest beach and the largest mangrove forest in the world.

Ilora and her design team chose none of these particular images. Instead, her gifted hands stitched a typical village scene where time appears to be standing still. In reality, it continues to move forward within the natural rhythms still evident in rural settings. Hard at work, pounding grain, two beautiful young women dressed in brightly patterned dresses ease their workloads with shared laughter and camaraderie.

"What the women are doing is very traditional," says Ilora. From village to village throughout the harvest months, this scene unfolds repeatedly. In the intricate stitches that tell the story, Ilora illustrates the Bangladesh needlework tradition of rural folk embroidery. Bangladeshis are known for their fine weaving and complex needle-work, which are experiencing a revival. Embroidered patchwork quilts known as *nakshi-kantha* are the most well known examples of folk embroidery and, like the quilt design, often depict village stories.

Ilora learned needlework skills when she was young and later pursued formal art studies. Before they moved to Toronto, and before becoming first-time parents to two-year-old Irisha, Ilora exhibited her work in Montréal; she has even had her work reproduced and shown in Bangladesh. Eventually she will return to the passion she says has "a calming effect" on her. For now, being a full-time mother is more than enough to fill her days.

The Dancing Woman

Shanawdithit, the last known of the Beothuk, the Aboriginal inhabitants of Newfoundland, has been dead for over 175 years. She was buried on the south side of St. John's harbour in 1829, having succumbed to "the white man's disease," tuberculosis. Fur trappers had found her near starvation six years earlier, along with her sister and mother who died soon after. The Beothuk expired from diseases and malnutrition caused by loss of territory and food sources, as well as being killed by British settlers and rival Mi'gmaq. A search of the territory two years before her death could locate no other survivors. Some of her remaining kin may have made their way to the mainland aboard their unique high-sided, oceangoing canoes, to be absorbed by the Montagnais or Naskapi.

After living with British settlers for more than five years, Shanawdithit was taken to St. John's to live with William Eppes Cormack, who founded the Beothuk Institution. She gained confidence to communicate information about her people during the four months under his care. He recorded details about her life from her drawings of artefacts and maps of camp locations. Shanawdithit's rough-English translations helped him document a list of words from her language. The word *Beothuk* means "people," and was the term they applied to themselves. Because they used ochre or iron-rich soil mixed with grease on their bodies and belongings as a tribal marker, the first sighting of these Natives is said to have led to the appellation "Red Indians."

Studio Inspirations stitchers designed the caribou-skin block layered on black wool felt, in memory of the Beothuk. They relied heavily on the legacy Shanawdithit left through her drawings. The floss-embroidered image of a dancing woman dressed in Native clothing is reproduced from a detailed drawing Shanawdithit created using red paint. That colour is believed to have represented life and health. The archaeological site at Boyd's Cove, Newfoundland, one of the most significant Beothuk campsites discovered to date, provided further inspiration. Embellishments on the crumpled skin, reminiscent of an unearthed parchment, include bark (used as a building material), shell beads, rabbit- and seal-skin that might have been part of Shanawdithit's daily life.

This "archaeological site map" respectfully honours one of Canada's first people, an independent, elusive tribe of hunter-gatherers who valued their traditional way of life and never acquired guns. Detrimental conditions and encroaching settlement that slowly cut off their seasonal and coastal food sources pushed the Beothuk from their lands, then pushed them to the brink of extinction and over it.

Beothuk

Shawnadithit's dancing woman beckons from a culture extinct since 1829.

Dominica

> "We didn't have much,
> but we were always happy."
>
> *Sheila Hill*

Pride of appearance

Every year when the Caribbean community in Brampton, Ontario, holds its annual cultural events, Sheila Hill dons the lacy white cotton petticoat, colourful skirt and head wrap that are typical of the island of Dominica. "I feel a lot of pride when I wear that costume," she says. Years ago women would wear this outfit, called a *douillette*, whenever they dressed for any festive or formal occasion. Called "Dominica" by Christopher Columbus because he spotted it on a Sunday, the island was colonized by Britain, but taken away by France during the 1700s. Britain later got it back (and eventually Dominica gained independence in 1978), but not before the French language and culture, and the Roman Catholic church, had made their mark.

The fourth of six children, Sheila grew up in the village of Wesley (named after John Wesley, whose Methodist church became the second-largest after the Roman Catholics). "We didn't have much but we were always happy," she remembers. After chores, she and her friends would play marbles with pebbles, skip rope or play hopscotch. The abundant tropical fruit provided both nutrition and entertainment. "We enjoyed all our natural fruit: mangoes falling from the trees, ripe bananas, and guavas," she says. "We could just climb trees and pick, eat, and enjoy." When she was twelve, Sheila went to school in the capital city, Roseau, returning later to teach in her hometown for a few years before emigrating.

In April 1969, at the age of twenty-one, she left home. "I was just young and adventurous," she says of her decision to emigrate alone. She had one friend in Toronto, and at that time Canada was looking for people to move here. Soon she found a clerical job, and several months later she was joined by her fiancé, Richard. The two built a life here, raised a son and a daughter and now have a grandson and a granddaughter.

"I find Canada is such a blessed country," says Sheila, who has worked for one company for thirty years, as an accountant. Though she maintains strong connections with the Caribbean community, and goes home to Dominica almost every year, she enjoys the richness of cultures that make up the Canadian fabric. In the Dominican block that Sheila made, there is a Sisserou parrot, the island's national bird — one of two parrots found nowhere else in the world — and a *bwa kwaib*, the national flower in the Creole language. Between them, in the centre of the block, is a Dominican lady wearing the same type of colourful head wrap and skirt with the white petticoat peeking out that makes Sheila so proud each time she dons her own.

Wantok

The Papuans of New Guinea are not given to complaining. Up to eighty percent live in primitive rural areas and support themselves through subsistence agriculture. Bonnie Weppler, a missionary, living and working with them for six years, describes the Papuans as materially poor but "incredibly resilient, patient and very resourceful." Time spent waiting is turned into an opportunity to chat with friends and neighbours. Heading on a journey, their motto is "When I get there, I get there." In contrast to Westerners governed by the clock, time is not a priority for Papuans.

What they value most, says Bonnie, is cultivating a strong sense of community. Ferreting out information about everyone in their midst is considered both a pleasure and a duty. Bonnie laughs as she recalls situations where this mindset clashed with her Western concept of privacy. As a single woman, she was frequently a natural target for routine cross-examinations. Community campfire meetings reflect a similar scrutiny of all members. If the issue is a domestic dispute, everyone offers up opinions and judgments. "There might be a lot of shouting," says Bonnie, "but resolutions are inevitable." Children are considered heroes, and are quickly absorbed into other family structures should they lose their own parents. Bride price payments, death rituals and exchange ceremonies all emphasize the value of people. In this fluid social system called *wantok*, the community is the family and its members are cared for, monitored and accountable.

The materials featured in the block were gathered by Helen Dennet, who travelled to Papua New Guinea for authentic supplies. The Papuan skill at carving is highlighted by a three-dimensional *tiki,* a carving with human facial characteristics, set against a background of tapa cloth. Women make this cloth from the inner bark of the mulberry tree by pounding successive thin layers together. This sturdy cloth is used for clothing, ground coverings and ceremonial purposes. Despite outside influences, Papuans follow their own rhythms; work methods have changed little in thousands of years, but Bonnie adamantly believes "they're doing it the right way; *their way.*" In urban centres the modern world has made incursions, but in rural areas people have minimal outside contact.

Papuans live in a tropical landscape that serves up a daily feast of vivid colours and scents, teeming with extraordinary birds, butterflies and flowers. By necessity, Bonnie has become resourceful. She says, "Now, I'm like that television character, McGyver. I can fix anything with whatever's lying around." Bonnie is humbled by the realization that in many important ways the Papuans have taught her more than she's taught them. They have shared their caring, their hearts, their sense of what is truly important in life, and they have fostered in her a newfound resiliency.

Papua New Guinea

" When I get there,
I get there. "

Papuan motto

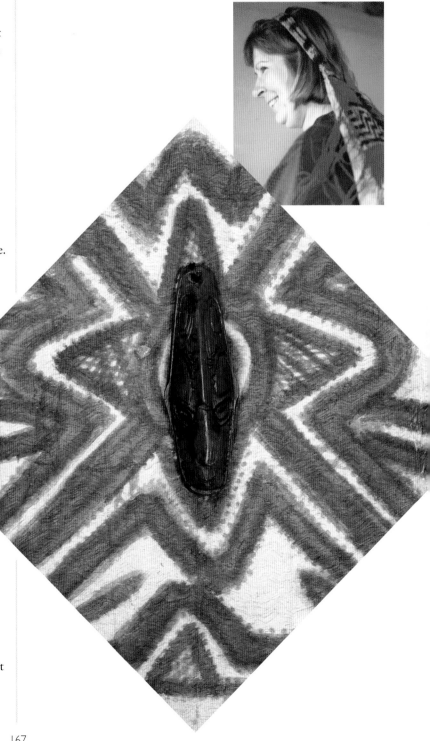

Guatemala

The fabulous quetzal bird guards traditional Guatemalan values in a precarious world.

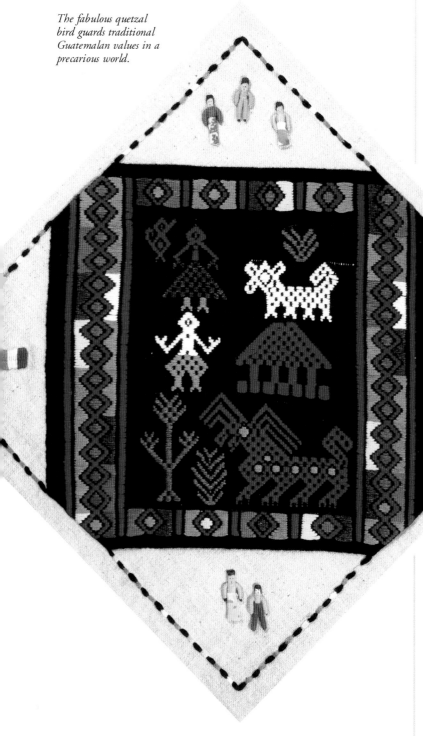

A living art

Textile production in Guatemala is still a living art, one that serves both practical and cultural purposes. While many other cultural aspects are rapidly disappearing, weaving endures partly because of the values it holds for the weavers. In many families, creating and selling woven goods provides the only source of income. Equally important for the women who patiently work bright, hand-spun wool into intricate designs for hours on end is the emotional involvement in their craft.

Mayan weavers secure a back-strap (or stick) loom, called a *telar de mano*, on their hips, then squat or semi-sit to put tension on the loom's warp yarns. Their patterns express aspects of spirituality and community, and each design is a form of identity since it is associated with a specific village or group. For many women who find pleasure and tranquility in the repetitive actions, weaving beautiful clothing in this long-established manner is a tangible way of expressing their love for their families.

This cheerful block is typical of the bold and vibrant weaving of Guatemala. Catarina Tzep Sac (a Kuiche Tribe member, of the Nahual Weavers Group in Quiascasiguàn) created the woollen fabric background. She is also one of the few remaining crafters who makes the small, wrapped "worry doll" figures found in two groups on the block. According to Guatemalan tradition, "worry dolls" will resolve problems overnight when told of a difficulty and placed under one's pillow until morning. High into the left nook of the block, Catarina wove a beautiful *quetzal* bird surveying a vivid scene composed of a tree, home, and stylized people and animals.

Guatemalans have been brutally affected by thiry-six years of civil war; the indigenous population feels the brunt more severely than others, says Susan Murdock of Horizons of Friendship. Patricia Robolledo, executive director of the same international development organization, says the persecution of the native population has left a normally open and friendly people feeling "cautious with newcomers, especially foreigners." Appropriately, the *quetzal* bird, a national symbol of freedom, takes its time, looks forward and backwards, up and down. It is just like the people of Guatemala, who carefully weigh every decision, says Susan. Patience, love and planning, all Guatemalan characteristics, are also essential virtues in traditional weaving — and may be what will ensure the survival of this beautiful art.

A legacy of tradition

French colonizers named them *Têtes-de-boules,* or "roundheads," doubtless after the hat style they wore to protect themselves from black flies. But the nearly 5,000 Atikamekw of Québec prefer to call themselves *Irnu.* For centuries, they lived a generally nomadic life in which fishing, hunting and gathering augmented their agricultural efforts in the upper Saint-Maurice valley. They have managed to retain their traditional culture and Atikamekw, a widely spoken language related to Cree. However, their ancient way of life was irreparably altered by the incursion of modern developments. Their territory was affected by the arrival of trading posts, flooding from river dams, railroad construction, pollution from hydroelectric projects, and by commercial logging that started in their territory as early as the 1830s.

Today the forestry industry is a prime employer and an important economic activity, in addition to various traditional crafts such as bark basketry. In some areas, eco-tourism and the emergence of groomed snowmobile trails attract a growing number of visitors almost year-round. Native-run schools are well attended and off-reserve higher education is promoted. All this bodes well for the future of this nation.

Madame Alice Awashish Petiquay, of Wemotaci, is an elderly traditionalist who knows her people have a present and a future, but a past as well. And she doesn't want people to forget their history. "She has a strong interest in preserving traditional ways and lives with the deepest respect for nature," says her niece Valérie Petiquay, a cultural services coordinator for the Conseil de la Nation Atikamekw.

In the block she created to represent the Atikamekw, Mme Petiquay drew on the skills she learned in her youth to convey the essence of the past. She used modern cotton floss in the place of naturally dyed animal sinew, but worked on a smoked elk hide. Mme Petiquay embroidered a traditional floral pattern, embellished by a series of colourful borders. Such motifs are often found on mittens, moccasin vamps, or on vests. A bright orange and blue plaid fabric surrounds the central square. This type of dynamic material is used to make traditional baby carriers and once was widely used for women's skirts. "Some of the older women still wear this type of plaid skirt," says Valérie.

The Atikamekw Nation is working diligently to ensure a sound future, explains Valérie in French, the predominant second language of her people. "A lot of our effort goes into educational programmes, health care, social services, and economic and tourist development," she says. "We are concentrating on teaching youth the traditional ways of the Atikamekw 'six seasons' that are based on environmental respect and responsibility." Such diligence and care will certainly ensure that Mme Petiquay's legacy will be carried forward for future generations.

Atikamekw

Irnu

66 We are concentrating on teaching youth the traditional ways of the Atikamekw 'six seasons.' 99

Valérie Petiquay

Senegal

Every inch of space in Rosemary's house is filled with the rich colourful materials she has amassed over the years.

The fabricoholic

Rosemary Hamlin proclaims herself "an absolute, avid fabric collector; I even imagined starting a club called Fabricoholics Anonymous!" When you step into Rosemary's home, it becomes absolutely clear she is not exaggerating. From ceiling to floor, every inch of available space is filled with the rich, colourful materials she has amassed over the years, much of which comes from her life in Africa. She even uses small Senegalese wooden stools, just big enough to hold one cup of tea, to allow extra space for her collection. Her "addiction," as she laughingly calls it, is such that she once worried the weight of fabrics on the third floor "would bring down the house." Reassured she was safe by an ardent book collector, Rosemary pursues her passion with vigour.

Raised in Zimbabwe, Rosemary married a Canadian man whose work as a geologist took the family first to Madagascar and then to Senegal. They quickly fell in love with "the people, the climate, the slow pace of life and the humanity of Africa." Despite promises to contain her urges, Rosemary's textiles craving grew to the point where she took a part-time teaching position to support it. At the time, she could not have anticipated the important role her love of fabrics would play in filling the void left by her husband's sudden death. Through that traumatic experience, Rosemary learned "positive things about African culture … it was the Senegalese who were the most caring. They grieved with me and for me in a way that Europeans had forgotten." Living back in Canada, Rosemary wistfully admits, "My heart is in Africa…I would much prefer to be there."

Designing and sewing the Senegal block stirred happy recollections for Rosemary. "It makes you see and appreciate the value of things," she says. An ancient baobob tree worked in reverse appliqué forms the backdrop of the block. Although not the tallest tree, the baobab dominates the landscape of West Africa with its enormous girth. Myths and superstitions surround this tree. Its leaves, fruit and bark have many uses, but one of the strangest is that the hollow trunk is used as a burial place for *griots*, traditional minstrels.

Hand-dyed and printed African fabrics from her collection are displayed in the silhouetted women's clothing, reflecting the genuine admiration Rosemary feels for the Senegalese way of dressing. "Fabric has such a significant part in the lives and hearts of these wonderful people who look so elegant in their colourful, flowing garments." Now, she enjoys creating articles that incorporate her African textiles. The yard goods, once a weakness, now bring her strength, wrapped in warm memories.

Two wings to fly

On a fall afternoon in Cornwall, Ontario, Amal Mahmoud sits in her cozy kitchen with large windows overlooking a crescent-shaped swimming pool in a beautifully landscaped backyard. Endless sunshine streams through the tree branches, dappling the water, creating a serene environment. The quiet scene outside is a reflection of the real peace and gentleness embodied by this smiling woman who speaks with such warmth.

Amal and her husband, Medhat, have two sons and a daughter, and are waiting for the arrival of baby Jasmine in November. Amal mentions the family will be moving to Montréal soon where Medhat works in the telecommunications industry. Moving has become part of their lives. She is not disturbed by the move because she has lived in different countries and enjoys change. "As long as I am with my little family and the important pillars of my life are in place," she adds. Still, she admits, immigrating to a new country was "a lot of hard work."

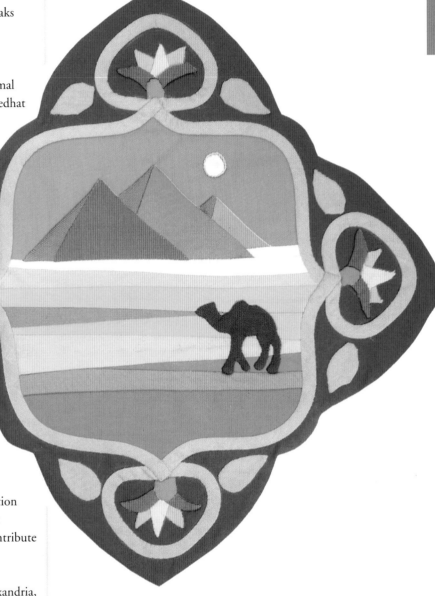

"Canada is a real multicultural country," she says, pleased to acknowledge what she's experienced since her arrival four years ago. "There is no one dominant culture; this creates the uniqueness of Canada's multicultural beauty where individual differences are respected," she says. The children have adapted well, and regular visits to Egypt allow them to keep in touch with their culture. "It's not difficult to combine two cultures and have a good mix," says Amal. "It's like having two wings to be able to fly." But while tradition is essential to their lives, Amal feels that wrapping oneself too tightly in tradition can create a cocoon. Balance is needed. "This is very important because the community is where my children will grow and contribute and interact."

In Egypt, a land of great contrasts, the Mahmouds lived in Alexandria, a Mediterranean port city populated by a mosaic of cultures. "It is beautiful and crowded. You can hardly find an inactive, quiet corner," Amal says. In addition to the inhabitants, there are the tourists flocking to magnificent ancient monuments, such as the famous pyramids of Giza that grace the Egypt block. Amal and Medhat wanted to convey their country's "warm spirit" in their design. The appliqué work, a traditional art form customarily done by men, also symbolizes the country's leading role as a cotton producer. However, they say that the soft turquoise of the Nile, the sky, and the golden colours of the sun, sand and desert are the true reflections of the gentle essence of the Egyptian character.

“In Canada people really respect you as an individual with differences.”

Amal Mahmoud

Kuwait

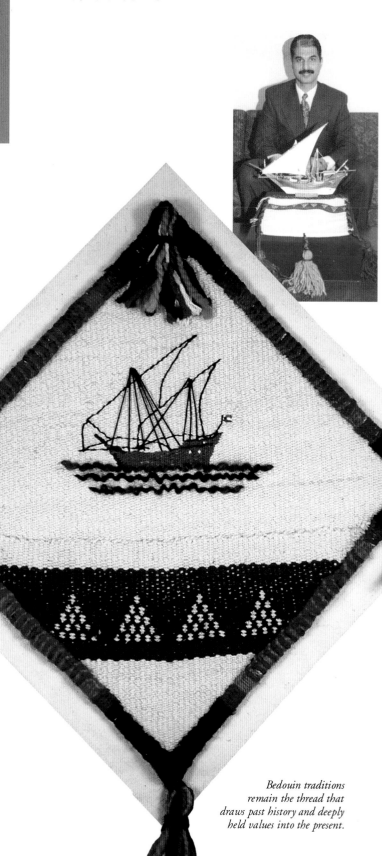

Bedouin traditions remain the thread that draws past history and deeply held values into the present.

Al Sadu

In a land that has undergone drastic and rapid change and survived the trauma of war, Bedouin traditions remain the thread that draws past history and deeply held values into the present. The art of Bedouin weaving, called *al sadu* in Arabic, records a passing way of life. This ancient art uses designs that reflect an instinctive awareness of the natural but stark beauty of the desert.

His Excellency Majdi Al Dhafiri, from the Embassy for the State of Kuwait in Ottawa, provided the woven bag from which the block was made. It was from his personal collection, a treasured reminder of home. He explained that only women weave the patterns and braid the cords and tassels used to make a variety of cushions, rugs, saddle and storage bags, and various decorative items for their homes and camels. The yarn used is made from the wool and hair of camels, sheep and goats, and is usually coloured using dyes derived from desert plants.

A nomadic people, the Bedouins did their shearing, carding and spinning while on the move. But the weaving itself was done mostly during the summer when the fierce heat (the average daily temperature is 33C) forced them to stay close to precious sources of water. The crafts and skills of the Bedouins were in danger of disappearing due to encroaching modernity. Fortunately the government has endeavoured to preserve the ancient techniques by establishing co-operatives such as Al Sadu House. This will allow the country to continue the Bedouin weaving legacy that reflects Kuwait's rich cultural heritage.

The oil industry has radically changed the structure of everyday life in Kuwait, a country whose life was once inextricably bonded to the sea and the desert. The embroidered dhow, a wooden ship uniquely rigged with triangular sails, shown on the block, represents the long history of maritime life: shipbuilding, trading, and the dangerous work of pearl diving. In the early 20th century, over 800 *dhows* — with crews of over 10,000 sailors and divers — plied the waters of the Persian Gulf and farther. Ambassador Al Dhafiri passionately recounted tales of the pearl divers and their way of life. Sea songs are an important and distinctive Kuwaiti art form linked to pearl diving. Each task on the *dhow* was accompanied by special songs and dances, from the time the ship was being prepared for the voyage to its return, when the fishermen's songs alerted the women on shore of their safe homecoming.

The time-honoured arts of the Bedouin are being nurtured to provide a thread of continuity in a rapidly changing life and landscape. And while Ambassador Al Dhafiri has high praise for the individual freedom and opportunities available to all ethnic groups in Canada, he feels this thread often pulls Kuwaitis homeward.

The eagle's eye

In 1877, Chief Sitting Bull led his Lakota tribe from the United States twenty miles across the border into Saskatchewan. He was seeking refuge from the U.S. Army after the Battle of the Little Bighorn. When he returned to the States four years later, several hundred Lakota decided to remain in Canada. They eventually petitioned the federal government for a reserve on the land they occupied southeast of Moose Jaw. Although granted the hilly ranchland in 1909, it was not until 1930 that the reluctant wheels of government bureaucracy finally turned in their favour and the Wood Mountain Reserve achieved permanent status. By the time of the 2001 national census, the registered Lakota population on the Reserve had dwindled to ten, but many more are entitled to live there.

Among those few residents are Leonard Lethbridge Sr., and his wife Mary Ann and their daughter, Julia. Born on the Reserve in 1931, Leonard, whose Lakota name is Itonka Ska, was raised by his grandmother, Wanbli Sunpagewin. He followed in the steps of his Teton Sioux forebears when he travelled to Montana at nineteen to work for the railroad. He changed career paths a few times, eventually becoming "adventurous and moving to Los Angeles" in 1957. Mary says, "Being 'urban Indians,' we were far from anything in the way of First Nations." When Leonard retired as postmaster with the U.S. Postal Service in 1993, the family returned to his place of birth. From Wood Mountain, it was a 300-mile drive to find the "right beads and materials" to meet the challenges of making the life-like image on the Lakota block.

The Lakota considered traditional work with porcupine quills and beads to be a powerful endeavour with strong ties to the supernatural. Oral tradition tells of Double Woman, or *Winyan Nonpapika*. Through dreams sent to them by her, women are granted visions of creative, original designs and are able to create exquisite needlework. The beaded eagle head Leonard and Mary designed and created for the Lakota block is so vivid, its eye seems to follow the viewer. The skilled use of directional beading and subtle shading gives the impression of ruffs and feathers.

> It is believed the eagle's spirit stays with the feather after it dies.

Greatly respected by the Lakota, the eagle is said to act as a messenger for the Great Spirit, providing guidance to Councils and protecting hunters and warriors. Eagle feathers are worn as badges of honour. Additional meaning is conveyed through the type and colour of eagle feather, as well as the way it is cut and worn. It is believed the eagle's spirit stays with the feathers after it dies. Eagle feathers give the Lakota strength and serve as strong reminders to appreciate and respect each other and all creation.

Niger

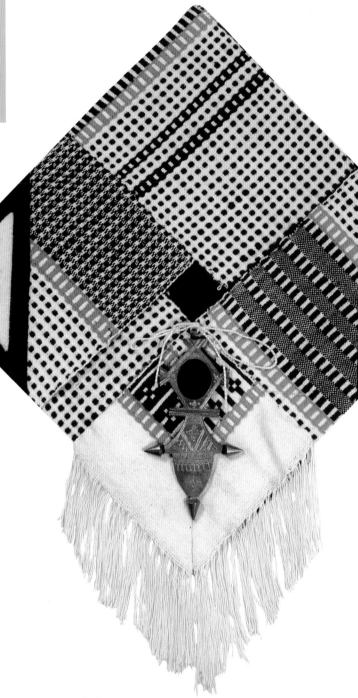

Croix d'Agadez

In the central part of Niger where the air is hot and dry and the winds encourage the ever-encroaching Sahara Desert, the "city of a thousand wonders," Agadez, rises out of the sand dunes like a mirage. Agadez prospered for centuries as a transit for camel caravans and Tuareg nomads along the trans-Sahara trade routes. The city teemed with merchants and artisans whose skills with silver and leather have been passed on from generation to generation. In Tuareg society, artisans are part of a distinct group of people called the Inadan.

The Inadan are a special caste within the Tuareg family system. In one sense, they are indentured servants or slaves, yet in another sense, they are held in high esteem. While a Tuareg aristocrat might expect an Inadan to use his expertise and exquisite handiwork to his benefit, the aristocrat would never dare to show disrespect by not giving in kind. Despite their low social status, the Inadan have guileful reputations of a mythical quality. It is said that the Inadan are "older than memory, proud as the crow, mischievous as the wind." They are also believed skilled in magic and may cast spells (*tzema* or *ettama*) on anyone showing them disrespect. Nigeriens (not to be confused with Nigerians from Nigeria) act with prudence when dealing with the world of magic. These strong beliefs may even have protected the famous Tree of Ténéré, which grew "out of nowhere, in the middle of nowhere" in the desert landscape. For more than three hundred years, this anomaly survived only to be irreversibly damaged by a truck crash in the mid-twentieth century. The remains of "The Tree" now rest in a museum in Niger's capital city of Niamey.

The Niger block's background is formed from typical, strip-cloth weaving with a geometric pattern, donated by the Niger ambassador, Her Excellency Rakiatou Mayaki. She spoke with pride about the weaving and the abilities of its makers to create intricate patterns. Hung against this backdrop, is a *Croix d'Agadez* (or Agadez Cross), worn as a talisman by both men and women. It protects the wearer from bad *juju* and is a powerful defence against the "evil eye." Originally, only men wore such crosses, the design of which is specific to each Tuareg village. Common to all designs are the four corners of the cross. Traditionally, a father would pass down a *Croix d'Agadez* to his son during a special ceremony that ended with these words: "My son, I give you the four corners of the world, because one cannot know where one will die." For Nigeriens who have left their country and their continent, these words now resonate with meaning, offering comfort and protection far from home.

> " It is said that the Inadan are older than memory, proud as the crow, mischievous as the wind. "

Magical motifs

Belief in magic is woven into the very fabric of life in Côte d'Ivoire, situated on the Gulf of Guinea in western Africa. Symbolism is everywhere on the clothing in displays of patterned, geometric motifs and stylized animals. The hand-painted designs relate generations-old stories and legends. According to traditional animist beliefs, the imagery possesses the power to protect or endow the wearer with special gifts or abilities.

Sixty diverse tribes inhabit three distinct geographic regions. Each tribe is independent and likely to have affiliations beyond its own borders. The official language of Côte d'Ivoire, independent from France since 1960, is French. However, French does not translate easily from the country's native tongues and dialects, which operate with different structures and logic. The unique textiles and decorative arts of each ethnic group allow a fuller, richer, form of communication that better transcends linguistic barriers.

Since her arrival in Canada in 1992, Hawaba Kebe has worked hard to overcome the obstacles she's encountered. While raising her young son on her own, Hawaba started a domestic cleaning company and then opened a small store in Ottawa in 2001. She imports a wide variety of goods from her homeland, as well as African videos, music, fabrics, clothing, cosmetics and foodstuffs. The store serves as a meeting place for many of her African customers. One day, Hawaba hopes to expand her shop to display more of the African treasures now stored in the basement awaiting their turn on crowded shelves and walls. Most of all, Hawaba dreams of hiring help to find some relief from running the store alone, seven days a week. The Association des Ivoiriens/Ivoiriennes de l'Outaouais is an important source of support for Hawaba, "it is like family, because we are all mostly alone here." With about fifty active members, it provides her with friendships, an opportunity to share celebrations, and a connection to home.

The materials that Hawaba contributed for the block include an example of *malinke* strip-cloth weaving, common in Côte d'Ivoire. Long, narrow strips of spun, raw cotton are woven by men and then sewn together. The example on the block features a geometric design that represents a stylized image of a cowrie shell, used to decorate festival headdresses. At either end of the vertical bar the arrow-like design represents the *tama,* or the "talking drum." The drums provide communication between villages such as the one depicted in miniature bronze casts. Though silent, *malinke* cloth speaks volumes, a revered and respected form of art that gives every day a little touch of magic.

Zimbabwe

A flower in winter

A small hibiscus bush in the front window of a neighbour's home was all it took to make Sarah Trevor feel connected to her beloved Zimbabwe during her first Canadian winter in 1980. While watering her neighbour's plants in her absence, Sarah found it a joy to tend the tropical flower amid the cold of Flin Flon, a northern mining town straddling the Saskatchewan-Manitoba border. "The hibiscus became a metaphor for me, flowering inside this warm cocoon with the snow outside," she says. In Zimbabwe, hibiscus bushes are so prolific that people grow them as hedges around their homes and even consume the edible flowers.

Born in England to a British father and a Canadian mother, Sarah and her family moved to Zimbabwe (formerly called Southern Rhodesia) when she was six. Her father set up a soft drink company there. Since the country is situated near the equator but has a high altitude, it enjoys a temperate climate. The abundant floral and animal life made Zimbabwe seem like one big garden to Sarah. People especially love the hand-sized wild flame lilies that grow everywhere. Despite political turmoil and hardship for the majority black population, Sarah remembers people who were tremendously resilient.

Zimbabwe is known for its mile-wide Victoria Falls, but of equal interest is Great Zimbabwe, a 14th-century archaeological site where a huge stone wall built by the Shona indicates a powerful trading empire. Into the block's border design, Sarah incorporated a rendition of the wall using wax instead of a traditional *sadza* batik method that uses cornmeal and water. A string of "lucky beans," inedible seeds that children use for counting, outlines the wall. At the centre of the block is a brilliant flame lily, embroidered by another Zimbabwean-Canadian, Sally Rood. The flower is set against a hand-thrown clay pot, designed by a young teenager and new immigrant to Canada, Joanne Majoko. Her grandmother makes these traditional vessels that are widely used. Every home in Zimbabwe has some in different sizes, from large ones for storage to small ones for flowers.

Sarah's two worlds — Africa and Canada — come together for her in Flin Flon. In this Canadian mining town, where her husband Buz is a geologist, she finds a link to the rich mineral wealth of Zimbabwe. Mining is also what brought Sally and Joanne's families to Flin Flon. Sarah likes decorating her work office at the high school library with African fabrics and enjoys listening to African music. Since that first cold winter when she found joy in the flowering hibiscus, she has become Canadian enough to enjoy kayaking in summer — and to love winter.

> " The hibiscus became a metaphor for me, flowering inside this warm cocoon with the snow outside. "
>
> *Sarah Trevor*

Birchbark and maple syrup

The Ojibwe people of the Great Lakes region were resourceful hunters and gatherers who used the materials they found in practical and creative ways. Before salt was introduced, for example, they used maple syrup for seasoning their food, as well as for making sugar cakes and candy. They also fashioned birchbark into everything from utensils and storage containers to canoes and wigwam coverings. In August and September, they harvested wild rice from nearby lakes, fished in fall and winter, and hunted and trapped for food and clothing. They also grew what are called the Three Sisters — corn, beans and squash — to supplement their diet.

Once the largest and most powerful tribe around the Great Lakes, the Ojibwe are now spread from Ontario to Alberta. Their name comes from the Algonquin word *otchipwa*, which means "to pucker" and refers to the puckered seam the Ojibwe used in making moccasins. In Canada, however, many Ojibwe refer to themselves as Anishnabe or Anishinaabe, which means "original men," or simply "people."

Their traditional clothing was made of buckskin, with fur outer garments added for warmth in winter. Laughter and sharing were part of the cold nights, as the women spent the long, dark hours inside their wigwams making intricate quill and moose-hair designs to add to the brightly dyed moccasins, entertaining each other with stories while they worked.

Although they no longer use maple syrup and birch bark for quite so many purposes, the Ojibwe are still creative and resourceful. Marlene Shawanda, a mother of two and a beadwork designer in Wikwemikong on Ontario's Manitoulin Island, chose the Ojibwe rose as the central symbol on the block to represent her people. She beaded it onto red felt with a caribou hide border. Reaching out from the rose are stems and leaves, each one indicating an ordinal point of the compass.

Today, the Ojibwe continue the practice of traditional ways in their communities on Manitoulin Island. Although preparation methods have changed, traditional foods are still available, especially during social gatherings such as dances, ceremonies and sweat lodges. Celebrations such as annual powwows provide an opportunity to share a vibrant and proud culture through song and dance, with both Natives and non-Natives alike.

Benin

La sortie du roi *shows the king and his entourage, who must accompany him everywhere he goes.*

Legends in cloth

A long, narrow country on the west coast of Africa, Benin has the dubious distinction of having once been called the "Slave Coast." Fifteen years after becoming independent from France and after decades of political unrest, the country changed its name from Dahomey to the Republic of Benin in 1975. Dahomey was ruled by a succession of traditional kings starting in the 17th century through to the early 1900s. These kings commissioned large groups of regional specialists, such as bronze-casters, precious-metal workers, wood carvers, potters, weavers, embroiderers and appliqué-makers. Mme Fernande Houngbedji, of the Benin Embassy in Ottawa, points out that these "royal arts" are still practised today and are much valued.

Men are the traditional appliqué-makers in this predominantly French-speaking nation. Their carefully stitched motifs recount legends and sayings using the shapes of birds, animals and objects from everyday life. Brightly coloured cottons are meticulously applied onto a larger surface, most often a white fabric background. These narrative folk traditions communicate important information about cultural identity and belief systems to successive generations. The patterns can be found on tapestries, in textiles and on household items such as tablecloths.

Legends teach that each of Benin's twelve recognized kings adopted symbols to represent particular characteristics of his reign. These were always drawn from indigenous animals or items found in the kingdom. As an example, Mme Houngbedji relates the story of King Houégbadja (1645–1685), whose enemies lured him aboard a fishing boat. Forewarned of danger, he escaped before being ensnared in a fishing net. His symbols are a fish and fishnet, and from this story originated the Abomey saying "the fish that refuses the net will not enter."

Created on black—the colour of mourning—this block shows the melodic drum and bird that represent the powerful and influential first king Gangnihessou (father of Houégbadja) at the upper left. In some works, the *humanche* (a farm implement) is also used because he actively promoted agriculture "for the people and the country." At three o'clock, the diving shark is the symbol of the intelligent and courageous Béhanzin, the last of the traditional kings, while the mighty lion identifies spirited King Glèlè. Cowrie shells, symbols of power and destiny, and widely used in early trading, usually represent money, but they are sometimes associated with the animist religion Voodoo, according to Mme Houngbedji. Benin is considered the birthplace of Voodoo; from there, slaves transported it wherever they went. Voodoo was declared the official religion of Benin in 1996, and is practised alongside Islam and Christianity.

The Beninois take pride in their friendly nature and welcome others openly, eager to learn about strangers to their country. They are very adaptable, Mme Houngbedji stresses, and can be found everywhere, "There is even one of us at the North Pole!"

An elephant never forgets

The daughter of a banker and the eldest of four children, Pauline Siva grew up in a comfortable home in Colombo, the capital of Sri Lanka. A bright student, she learned the traditional skills of embroidery and knitting from her mother, but she didn't care for cooking. "I didn't know how to make tea when I got married!" she remembers.

She met her future husband, Desmond, when she was nineteen. Her parents didn't approve at first because arranged marriages were the norm then, and they wanted her to study to become a doctor. Pauline and Desmond married a couple of years later and he soon took a job in Saudi Arabia. Pauline and their daughter, Premila, followed. Although it was initially difficult to leave her homeland, the family settled in Saudi Arabia for seventeen years and had two sons, Michael and Milroy. During this time, Pauline renewed her interest in needlework, meeting with other Sri Lankan expatriates to alleviate her loneliness, sewing and doing cross-stitch.

In December 1995, the Sivas visited Canada with a view to moving here. "I told my husband I didn't like Canada," Pauline admits. She had never seen snow, nor experienced such cold. But they immigrated anyway, and she quickly adjusted. In Canada, she has the best of both worlds — she doesn't have to fear ethnic riots, and all the Sri Lankan friends she made in Saudi Arabia are now part of her community here. The friendships have even carried on to the next generation.

Pauline keeps busy with a craft group at her church, and has become involved in pastoral care, making small receiving blankets for newborns and afghans for the sick. Her creativity and her skill with a needle made her a natural choice to create the Sri Lanka block. Pauline is very fond of elephants, which are found on decorations throughout her home. For the block, she created an elaborately dressed elephant similar to those that participate in the street parade in the Perahera, a national festival. The Asian elephant population in Sri Lanka has diminished from 20,000 in the 19th century, to less than 3,000 wild elephants and 500 captive ones, which raises concerns over their possible extinction.

While Pauline was making the block in the summer of 2002, her middle child, a university student and a talented pianist, suddenly died of a recently diagnosed heart disease. Overwhelmed with grief for a time, Pauline stopped working on the block; however, she found that stitching brought her comfort. She dedicated herself to making her beautiful batik and bejewelled elephant as a memorial to her son, Michael.

Tanzania

Special bonds

The "special woman" in Martha Jane Makeja's life delivered her into this world. In that moment, Martha O. Jorgensen, missionary, midwife and teacher in Tanzania, was transformed into a grandmother. The metamorphosis occurred through the bonds forged with Martha's teenaged mother long before she gave birth to her first daughter. The photo of Miss Jorgensen standing next to Martha's mother shows a woman of Scandinavian background. Her eyes seem to radiate a no-nonsense attitude that dovetails perfectly with the tall, sturdy body. But another look reveals an unmistakable glimmer of love. Her soft voice made husky by the wonder of unconditional love, Martha says: "She took care of us like we were her *real* granddaughters."

Martha is quiet for a time, her dark eyes and beautifully sculpted face aglow with memories. Miss Jorgensen dispensed instruction in housekeeping, school subjects, and those important lessons of daily life in a country weakened by poverty. "I always carried her basket of sewing materials to school," she remembers. As a small child, Martha learned to crochet, knit and embroider, sitting next to Miss Jorgensen.

Martha sees the circle completed, from sewing classes to the Invitation Project. Martha imagines Miss Jorgensen looking down with pride at Invitation's official launch. Laughing softly, she whispers with conviction: "She *will* be there." Martha and her daughter Lillian Kwofie — who was also delivered by Miss Jorgensen — collaborated on the quilt block, an embroidered version of Tanzania's coat of arms, which has Mount Kilimanjaro in the background. Tanzania was formed in 1964, the country's name derived from the combination of Tanganyika and Zanzibar. The land is rich in minerals, fertile red soil, lakes, and takes pride in gender equality, represented by the man and woman flanking the shield.

Her own future as a midwife seemed destined from the moment Miss Jorgensen placed a newborn in Martha's arms. Delighted laughter ripples out of her mouth. "Most every day I held a new baby," she says. And the indescribable feel of new life in her hands made her "so happy" she chose to follow in her "grandmother"'s footsteps, bringing hundreds of babies into the world. After Miss Jorgensen returned to Norway, the bond continued through visits and letters, until she died in 1970. Martha talks about her family and her ninety-seven-year-old mother still living in Tanzania, and she knows she was blessed with a very special relationship — from the first day of her life.

> " Most every day
> I held a new baby. "
>
> *Martha Jane Makeja*

A family of women

Olga Fortin's eyes are luminous when she tells the story of her first serious beadwork project at sixteen. She was excited as she gathered the materials needed to create a stunning pair of white, leather gauntlets. As the story unfolds, her mouth twitches with suppressed laughter. How proud she was of the soft fur trim, the beautiful beads, meticulously and strategically placed! Olga strives for composure to finish the story, but laughter unapologetically claims her. "I must have done a good job because someone eventually stole them!" says this mother of six, from Avonmore, Ontario.

A member of the Cree First Nation, Olga belongs to one of Canada's largest Native groups. About 200,000 Cree live across Canada from the Rocky Mountains to the Atlantic Ocean. There are five major Cree dialects of their Algonquian language. They share a common culture, yet each group is distinctly shaped by regions. With the beaded and quilled block she designed and created, Olga represents the Central Cree. Flattened, dyed porcupine quills are shaped into the circle of life, with red, black, yellow and white points symbolizing the world's people. The hovering eagle represents spirituality, while the deer is honoured for its life-sustaining gifts. The beading is exact, and the earth tone colours pleasing to the eye. Every aspect of the block is in perfect balance.

"I'm a perfectionist," says Olga, wincing slightly, as if admitting a failing or a character trait that doesn't always mix with life's imperfections. Despite life's occasional sharp curves, Olga is open to the elements of laughter in the stories she shares. Her association with Invitation began when she volunteered several years ago, joining the energetic ranks of women stitching, laughing and sharing stories as they worked. The essence of these communal gatherings reminds Olga of her "family of women" back home in Manitoba. Life could be difficult at times, but that made the moments of laughter that much sweeter. "I miss that a lot," she acknowledges.

Her mother and Aunt Violet play leading roles in the story she loves best. The two sisters were hard at work scraping a hide, when Violet, ten years younger, suddenly thought of a way to make the work go *much* faster. Before Olga's mother had a chance to open her mouth in horror and protest, Violet was back with a power-sander, putting the hide through a test-run. Both were amazed at how well it worked! Moments later, alerted by the sander's hum, their mother (Olga's grandmother) appeared on the scene. What she saw was so far off the beaten, traditional path, that it momentarily stunned her. She recovered long enough to ask: "Are you girls crazy?" Then laughter engulfed them all.

Cuba

Ana Warren remembers that when she grew up in Cuba "music was always there, everywhere."

Singing "Ana Cristina"

Ana Warren lived in Cuba until the age of twenty-one, where she recalls daily life as being infused with art and music in all its manifestations. She met her future husband, Gaby, in Havana in 1963. He was then a young Canadian diplomat on his first foreign posting. An ardent jazz fan, he had brought music and records with him, but in post-revolutionary Cuba, such interests were considered "semi-subversive."

Ana and Gaby hosted private "open houses" for Cuban jazz musicians starved for the sound of the outside world. They developed lifelong friendships with artists such as jazz pianist Chucho Valdés, who became the director of the Havana Jazz Festival and toured the world with his group Irakere, and then-sixteen-year-old Paquito D'Rivera, who escaped Cuba in 1980 to become a top U.S. jazz musician. Departing from Cuba, Gaby took plenty of art and musical recordings to keep Ana's island alive in their hearts. She, however, was only allowed to take some clothing and her shoes.

In her block, Ana has framed a glimpse of her past through a window onto Cuba. The view embodies images that represent the very essence of her life in Cuba. A multi-coloured, fan-shaped stained glass, called *medios puntos,* decorates the main entrance and the windows of many homes, allowing sunlight to filter through when all the doors and blinds are shut to keep out the heat. Ana explains that European settlers were the first to adopt this art form for practical reasons and to add colour and ornamentation to their homes.

Vertical wrought-iron bars invariably embellish windows, balconies and outside walls. Ana fondly remembers the decorative iron railing from the balcony of her home where she and her sister would play for hours, watching the people below. They also remind her of the courtyard decorated with flowerpots where her mother would sit to sew or embroider.

Ana distinctly remembers music as being "always there, everywhere" in Cuba, especially during public events such as the carnival. "My favourite was the conga drums… I could hear their sound coming over the hills when they were practising for carnival, and I couldn't fall asleep until I had heard it all." In her block, she represents this music with a pair of maracas centred beneath the window.

The Warrens remain deeply involved in the Ottawa music scene. Accompanied by jazz musicians at his favourite club one warm June evening in 2003, exactly forty years after meeting Ana, Gaby surprised his wife and a room full of guests by singing a love song he had composed in her honour, entitled "Ana Cristina." There wasn't a dry eye in the house.

Nothing but the shirt on his back

Justin Laku arrived in Canada from Sudan, via Cairo, in 1996, bringing nothing but a few clothes, mostly colourfully embroidered shirts that were his only tangible link to his past. Justin is a refugee from one of the longest and most devastating civil wars in history, a war that has taken over two million lives.

He has a compassionate heart and has always wanted to help others. Three of his uncles were Anglican bishops, and he trained as a pastor in Cairo, where he ministered to fellow Africans, especially displaced Sudanese. Through his involvement with the Canadian Mennonite Central Committee in Cairo, he developed lasting friendships with Canadians. He especially appreciated their caring, honesty and openness, qualities he continues to enjoy in his new friends in Ottawa, where he now lives and studies health sciences.

Watching the suffering in his own family and homeland, Justin feels both despair and a strong resolve to push for change. A burning desire for peace in the world drives him to be politically active in Canada. Justin passionately discusses the huge contrast between the reality in so many poor and troubled areas, and the peace and prosperity enjoyed by most North Americans. He worries that this comfort breeds apathy and hardness of heart toward those in need. "Canada is very rich in many ways, but Canadians need to listen to the stories of newcomers to bridge the gap."

Justin admits to learning recently the most powerful lesson of all: "You become hostage to the anger [you feel] toward someone who has wronged you. If you forgive that person, you free yourself." This is the message that he speaks for himself, for his Sudanese compatriots, and for all Canadians.

Despite the strife and ugliness that war has brought to Sudan, Justin wants to share the beauty of his country. He divided his block into three ovals using pieces of a copper bracelet worn as a sign of adulthood, and an indication of the country's rich mineral resources. Water, too, is vital, and is represented by the embroidered boat. In the capital city of Khartoum, the Blue Nile and the White Nile join to create the flow of the great Nile, the longest river in the world. A lifeline to the nation, the river facilitates commerce, creates a highway to other African nations, and provides irrigation for arable land. A mud and grass hut with a conical roof is a traditional dwelling found in many areas. Below is a palm tree, the only tree that survives in the arid Sahara Desert. Surrounding each oval are highlights in gold stitching in a pattern characteristic of those found on men's clothing — in this case, a tie-dyed shirt off Justin's own back.

Sudan

" Canada is very rich in many ways, but Canadians need to listen to the stories of newcomers to bridge the gap. "

Justin Laku

Costa Rica

The peaceful jewel

Lovely groupings of creamy orchids in Ana and Carlos Miranda's elegant home serve as dramatic reminders that these exquisite flowers bloom all year long in Costa Rica. The *Guardia morada*, a magnificent purple orchid, is the country's national flower and is said to evoke love, peace and good fortune. The Mirandas' vibrant home conveys a strong sense of the tropics. Scattered across chairs and couches are dozens of cushions worked in eye-catching needlepoint. The family's fourteen-year-old cat rests peacefully against one, blissfully unconcerned that the beautiful textile art enfolding him has been his mistress's passion for nearly as many years as he's been around.

Ana is in her first foreign posting with her husband, the Costa Rican ambassador in Ottawa. Amid the colourful touches from her native land in her living room, Ana admits she's a little homesick: "I have travelled for holidays," she says, "but I have never lived in a foreign country before." On a cheerier note, she adds, "But I have made very good Canadian friends in the fourteen years here."

The block Ana created contains the same vivid tones as her home. The complex, balanced motif speaks to the sensitive nature of her people and their peaceful way of life. This nation's serene existence has endured for four centuries, earning the country and then-president Oscar Arias the 1987 Nobel Peace Prize for his attempts to spread their example of peace to the rest of Central America. The centre medallion is a miniature *carreta,* or ox-cart wheel, recreated by painter Brenda Levert, who copied a larger original, colourful wooden wheel hand-painted by a Costa Rican artist. One of the country's predominant examples of folk art, the *carretas* (still used occasionally for practical purposes), are drawn by oxen and rumble, en masse, through the streets during the annual ox-cart festival. Ana's jewel-coloured wool needlepoint surrounds the wheel of the design. To the concentrated eye, the geometric images seem to spin.

Costa Rican hospitality and the carefree spirit of its inhabitants are unmatched. They are justifiably proud of their achievements, such as a ninety-six percent literacy rate. They also take satisfaction in caring for their environment. Costa Rica has received international acclaim for its successful development of a growing eco-tourism industry. This Central American jewel seems to have it all: volcanoes and caves, rainforests and secluded beaches, jungles and spectacular waterfalls, and 850 species of birds. With so much to choose from, Ana says it was a delight for her to simply share "a little piece of my country" with the world.

Mothers

In meeting Florence Pilling, who belongs to the North Peigan, of the Apotohsi Piikuni Nation, one senses an aura of serenity around her. It's there not because she's marched through life unscathed, or had others fight her battles. It's there because she's learned something from every battle.

Since 1989, she's been part of the team at Head-Smashed-In-Buffalo Jump, an interpretative centre and World Heritage Site located in the Porcupine Hills of Southern Alberta. One of the largest and best-preserved bison jump sites in North America, it offers visitors a hands-on overview of the Plains Indian lifestyle. Working in this educational environment has taught Florence that discovering pride and joy in one's heritage is crucial to sustaining it.

For Florence, joy manifests itself in life's small gifts — in the surprising wonder she feels when her thirteen-year-old grandson announces he's "not too old for a hug" even with peers looking on. She relates this in words, but her eyes tell the story, flickering with emotions bright as sunlight dancing on water. "There was none of that [hugging] going on when I was growing up," she says. Although time has allowed her to understand and respect her parents' way of showing love, something in Florence's heart promised there would be "lots of hugs" when she became a mother.

Yet memories of her own mother tell of a woman who was "always there" for the family, patiently passing on traditional skills to her nine children. "She taught me how to sew and quilt," says Florence, while her sister, Mae, learned the art of beading. These artistic skills were brought full circle in the creation of the Peigan quilt block with its embroidered buffalo, the Rockies, the four colours of man and the changing seasons. Making the block "didn't take long," says Florence who sews about as fast as her sister beads. And when her sister isn't beading, she's busy building and supplying tepees for ceremonial powwow and Annual Indian Days. Her pattern is based on a late-19th-century Yellow Sun tepee that belongs to their ninty-four-year-old father. Florence notes with pride: "Mae can build a tepee in less than a week."

Florence sees the younger generation also moving toward some of the old traditions. While her son and daughter-in-law are carriers of "ceremonial bundles" at annual Native celebrations, her grandchildren enjoy performing the ceremonial dances. This is all good, she says, but her hope is that they finish their education, "then turn around and help their band members." Mae's daughter, an RCMP officer, is not the only younger role model framing this hope. There are others. But there's little doubt when it comes to seasoned role models, Mae and Florence lead the way.

Peigan
Apatohsi Piikuni

"Mae can build a tepee in less than a week."

Florence Pilling

Bosnia-Herzegovina

> " Did we really
> survive all those
> terrible times? "
>
> *Amira Geljo-Berverovic
> and Mina Ganic*

As Canadian as pie

When Amira Geljo-Berberovic and her husband, Emir, touched down on Canadian soil in 1994, she said her name out loud, revelling in the freedom with each breath she took. It was a defining moment, made sweeter still by the warm welcome they received. In leaving Bosnia, they had left behind the terrors of "ethnic cleansing." Their friend Mina Ganic, whose husband spent two years under house arrest, describes her journey from her hometown of Banja Luka as "away from a dark environment...to a wonderful place of light and freedom." Still, their hearts ache for the

family and friends they left behind. Both women have now created new lives for themselves and their families in Canada, but sometimes they shudder and wonder "Did we really survive all those terrible times?"

The Bosnia-Herzegovina block, designed by Amira and Emir and stitched by Mina, has freedom as its theme. It reminds them that the difficult struggle was worthwhile. The image of a man, his right hand upraised, is taken from a monumental, medieval tombstone in Radimlja, near Stolac. Tens of thousands of these legendary symbols, called stecci, proliferated in the 12th to 15th centuries throughout Bosnia. Embroidered in silver on deep blue silk, the raised hand has come to represent freedom and the accompanying tenets of human rights to Bosnians.

Mina says domestic arts are valued in Bosnian households, including the fundamental skill of needlework passed on by women. In modern, urban areas, most women work, while still accomplishing the larger share of household and family management. Mina says women "developed a special strategy to survive" during the war. "They knew many things," she adds, such as adapting recipes to stretch food rations. Despite her arthritis, Mina continues to do what she loves in her newfound leisure time: crochet and sewing. She believes, "It's good for the hands and good for the soul."

Both families are working hard to integrate into their new society, but sometimes it's the little things that present a challenge. One September evening, Amira, Emir and Esther Bryan were sharing a delicious dinner prepared by Amira, when she lamented that she couldn't be truly Canadian until she learned to make pie. No sooner said, a spontaneous pie-baking session began! After a quick trip to the corner store, the women donned aprons and Esther guided her through the process. Soon the smells of Amira's first pies wafted through the apartment. Mastering such a culinary challenge was the least Amira felt she should do for the country that enfolds her in love and safety.

Rainbow nation

Jodi-Marie Horne's fascination with Africa led her to correspond and exchange material with a fellow quilter in Johannesburg, South Africa. The friendship that sprang up and endured for ten years brought the reality of South Africa into sharper focus for her, but her knowledge and respect grew even more while she researched the history of that beleaguered country to create the South Africa quilt block.

Politically divided into nine provinces, South Africa is a multi-racial country with eleven official languages. The landscape is diverse and dramatic. Rich in minerals, it attracted Dutch colonists as early as the 1600s. With the discovery of diamonds and gold in the late 1800s, native blacks were forced to become tenants or labourers, or to live on reserves. From the mid- to late-20th century, the Union of South Africa, established in 1902, was ruled by the law of apartheid, the enforced separation of whites and blacks. Nelson Mandela's presidency in 1994, following a twenty-seven-year imprisonment for protesting apartheid, came with a promise that South Africa would be a "rainbow nation" free from the system that had bred inequality and hatred. Change continues today, although often at a high cost in human lives.

A quilter for twenty-five years and currently president of the Canadian Quilters' Association / Association Canadienne de la Courtepointe, Jodi-Marie's passion begins with the idea and carries on to the design and execution. Her newly acquired historical and cultural knowledge of South Africa translated into a dynamic design. The central rainbow represents South Africa's ethnic diversity, a rich kaleidoscope of 40 million people. Flanking the block are strips of interlaced triangles in vibrant colours typical of beaded bracelets and necklaces worn by South Africans. These bold, geometric designs are also painted on many homes. Two samples of small-scale beadwork, both ornamental and symbolic, traditionally announce ethnic identity, age group, or marriage status. Using appliquéd batik and her own hand-dyed fabrics, detailed with surface embroidery, Jodi-Marie created the country's national flower, the blooming giant protea.

Jodi-Marie has a profound respect for the blacks of South Africa. The strength and hope they maintained in the face of incredible suffering and hardship leaves her humbled. "I admire them for overcoming their struggles and maintaining their heritage," she says from her Alberta home. Jodi-Marie was pleased to honour her South African friend by creating this block, yet she admits she worries about her since they lost contact during the unsettled times in Johannesburg. "I don't even know if she and her husband are still there," she says.

Seychelles

Myth of the sea coconut

"Family is our lifeline," says thirty-three-year-old Elsa Hoarau-Antat, her dark eyes dancing. "Because we have such close-knit extended families, at fourteen it felt perfectly natural for my parents to send my brother and me to live with our uncle in New York to further our studies." In 1988 Elsa and her brother united with their parents and siblings who had settled in Montréal, joining the Seychelles community of about 5,000.

In 1994, Elsa helped found La Communauté des Femmes Seychelloises du Québec to help fellow countrywomen and their families integrate into Québec society. Their mandate is to help newcomers adapt to cultural and social differences, as well as provide help with government protocol surrounding family issues such as birth, death and marriage. In addition, the group organizes potluck dinners, concerts, poetry readings and arranges the Seychelles' participation in the annual Festival des Enfants de Montréal, during which children of all nations showcase music, dance and costumes. "It is so important to keep our culture alive," says Elsa. "We especially love our two traditional dances, the drum-dominated *moutya*, which originated in Africa, and the upbeat, melodious *sega*, with its strong Indian influence." The *sega*'s hip movement with one foot positioned higher than the other resembles traditional Indian dancing. Seychellois' love of laughter is reflected in the often-humorous lyrics of the *sega*. In one well-known song a bitter friend complains to one who betrayed her,"I'll never tell you my secrets again."

Elsa and fellow Seychelloises Chantal Dubignon and Lita Soleil pooled their creativity to design the block, but it was Lita who did the stitching using a variety of surface embroidery. The block features five splashes of colour, the same ones that appear on their flag, each with a symbolic image — blue ocean, yellow sun, white beaches, green vegetation and red-blooded people.

Prominent at the centre is the Seychelles' famous *Coco de mer*, bearer of the largest nut in the world, renowned for its many uses. A special export permit is needed to remove even a single nut from the island. According to folklore, the huge (often 40 pound) coconut was first discovered floating in the sea, leading to the belief that it grew under the water — and the misnomer "Sea coconut." The unique fruit of the female plant resembles a shapely behind, while the male plant's resembles a distinct male organ. The legend goes that under cover of a dark monsoon night, the two coconuts mate. However, this has never been confirmed. There is an ominous curse attached to the myth: "Misery to all who witness this phenomenon." As far as the Seychelles people know, no one has ever seen it...and lived to tell the tale.

"We especially love our two traditional dances, the *moutya* and the *sega*."

Elsa Hoarau-Antat

The guessing game

Mary Anne Charlie of the Kaska Dene, in Watson Lake, southeast Yukon, always enjoys participating in "stick handling" competitions. Not part of a hockey game, "stick handling," or "stick gambling," is a popular traditional Dene game. It requires an intuitive ability to read other people, and at one time, women were considered too powerful to play. Mary's father, who used to play for days and weeks on end, taught her the game.

Two teams of six players kneeling in a row face each other in this highly competitive game. Moving to the cadence of beating drums, each team takes turns as its players pass a small token, an *idzi*, from hand to hand. The "pointer" of the opposite team tries to eliminate the opponent holding the *idzi* when the drumming stops. He collects a counting stick for a correct guess, eliminating the player, or forfeits a stick for an incorrect guess. The goal is to eliminate the other team and win the most counting sticks.

Mary loves the challenge of finding the *idzi*. The best way is to pay attention to the opponent's eyes, she says. "Most of the time their eyes wander in the direction of whichever hand they are hiding something in," Mary reveals. When she first began to play, Mary felt self-conscious about people staring at her. She would close her eyes, concentrate on the drumming, and "enter into my own little world" to relieve her stress. Mary's nine-year-old (and eldest) grandson isn't interested in learning her favourite game. "He much prefers going off to hunt and fish in the bush with his father," says Mary, "and the two-year old is too young!"

When her band in Watson Lake hosted a recent "stick handling" competition that offered a $5,000 prize, Mary agreed to help prepare the celebratory banquet of moose stew and bannock afterwards. The laughter during the competition and the socializing afterward gave Mary a much-needed break from her everyday responsibilities. She gives generously of her time in her community, her heart a well-spring of compassion. Mary sits on the board of a women's shelter, the Helping Hope Association, and spends much of her time caring for her ageing, diabetic mother.

Mary's greatest wish for her community is for a complex where elders can receive care on the reserve. Mary explains: "Elders fear being forgotten if they go to hospitals far from their people." She cherishes moments spent listening to her mother tell stories of long ago. As the custodians of the peoples' collective memory, elders have valuable knowledge to pass on to the younger generations — including how to best outwit their opponents.

Kaska Dene

Equatorial Guinea

A hard road ahead

Equatorial Guinea, a tiny, beautiful country on the west coast of central Africa, became an independent republic in 1963. In addition to the forested mainland region of Mbini, there are five inhabited, cloud-covered volcanic islands offshore. The main crop and industry on the island of Bioko is cocoa, grown in fertile soil enriched by its three extinct volcanoes. Despite the development of petroleum reserves discovered in the mid-1980s, and the production that began in 1996, this nation remains desperately poor. Economic benefits have yet to filter down to the population and lead to an improved standard of living.

Citizens of the former Spanish Guinea, ruled by Spain for 190 years before gaining its independence, have a life expectancy of just fifty-five years. Seventy-five percent of the population earn meagre livelihoods from agriculture. Timber exports of okume, mahogany and walnut also provide some employment. Weaving, leatherwork and basketry are some of the local crafts.

Spanish and French are official languages. On Bioko and Annobón islands, the indigenous inhabitants are mainly descendants of black Portuguese slaves. There is a revival of ancient customs despite the influence of the Spanish culture and the dominant Roman Catholic religion. The Fang, the main ethnic group on the mainland, make up eighty percent of the population and speak a Bantu language. They hold strongly to their traditions, which include music and dance. Sorcerers who practise "black magic" are esteemed members of this community.

Decades of corruption and abuse of power have devasted the country. Under the first president of Equatorial Guinea, who declared himself President for Life in 1972, all government functions collapsed. The ensuing rule of terror led to the exile or death of up to one-third of the population. The dictator was overthrown in 1979. The road to recovery is long and hard. International partnerships are being encouraged to relieve poverty, advance understanding of wildlife, and preserve forested lands.

Vestiges of hope reside in the potential of the people and their land. The silk cottonwood tree on African cotton is central to the design and the main element of the country's flag. The block, designed by Eva D'Amico, is bordered by colourful printed fabrics and raffia, and showcases stamped lizards, birds, snakes and turtles; reminders of the innate beauty still found in Equatorial Guinea.

Ebb and flow

At the time of Nikil Regenvanu's impending birth, his father and mother — a minister and a theology teacher who had met at college — travelled to her home country of Australia for the delivery of their son. Three weeks later, baby Nikil returned to Vanuatu, his father's homeland where he spent his childhood. Nikil later went back to Australia to attend highschool and university, and even spent some time in England. His real world, however, was Vanuatu, an archipelago of more than eighty islands in the southwest Pacific Ocean.

Since his adolescence Nikil has been like the tide, moving out, but always flowing back to his home shores.

Vanuatu was known as the New Hebrides until its independence in 1980, having been jointly governed by France and Britain since 1906. In addition to those two countries, Vanuatu has strong cultural and economic ties to Australia and New Zealand. Melanesians make up most of the predominantly Christian population of 196,000, followed by Asians, Europeans and Polynesians. The official languages are English, French and Bislama, a form of Pidgin. Most of the population is rural, sustained through subsistence agriculture or smallholder farming. Now, tourism is one of the country's fastest growing sectors, particularly with its exposure to viewers of the 2004 season of *Survivor,* the popular reality television programme. Long before that, the developing island country was the setting for author James Michener's *South Pacific.*

The Regenvanu family lived on the island of Uripiv in Port Vila, Vanuatu's capital and the largest urban community with a population of 33,700. Since his highschool days Nikil was like the tide, moving out, but always flowing back to his home shores. It was during one of these trips home that his life changed forever. "I met my wife, Heidi," he says. "We fell in love and got married." In 2001, the couple immigrated with their seven-year-old son Elijah and their newborn daughter Kali, settling in Vancouver, British Columbia, where Nikil works as a provincial legislative assistant.

Nikil says Vanuatu is a balance between "custom and religion," so he chose that theme for the block. Within the mainly Christian environment, traditional values or "custom" have continued to play an important role. His block design reflects this relationship: A white cross within a red circle encompassed by a yellow pig's tusk, traditional symbol of "custom," is enclosed within a diamond, framed by a mat of woven Pandanus leaves, a material used in many aspects of daily life. The green background represents the lush, tropical vegetation of the islands. Nikil carries with him many memories of his island environment, enriching his Canadian life. He says Canada is really a mosaic with separate and distinct cultures, each free to grow and thrive. "I think the Quilt Project is an excellent way to reflect that."

The Gambia

> " When you're that small, you don't have time to fight…small is good sometimes. "
>
> *Abai Coker*

African roots

With a smile, Abai Coker calls himself "Mr. Stress-free" and certainly, he has a way of putting others at ease with his soft-spoken manner. It is an amazing talent given the amount of responsibility he carries. It is even difficult to predict where he will be from one moment to the next. After he arrived in Canada in 1972, Abai used his teaching experience to work with an English as a Second Language (ESL) program. Later, he became the Outreach Administrator for Ottawa Carleton School Board and the President of Canadian African Solidarity. As part of his mandate with the Board, he administrates twenty-six ESL and Employment Skills schools in Ottawa.

The Gambia is Africa's smallest nation, a long narrow strip bordering the Gambia River and almost entirely shut in by Senegal. Commenting on the country's peaceful nature, Abai chuckles. "When you're that small, you don't have time to fight…small is good sometimes." He describes most Gambians as carefree and tolerant, attitudes that filter into the religious environment as well. While the population of the country is ninety percent Muslim and only nine percent Christian, both Christmas and Easter are national holidays. It is not uncommon for members of a family to practise both religions. "It never causes a problem; religion just doesn't come up in conversation," Abai states. The various religious practises are simply respected and worked around, because family is more important.

Even the national style of dress for men reflects the people's easy-going manner. They know how to dress for comfort in the heat and humidity of their homeland. As illustrated on the block, most men wear colourful, hand-embroidered, cotton tunic-tops called *dashiki*, worn with loose-fitting drawstring pants and matching *kofi* hats. The dynamic patterns are achieved using the wax resist process to dye soft, breathable cottons. Deep folds on the top and needlework trim identify this distinctly Gambian attire.

Abai takes his wife, mother, and two children home to the Gambia every two years. His nuclear family is uncommonly small by Gambian standards. Members of his extended family often have seven or eight children. Gambian society is matriarchal and the women make traditional customs flow so easily into everyday life that Abai admits, "They are difficult to pinpoint."

Gambians' pride in their country, though relaxed, certainly does not lack lustre, especially since gaining full independence from Britain in 1970. The setting for Alex Hailey's famous *Roots*, the Gambia hosts a Roots Homecoming Festival every June, since 1996, to encourage Black Canadians, Americans and Europeans to get in touch with their African roots. Welcomed by the warm smiles and hospitality of the Gambians, many do come and do, indeed, feel a renewed sense of pride in their heritage!

Watching and wanting

Her voice is young and strong and full of laughter. You can almost hear the twinkle in her eye. "I don't act my age," admits Emily Flowers. She believes that maintaining her own home, even shovelling snow after frequent storms, keeps her young. She chuckles, "You haven't seen snow until you've seen Labrador snow!" The mother of three adults, she likes to stay active, especially with her artwork. She loves beautiful pieces. She creates caribou hair sculptures, traditional sealskin moccasins and mitts, dream-catchers, and special "tea dolls."

Emily grew up in Sango Bay near the Innu community of Davis Inlet. This is where she first saw Labrador "tea dolls" made by the Innu. The dolls were stuffed with tea for the long trips made by the migratory hunters and their families. "Children loved their dolls, took care of them, and this way they could carry part of the load," explains Emily.

Her dolls are dressed in distinctive Inuit clothing. The doll on the block is wearing an *amauti*, with a baby's face peeking out next to the mother. Emily exclaims, "Oh my! When I finished embroidering his little face, I saw my grandson Dustin looking back at me. It looks just like him!" The Inuit woman wears boots with sealskin legs and smoke-tanned caribou soles. Two *inukshuks*, used as guideposts and food caches in the Arctic featured white tanned caribou skin. Below sits an *ulu*, exclusively a women's tool that honours their work.

Emily's art started on a practical basis, before it evolved into her livelihood. "My mother and my grandmother taught me a little bit, but ninty percent of what I know I learned by watching and wanting," states Emily. "As an Aboriginal, you grow up with it, you just 'know it.' You have to have clothing, mitts, boots to survive in the cold." She prefers some traditional ways, cooking fresh-caught salmon, caribou, or partridge when she can get it. "The fresher, the better," she says with relish. One regret is that she cannot speak the language of her people. "My grandparents spoke it, and I *wish, wish, wish,* I'd had the opportunity," Emily says sadly. "We were somewhat shamed into giving up our ways, but those were the times." Her language is not taught in schools, but Emily hopes renewed pride in Inuit heritage will spark a revival.

Although life has not always been easy, Emily is thankful to earn a living through her art and to be able to express herself through the block. Interlocked, raised beadwork represents the spectacular Northern Lights around the doll and a glowing lemon sun. Humbly, Emily says, "The sun gives us so much, but of course, God gives it first."

Labrador Inuit

> " Children loved their dolls, took care of them, and this way they could carry part of the load. "
>
> *Emily Flowers*

Indonesia

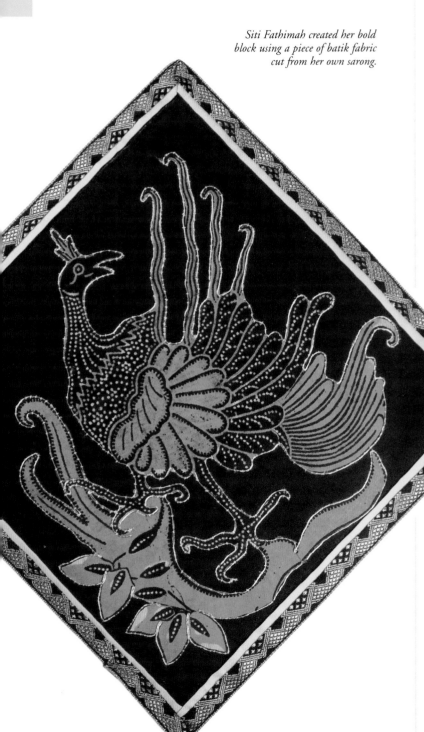

Siti Fathimah created her bold block using a piece of batik fabric cut from her own sarong.

Unity in Diversity

Petite, dark-haired and soft-spoken, Siti Fathimah is an Indonesian student at McGill University in Montréal, where she lives with her young child in a small apartment. Siti is passionate about her homeland and belongs to the Association of Indonesian Students in Canada. It is called PERMIKA, an acronym for its name in Bhasa Indonesia, the official language of her country. This is a modified form of Malay that was adopted to foster unity in the predominantly Muslim nation of over 360 diverse ethnic groups, multiple languages (English, Dutch and 583 dialects are spoken), and traditions. Such student associations are found around the world, promoting knowledge and understanding of Indonesia's culture and providing a social support network for scholars far from home.

Indonesia is the world's largest archipelago; 6,000 islands of its more than 14,000 are inhabited. In its position straddling the equator in southeastern Asia's "Pacific Ring of Fire," Indonesia counts 400 volcanoes (including the famous Cracatoa), of which 70 are active. It is home to the *ora* — the world's largest monitor lizard, known in English as the Komodo dragon, and the world's largest flower, *Rafflesia arnoldii*. The quintessential fabric of Indonesia, batik, is world renowned for the intricate hand-printed designs made with resist-dyeing methods. The name batik is said to derive from *tik*, the Indonesian word for dot, one method of applying the patterns. Luxurious *ikat* (made by tying threads together before dyeing the fabric) and *songket* (silk interwoven with gold or silver threads) are special-occasion fabrics.

Siti created her bold block using a piece of batik fabric cut from her own sarong. She learned to do the typical style of gold couch-work to outline the stylized peacock, heightening his regal demeanour as he struts with his long tail coverts fanned out to attract peahens. Colourful peafowl, both wild and domesticated, are found throughout Indonesia where they are part of art, history, modern culture and mythology. The peacock is said to guard the gates to Paradise, while Greek legend explains the 100 eyes of defeated Argus were placed on the feathers of the peacock to forever keep watch.

Western dress is now preferred in the large cities, Siti explains, but both men and women still wear long, cotton wrap-around skirts, the *sarung* and *kain*, respectively. The textiles vary in colour and vividness, design motifs and material according to region, often revealing Chinese, Dutch, Arab and, now, European influences. Over this, women wear a long-sleeved jacket, or *kebaya*, while men wear baggy trousers with theirs. Their culture is not one to complain, argue or confront. Like Siti, the people have strong attachments to their families but see themselves as connected to the wider community as well, embodying a sense of mutual co-operation that is enshrined in Indonesia's national motto: Unity in Diversity.

Something more

With five years of nursing experience under her belt, then-thirty-one-year-old Elva Morden decided 1961 was the year to search for something *more*. Soon after, she made her way to the Kingdom of Swaziland, a small country dwarfed by its neighbour, South Africa. She worked as a medical missionary, travelling along bumpy dirt roads in a Toyota pickup truck. Elva, now in her seventies, remembers the steep roads well. Much of the country is covered with ridges. They range from 6,000 feet in the High Veld to a mere 400 feet in the Low Veld. "The roads," she says, "looked like they were hung from the side of the mountain."

Elva modestly admits that of all possible dangers, driving the roads rated highest. But, it was all in a day's work. Her first hospital base was located in central Swaziland. When fifteen out-station clinics were established for rural populations, Elva's routine changed considerably. Doctors spent only half a day per month at each clinic, she explains, from her home in Abbotsford, British Columbia. "The rest of the time, a Swazi nurse and I did all the work." Where there were no actual clinics, she recollects, "We just went out and held them under a tree."

Later, Elva had direct supervision of thirty-two region-wide clinics. "I had to get the drugs out to them. I had to visit every clinic at least three times a month, which meant doing a few each day," she says. Only patients they couldn't handle were sent to the hospital. "But," she emphasizes, "you handled everything you possibly could!" Yet over the next eighteen years, while clocking up to 1,500 kilometres a month, she managed to establish natal and child-care clinics at each station. These were years of "great challenges and rewards."

Elva was also a midwife and an ordained minister. When she wasn't nursing, delivering babies, providing church services, or doing general missionary work, she sometimes took holidays. But it was crafts and needlework that offered relaxation at day's end. Her textile contribution to *Invitation* is a piece of printed fabric, typical of imported cottons Swazi women make into garments. Embellished with French knots and surface embroidery, the image shows a Native man and woman walking down a road with the mountains as a backdrop. Leopard-print fabric undulates around the border, recalling the lithe movements of this big cat.

When Elva's health became an issue in 1984, she returned to Canada. She loved the "congenial people" she had worked with for more than two decades, but a surprise awaited her in Canada. Love found *her*. In a voice that still holds traces of surprise, she says happily, "I got married!"

Swaziland

> " The roads looked like they were hung from the mountain. "
>
> *Elva Morden*

Congo Brazzaville

In her own words

Marie-Léontine Tsibinda was a published author in Congo Brazzaville, part of the Cercle Litéraire, a writers group she co-founded. Later, artists in other fields joined and MédiaAfrique was born. In 1996, Maire-Léontine flew to Paris, France, to accept Le Prix UNESCO Aschberg for best new foreign writer for her short story *Les Pagnes Mouillés*. It was a great achievement! It was also the beginning of a descent into terror.

In 1997, civil war broke out, and her fame, her writing, and her TV appearances made her suspect. Though non-partisan, she became a target. Her home with all her possessions including her writing was burned. She and her six children fled for their lives, eventually finding asylum in Canada in 2001. Understandably, the block image of mother and child, styled after a treasured carving from her home, evinces a poignant stirring of emotions deep in Maire-Léontine's soul. The best way to understand Marie-Léontine is to let her own powerful words, abridged and translated from *Renaître des Cendres* (Out of the Ashes), speak:

Man, among the numerous species of divine creation, counts himself the most intelligent. He thinks, therefore he is. He thinks, therefore he is capable of reason. But how can one explain that this intelligence, which burns in him, leads him to systematically commit acts as barbarous, as criminal, as war?

This is a question I never cease to ask myself since the sound of heavy boots, the report of cannons and other terrifying and horrific sounds have ceaselessly destroyed the dawn of hope for my country… Why does man, instead of defending the ideals of peace, let germinate in his head the strategies of war that set aflame and drench in blood the earth that we all have as our inheritance?

…Congo Brazzaville had become a field of fire and blood. The militia burnt everything in their way, pillaging, raping, and exterminating families without remorse. …Faced with such barbarism, I had only one reasonable solution: flee for the lives of my children and my own. I am the mother of six children, one of whom is a girl. Many mothers, I assure you, didn't get that chance.

Fleeing the Congo, I took refuge in Niger…until November 2001, the date that I felt Canadian soil for the first time. It was cold, but I had found peace. The courage to survive, I drew from the joy of my children…the foundations of a new life have begun. For life is stubborn, obstinate. It refuses to die… Am I master of my own fate? … Will I rise from the ashes to walk towards the sun, towards freedom, like a butterfly in the immensity of a blue sky? Yes, why not? For our ideas, put together, are like bees that bring out the best in us to face those who lie and speak of love, all the while singing the horrible song of war.

" November 2001, the date that I felt Canadian soil for the first time. It was cold, but I had found peace. "

Marie-Léontine Tsibunda

Inspired by nature

The far northern lands along the present-day Alberta-Saskatchewan border have been Beaver territory for thousands of years. Like generations of Beaver women before her, Ida Kushneryk draws inspiration for her beadwork from the sparse vegetation she sees around her. Although she occasionally re-uses patterns, she likes the variety that nature suggests.

As a child, Ida learned the time-honoured techniques of beading from her mother, but for many years the skill lay dormant. As the eldest girl with eleven siblings, Ida was "busy with everything," helping to care for the other kids. Her family mostly lived a settled life, but her parents often went camping and hunting for food. In quieter times, Ida learned to crochet, knit, embroider and sew. She used her abilities as a seamstress to make items mostly for herself and for her home.

Before her mother died some years ago, Ida took up beadwork again. Now retired from providing homecare to elders on her reserve, Ida finds beadwork a welcome form of artistic expression. She uses it in both traditional and practical ways. For the Beaver block, Ida chose a thick "Native-tanned" moose hide as her background, acknowledging moose as a dietary staple for the Beaver people. Set against the tobacco-coloured skin, a large "Alberta rose" and its delicate buds appear to glow with life. An outer translucent coating over bright pink and lime *rocaille* (or *rochelli*) beads gives them vibrant depth. The smoky scent of the hide lingers, wafting up occasionally to conjure images of slow-burning fires.

Ida's band, near High Level, Alberta, resulted when two bands amalgamated in 1899. It has the oldest traceable history of the remaining Beaver bands, going back to 1650. The Beaver Nation had splintered into three groups in the 1600s: Beaver, Sarcee (Tsuu Tsina), and Strongbow (now extinct). They are also related to the Slavey and Chippewyan. Many Beaver bands were pushed westward by the Cree and became absorbed by them or the Sekani. Generally, these groups speak dialects of the Athapaskan-rooted Dene language. Ida's father was Beaver and her mother, Cree. Today, Ida uses English in her home because she is the only speaker of Cree on her reservation.

Ida has passed on some of her skills to her three daughters. Only one of them makes traditional items such as mitts and moccasins, but "only when she has time," says Ida. Once again, the demands of daily life and raising a family push the ancient tradition to the back burner, to be rekindled when time and inspiration permit.

Beaver

Dunneza

Madagascar

*Sister Méline Razafindravao and
Sylvie Andriantsara-Razanajato*

With you, wherever you go

Three pieces from a *lamba*, a large shawl woven from cotton, wool, or silk (a *lamba-landy*), form the backdrop for the block from Madagascar. Blockmakers Sylvie Andriantsara-Razanajato and Sister Méline Razafindravao explain that the type of *lamba* used and the manner it is worn depend on the occasion and on a person's social position. For example, young girls wear their *lambas-blancs* folded in two, while married women unfold them. Usually placed under one arm and draped over the opposite shoulder, it is used as a head covering if the wearer is in mourning. *Lambas* can also substitute as blankets in winter. They are worn at special occasions at the École Malgache de Montréal or other associations, where Sylvie and Sister Méline meet with their fellow Malagasies.

Both men and women wear a *lamba* throughout their lives and even into the hereafter, because special *lambas* serve as burial shrouds. In a ceremony called *Famadihana*, families exhume the remains of their relatives a number of years after their passing to rewrap them in a new *lambamena*, preferably ones made of thick silk native to Madagascar. According to Sylvie, this ceremony is considered a means to ensure a "continuing flow of blessings" for the deceased and helps maintain "well-disposed ancestors." For those whose remains cannot be recovered, wooden statues are dutifully dressed in *lambas*. This ritual to respect the dead is considered so important that in 1998 Sylvie and her family travelled to Madagascar to rewrap her father. Her deceased brother will receive the same treatment when the time comes, but Sylvie wonders how her family in Canada will be able to continue the tradition for her generation.

In addition to weaving, embroidery is an important art in Madagascar. Floral motifs and scenes of everyday life are embroidered on *lambas*, household linens and clothing. Sister Méline, who was sent to Canada by her order, Les Soeurs de Marie Réparatrice, learned embroidery from her mother. She remembers trying to work on her mother's pieces when her mother was out, hoping she wouldn't notice the difference in workmanship.

Sister Méline has depicted women with distinctive hairstyles, each from a specific geographical region. Embroidery, *lambas* and hairstyles are all important markers in the rituals of daily living, to indicate "who you are, where you have been and where you are going." These elements form essential parts of the Malagasy identity nationally, regionally and individually, no matter how far from home one may go.

Khotso, pula, nala

Lesotho's motto reveals the deepest hopes of its people, the Basotho. This agricultural land, bordered on all sides by South Africa and with elevations above a thousand metres in the peaks of the Drakensberg Range, has had its share of historical and cultural upheaval. And yet, it has persevered with its hope-filled motto: *khotso, pula, nala,* meaning peace, rain, prosperity.

Although Lesotho has known the ravages of war in the past, it is a peaceful region today. The original inhabitants were the remains of ethnic groups scattered during the Zulu uprisings of the 1800s. They rallied around Moshoeshoe I (pronounced *mo-shway-shway*), a remarkable leader and military tactician who succeeded in uniting the small groups into the Sotho nation. He defended his people against Zulu raids and preserved their independence from Boer and British would-be colonizers. Eventually protectorate status was gained from Britain. A constitutional government was established in 1993, then violent protests followed in the late 1990s, but reforms have since restored political stability.

The appliquéd and hand-quilted Lesotho block created by the Matsieng Quilters has characteristic designs that draw on images from everyday life. It depicts a shepherd, dressed in customary mountain clothing, tending a flock of sheep. The conical, loop-topped *mokorotlo* or Basotho hat he wears reflects the shape of the roofs in the background. It is a unique and distinctive head covering worn by farmers and dignitaries alike. The design of the *mokorotlo*, woven from *loti* grass on a frame of *moseha* grass found only in the Maloti Mountains, protects farmers from the blazing sun and infrequent but heavy rains essential to their agricultural existence.

Financial prosperity has proven somewhat elusive for Lesotho, formerly called Basutoland. The government of this developing country continues to seek ways to improve the economy. The Lesotho Highlands Water Project involves the construction of a series of tunnels and dams to transport water from Lesotho's Orange River to South Africa's industrial heartland, in return for royalties and hydroelectric power. While the anticipated revenue is positive, there are concerns about the negative effects of this type of development. Thousands of Basotho have been relocated to make way for the project. Such relocations have a huge impact on the livelihood, self-sufficiency and self-esteem of the people, at a time when social relations and attitudes were already undergoing dramatic changes. In the meantime, there is still hope that *khotso, pula* and *nala* will come to rest on the verdant slopes of Lesotho.

Lesotho

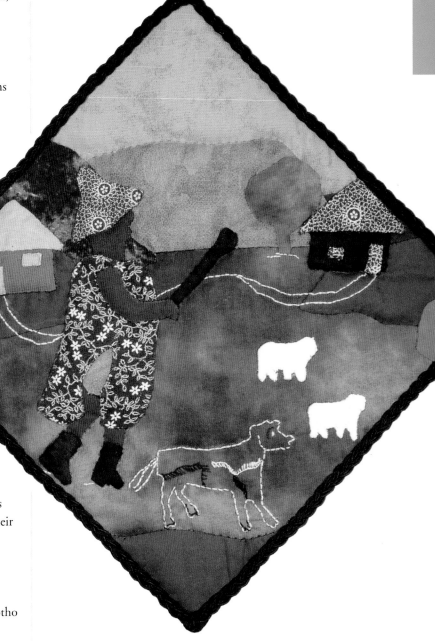

Khotso, pula, nala, the motto of Lesotho, means peace, rain, prosperity.

Grenada

" We look for the things
in the situation that
we can laugh about. "

Roslyn Bullen

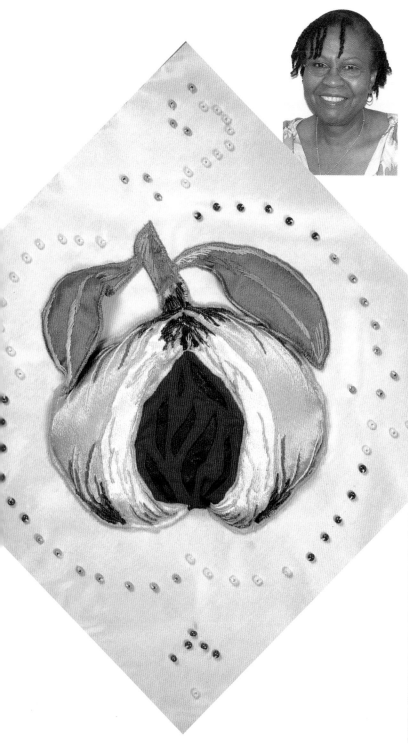

The spice of life

As a child, Roslyn Bullen was taught to move forward with joy and buoyancy, expecting only the best from life. But, life hasn't always been easy. Like many other countries, the beautiful island home she left behind thirty-five years ago has had its share of unrest and, on occasion, has felt the fury of nature's hand.

But in Grenada, where no building is allowed to rise above the height of a coconut palm, where colour is rich and varied and the sounds of calypso, reggae and jazz float on spice-scented breezes, Grenadians keep a positive attitude. "We also suffer; we mourn," Roslyn acknowledges, "but then we look for the things in the situation that we can laugh about." She describes her typical countryman as having a caring spirit and loving to laugh. "We don't stay hurt for too long …whatever happens, it happens; we deal with it and we move on."

At age ten, the last thing Roslyn wanted to do was help her aunt with constant dressmaking chores. "But, there was nothing I could do about it," she remembers. So she stopped resisting and began to sew — for the family, for herself, for her friends. She has fond memories of designing graduation dresses for herself and two close friends. In time, what had begun as a chore became a pleasure, and then a career.

After she emigrated, Roslyn studied fashion design in Toronto and New York, and eventually settled in Toronto where she works in the fashion and crafts industry. Her love of texture and colour is evident in her block where a dramatic three-dimensional nutmeg showers the senses with its bright, silky plumpness. Grenada, known as the Isle of Spice, produces some seventy-two different spices. One of the small island's richest exports, every part of the exotic nutmeg is used. The yellow pods are processed to make candy and juices. The brown nut is ground into nutmeg powder, and its bright-red outer skin is another spice — highly prized mace. Even the brilliant green leaves are used for oil and the shells, for garden mulch.

Roslyn regularly visits her sister and her friends in Grenada. Though much has changed since she moved away, the sulphur pools they used to swim in as children remain. They have become a popular tourist destination. She chuckles. "It's *the* thing to do." Roslyn's infectious laughter and her exuberant approach to life are not wasted, any more than the parts of the colourful, spicy nutmeg. She channels her overflow of energy into organizing cultural events, particularly those aimed at the younger generation. "I would like them to hold on to their heritage," Roslyn says hopefully. "In particular I want them to keep their resiliency, to retain that buoyant spirit."

200

Show the world

The Wuikinuxv block is a priceless legacy left to the Wuikinuxv by Barbara Johnson's late sister. Before Sharon Johnson-Chernoff lost her fight against cancer, she received a vision from the ancestors. In it, she was presented with a design and a message telling her to "show the world that we are." She drew that design on a card and sealed it in an envelope to be opened upon her death. Barbara (Aixcemga, meaning Well Shining Woman) and her family have treasured that card for the past ten years. Barbara saw the invitation to make a block as an opportunity to carry out the ancestors' directive on her sister's behalf.

Barbara learned to bead, sew blankets and make vests while growing up. She has since added painting to her repertoire. Her artistic renderings appear on the beautiful paddles carved by her husband, Charles. With every stroke of paint, she feels gratitude for his quiet strength that sustained her through the death of her sister and other loved ones. Barbara tapped into that strength and paid it forward in her work as a "houseparent" for teenagers who have to leave their community to attend high school, and as a community support person.

From her home in Port Hardy, Barbara lovingly painted and stitched onto cotton backing the abstract design her sister envisioned. Working quietly, she felt spiritually connected to her sister and the ancestors. For the past ten thousand years, home to the Wuikinuxv has been the area along the Wannock separating Rivers Inlet from Owikeno Lake in the Pacific Northeast of British Columbia. Before the arrival of the white man, the Wuikinuxv enjoyed the benefits of their advantageous location along a vital Native trade route surrounded by an abundance of natural resources. On this foundation they built a complex and well-organized society. They lived mainly on the millions of salmon that swam upriver to spawn. White people were quick to exploit the fish stocks, building sixteen canneries around Rivers Inlet during the late 1800s. The lives of the Wuikinuxv were significantly marked by cannery life. Many Wuikinuxv elders remember working in the canneries, Barbara's parents among them. Despite the changes, the old ways and the elders' teachings were never lost.

Barbara is proud of her heritage and the Wuikinuxv who were once described as a "strong, hard lot" by missionaries attempting to convert them to Christianity. The people remained unshakeable, true to their belief in *Giakas shees Himaskasu*, the Big Power from above. Barbara's heart beats with contentment while watching her son and his peers lead traditional drumming and singing. She rests assured by the knowledge that through people like them, Wuikinuxv culture will be preserved and carried on by the next generation — showing the world that they *are*.

Oweekeno

Wuikinuxv

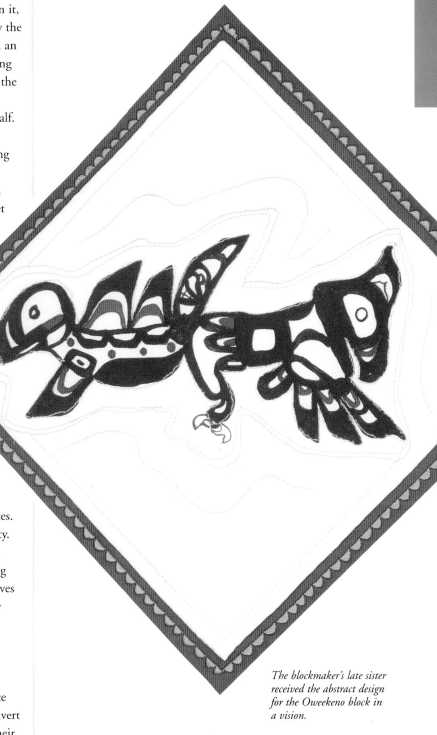

The blockmaker's late sister received the abstract design for the Oweekeno block in a vision.

❝Show the world that we are.❞
Sharon Johnson-Chernoff

201

Lebanon

The memory window

When Rita Attieh was asked to participate in the Invitation Project, the timing was perfect. She'd been in Canada less than a year and though she was adapting well, she had underestimated how much she would miss her mother and siblings — how much she would miss her Lebanon. The sounds of church bells ringing on Sundays and the scent of her favourite flowers are among her sweetest memories. "I was eager to participate," she says. The creative challenge appealed to her, but so did the opportunity to express love for her birth country.

Skilled at embroidery, Rita also enjoys fabric painting and cutwork design. Her beautiful work is a feast for the senses. Although she is soft spoken, almost shy, the dazzling items she creates speak eloquently for her. She favours extravagant materials filled with shimmering colour: gossamer tulle, organza, silk, sheer cotton and satin. She's happiest when she's working out a design. "It's a good feeling," she says. "It's like I'm putting something of myself into the work." This is evident in her block featuring the ancient cedars of Lebanon, hand painted on silk, and viewed through an arched window. The famous trees symbolize strength, holiness and eternity. Delicately embroidered clusters of grapes represent wine, "part of daily life" in Lebanon. The fruit hangs from intricately entwined gold-work vines framing the window, evocative of the luxurious embellishments found on clothing and linens reserved for special occasions.

Rita is now connected to the large Lebanese community in Ottawa through her job as a settlement counsellor at the Lebanese and Arab Social Services Agency. It helps her keep in touch with her culture. "I'm with the Lebanese all the time," she laughs. Still, she was sad she couldn't be home with her brother and her sister-in-law to celebrate the arrival of their new baby daughter. She shrugs her shoulders, "No matter how much some of your family is around, you always miss those who are absent." Rita's large dark eyes glitter with light when she speaks of an anticipated reunion with her sister. Renewed contacts, cultural traditions, particularly special family celebrations, are all very important to her.

Balancing full-time employment with the needs of her family, her husband and two sons, occupies much of Rita's time. Although the fabric and project supplies in her studio tug at her heart when she walks by, they must wait. For now, the fast pace of life in Canada means she must be content to dream of creative designs and of Lebanon. Yet, she sees things clearly through the window of her heart.

> " No matter how much some of your family is around, you always miss those who are absent. "
>
> *Rita Attieh*

The way of the cloth

Legend says two men observed a spider weave its web in the Ghanaian village of Bonwire and wondered what would happen if they copied the spider's skills using cotton thread. What they produced has evolved into a colourful, geometric style of weaving known as *kente* cloth — always made outdoors and exclusively by men — that has come to symbolize Ghanaian culture and history. *Kente*, woven in narrow strips and then sewn together, is now made into robes worn by government officials and is used for wall hangings, bell pulls and other decorative items.

The brightly woven material has also become popular among black ministers in North America. They wear *kente* liturgical stoles to remind them of their roots: eighty percent of African slaves who arrived in North America originated in Ghana. Eager to reclaim a past that was stolen from them, many Afro-Americans try to obtain a piece of *kente* to reconnect them to their roots.

Ghanaian-Canadians use *kente* cloth for every special occasion, says Gerald Arhin, from baby-naming ceremonies in the home to the annual celebration of Ghanaian independence on March 6. "We wear it and we use it for decoration," he explains. When he's celebrating, he wears a wide piece of *kente* draped over his shoulder; women usually tie a piece around their waists. Another Ghanaian, Dr. Tom Forson, donated his cumberbund for the centre of the block. People also use it for scarves, headpieces, and belts. When he wears *kente*, "the feeling is fantastic," exclaims Gerald. The cloth he wears usually has yellow for the richness of the Ghanaian culture and land, green for the forestry and fertility of the land, and red for the sweat and hard work, as well as the successes of Ghanaian pioneers. The colours and patterns bring Gerald closer to home and his family members who still live in Ghana.

Ghana is also known for its carved wooden stools. The stylized stool woven into the *kente* cloth at the centre of the Ghana block represents a throne, from which the village chief gets his energy. The stool symbolizes the chief's authority and the soul of his people. The Golden Stool is the most sacred of all symbols, especially to the Ashanti people, who are the largest group in Ghana, for it embodies all the ancient traditions and the spirits of their ancestors. "The stool symbolizes royalty," says Gerald, who donated the piece of cloth. "The stool is only found in the royal families." Gerald's wife, Stella, is from a Ghanaian royal family, which means her ancestors founded the city from which she comes. Because the society is matrilineal, if they returned to live in Stella's home community, the couple's two young boys would be eligible to become the chief or king.

Kente cloth, made outdoors exclusively by men, symbolizes Ghanaian culture.

Rwanda

One extended family

At Félicité Murangira's front door, the visitor is greeted with the rare warmth usually reserved for close family and friends. An unconditional welcome not only forms the basis of Félicité's work, it also reflects her African culture. She believes that on a universal level, everyone is connected, therefore everyone is part of one extended family.

Félicité's twelve years as a community worker helped her see that adopting the philosophy that the world is one family could be effective in her work as coordinator of an HIV/AIDS prevention program for Ottawa's African-Caribbean community. In her culture, young people preparing for marriage or other tradition-al events are guided by family and community members. She felt that this type of mentoring could also work well in the context of a community prevention program.

Félicité began instilling the one-family approach in her own home when her two Canadian-born children were very young. "The children of your neighbours," she told them, "are part of your family." When someone came to the house, they would have to share whatever they had. "What if we don't have enough?" they protested. Félicité was firm, "In our culture you always have enough. Even if you just have one plate of food, you will share that plate." The children, now in their teens, were also encouraged to think of their neighbours as aunties, uncles, cousins and grandparents. This sometimes caused some confusion when the children were younger. Félicité laughs remembering a visit to Rwanda in 1989. After introducing them to several "grandmothers," her eldest child asked: "How many grandmothers do we have?"

The children met their own grandmother, an extraordinarily courageous woman, during that visit. Unknowingly, it was the last time they saw her. Four years later, she was killed by guerilla gunfire, another casualty of Rwanda's brutal civil war. Yet there is no bitterness in Félicité's voice. She speaks instead of peace, forgiveness and rebuilding families, and this is reflected in the Rwanda block.

She chose a miniature handwoven *agaseke* basket, with its distinctive conical top, because it has become a national symbol of Rwanda. Placed at the centre, it represents enduring family values. The baskets are used for carrying goods, including gifts for newlyweds and new mothers. Making baskets has become a source of income for many Rwandan women, as well as a means of reconciliation for families torn apart by civil war. Félicité had decided to take a break from community work, but a colleague convinced her to consider the Aids project. "I think I can make a difference," she says. And she does.

The bounty of Mother Earth

The Chipewyan are an Athapaskan-speaking people living in the sub-Arctic region that ranges from Churchill, Manitoba, on Hudson Bay, westward across the top of the Prairie Provinces to Great Slave Lake in the Northwest Territories. They have occupied this territory for centuries, living as nomadic hunters who followed the seasonal migration of abundant caribou herds. Small game and fish added to their diet. During the brief summer months, they travelled the many lakes and rivers in canoes, but when winter came in cold, biting blasts, they relied on snowshoes and toboggans.

The Ojibwe gave the Chipewyans their name. It means "pointed skins" and referred to the particular style of shirt the Chipewyans wore. Made of caribou skin with long sleeves, the shirt had tails tapered to a point in front and back. In the Chipewyan way of life, caribou skins were used for virtually everything: tepee covers, carrying cases and satchels, the webbing on snowshoes. Eight to ten caribou skins would furnish one adult with a complete set of winter clothing.

Shamans of the Chipewyan people narrated mythological stories that used indigenous animals as symbolic figures. The characteristics attributed to these animals serve as reflections of Chipewyan values. The bear represents introspection, opening the door to the subconscious mind by way of dreams and the imagination. The wolf is a teacher who guides the children of Earth by sharing his knowledge and instilling strong family values within the hearts of the people. Perseverance, fortified by a healthy belief in one's self, is embodied in the wolverine. The whale represents the collective memory of the Chipewyan and records the history of Mother Earth. Still called "Turtle Island" by many First Nations peoples, North America is symbolized by the turtle.

In their mythology, it is the eagle, however, that is the animal closest to the Great Spirit. It is particularly appropriate that the Chipewyan block is an embroidered rendering of an eagle gripping a fish in its sharp talons, flying above a scenic backdrop. A gift of an eagle feather has to be earned through acts of caring, generosity and kindness, and for being the kind of person children can admire and emulate. Even arrows were considered most powerful when plumed with eagle feathers. Chipewyan spiritual beliefs also applied to the fish and fishing. Special ceremonies would be held before the fishermen cast their nets, in the hope it would ensure a plentiful yield. Prayers of gratitude from the hearts of the people would be directed to the eagle, which would then carry them soaring high in the sky to the Great Spirit.

Chipewyan

Denesuline

A gift of an eagle feather has to be earned through acts of caring, generosity and kindness.

Brunei Darussalam

An artist's dream

Avy Loftus, a Montréal-based artist and batik designer, dreamed of becoming an artist at a young age. When the time came to pursue a path of serious study, she was excited but also nervous. She had loving parents but she couldn't predict their response. She remembers their resistance, echoed by friends and other family: "Don't do it. There's no money there. It's not a prestigious thing in our society." The last plea spoke the loudest. Avy mimics it, twisting her beautiful, delicate features into a mock scowl. "An artist! What's that?" In Canada, however, she discovered it wasn't only the Asian culture that thought working as an artist fell dangerously short of a *real job*. Talking about this universal connection unleashes a ripple of spontaneous laughter, followed by a shrug that absolves her parents of any wrongdoing. They wanted her to become a doctor, a lawyer — anything but a *struggling artist*.

Back in Jakarta, she bowed to her parent's wishes. The first born in an Indonesian family, she was "a model for the other siblings," she explains. Her voice is soft now, reliving the moment she surrendered her dream. In pre-med studies, she barely lasted the year before her parents finally relented. Switching to Language and Arts, she earned a degree and went on to work in the educational system. It was a compromise she learned to live with, and then grew to love. Yet when she realized her real dream still burned with a steady glow, she reached for it once more.

While creating the Brunei block, Avy spoke of her journey since claiming that dream. She has had numerous collective and solo exhibitions in Canada, the United States, Japan and Indonesia. She's won some awards, but says, "It's not easy. You have to be self-disciplined, motivated." Candid eyes reveal victories and struggles balanced by a visible happiness. Marriage, motherhood, and working as an artist are the blessings that temper the struggles, turning them into pathways of growth.

Avy recreated Brunei's national flower, the Bunga Simpor, out of amber-coloured beads, stitched against a lemon-green silk batik background. She feels the flowering tree perfectly captures the resiliency of the country and its people — a mix of Malays, Chinese and indigenous groups who, with the discovery of oil in 1929, escaped geographical obscurity. Prosperous for centuries, with control over much of Borneo and the southern Philippines, this now-tiny Islamic sultanate is surrounded by Malaysia and the South China Sea. Suddenly oil-rich, the economy exploded into a kind of "conspicuous, showy bloom" that best describes the Simpor. The flower, like Brunei, and like Avy, is outwardly beautiful and exotic, while inside it is strong, hardy enough to grow and survive anywhere.

Avy Loftus feels that the flowering tree, Bunga Simpor, perfectly captures the resiliency of the country and its people.

Una cassetta in Canada

Great food, full-bodied wine, family and friends, liberally mixed with hearty laughter and animated conversations, are the elements of a good time — Italian-style. The "small lunch" served at a gathering of Ottawa's Gruppo Anziani was nothing short of a gourmet feast. The women placed fragrant specialties on linen-covered tables while the men poured drinks. The festivities were enhanced by outbreaks of singing as the group lustily performed, for each new visitor, the charming tune that is such a part of this celebration.

Ottawa's Gruppo Anziani who designed the Italy block: Maria Bonacci, Pierina Costanza, Ariella Hostetter, Anna Chiappa, Carmela Buda.

The house featured in the Italy block is based on a popular song called "*Una cassetta in Canada*" (A little house in Canada). A big prizewinner at the San Remo song festival in 1957, the song described the dream of many Italians to own a small house surrounded by *vasche di pesciolini e tanti fiori di lillà* (pools of little fish and many lilacs). Over the years many immigrated to Canada to follow that dream; today there are over one million people of Italian descent living on Canadian soil. That house inspired the block designed by Anna Chiappa, Ariella Hostetter, Pierina Costanza and Carmela Buda, but stitched by Pierina.

Maria Bonacci created the fine vine and leaf cutwork border in the block. She began stitching at age three, under the rigorous tutelage of nuns in an Italian convent. "Your stitches had to be perfect or you couldn't go home on the weekend," she remembers. It took a whole day to sew each *giornato* hem on the bottom of sheets. Even where no one would see them, the stitches had to be sewn evenly along the same thread of the fabric. "When I got married, I had linens for the wedding night, for visitors, for the priest's visit, for everyday, for every occasion, and they all had to be pressed. I was delighted when I moved to Canada, and I discovered Simpson Sears and Permapress," she exclaims. "No more ironing!"

Beautifully embroidered linens are an integral part of important life events in Italy. Traditionally, women had to begin marriage preparations early — very early! "Forty-eight sheets and forty-eight pillowcases to embroider," sings out Carmela. "NO, forty-eight *sets* of pillowcases" correct the others, "…and towels, and…. Everybody used to do that." Even after many years of marriage, each woman admits she still has linens saved for a special occasion.

"My grandmother took the train to Venice from her small town in the Dolomite Mountains to buy my wedding gift," recalls Ariella. "She shopped for an exquisite white-on-white, hand-embroidered tablecloth that was so expensive all my aunts had to chip in to buy it for me." To this day, that tablecloth remains a treasured link to her family, to her mother and to her grandmother. Threads can indeed tie generations together.

Honduras

Stitching history

Sandra Vasquez learned the importance of family and helping those in need from her mother, whose life exemplified these virtues. But it was only after she was gone that Sandra realized the true value of her legacy. She followed in her mother's footsteps with her own three daughters. She made sacrifices to be home with them every day, so they could discuss "what was good and what was bad in life," and to make sure they made wise choices.

The Vasquez family left Honduras in 1985 to start a better life in Canada. Sandra's husband is a gifted prosthesis maker and she is a talented seamstress who learned to sew from her mother — another treasured gift. Early in her husband's career, Sandra realized that his clients faced real challenges simply to get dressed, because no clothing was available to meet their special needs. Her innate desire to help others led Sandra to establish her own shop, where she designed and sewed some of the first clothing on the market for the physically disabled. This work brought her great satisfaction. (Sandra's husband likes to tease her that she takes on other people's problems because she doesn't have enough of her own.)

She still sews for others, but since her eyesight is failing she makes mostly large pieces now. With only thirty-five percent of her vision left, Sandra cheerfully, yet with great determination and the aid of several magnifying glasses, reproduced in embroidery the two-storey, rose-coloured Mayan structure that graces the Honduras block. Excavators who unearthed the temple in near-perfect condition in 1989 dubbed it "Rosalila," because of its unusual rose colour. Intricate designs in fine stitching call to mind the elaborate stucco bas-reliefs on its ancient façade. Sandra admits that she only came to appreciate the importance of Mayan ruins after she came to Canada. In recent decades, Mayan history has become a source of national pride in Honduras and is now being taught in schools. It serves as an affirmation of a rich heritage at a time when poverty, unrest and struggle are daily realities.

Sandra lives near her adult daughters. Every day she lovingly cares for her little granddaughter, Alexandra, and teaches her to speak both French and Spanish. Spanish is important to their family, says Sandra as she cuddles Alexandra, not just to stay connected to their Honduran roots, but to communicate her principles and ideals. If they don't understand her newly acquired French, she delivers the message clearly in Spanish. For Sandra, passing on good values that form the foundation of life is her most important role.

How sweet it is

Reta Sands has only to step into her backyard to find the sweetgrass that grows wild here and there on Potowatomi Island. This fragrant grass has a rich, earthy scent, true to its name. It is used by many First Nations in central and western Canada. For the Potowatomi, "It mainly has been our economy," says Reta. "We make anything we can to earn a living." Aromatic baskets, braids, picture frames, decorative cups and saucers, bowls and vases are all woven from *wiingashk.* The Potowatomi also use the sweetgrass for spiritual purposes, burning it to smudge (or cleanse) both beings and belongings, or by simply holding a braid while praying.

Reta was born, raised and still lives on Potowatomi Island, one of five islands that make up the Walpole Island region in southwestern Ontario. As a child she learned to speak an Ojibwe dialect that incorporates words from the Potowatomi and Odawa languages. When she was about eight years old, her grandmother taught her how to weave mats out of sweetgrass, which they would sell for forty cents each. Reta remembers that she and her grand-mother would make about a dozen mats and then go into town and come back with eggs and butter. "That was over sixty years ago," says Reta. Now she mostly braids, but the skill of weaving sweetgrass into baskets and other creations is popular among people of the area.

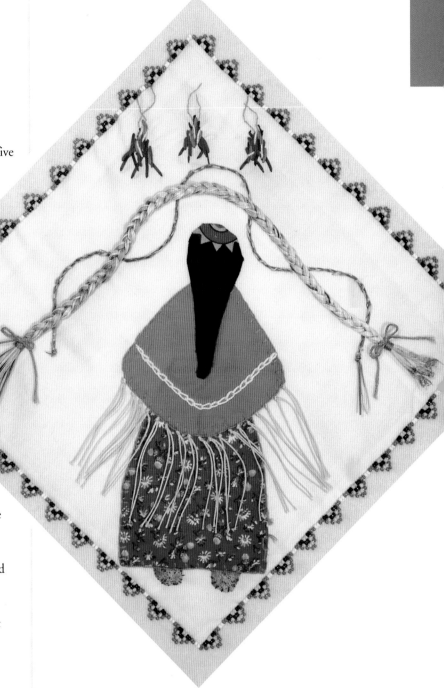

Now retired from a thirty-three-year career as an elementary school teacher, Reta had four children of her own. Her son carries on the tradition of making splint baskets from black ash. After a long, straight length of the ash tree is cut, the bark is scraped off the trees, the logs are pounded and then the splints are shaved and dyed. Reta recalls helping her grandmother make these baskets when she was young. "She let me do the easy part," she says. "I did the weaving. Nookimis [grandmother] would begin the bottom and would finish the top of the basket."

An avid quilt-maker, Reta is a member of two quilting groups that meet each week. A few women from the Walpole Island Quilters shared their ideas and fashioned the Potowatomi block. It features an appliquéd, traditionally dressed woman wrapped in a fringed shawl, with a single thick braid down her back. In the upper point of the block, three embroidered fires signify the alliance between the Potawatomi, the Ojibwe and the Odawa, called the Council of the Three Fires, in which they were the Firekeepers. In an arch above her head are two sizes of sweetgrass braid, a special reminder of the fragrant plant that provides for the people, economically and spiritually.

Gibraltar

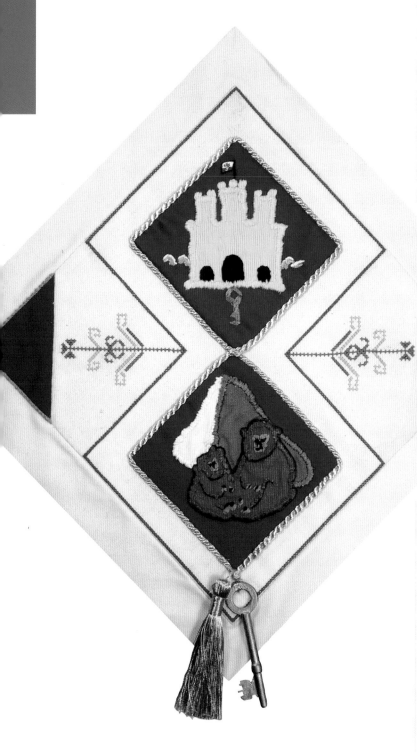

The Rock

People usually think of "The Rock" as the promontory protruding from the southwest coast of Spain, renowned for its role as a military defense base at the entrance to the Mediterranean. The people of Gibraltar, a mix of Genoese, Maltese, Portuguese, Moroccan, Indian, Spanish and Gibraltarian or other British, are almost an afterthought. But for Anna Maria Tosso, a recent law graduate now working in Winnipeg, this British territory has an identity of its own. "I wanted Gibraltar to be recognized as a separate culture," she says.

Anna accepted the challenge of creating the block to represent her father's homeland. As she worked, she thought of her father who had emigrated in the 1960s, yet she drew even more on her own collected memories. Anna was thirteen when she made the first of many trips to Gibraltar to visit her father's family, whose roots can be traced to the Peace of Utrecht in 1713. Spain ceded Gibraltar to Britain in this series of treaties after the War of the Spanish Succession. "He was the only member of his family adventurous enough to leave Gibraltar," she says of her father.

She has indelible memories of trekking up the mountain in Gibraltar to watch the semi-wild Barbary apes. They are actually tailless monkeys called macaques, which roam free at Queen's Gate and the Great Siege Tunnels. Legend warns that if the apes ever leave The Rock, Britain will lose Gibraltar. Anna chose these signature primates to appear on the quilt block, along with the appliquéd three-tower castle set against a backdrop of sea waves. Anna worked on the block from Canada, coordinating embroidery and appliqué work done in Gibraltar by Rebecca Faller and Paola Purswani. The large golden key donated by the Voice of Gibraltar Group from their collection symbolizes Gibraltar's strategic position as the "key to the Mediterranean."

No food can be grown on Gibraltar, so everything is imported. It is often said that "the whole world is for sale" in its stores. With an economy fueled by offshore banking and tourism, there are more registered companies in Gibraltar than inhabitants. The territory is tiny, only about three miles long by one mile wide, not counting the airstrip. "I think every family owns two cars," Anna laughs. Each morning, people leave their 18th-century British Regency town to head to work across the border in Spain. She recalls the sounds of the early morning rush hour, with every car locked in, bumper to bumper; then the honking would begin, building to an ear-shattering crescendo, a familiar reminder of Anna's 21st-century North America.

Coffee's on!

Coffee houses in Syria bear no resemblance to popular Western ones where double lattes are the tall order of the day. "The ambience is not the same," says Norma Moussa, a retired elementary school teacher living in Joliette, Québec. Norma came to Canada with her two sons in 1973, joining her Syrian-born husband Michael, who is also a teacher. "For us, the coffee houses are more of a social gathering," she explains. People come from the same neighborhood; they know each other. Men relax smoking water pipes nicknamed "hubble bubbles." The music blares, while cards, backgammon and other board games are played amid lively cheering from onlookers. The talk is vibrant, for Syrians love to talk.

Located in the Middle East, bordered by Turkey, Iraq, Jordan, Lebanon, and the Mediterranean Sea, Syria has had coffee houses since ancient times. They have been a gathering place for men to speak the language of men, playing an important role in Arabic culture. Norma is quick to point out that while Arab men and women are often separated socially, husbands and wives *do* socialize together, with their families and friends.

The women, too, have their own gathering places. "We visit each other," Norma says. Their afternoon or evening visits are often "elaborate" get-togethers with many women in attendance. Coffee, tea, and homemade fruit drinks are served along with cakes, pastries and other tempting sweets. The women talk of many things, but mostly "about all their problems," says Norma. She adds with a chuckle that psychologists aren't needed in Syria "because people don't go to them. The women talk to *each other*," she explains. Once the serious issues have been sorted through, the women turn to the lighter side of socializing. For instance, when the sediment from their rich and strong Turkish coffee comes into view, "It's almost an automatic reaction to tip the coffee cup to read one's fortune," says Norma, laughing again.

Throughout history, Syria's capital city of Damascus has been famous for its luxurious fabrics, often embroidered with gold and silver threads. The block, with its background of jacquard damask (named for the city), features a three-dimensional, solid brass *cezve* — an elegant, long-handled coffee pot used to make Turkish coffee. Norma embroidered a stitched golden tray surrounded by dense shafts of wheat and olive trees, symbols of Syria's agricultural bounty. "Wherever you go, the coffee is always ready to offer," Norma says. "Coffee is the symbol of hospitality in Syria."

Syria

> "It's almost an automatic reaction to tip the coffee cup to read one's fortune."
>
> *Norma Moussa*

211

Saudi Arabia

"My visits to friends were always unbelievable feasts with great hospitality shown each time."

Sabiha Imran

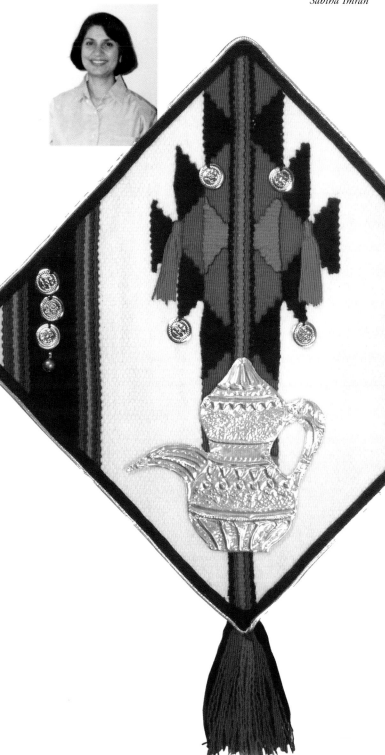

Heartfelt thanks

For Sabiha Imran, creating this block was a chance "to give something back" to the people who enriched her life and broadened her horizons during her twenty years in Saudi Arabia. As she planned and created the design, her memories surfaced, "renewing associations, acquaintances…pleasant and poignant moments of [her] time spent there." She recalls her years in the Middle East as rewarding ones with a busy social life, full involvement in everyday activities, teaching art in schools, exhibiting her work, and learning from a people who "gave a lot of respect and friendship."

Sabiha carefully researched the needlework history of Saudi Arabia and found that weaving is an important part of the culture. Traditional designs are generally geometric or floral because the depiction of humans and other living creatures is avoided for religious reasons. Bright, aggressive colours reflect the Saudis' love of the bold, and the raw environment of the desert. The most common colours are red, black and white, usually on a natural camel shade, sometimes with touches of orange, blue and green.

Saudi Arabia is home to the world's largest sand desert, the Rub al-Khali. Resources can be scarce in this country, particularly for the nomadic, tribal Bedouin in more remote areas. The Bedouins embody the Saudi's social and cultural values of honour, valour, chivalry and hospitality. Often, women have only tassels and coins to embellish their garments. They drill tiny holes in coins and hang them around their veil and in the front of a dress.

Sabiha used a richly textured, handwoven material taken from one of her own floor cushions as the base of her block. She incorporated the colours and patterns frequently used by Saudi weavers and ornamented it with coins she had saved for many years.

"My visits to friends were always unbelievable feasts, with great hospitality shown each and every time," recalls Sabiha. Saudis are rich in warmth, simplicity and hospitality, she says. During the many social visits of each day, it is customary to serve friends and family a *kahwa*, a special blend of coffee spiced with cardamon, poured from an Arabic coffeepot called a *dallah*.

A multi-talented artist and decorator with many speciality diplomas, as well as a degree in commerce, Sabiha works in diverse media. She used her experience in embossing pewter sheets, a technique she learned while living in Saudi Arabia, to create a pewter *dallah* to convey the Saudis' strong sense of hospitality. The engraved replica, as well as the long-treasured coins and cushion she incorporated into her design, make this a truly personal contribution — straight from the heart.

History in a bead

Lorna Thomas-Hill of the Wolf Clan, Cayuga First Nation, spent fifteen years teaching her language through the Indian Education program in Niagara Falls, New York. A friend, who weekly taught traditional beading in the same school, repeatedly invited Lorna to join the class. As the only adult student, the soft-spoken Cultural Specialist Coordinator needed coaxing, but was soon captivated. When her pastime became a passion and leisure craft became cottage industry, Lorna left her job to bead full-time. Today, she sees her beadwork as a path to preserving and continuing the venerable art, history and teachings of her people. Now, all ten of Lorna's children bead — and her nineteen grandchildren are learning.

But it was her son, Samuel Thomas, who has made it his life's work, who moved it from traditional craft to fine art. Over the past twenty-five years, Sam has won over sixty national and international awards for his Iroquoian art. His work is shown and collected throughout Canada, the United States and abroad, from the Smithsonian to the Royal Ontario Museum. Mostly self-taught, he studied intensively to learn the basics of hand tanning deer- and moose-hides, and to make moccasins. He later obtained the entire pattern collection of an elder who had shared her skills with him. Sam perfected his raised beadwork, an exclusive Iroquoian technique where beads are sewn one on top of the other to create three-dimensional pieces. Beginning with traditional forms dating to the 1700s, Sam has evolved the designs into his own style. Always dedicated, Sam continues to research ideas with museums, anthropologists, ethnologists and private collectors around the globe. Endlessly creative, Sam says, "The interesting part is to take an idea and expand it into beads."

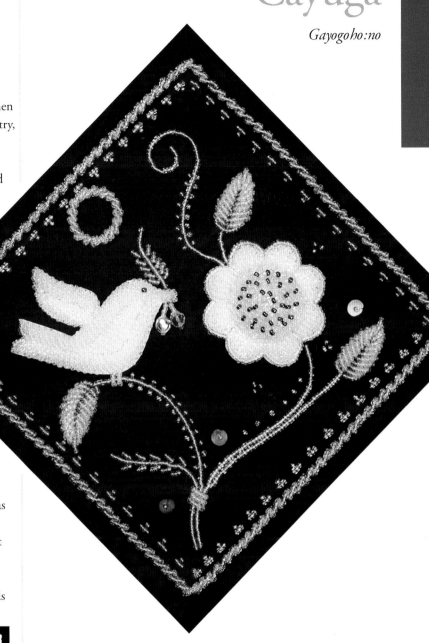

For the Cayuga block, Lorna and Sam worked iridescent white beads on plush burgundy velvet. The dove symbolizes peace, the circle eternity and continuity of life, while the strawberry flower signifies the defeat of winter, of good over evil. The strawberry is revered among the Woodlands nations as the first fruit of Mother Earth, its juice important in spiritual rituals. Mother and son say it is important "to incorporate culture and teaching" into their work.

Sharing their ideas has taken the pair on a long journey, physically as well as artistically. Their latest endeavour is a co-operative beading project in Kenya. Before that, their exhibit "*Ska-Ni-kwat* — The Power of the Good Mind" took them across North America, and was exhibited at the United Nations in New York. A collaborative work, Sam says it was designed, "to show that it is possible to work together, put aside differences, share and love one another."

Cayuga
Gayogoho:no

> " The interesting thing is to take an idea and expand it into beads. "
>
> *Samuel Thomas*

213

Kazakhstan

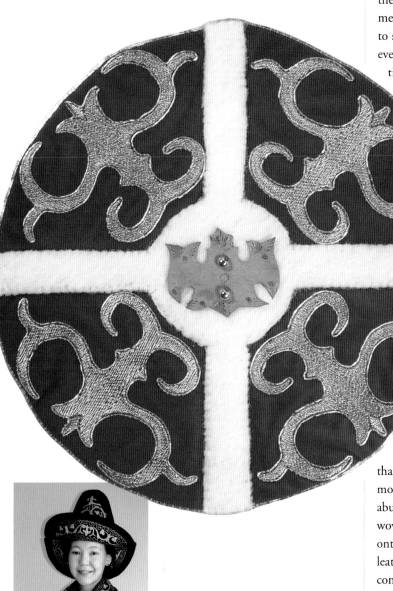

Aselka Syzdykova

Underneath the beautiful perfection

Every spring the people of Kazakhstan gather together in their *yurts* (portable, felt-covered tents) to celebrate the New Year, not only in the countryside but also in city parks and backyards. They prepare meals and brew a drink from grains and fermented mare's milk to share with friends and strangers. "There is food and drink for everyone," says Aselka Syzdykova. No one goes hungry during this time of new beginnings, called Nauryz, which celebrates fertility and forgiveness. The *yurts* themselves are symbolic: round like the Earth, their ceiling openings connect dwellers to the universe and allow them to see the stars and sky.

Before coming to Canada with her husband in 2001, Aselka studied electrical engineering and business administration in Almaty, Kazakhstan's former capital and largest city. Once a stop on the Silk Road, the China-Europe trade route, Almaty is famous for its orchards and its name means "father of apples." The ninth-largest country in the world, about one-third the size of Canada, Kazakhstan contains rich mineral deposits including iron and gold. Despite its size, the country has a relatively small population, with more than half of its inhabitants native nomadic Kazakhs. Many Russians also settled there when the country was part of the Soviet Union.

The Kazakhs still move their *yurts*, and their herds of cattle and flocks of sheep to summer pastures. The sheep provide wool that is made into felt and woven into rugs and textiles. The country's most impressive textiles come from the northeast, where Kazakhstan abuts Russia, China and Mongolia. One of the favourite patterns, woven into *tekemets* (carpets), featured in clothing, and stitched onto the Kazakhstan block is a stylized set of ram's horns. A small leatherwork medallion sits atop crossbars, which represents the construction of the *yurt*.

Aselka's family is still in Kazakhstan, but she keeps in contact with them through postcards, e-mails, and phone calls. "Sometimes I feel like I'm in the middle of them still," she says. Family life is important to the people of Kazakhstan, with grandmothers, or *azjhes*, holding a special place. In Canada, Aselka now works as an administrator for a ballet school. She spends much of her spare time painting in watercolours and acrylics, establishing a connection between dance and visual art. She loves to watch the process of creating dance and to see "what is underneath the beautiful perfection" of the end result. When she paints, it is this creative process that motivates her. Aselka participated in her first art exhibition, "Budding Artists," at the Orleans Art Centre near Ottawa in 2002. It went "very well" she says, but "I paint for myself, for joy, rather than for approval of peers or society."

Changing times

The federation of seven sovereign states on the southeastern coast of the Arabian Peninsula known as the United Arab Emirates (UAE) was home to artist and blockmaker Shireen Kamran for five years. "It was a spiritual time for me," she recalls. "I loved my experience of living there." Shireen acknowledges that it was very much a man's world; however, at the start of the 21st century, women make up sixty-six percent of the students at Emirates National University, forty percent of government employees, eighty percent of nurses, and thirty-three percent of all doctors, pharmacists and technicians.

Since oil discoveries in the 1940s, the country has modernized rapidly. Export revenues have improved education and health care, and irrigated desert landscapes have become gardens and green fields. The capital city, Abu Dhabi, is known as the Garden City of the Gulf. Shireen's husband was teaching engineering in the Emirates, which is not unusual given that more than eighty percent of the work force is non-Emirati. Established in 1971, the UAE has a long-standing, stable government.

Shireen is an artist/painter who loves to use textures in her oil paintings. "My artwork tends to draw on my new cultural environment and my past," says Shireen. "I love textiles and textures. They remind people of the old fabrics." The block she created features multiple layers of appliquéd, golden fabrics to represent a *dallah*, the long-spouted coffee pot symbolic of Arab hospitality and sociability. Cardamom-spiced coffee is served after meals or before business deals, whenever Emiratis get together. The *dallah* rests atop a handwoven cloth background that incorporates traditional Bedouin colours of deep red, black, indigo, green and natural tones.

Another sign of change in the UAE is the blend of modern and the centuries-old clothing styles. Many men wear a loose-fitting white cotton shirt-dress called a *dishdasha* and a tied head covering, while traditional women dress in the enveloping black *abaya*, a headscarf, and a *burqa* (or *burkha*) facemask. Younger women often sport modern outfits, but still wear the head scarf. Clearly defined roles that offer members security, advice and comfort exist in extended families. A typical family takes care of its elderly at home, where several generations may form the household. A traditional man will still negotiate a "bride price" with the father of his intended and the government has even established a Marriage Fund to enable Emirati men to meet the high cost of marrying Emirati women. Despite the vestiges of ancient ways, "the UAE has become more modern and cosmopolitan, and is more open and relaxed in the last ten years," affirms Shireen.

United Arab Emirates

" My artwork tends to draw on my new cultural environment and my past. "

Shireen Kamran

Cameroon

Maman Blandine

Surrounded by mountains of fabric of every description and her collection of old sewing machines, Blandine Ghaho reminisces about her life in Cameroon, the land of her birth. Her broad smile and welcoming face show the great love she nurtures for her country often nicknamed "Africa in miniature." The Republic of Cameroon is home to some 200 ethnic groups, a true cross-section of races, nations, and African tribes, from Arab to Fulani, Bantu to Pygmy. The landscape, as varied as the people who inhabit it, includes deserts, equatorial forests, large steppes, plains, as well as lakes, rivers and the sea.

Each region and each tribe is known for its own special craft. One of these is the ancient art of batik — intricate designs created by painting fabric with wax, vegetable paste or, sometimes, aged mud, to resist sequential immersions in dyes. Each stage in the design requires removal of the first resist, and then careful reapplication to the areas requiring protection from subsequent colours. An example of this techique, the hand-dyed cotton in Blandine's block is typically used by women for their daily dress and for wrapping their distinctive headdresses. Scenes of everyday life, men and women at work, or women in the home, are common themes. The cowrie shell, once used as the country's currency, now forms part of the decoration on clothing and is often used as jewellery. The gold fabric and thread used as borders have a special significance. Cameroonians believe that wearing gold surrounds an individual with protection, followed by good fortune and, as a practicality, it also provides insurance in case of hard times.

In Cameroon, Blandine trained future teachers. She had to be knowledgeable in all subjects, including trades and agriculture, particularly the operation of coffee and cocoa plantations, as well as the tailoring of clothes. She fled her homeland for political reasons and arrived in Montréal unable to work as a teacher without an official Canadian teaching certificate. Since then, Blandine has relied on her dressmaking skills to earn a living.

Known in the Montréal-African community as Maman Blandine, she continues teaching, cooking for large gatherings, sewing African-style clothing, and mentoring. Maman Blandine happily confides that one of the more rewarding aspects of her new life occurs in her small, overcrowded shop where people share their personal stories as she stitches, and she dispenses advice and wisdom born of her long experience.

Communicating by design

The Inuit of the Kivalliq region of Nunavut comprise numerous independent bands each with distinct identities. Band members are as few as five persons and up to 3,000 people, at Iqaluit. Situated along Hudson Bay and inland to the west, these bands were called Caribou Inuit because of their dependence on the animal. The caribou was a key to their survival and every part was used for food, clothing, utensils, and tools. When nomadic bands met, they used to participate in friendly competitions that became the basis for the modern Arctic Winter Games. The competitions helped build strength and endurance, important in the larger game of survival on the barren tundra where the Inuit moved with the migrating caribou herds.

Today's annual Games allow communities to gather and provide a diversion from the cold northern climate. Possibly the toughest of the traditional games is the One-foot High Kick. A combination of extreme coordination and power, it requires the athlete to kick a small, suspended sealskin target with one foot, and then to land with balanced control on the kicking foot. The world record of an incredible 9 feet, 6 inches was tied at the Native Youth Olympics in 2003. The Kivalliq block sports a scene portraying this game, surrounded by bright yellow calico fabric, which was once a popular trading item from the Hudson's Bay Company. The addition of a polar bear and the woman's tool, the *ulu*, carved from caribou bone, highlight their importance to the Inuit.

The block is a joint effort between Victoria Kayuryuk and Nancy Kangiryuaq of Baker Lake. Both women began sewing as little girls. Victoria helped her mother put insoles into *kamiks* and sleeves on parkas. Later she turned her skills to other artistic endeavours, such as printmaking and sewing wall hangings. Through her work, she relates personal stories and those of the people of Kivalliq. Design as a form of communication is an old practice. Patterns on clothing provided information as to the wearer's age, gender, social status, occupation, and geographic location. Victoria and Nancy's images depict an earlier life when their families subsisted on the land, hunting caribou and fishing in the many lakes and rivers and along the coast. Today, many Inuit have moved to northern, urban areas to seek employment, which for the most part is still extremely difficult to find.

Victoria and Nancy do not create art simply for art's sake. The process feeds a desire to touch people's lives. When Victoria was told that her art helped people heal in their life journeys, it reconfirmed her decision to share her artwork. Proud to share their stories and life experiences, the women's work speaks volumes of a deep love for their heritage. In a sense, Victoria and Nancy wear their hearts on their proverbial sleeves.

Nancy Kangiryuaq

Cambodia

" As a survivor, my spirit is composed and strong and optimistic. "

Sophol Tan Tuok

Of strong spirit

During the Khmer Rouge's reign of terror, Cambodian culture was virtually destroyed along with an estimated two million people. Yet, many ancient temples, including the famous Angkor Wat, survived. With its five towers, perfect symmetry and exquisite bas-reliefs, it is one of the most inspired religious monuments ever built. Unlike the other temples, it faces west, thus its sandstone façade reflects the sunset's peaceful beauty. That reflection is the spiritual heart and identity of Cambodia.

Against great odds, Sophal Tan Tuok also survived. Her entire family perished in Cambodia. Possessing uncommon courage, Sophal was just seventeen and completely alone when she left her homeland. "As a survivor," she says, "my spirit is composed and strong and optimistic."

Cambodian culture frowns on single women living alone, so Sophal married soon after arriving in Canada. From the time she met her Cambodian-born husband at a language class in Montréal, she has not looked back. Her melodic voice details a busy life of raising four children, operating a family jewellery business, and devoting time to community work.

When the talk turns to traditional Cambodian silk weaving, Sophal becomes animated. "I love it," she exclaims. Her cupboard reveals a treasure trove of handwoven silks, some with intricate patterns of silver and gold. When asked her plans for it, she breaks into excited laughter. Her passion is silk and she can hardly wait to design something special. For the block's background she chose prized *ikat* silk, where each strand is individually dyed before it is woven into the rich, colourful patterns. In the centre, Sophal pinned a gold *apsara* dancer, symbolic of the country's love of music and dance.

So much talk of Cambodia wrings out an admission. She does want to return to her homeland even though she knows she will confront painful memories. "But I just don't want to see it right now; it's not the time." She was pleased though, when her husband and seventeen-year-old daughter, Sopie, made the trip together last year. Traditions are important and they make an effort to share family history and Cambodian culture with their children.

It's been nearly twenty-five years since Sophal left Cambodia. The pull is strong and the thought keeps gnawing at her, prompting a vow: she *will* return. It seems important to her to go by herself. She says she will visit the temples, see the silkworm farms for the first time, and buy much-loved gemstones. "Soon," she says. Soon, she will go back.

Mystic tapestry

Wales

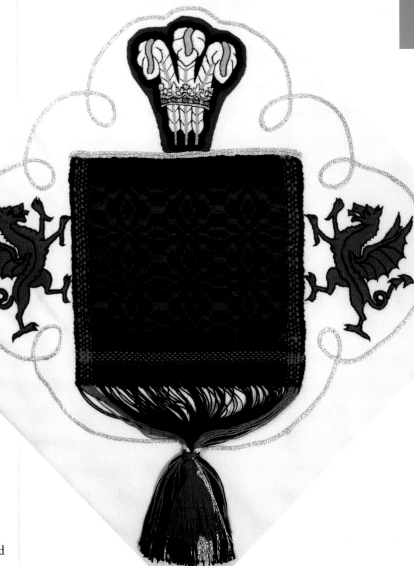

Riding the train from London to Aberystwyth to study law at the University of Wales, Peter Wells was struck by the "mystic tapestry" of the countryside. Fog and mist lifted like the veil of a beautiful woman, revealing glimpses of ancient castles and abbeys, glittering against emerald hillsides. Although the spectacular scenery left an indelible impact, it was the Welsh "positive approach to life," their smiles and genuine consideration, that thoroughly charmed him.

Likewise captivated by the charms of her Welsh-born suitor named Jock, Daphne Howells married him. Some forty years later, this avid weaver was asked to create a piece of "Welsh weaving" for the Wales block. All agreed this was *the* representative fabric of Wales, known as a nation of weavers. In Canada's pioneer days, itinerant Welsh weavers went from door to door, weaving the new season's spun wools. Daphne chose a heritage diamond design, which produces a pattern of stylized crosses, worked in black and red wool. Dark colours were favoured in coal-mining areas because soot was less visible upon them. To top the block, an embroidered crest with three ostrich feathers, stitched by Elsie Sloan, symbolizes bravery and traces its origins to the 1343 Battle of Crecy. Lore says the Prince of Wales collected the feathers from his fallen enemies. Feathers remain part of the present-day Prince's coat-of-arms. The Red Dragon heraldic symbols, meticulously brought to life by Reina Cross, frame the weaving and portray the legendary courage of the Welsh.

Pomp and pageantry are celebrated aspects of Welsh life. Their patron, Saint David, is honoured on March 1st by Welshmen around the world who "wear the leek," a custom since the 1300s, and since the 20th century, by wearing a daffodil. The Welsh love to sing, play music, and pen poetry. Little wonder they embrace a weeklong "Gathering of the Bard" at the Royal National Eisteddfod. Roots of the unique custom date back to a "bardic competition" held in Cardigan Castle in 1176, with the modern *eisteddfod* developing in the late 1700s. The goal was to restore some measure of quality and dignity to Welsh-language culture through spontaneous poetry-writing competitions, originally held in local taverns throughout the country. Wales distinguishes itself through the survival of the Welsh language, which in 1994, was given equal footing with English.

As for romance, it appears to be woven into the genetic fabric of the Welsh. Daphne's husband was an enthusiastic woodworker who built some of her sixteen looms. Shortly after Jock passed away, she came across his unfinished birthday gift to her in his workshop. She immediately recognized the delicate carved outline of a Welsh "lovespoon," a centuries-old token young men give to the girls they love.

In Canada's pioneer days itinerant Welsh weavers went from door to door weaving the new season's spun wools.

219

Northern Ireland

" Embroidery
is my life. "

Cynthia Jackson

Land of legends and lessons

The Giant's Causeway is an outcropping of some 40,000 massive black basalt columns rising out of the sea. Formed through volcanic activity some 50 to 60 million years ago, the hexagonal rocks found along the coast in County Antrim are clearly the work of the mythical giant Finn Macumhail (MacCool), according to local folklore. Finn was capable of amazing feats of strength and magic. To do battle with his rival, who lived across the sea in Scotland, he tore pieces of volcanic rock into columns to make a crossing. A more romantic version of the tale claims Finn fell in love with a lady giant and built the walkway to bring her home to Ireland from Staffa, in the Hebrides.

Whichever story one chooses, blockmaker Cynthia Jackson felt it was imperative to focus on a unique symbol for Northern Ireland. "It was difficult to settle on something that wasn't contentious, relating to the strife. Most Irish symbols can be attributed to either side …I wanted the block to include everybody." The Troubles, as they are known, have existed for close to a century, but for Cynthia, her beautifully stitched and embroidered block is an expression of hope for common ground in the future.

Cynthia chose a foundation of white Belfast linen, reflecting the country's beauty and strength. Making linen was once a thriving cottage industry and an economic mainstay. To form the Causeway, Cynthia used a combination of the traditional bound-thread and pulled-thread techniques to create various textures. Drawing on her two-year apprenticeship at the Royal School of Needlework, Cynthia developed a pattern for the block border that includes tied Saint Patrick's crosses and shamrocks, both traditional Irish symbols. Saint Patrick, the patron saint of Ireland, arrived in A.D. 432 and converted the entire island to Christianity by the time of his death. He is said to have used the shamrock to illustrate the Holy Trinity — three separate and unique powers existing in harmony and unity.

"I find stitched textiles are much more recognized as an art form in the United Kingdom," says Cynthia. "My goal is to have Canadians understand it is an art. The skills can be used in traditional ways or be very free." Cynthia, one of the first to hold a teaching certificate from the Embroiderers Association of Canada, passes on her passion for stitching in classes she gives internationally. "Embroidery is my life!" she proclaims. One day she hopes to spend time in the land of her grandfather, to further explore her Celtic roots. "My Irish ancestry peeks through all parts of my life," she notes, just like the glimpses of colour showing through her beautiful thread-work.

A family affair

Hélène Gros-Louis spent her idyllic childhood at a hunting and fishing lodge called the Sanford Club that was tucked away deep in the Québec woodlands near Lac St. Jean. The third child of a large, close-knit family, Hélène remembers how a tutor was brought in to teach the children; they had one for almost every grade. The Sanford Club was owned by wealthy Americans and managed by her parents. Her father also acted as a hunting guide, sharing his knowledge inherited from generations of his Huron-Wendat ancestors. The peaceful setting attracted many famous visitors; Hélène remembers hearing notable names such as Churchill and Colgate as a child.

The historical significance of these figures was lost on young Hélène. What captivated her interest were the Huron-Wendat crafts that kept her grandmother's hands constantly occupied. Through patient observation, Hélène learned how to sew, bead and tuft moose hair. Making "tufts" with hair taken from the back of a moose is a Wendat practise that is "quite tricky and takes strength," says Hélène.

Her skills merged seamlessly with those of her husband, Jean-Marie Gros-Louis, who descends from a long line of great hunters and trappers. Together, this husband and wife team makes leather shirts and other items in their home on the Wendake Reserve near Lorette, Québec. Jean-Marie cuts the leather while Hélène sews and embellishes it with beadwork and tufted moose hair. They sell their products at Le Petit Huron Moc, a Native arts store owned by Jean-Marie's brother, Gilles. A hunter and trapper like his brother, Gilles is deeply involved in the Wendat artisan community. Hélène inspired creative passions in her two daughters, keeping Wendat traditional crafts alive. In fact, everyone is involved in some way. "It's a family story," Hélène affirms.

The larger family of the Wendat is represented on the block by the "tree-of-life," resembling a Canadian balsam, created in a beaded outline and accented with caribou tufting. The Wendat used such trees to build dugout canoes and magnificent longhouses averaging 40 to 50 feet in length by 30 feet high. Even more important, it symbolized the people's strength and connection to nature and their ancestral homeland, on Georgian Bay in Ontario. In 1649, severely diminished by disease and war, the original four sub-nations of the Huron Confederacy were dispersed. Centuries later, hundreds of Wendat descendents returned to this homeland to celebrate the Feast of the Dead and to inter the remains of 500 ancestors who had been removed from a sacred burial ground and held at the Royal Ontario Museum for decades. It was a family reunion of the grandest kind.

Bahrain

Some scholars suggest that Bahrain may be the site of the biblical Garden of Eden.

The "Garden of Eden"

The Kingdom of Bahrain is an archipelago of thirty-three flat, sandy islands in the Persian Gulf. Amid this increasingly arid region dominated by desert, Bahrain's spring-fed greenery and lush dates give it the image of a mythological holy island. Some scholars even suggest that Bahrain may be the site of the biblical Garden of Eden.

The most impressive scene in the scorched desert is the phenomenal "Tree of Life," a 400-year-old mesquite tree that stands alone with no known source of water. Inexplicably, it flourishes in harsh, inhospitable conditions. The Bahraini people often discuss such mysteries as this with visitors and friends over a steaming cup of strong Arabian coffee. Coffee-drinking plays an important social and economic role in the country. Copious amount are consumed wherever people gather to tell stories, recite poetry, sing and dance, or enjoy sports. Bahrainis take pleasure in falconry, gazelle and hare coursing and, for the rich, horse- and camel-racing.

Often called "the Pearl of the Arabian Gulf," Bahrain was once a chief centre of pearling, with boatbuilding, weaving, pottery and other traditional industries. Numerous palm trees are used for making brooms, baskets and fans. Since the 1930s, however, oil reserves generate seventy-five percent of its revenue. This sudden wealth brought rapid modernization and improvement to Bahrain.

Distinctive gold-embroidered *thobes* (long tunics) and headdresses held by a black cord called an *agaal* identify Bahraini male clothing. Bahrain's block, stitched by Heather McKeller, features an example of the elaborate needlework used to embellish such traditional attire. The centre displays a variation of the Moon with Eight Rays design and, with the Ram's Horn motif, reflects the influence of Turkomen embroidery. Cypress trees, symbols of death and life, extend to each corner, while triangles, trees of life and more "moons" frame it. The centre cross within each "moon," formed by the absence of stitches, is a talismanic design called "the wide-open eye" and meant to ward off evil.

The vast majority of Bahrain's citizens are Arabs, who are either Sunni or Shiite Muslims. Small indigenous communities of Jewish minorities exist, and some Christian ones tend to be among the foreign workers in the land. Regardless of creed, whether or not Bahrain is the true location of the Garden of Eden will continue to be debated on the islands. Indeed there is no rush to settle this question since it makes for lively and convivial conversation over an aromatic cup of coffee.

Moko Jumbies

Viola Halley, a member of the St. Kitts Canadian Association of Toronto, fondly remembers the lush beauty of the islands of St. Kitts and Nevis. "Christmas is the best time to go" she urges, eyes bright. Christmas is when Kittitians celebrate Carnival, which begins on Boxing Day and ends on New Year's Day. It is the biggest event of the year.

The Carnival atmosphere is electric. The sounds of steel bands drift through the streets of Basseterre, the capital of St. Kitts. The streets overflow with revellers and street performers. Laughing children dressed in masquerade costume, brightly coloured ribbons flowing around them, dance and play, weaving their way through the crowd and between the stilted legs of the Moko Jumbies. Perched atop six to eight-foot stilts, the Moko Jumbies, dressed in vibrant costumes, parade the streets. Stilt walking is a skill that demands fine balance and agility, a way for men to show their ability.

Watching with bated breath as Moko Jumbies make their way through the crowds of partygoers, one wonders how they stay upright. Men attach the stilts by strapping them to their thighs from a second-storey window or verandah. Another six to eight inches is added to their height with a headpiece resembling the heart of the macaw plant in bloom. The macaw palm tree is extremely tall and thorny, and some believe that the word *moko* originated from the word macaw. Peacock feathers are fixed to the headpiece, reaching even higher toward the sky.

Viola collaborated with Gillian Legroulx to work out a design for the block. While Carnival was the main inspiration behind the final design featuring a Moko Jumbie, Gillian's favourite part of the block is the coconut palm trees. They are a reminder of sunny days spent with her mother eating coconuts. They would hire a local boy to shimmy up a palm tree to pick the coconuts. First, they would drink the sweet coconut water through a hole poked in the shell, and then, they would crack it open and eat the jelly-like pulp. "It tastes best that way," Gillian says, comparing it with the dried coconut found in most Canadian grocery stores.

Viola sees a strong future for expressions of their culture in St. Kitts and Nevis, and in Canada. "It will go on because they are teaching the children to dance, and they are participating in the festivals." Children are the real stars, Viola feels. They are the promise of a new day.

Nepal

Paul Mahler's photograph of Ama Dablam (Mother Goddess), her arms open, embracing all who pass her gates to Mt. Everest.

Goddess of the sky

Paul Mahler first travelled to Nepal, a Shangri-La for mountain climbers, in 1981. He walked up and down twisted, ancient streets lined with multi-roofed temples and stone sculptures. Everywhere he looked, spectacular colour surrounded him. The soft murmurings of chants and hymns became as familiar to him as the strains of Nepalese music, heralding an evening of singing and socializing. Flying home, he remembered the gleaming, white peaks of Nepal's tallest mountains, but most of all he remembered Mount Everest or, in Nepalese, Sagarmatha, Goddess of the Sky.

For a while Paul wondered if he had imagined it all — Nepal was the most beautiful place he'd ever seen! He went back for another visit, and then another and another. Each time, the same magic embraced him. He even learned the language. "My own version," he laughs, explaining that his limited vocabulary often meant speaking in the literal sense. Despite the occasional outbursts of laughter, people understood him. Over time, he travelled the country, and it seemed that no place was too remote, no community beyond his interest and eventual understanding. When his visits grew longer, he bought land and built a home so he could continue courting his "magical country."

Twenty-three years later, Paul's links with Nepal remain strong. He keeps in touch with Nepalese Canadians and has become such a trusted contact that the Canadian Nepalese Consulate asked him to represent them in the Invitation Project. In the block, fabric from a *topi*, Nepal's national cap, frames a beautifully embroidered mountain village scene. Made from woven cotton, it reflects the country's long history of weaving. The material in a *topi* and the way it is folded often signal a man's profession or his regional origins. This one comes from the lowlands and middle hills.

The Nepalese culture was shaped over the centuries by the Himalayas, a formidable barrier that kept them isolated from the outside world. Paul appreciates the unique way of life and describes the people as "uncomplicated, forthright, guileless and genuine. They are also optimistic, proud and generous in the purest sense." In their predominantly rural society, nearly eighty percent earn their livelihood through farming. The smooth functioning of Nepalese society rests on the enduring principles of community involvement and sharing. Western values championing individual success are a foreign concept. Yet, he says, Canada is held in high regard by the Nepalese.

Although Paul's travels to Nepal have lessened, nothing else has changed. His "mythical kingdom" still holds him in thrall. While practising his passion for free climbing, he's come close to death more than once. But mountain climbing remains as incredible and exciting to him as his experiences in Nepal. "There's nothing else like it," he says.

Take only what you need

The St'át'imc territory is located in the eastern edge of the Pacific Coast Mountain range and the western edge of the interior plateau of British Columbia, approximately a four-to-five-hour drive northeast of Vancouver. In this territory of approximately 160 kilometres by 160 kilometres, salmon taken from the rivers, creeks and lakes remains a daily staple. The St'át'imc use set nets, dip nets, gill nets and hook and line for fishing and are renowned for their method of wind-drying salmon for winter use. St'át'imc (pronounced similar to "Stat-li-um") value their way of life and are committed to passing on cultural knowledge and traditions.

Before the Indian Act Legislative system, the St'át'imc lived in permanent villages during the winter and travelled to various seasonal food-gathering places during spring, summer and autumn. Organized into clans, they were governed by elders and other chiefs in each village. Chiefs were people with specific skills or knowledge. An able hunter and a good orator would each be considered chiefs, earning the position through hard work and training. Their language, St'át'imcets, has been designated as part the Salishan linguistic group and consists of the Northern and Southern dialects.

St'át'imc artist Ted Napoleon, of the T'ít'q'et community located along the Fraser River, wanted to reflect the economic and social aspects of his people's way of life. Ted explains the importance of his design's centrepiece: "The hand-drum is a major method of musical expression in the tradition of my people." Other vital components of the St'át'imc way of life are hand painted on the taut deer hide. A woven cedar-root basket overflowing with berries represents the ongoing use of resources gathered from the land. A personal hand-drum, often used during social events and a fisherman using a dip net are illustrated. A deer, which provides meat, hide, antlers (used to make the buttons decorating the block), sinew and bone needles for sewing, remains an important part of St'át'imc culture.

Ted uses his art as "his personal expression of his culture and values," says his sister, Marilyn Napoleon. Through his work, Ted also exemplifies beautifully the St'át'imc principles of "live your culture and values and share your knowledge."

> The hand-drum is a major method of musical expression in the tradition of my people.
>
> *Ted Napoleon*

225

Albania

" Patterns were passed
down among families. "

Mary Kerim

Bujari

Mary Kerim's memories of her childhood in Albania remain vivid. One of Europe's smallest countries, it has the Albanian Alps in the interior and coastlines on both the Adriatic and Ionian Seas. Historically called Illyria, Albania has existed since before written accounts began. The 2,400-year-old city of Berat is known as "The Museum City" or "City of a Thousand Windows." Mary recalls, "Its little homes are built in steps on a mountain. The stones have been sun-bleached and when you look up the valley, it just gleams — it's white, absolutely white."

Textiles surrounded Mary as a child in Albania, where large flocks of sheep provided wool for household needs. She remembers her grandmother carding wool and knitting the spun yarn into socks and sweaters. Weaving looms, kept close to the kitchen, produced carpets, clothing and blankets. Elaborate embroidery, with all its regional variations, was part of costumes and household linens. "Patterns were passed down within families and when friends came to visit, we would show them how to do the stitches," says Mary.

Treasured family heirlooms in her Toronto home inspired Mary's design for the Albania block. "When I was young, we had two sets of full-length drapes on each window, one hand-crocheted and the other cotton, embroidered in silk thread." The block's decorative pillow design is reminiscent of those on the chairs in her parent's dining room. Silk floral embroidery brings to mind small, fragrant, courtyard gardens, while the crocheted lace trim came from her husband's family. Mary says, "Women would get their work done in the morning and visit together in the afternoon to do crochet or embroidery."

Delicate needlecrafts are in sharp contrast to the strength of character and noble qualities of the people themselves. Albania, meaning "Land of the Eagle," derives from a beautiful folktale of a young hunter who becomes king after he receives special gifts and protection from a mother eagle for saving her eaglet.

Known for their *bujari* (generosity of spirit) and loyalty, Albanians warmly welcome strangers and are true to their word even in extreme circumstances. When they perceive a need, they try to fill it. This is indeed true of Mary and her husband, also an Albanian Canadian. In 1954, they helped to establish the first mosque in Toronto, creating common ground for the Islamic community, a meeting place for Muslims from many different nations. Years later, Mary's generous spirit took her back to her homeland where the Communist government had destroyed the mosques and churches. There, she built the Qerim Ajce Mosque to honour her deceased husband and his family in their hometown of Bilisht. Mary Kerim's Albanian *bujari* had come full circle.

Mediterranean crossroads

In the small village of Matmata, 250 miles south of the capital of Tunisia, a constant stream of four-wheel-drive trucks and tour buses stop for the afternoon before continuing on to the desert safari or the next location on the package tour. The lunar-like landscape made it an ideal location for the desert scenes in the movie *Star Wars*. The village and its underground pit houses fit into the austere landscape. The Berbers have lived here for the last thousand years, sheltered from the extreme heat of the summer in identical underground houses with courtyards dug about twenty feet deep and rooms tunneled out from the sides.

Although the Republic of Tunisia is the smallest country in North Africa, its strategic position bordering the Mediterranean Sea allowed the Phoenicians, Romans, Vandals, Byzantines, Arabs, Ottomans, and the French to visit its shores. Each left their mark on the country. While it retains the old French colonial influence, it loses none of its authentic Arab flavor. Dating back to the 7th century A.D., the capital city of Tunis is one of the oldest cities in the Mediterranean region. It has a European feel displayed in its wrought-iron railings, louvered windows, sidewalk cafes and patisseries. Tunisia is a country that has one foot walking swiftly into the future and the other foot firmly planted in the past. Visitors flock to the ancient Roman ruins of Carthage, El-Jem or Dougga. Cap Bon Peninsula is a primary destination for tourists in search of dance clubs, restaurants, colourful shops, and the southeastern beaches with their blue and green Mediterranean water.

Tunisia is known for its distinctive woven carpets, pottery, copper, leather work and its very original gold embroidery, often featuring flat couch-work made into panels. Gold and silver stitching on clothing is the country's principal embroidery. Normally done on silk or velvet, the motifs are usually talismanic. Blockmaker Habiba Reda has chosen the fish, the great Tunisian good-luck symbol, and the Hand of Fatima as the theme for the Tunisia block. Symbolic renderings of the Hand of Fatima, the *Kmamsa*, can be seen everywhere in Tunisia: carved into front doors, painted with henna on women's hands and embroidered on clothing. Stitched on a teal silk background, the symbols are outlined in couched silver thread, augmented by gold flat-metal threadwork and sequins. Traditional beauty continues in a new light.

Maldives

> "Their lacquer ware shows how creative and clever the people are with such limited natural resources."
>
> *Joan M. McGrath*

A little piece of paradise

The Maldives are called "the last paradise on Earth." Visitors are quickly won over by the tall coconut palms, stunning white, sandy beaches and crystal-clear lagoons of this island republic. "The people are so cheerful and kind, and it is absolutely beautiful!" say Joan and Gerald McGrath, who fell in love with the islands when Gerald was posted there with the World Bank.

The exact origins of the Maldivian people are lost in antiquity, but for over 3,000 years, African, Arab and southeast Asian mariners have populated about 200 of the 1,196 islands that comprise the Maldives. The islands stretch thousands of kilometres, from the southwestern tip of India all the way to the equator. As a consultant in land administration, Gerald was called to advise on some of the archipelago's land problems. The main island of Malé, in need of more space, will eventually expand onto a new island by filling up parts of the reef with rocks and sand. Lack of usable land places limitations on agriculture and tourism.

While her husband wrestled with these issues, Joan spent a great deal of time sketching and painting scenes of daily life. "The fish market was most fascinating. There were docks filled with beautiful bright-coloured boats that would carry fish to the market onshore. The shark was down at one end and the tuna at the other," Joan says, recalling the sights and sounds of the daily fish transactions. Fishing was the island's main occupation until the arrival of tourism. The protective coral reefs surrounding each island are home to hundreds of species of tropical fish and countless forms of marine life. While ubiquitous, the marine life is still impressive to the locals. Joan remembers, "One day there was quite a fuss…there in the water was a huge shark patrolling the shoreline, with its fin cutting back and forth. The local people were very excited about it because it was so big. You could see it clearly from the second-floor window of the office building we were in!"

Carved pieces made from coconut palm wood covered with layers of lacquer are a speciality of the Maldives. Joan says, "Their lacquer ware shows how creative and clever the people are with such limited natural resources." For Joan, the small, deep orange-red and blue lid at the centre of the block carries fond memories of her unforgettable time in a tiny paradise.

Coming home

The summer Marilyn Cornelius started to play clarinet in a marching band in her parent's and grandparent's hometown of Oneida, Ontario, was the summer that determined her future. Born in London, Ontario, Marilyn grew up in Detroit, Michigan. During the summer months, her parents would take the kids to stay with their grandparents in the Oneida settlement southwest of London. One summer Marilyn was talked into joining the local marching band. "It was through the band that I met my husband," she smiles.

She married Neil W. Cornelius in 1976 and moved permanently to Oneida, where she began to learn more about her own traditions and culture. Neil had always been very interested in his people's history. He even wrote a university paper on different types of Oneida textiles, ribbons and beading. When Marilyn took up quilting, she looked for inspiration in the patterns of traditional beadwork and pottery, and incorporated them into her work. "Neil is my greatest resource," she says. "He would always help me out, letting me know what they used and didn't use." She learned how to do the quilting stitches from her grandmother, but Neil and his mother taught Marilyn to assemble the pieces and sew the quilt tops together.

Although Marilyn and Neil don't have any children of their own, they have many nieces and nephews "and even more in the next generation down." One niece, Rosalind Antone, is an artist. She designed the Oneida block and her sister, Tonya Lyn Antone, helped with the beadwork. As the centrepiece, Rosalind chose a turtle appliquéd on leather to represent North America, known as Turtle Island among Native peoples. The white pine on the turtle's back is the great Tree of Peace. The Oneida, or "People of the Standing Stone," are part of the Six Nations (or Haudenosaunee Confederation, with the Mohawk, Cayuga, Onondaga, Seneca and Tuscarora), who have this tree as part of their teachings. The calico border is typical of the colourful fabrics used to make dress shirts for men and dresses for women, whereas the beaded lower border is symbolic of the plant life important to the people.

Retired from her job in an insurance company, Marilyn now stays at home, where she can spend more time working on her crafts. She and Neil dream that one day they can start a business to market Oneida artwork. They are keen to see the arts and crafts of their people flourish.

Oneida

Tiionen'Iote

When Marilyn Cornelius took up quilting, she looked for inspiration in the patterns of traditional Oneida beadwork and pottery.

Bahamas

" To me, the Bahamas
are not part of the
stressed-out world
we live in today.
People move more
slowly, enjoy
their lives. "

Susan Cole

Conch chowder

"To me, the Bahamas are not part of the stressed-out world we live in today. People move more slowly, enjoy their lives, their surroundings and are not in a hurry to let life pass them by," reflects Susan Cole. Her Bahamian heritage has given her a confident optimism and a relaxed nature, even in her busy life in Canada.

When Christopher Columbus arrived on the islands, he named the area Bahamas from *baja mar*, meaning "islands of the shallow sea." Bahamians are blessed with an exceptional climate and culture. Their country comprises over 700 islands, of which only thirty are inhabited. Many islands remain remote and unspoiled. Susan remembers, "As a child, we would go on boat rides with family and friends. We would pull up to a tiny little island that might have a couple of palm trees on it and spend the day lounging at the beach, swimming in the clearest waters you have ever seen. It would be our own private oasis for the day. It was a barefoot, carefree life and a wonderful environment for a child to grow in."

The culture is a mix of island and colonial heritage, blended into a rare concord of beliefs, backgrounds and traditions. Bahamians have a long history of celebration. Junkanoo is the nation's most famous festival and is often called the centrepiece of Bahamian culture. The joyful island music, which includes reggae, steel drums and calypso, has become popular around the world.

Designing the block for the Bahamas led Susan to reflect on events and images from long ago. "I struggled initially because the image of the Bahamian flag kept influencing me; our flag symbolizes the sky, the sand and the sea, all touching the people. Then I thought of the conch. Not only is it a symbol of the sea, it is also a major ingredient in many of the traditional Bahamian recipes. Conch fritters, conch salad, conch chowder — yum! I also discovered that the conch is on the Bahamian coat of arms." Gently folded Bahamian sea-island cotton recalls the soft winds and blue skies of days spent by the sea. Iridescent netting and threads create the appearance of white sandy beaches shimmering under the hot sun. Since Susan's memories of walking among the woven bags and baskets at the straw market were especially vivid, a raffia braid became the frame for the scene, completing the picture of the Bahamas both visually and emotionally.

Susan hopes that the spirit of Bahamians, the music of the steel drums and the country's crafts will be embraced by the next generation. Playfully she adds, "Personally, I hope my mom passes on her recipes for conch chowder and banana bread. I just love Bahamian food!"

Rags into riches

Until they moved to Canada in 1990, Samira Elmasri, her husband and three children, never thought they would leave their beloved homeland. She explains that being Libyan is like being part of a big family. "We are not people who easily immigrate to other countries."

Samira's father was well known and respected in Libya, where he worked in government until a coup d'état disrupted their lives. He was much loved in his own family, especially by his daughters. Unlike many Libyan men, he was close to his girls — he ate with them, sought their opinions and discussed his work. His daughters were among the first women in Libya to drive a car. Samira and her sisters had freedom and a good education, but because Samira's father had lost his own parents when he was very young, he didn't sleep well when his children were away. He couldn't bear the thought of separation, so Samira, who wanted to study art in Italy, stayed in Libya and became a teacher. "I discovered that I could still use my creativity," she says.

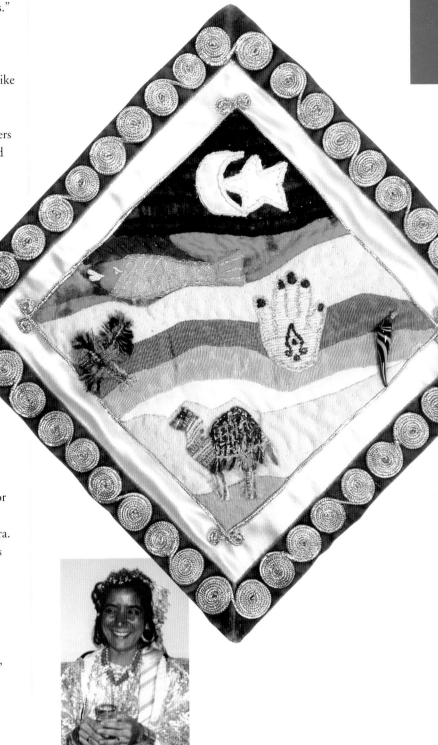

Sadly, Samira and her father were separated nonetheless when she emigrated. Making art, when it is part of someone's very being — as it is for Samira — is a calling that cannot be denied, no matter where you live. Everywhere in her home, in her activities, in her dress and in her conversation, her artist's nature bubbles out. She has created heavily textured rich-orange walls in her kitchen, and in the living room, arches reflect the colours of the desert and shapes of Libyan architecture. "My kitchen, my home, is a continuous work in progress," laughs Samira.

Since coming to Canada she has, in particular, renewed her love for quilting. "When I was small, my grandmother had cut squares of remnants for me, and I made a little tablecloth," remembers Samira. "She called it my rag tablecloth. I hadn't thought about it for years until I came here. My passion for quilting started all over again." When Samira called her mother to ask where the tablecloth was and found it was long gone, she wept.

Now Samira collects lots of "rags," giving them new life in many different ways. Even a piece of her daughter's wedding dress fabric, outlined by embroidered ribbon, is included in the Libya block. Samira used the colours and textures of her favourite natural silks to enhance her design. She created a fluid, layered night sky, contrasted with dunes blown into ever-changing shapes by sand storms. Superimposed on this are the moon and a star, important guides to sea- and desert-travellers. Through these elements, as in all her art, Samira honours the cultural and physical landscape that is deeply ingrained in her heart.

Gabon

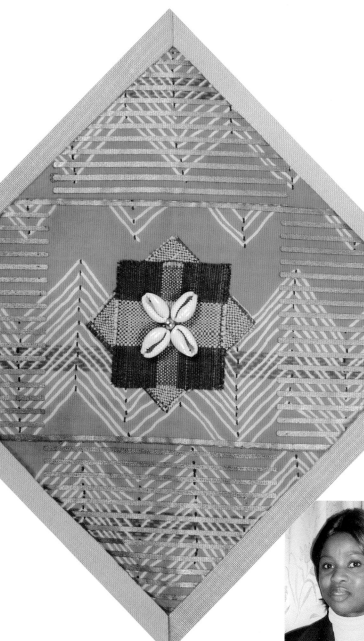

Peaceful refuge

Known as French Equatorial Africa before achieving independence in 1960, Gabon borders the ocean on the western coast of Africa. Because it straddles the equator, its climate is stable — just heat, more heat, and humidity. Henriette Ognaligui Gauthier, with the Embassy of Gabon in Ottawa, says it rains nine months of the year. She views this optimistically, because Gabon is eager to develop agriculture. More than three-quarters of the country is covered in lush, dense rain forests containing many woods that are desirable exports. Gabon's soil is rich with minerals that are processed outside the country, including petroleum, uranium and one of the world's largest deposits of iron ore.

At home, the Gabonese make creative use of many natural materials. The grassy fibres from palm leaves are dried and made into an astounding array of raffia articles. At the centre of the Gabon block is an example of raffia cloth, once used for clothing. Even today, it is used for daily articles and can be woven to make fine silken fabric for ceremonial garb. The Fang and other tribal groups carve beautiful face and full-head masks from indigenous wood. *Mpingou* stone is sculpted in bas-relief to form large, weighty tableaux. Musical instruments, foods and traditions are all drawn from nature's bounty.

This is a developing nation with an ancient history and modern cities. Its small population still has close ties to France, whose influences on the former colony are very strong. French is the official language, understood by all, despite there being forty dialects used in the nine provinces, says Henriette. This land whose original inhabitants were Pygmies receives thousands of immigrants each year as residents of war-torn neighbouring countries cross Gabon's border in search of stability.

Henriette describes her countrymen as "very open, very hospitable and very peaceful. We dislike conflict. People come from all over to find jobs, as we have few laws that prevent immigrants from working." She is pleased with the acceptance shown in her society. "With such diverse ethnic origins in the population, even young children are used to many different people. People are religiously tolerant of one another." Women have equal status and pay equity with men, she reports. The same opportunities exist for both, though she concedes, "women haven't always taken advantage of the possibilities at the same rate as the men." Perhaps Gabon's greatest wealth and exports are the Gabonese people themselves, extending their tolerant and generous attitude to their fellow men.

> " With such diverse ethnic origins in the population, even young children are used to many different people. "
>
> *Henriette Ognaligui Gauthier*

The turtle's tale

In the 1930s, Francis Baptiste was a young child of the Okanagan Nation under the tutorage of Anthony Walsh, who had arrived at the Osoyoos Indian Reserve in southern British Columbia to teach the children. Fascinated by the culture and the talents of his young charges, Walsh coaxed them to sing traditional songs, tell legends and paint pictures. Francis Baptiste showed exceptional talent and became the first Canadian boy to win a Royal Drawing Society competition for Commonwealth children with his painting on a piece of buckskin.

Francis became a well-known artist whose works were exhibited in several countries. Despite his fame, he stayed on the reserve, where he and his wife raised a family of twelve children. One of their sons, Richard, was partially deaf and spent much of his time with his grandparents instead of going out to play. His disability turned out to be a blessing, as he learned much more than the other children about his culture and the traditional ways.

Richard and his wife, Colleen, a non-Aboriginal woman who grew up a short distance from the reserve, have three children. Again the Okanagan history is passed on as Richard teaches his teenage sons, Wade and Ryan, the traditional hunting ways. When they get their first deer, for example, "they have to give everything away except the antlers," explains Colleen. They also go fishing and collect Indian tea from bushes high up in the hills, and red willow tea for healing the effects of poison ivy.

Although she is not officially Okanagan, Colleen has lived on the Osoyoos Reserve near the American border for about twenty years and is very much at home among its 350 people. As community-kitchen coordinator, she teaches cooking to kindergarten children, works with the local health department, and sometimes makes a huge pot of soup to share with the entire community.

At the request of Okanagan Chief Clarence Louie, Colleen created the block to represent the Okanagan people. She is known for her quilting and beadwork, and here works on the same kind of buckskin canvas that her late father-in-law, Francis Baptiste, once used, painting an image of the all-knowing coyote to symbolize the people's legends.

In 2000, an anthropologist came to the community to work with the children in retelling the legends and stories that Anthony Walsh had awakened seventy years earlier. In 2004, the children made their own costumes and produced a play based on the legend *How the Turtle Got Its Tail.* Richard and Colleen's seven-year-old daughter, Taylor, Francis Baptiste's granddaughter, played "Turtle" and once again an ancient legacy was passed on to an eager young generation.

Okanagan

Suk'naqinx

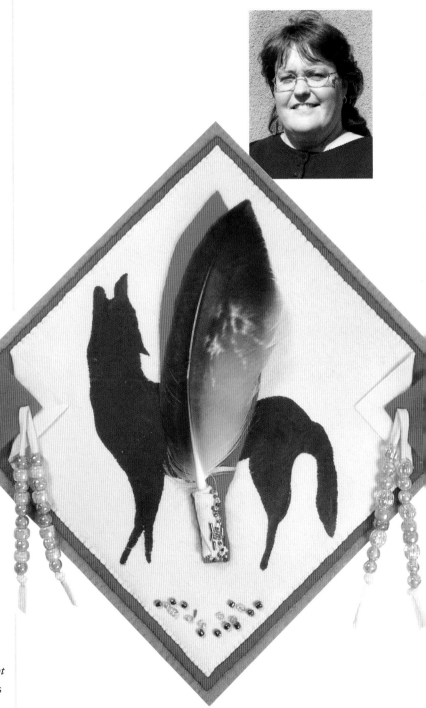

233

Morocco

Riches of the marketplace

The lure of joining a French-speaking society in a Western country brought brothers Khalid and Jalil Ben Thami to Montréal in 1998. Leaving behind their homeland in the northwest corner of the African continent, the two men created a home-away-from-home in their shop called Le Marrakech Store. The brothers go to great lengths to fill their shop with a wide display of goods, saleable or not. They have fashioned "a place of discovery" for Canadian shoppers — a visual feast of crafts from all over Morocco. Stepping through the door into their miniature market evokes images of the famous "souks," where stalls in narrow walkways and tunnels sell handmade goods of every description. Most Westerners know of these exotic Moroccan markets from popular films such as *Casablanca* and *Lawrence of Arabia*.

Early on, Khalid developed a profound respect for craftsmanship. Quality, skill and craftsmanship are much admired in Moroccan society. Morocco's famed leatherwork, *Maroquinerie,* has been highly prized since the 16th century. Rugs, whether silk or wool kilims, Berber carpets, hammered silver mirrors, cushions, jewellery and furniture all represent time-honoured crafts. The brothers collect many pieces to showcase the varied talents and the range of objects made by their compatriots.

The materials and skills used in the Morocco block express the people's love of diversity. A *fibule*, the specially crafted brooch that clasps women's handwoven shawls, is pinned in the centre. Taking its inspiration from the enamelled pin, the colourful embroidery style is from Meknès, one of several towns with a longstanding reputation for distinctive needlework. Moroccan textile arts are defined by their visual intricacy and by a preference for abstract forms and repetition in their design.

For the brothers, the diversity of cultures, the familiar French language and the international flavour of Montréal make their new home in Canada an inviting environment in which to build a new life and share the richness of their culture.

Khalid and Jalil Ben Thami have fashioned "a place of discovery" for Canadians.

Then and now

Qatar is an incongruity — a desert country surrounded by water. It juts northward from Saudi Arabia into the Persian Gulf, a small peninsula about the size of Jamaica. Originally settled by nomads from the interior Arabian Peninsula, Qatar (pronounced *KUT-ter*) was a British protectorate at the beginning of the 20th century but became totally autonomous in 1971. With one of the fastest-growing economies in the world, and a per capita income that hovers around US $28,000, Qatar thrives from sales of petroleum and huge natural gas deposits said to be enough to heat all U.S. homes for over a century.

Although it is one of the most conservative Arab nations, Qatar now has unprecedented access to modern ideas and opportunities. Women out-number men at the universities, which includes a branch of Cornell University's medical school, yet attend segregated classes. Traditional Bedouin culture and history is still passed on through poetry and song, strongly influenced by the Islamic religion. Each household is part of a clan, which is a group of related families, and ties among these family members remain strong. Hospitality is a very important feature of Qatari life, though to this day men and women rarely socialize together.

When blockmaker Hanan al-Hammadi arrived from Qatar in 2003, the Canadian climate presented the most immediate change. "I really miss the hot, dry weather of Qatar," says Hanan. She has a hectic schedule as mother of young Omar and as an intern and resident in family medicine in Montréal. She misses the communal meals that are typical of family life in Qatar, but experiences such occasions with the "extended family" of the Arab community many weekends. "In my culture, members of the family look after one another," she muses. "When one cooks, one also offers food to one's neighbour."

Hanan and her dermatologist husband try to carry on this tradition in Montréal — particularly at holiday times. Among the most important holidays is Eid al-Fitr, which ends Ramadan, the ninth month of the Islamic calendar and the period of daytime fasting. Even the 400,000 "guest workers," foreigners who bolster the native Qatari population of about 200,000, are expected to refrain from eating, drinking and smoking in public during Ramadan.

In Qatar, traditional clothing dominates, though younger women are likely to wear Western garments under their long black *abayas* or *al-darraas*. Intricate patterns in fine silver or gold *al-zari* embroidery embellish indoor dress. Similar gold threadwork outlines the medallion on the Qatar block. The design replicates a seal found on their bank currency (called the riyal). It shows the importance of palm trees (for food and oil) and the distinctive boat called a *dhow*, supported by crossed sabres.

> " In my culture…when one cooks, one also offers food to one's neighbour. "
>
> *Hanan al-Hammadi*

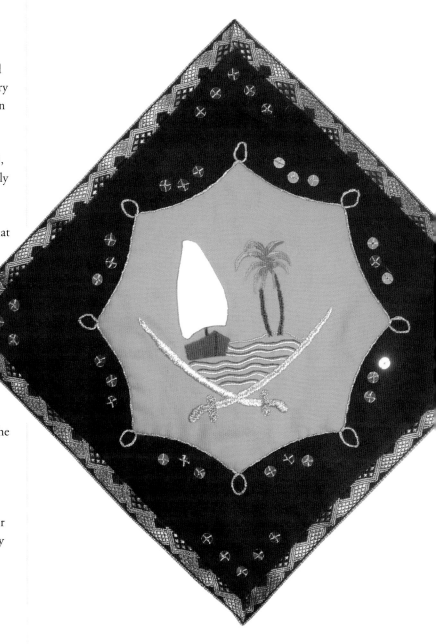

Philippines

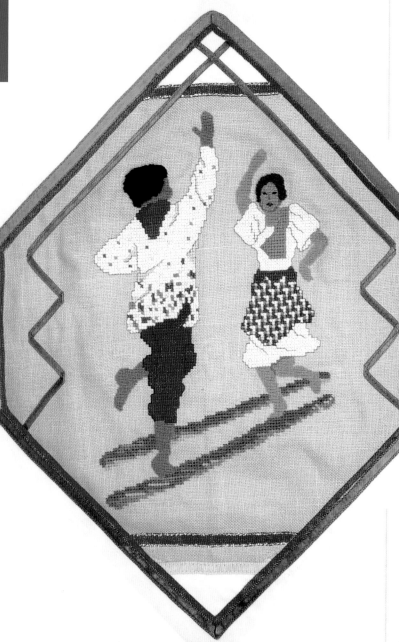

Tinikling

Like many immigrants who move to Canada from warmer climes, Annie Miaral misses the great weather of the Philippines. She also misses the hundred species of orchids and the fiestas, but she especially misses the dancing. "*Tinikling* is the national dance — and it requires a lot of practise," Annie chuckles. In this dance for one or two persons, the participants are said to imitate the movements of the *tikling* birds as they wade between grass stems, over tree branches, or avoid bamboo traps set by farmers in the rice paddies. "Dancers try to imitate the bird's grace and speed in their steps between two poles that are pounded on the floor and then together in rhythmic sequence," she explains. "There are lots of bruised ankles when you are learning!" The Philippines block portrays an embroidered *tinikling* couple wearing traditional costumes in bright red, blue and white.

Annie says Filipinos "love to party and dance." There is always a fiesta underway somewhere on the islands. There are parades, concerts and fireworks to celebrate events grounded in religion, fishing, planting, harvesting or the nation's tumultuous history.

Filipinos declared their independence from Spain in 1898 through armed conflict. Unfortunately, the Spanish–American War broke out and Spain ceded the islands to the Americans, who then introduced the English language and democracy. When the Philippines finally regained independence in 1946, the Americans maintained their army bases there and claimed rights to many natural resources. The elite kept economic power and under the twenty-one-year rule of dictator Ferdinand Marcos, the gap between the rich and the poor increased. He was finally driven out of the country after the 1986 elections. Political prisoners were released and free speech was restored, but the nation faces serious issues of debt, reform, deforestation and overpopulation. Many ethnic groups, speaking eighty-seven different languages, inhabit the more than 7,000 islands that make up the Philippines. More than 300,000 Filipinos now live in Canada.

A chemistry teacher in her homeland, Annie arrived in Canada in 1989 as an economic refugee and worked as a domestic. When she identified "much injustice" in the bureaucratic immigration system, she took action. She was elected president of the Ottawa Multi-Cultural Homemakers Association, educating and lobbying on behalf of all domestics. Annie keeps the Filipino spirit alive as president of the Philippine Folk Art Society in Québec. She promotes her culture through music, dance and art. She remarks, "Every time I see someone performing the *tinikling* dance, I feel proud that it is distinctly Filipino."

> " Dancers try to imitate the bird's grace and speed in their steps between the two poles. "
>
> *Annie Miaral*

The next generation

Margaret Apt of the Passamaquoddy First Nation was living in Perry, Maine, when as a child she snitched a few flowers from a neighbour's garden. She was taking them for her grandmother. This made it right in her eyes. But suddenly the neighbour was there, telling her why it was wrong. As instructed, Margaret took the flowers home and confessed, with the neighbour's ominous warning trailing behind her: "Tell your grandmother I'll be over later."

Big or small, theft was theft, and like a five-bell alarm, the traditional community safeguards dropped into place. Margaret laughs, recalling *all* her ensuing confessions. She considers it fortunate to have grown up in that time, when only the Passamaquoddy language was spoken in the village. Her cultural education, through "parents, elders and the community," embraced her like a warm, sturdy cloak. "It was the whole community that raised the children," she explains, "not just one set of parents."

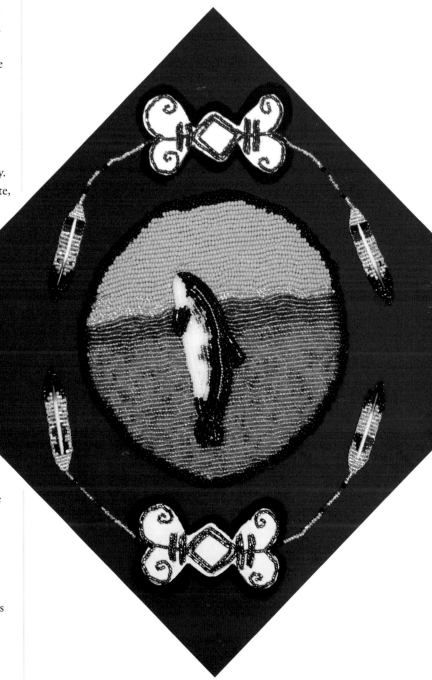

In the last twenty years, she has seen this integral part of the Passamaquoddy culture erode. A former tribal councillor, Margaret says the "constant struggle" is keeping the youth connected culturally. Annual events such as the Indian Day Weekend celebrate and educate, but Margaret looks beyond that. "It is something that needs to be done on a daily basis to take hold and flourish." She raised five children, reminding them: "Never forget who you are or where you came from." But the fast-paced world viewed through the eyes of her six grandchildren and their peers — the next generation — is different. "They know who they are," Margaret observes, "but they don't know where they fit into the grand scheme of things."

Margaret knows where she fits in, especially when she steps through the doors of the Waponahki Museum and Resource Center where she has worked for eight years. Surrounded by tangible history, she has reason to be proud and connected. Excitement rides high in the Language Room, where she is working on a second, expanded edition of a Passamaquoddy-language dictionary. It will have about 26,000 more words than the first 3,000-word edition, Margaret says, pleased that the Center has evolved as a place of community pride.

It is this community pride that Margaret and collaborators Tonia Smith and Debbie Yarmal bring to the Passamaquoddy block. They feel it is important that the "People of the Pollock," who have always lived along the Atlantic Coast between New Brunswick and Maine, be represented as a people who have their roots in Canada. Their connection to the sea and its bounty of sustaining marine life is beautifully expressed in the beaded porpoise leaping from the blue waters of Passamaquoddy Bay.

Liechtenstein

> As a child, to see a castle that actually had a prince and princess living in it was magic! "
>
> *Ruth Lewis*

The little kingdom

Ruth Lewis has always felt an affinity for Liechtenstein — a tiny kingdom gently nestled in the Rhine Valley. She recounts with a hint of longing in her voice the great many times she has seen the magnificent scenery and breathtaking beauty of this land as she travelled home to Switzerland, and she marvels that a country with no army has remained peaceful and neutral for hundreds of years.

Ruth's strongest memory of Liechtenstein, and the theme of this block, is Schloss Vaduz (Vaduz Castle), the official residence of the ruling prince and his family since 1938. The castle, once used as a barracks, a prison, a restaurant, and as a temporary seat of administration, sits high on an outcrop of rock and provides a spectacular view of the village and valley below. Ruth remembers, "As a child, to see a castle that actually had a prince and princess living in it was magic!" It seemed only natural that this 13th-century architectural treasure to become the central image of her block.

Mindful of her responsibility to justly represent the country, Ruth consulted a friend, and then the friend of her friend who lives in Liechtenstein, for their thoughts. Photographs, books and articles she received confirmed that the castle was indeed the right choice. Her resulting block features an embroidered depiction of Schloss Vaduz framed against an outline of handpainted mountains. Each mountain has a name and can be identified easily by Liechtensteiners. The needlework framing the scene is a typical folk-art design often used on buildings and wood furniture, as well as around door and window frames.

Once an agricultural nation, Liechtenstein has rapidly become industrialized since the 1960s. Although there is still no airport nor even a major railway station in the capital city, the country has much to offer. Still, Ruth suspects that travellers who hurry through on their way to somewhere else often miss the magic and beauty of her little fairy-tale kingdom.

Engineering a future

Meeting challenges has been a part of Tatiana Zmeu-Sanina's life since she came to Canada from Moldova in 1992, one year after the collapse of the Soviet Union. A civil engineer in her native country, which boasts a ninety-nine-percent literacy rate and widespread higher education, this petite blonde now builds communities through links to her past, rather than structures. She teaches the Russian language to children through the Holy Trinity Russian Orthodox Church in Toronto, the largest parish school of its kind in North America.

When Tatiana and her family arrived here, she and her husband had only some night-class English lessons under their belts. "We knew no one here; my first friend was a dictionary!" she says, laughing. They eventually succeeded in obtaining their Canadian citizenship with the support of their church and the Russian Canadian Cultural Aid Society. Pleased with her new status, Tatiana still treasures her memories of growing up in Chisinau (Kishinev), the capital city, located in the lush central region. One of the main producers of food and wine for the USSR, this fertile country half the size of New Brunswick is bordered by Romania to the west and Ukraine on the north, east and south.

Julia Sanina, Tatiana's mother-in-law, who lives in Moldova, is a skilled needle-worker. She sends Tatiana many embroidered pieces along with her frequent correspondence, providing a textile link to their homeland. It was natural for Tatiana to ask Julia to help make the Moldova block. Encouraged by Julia, Tatiana revived the basic embroidery skills she had learned in school. Russia, Turkey and Romania influenced Moldova's distinctive designs, and needlework is customarily used to decorate national costumes and household linens.

The geometric pattern the two women created together for the Moldova block incorporates complex symbolism. Tatiana points out: squares represent wealth; diamonds are a sign of family prosperity; horns reflect the desire to have a large herd of cattle; straight paths express wishes for happiness; winding paths represent creeks or rivers full of water. Each colour has its own meaning, too. White stands for purity, truthfulness and sincerity; blue denotes peace; green signifies calmness; black represents the fertile soil; and red, the blood spilled in defence of the country.

The years in Canada have brought many changes to Tatiana's family. The tattered dictionary is no longer a constant companion, her husband is self-employed, and their two children are in university. Since they can rarely afford to return to Moldova, plans to visit their many family members in Russia and Moldova come together carefully. In the meantime, a warm and welcoming Tatiana quietly helps young people remember the road their parents took and how important it is to connect with their heritage.

> We knew no one here; my first friend was a dictionary.
>
> *Tatiana Zmeu-Sanina*

Slovakia

Elena Cincik-Mirga and Esther Bryan

When Esther met Elena

When artist Esther Bryan (née Gazdik) went in search of her Slovak roots, she began at ground zero. Forty years earlier, her father had left his East European homeland and the painful realities of his youth behind. "He spoke very little of Slovakia," Esther remembers. Yet the family sensed a lingering sadness behind the silence.

The experience of language teacher Elena Cincik-Mirga and her family was quite the opposite. Traditional culture played like a finely tuned violin in the Cincik household. Elena's father, a language professor, insisted they speak only Slovak at home. There were occasional family rebellions, but nothing serious, says Elena. She laughs suddenly, remembering postcards she sent her parents as a young adult. To please them, she wrote cheery notes in Slovak. Upon her return, she found them vigorously corrected for spelling and grammar.

Still laughing, she admits her father might have been culturally heavy-handed, but he certainly realized his goal. Elena married a Slovak broadcast journalist. She and Vojtech are thoroughly immersed in Montréal's Slovak community. So often did they open their doors to new immigrants and visiting compatriots, their home was affectionately called the Mirga Motel. It overflows with things Slovak: glassware, pottery, carvings and textiles. "Any broken Slovak pottery and ceramics go into my Slovak garden," she says. Elena has planted a cheerful mix of white, blue and red flowers, celebrating the colours of the centuries-old Slovak national emblem.

When Esther met Elena, they found a perfect fit. "What she took for granted in her Slovak family and community, I craved to learn," says Esther. "She even helped me translate letters into Slovak for my relatives. Elena came to feel that she actually knew them and sought them out when she was in Slovakia." In turn, Esther's thirst for her heritage refreshed Elena's view of her culture.

Slovakia is particularly famous for its many distinctive regional embroidery styles, of which several are shown in the block. The central Čicmany embroidery is stitched in traditional yellows, oranges and reds, all-red cross-stitch frames it, and Slovak symbols in surface embroidery grace each corner. Naturally, the dove symbolizes peace, while the heart proclaims victory over adversity through love of others.

The enthusiastic introduction to the Slovak community Esther received from the Mirgas is a gift she treasures. The experience has enriched her life through personal discovery and the forging of precious relationships with family and new friends. Although Esther still struggles with the Slovak language, she used what she has learned on a return trip to Slovakia with her parents, overjoyed to share the journey to see family once more.

Like seeds upon the land

In British Columbia, where mountains, rivers and wildlife only come in size large, and giant trees reach for the sky to form a natural cathedral, diminutive Melodie Johnson uses tiny stitches to tell the ancient stories of her people. The Tsimshian settled centuries ago along the northwest coast, from Kitasoo, south of Princess Royal Island, to Laxkw'alaams in the north, and as far inland as Terrace. A member of the Kitsumkalum band in Terrace, Melodie believes fervently in her grandfather Roy Innes' words: "Our people belong to the land, and they have been here forever; they were like seeds."

Melodie's grandmother Beatrice Starr told her she follows the matrilineal line of the Killer Whale clan, also known as Blackfish, or Gisputwadae in the Smalgyax language, in the house of the Bumping Whales or Kitkatla. She has taken on the responsibility of being a role model for the young. Melodie strongly believes, "Education and culture are the keys to success — both promote pride and self-esteem. A person's roots are the key to identity. It is the responsibility of mothers, aunts, sisters and friends to be there for the young people who need help along the way to attain their goals in life." Her own three children and eight grandchildren bring her great joy and fulfilment.

At the age of fifteen, Melodie joined a dance group in Prince Rupert and was required to learn to make a traditional button blanket. She later used her skills to make one for her eldest daughter's puberty party, and another for the birth of her youngest daughter's first child. She created a vest with traditional designs for her son's graduation from law school. Now she instructs beadwork and basket-weaving classes, teaches Native dancing, and creates robes and regalia for people from across Canada. Melodie also designed a button blanket for Ed Schreyer, Canada's 22nd Governor General.

The history and stories of her ancestors become intricate designs, no two identical, sending a message with each work of art. Melodie *must* dream an important design before she can create it. Her dream of the woman spirit, who protects the tribe, inspired the Tsimshian block. The red Melton cloth signifies the women who are the givers of life, populating the tribes, while the circle represents the cycles of life. Four mother-of-pearl buttons mark the cardinal directions, representing air, water, land and animals. To honour the fact that Tsimshian live off the land and the animals and creatures of the sea, an abalone-shell eye gives the whale sight. Melodie says she chose this very simple, old-style Blackfish design to honour the people who have passed on the wisdom of her ancestors.

Tsimshian

Tsmyeen

> "Our people belong to the land, and they have been here forever; they were like seeds."
>
> *Melodie P. Johnson*

241

Sweden

> I believe in celebrating anything you can.
>
> *Britt Lepa*

The IKEA cure

For several years Britt Lepa sailed the seas with her young children aboard the ships captained by her husband, George. As the children grew older and long trips away from school became impossible, George accepted a shore job in Montréal so the family could be together. There the Norwegian Seaman's Church linked the Lepas to their homeland. Operated by the Scandinavian governments, Seaman's churches meet the spiritual, recreational and community needs of sailors and their families in ports around the world. It became a haven for Britt whenever life was a little lonely, connecting her to people who understood her "Swedish ways."

Each year the church held a huge bazaar where handmade traditional arts and crafts, Scandinavian goods and foodstuffs were sold. An avid cook, Britt often picked up a year's worth of cooking supplies, such as vanilla sugar, caviar and goat's cheese. Britt notes that Swedes are usually reserved, while Canadians are more open. Britt has adopted this open, welcoming attitude and loves cooking for a crowd. She admits that she is expecting "only" twenty-one guests for a formal sit-down Christmas dinner in the small Toronto apartment where she now lives. Britt laughs when she relates her son's assessment of her: "You are the most Swedish person I know, in such a Canadian way!"

Indeed, her family observes both Swedish fêtes and Canadian holidays. On December 13, the arrival of Santa Lucia — the Queen of Light — is marked with girls dressed in white, wearing lingonberry wreaths adorned with candles and trailing red ribbons. Christmas is celebrated on December 24 with an elaborate *smorgasbord* that includes mustard-spiced ham, pickled herring, *gravelax* (cured salmon), meatballs, spareribs, red cabbage, nuts and sweets. The much-enjoyed Canadian turkey is relegated to Thanksgiving in October. Valborg marks the arrival of spring, and on the summer solstice wreaths of poppies, daisies and cornflowers (embroidered on the block) are raised on the midsummer pole to mark the new season. Britt says, "After our long, dark winters, it is joyful to celebrate spring and summer, the arrival of life. I believe in celebrating anything you can!"

Britt's home reflects an eclectic blend of Swedish and Canadian influences: teak mixed with maple furniture; cobalt blue and white interspersed with floral chintzes and Canadian quilts. Collections of Kosta Boda crystal, English teacups and *Dala Hästen* (the painted wooden horses that adorn the block) fill nooks and crannies.

Having lived Canada since the mid-1960s, Britt confesses her cure for her occasional bouts of homesickness is a good dose of IKEA! Britt likes to wander slowly through the store, reading all the Swedish words. She then treats herself to a simple lunch: a shrimp sandwich, good Swedish coffee and *mazarin* (almond pastry). Then, with her heart bubbling with joy and contentment, she heads home.

My place to be

In the beginning of time, God created the wonders of the world. When He was finished, He saw that He had many leftover pieces. He had parts of rivers and valleys, of oceans and lakes, of glaciers and deserts, of mountains and forests, and of meadows and hills. Rather than let such beauty go to waste, God put them all together and cast them to the most remote corner of the earth. This is how Chile was born.

Given the dramatic geography and contrasting climate of Chile, the inspiration behind this beautiful legend is easy to understand. Such creation myths reverberate with a fundamental human aspiration — the deep-felt desire to create and express oneself.

For Elizabeth Comas, an energetic and confident Chilean-Canadian, this innate yearning has always been a part of her life. "I had this design motivation inside me, and I always wanted to become a designer, so I quit everything and went to school here in Canada." She comes by the desire honestly, because the art of weaving, and the making of pottery and silver jewellery continue to play an important role in Chilean culture, and in her own family. "My parents are very talented in design and art," she says. "I'm now discovering that creativity. As you get older, you get more chances to see who you are." She feels strongly about her identity both as an artist and a Chilean-Canadian. "When I visited Chile, I confirmed the feeling that Chile was my mother's place to be. When I became a Canadian citizen, this became my country, and here I'm going to stay."

Today, Elizabeth has achieved her dream. As a clothing and costume designer, she has worked for pattern companies, theatre companies and the National Ballet of Canada. She now works in her home studio, which is filled with elegant gowns and costumes awaiting completion. For her block, Elizabeth chose to stitch scarlet bellflowers, or *copihues* (pronounced *copy-wiz*), on a black velvet background. This is Chile's national flower, found only in the southern part of the country. Velvet is often used for costume belts, and the national "tricolor," in red, white and blue, is found throughout the country, in clothing decorations, draped in ceremonial bunting and on the country's flag. Elizabeth re-made the block four times, wanting to get it just right. "I'm happy with this one because it's a one-of-a-kind piece for me," she says.

Elizabeth hopes that the people viewing the many blocks will perceive what lies *behind* the Quilt — all the energy, time, emotion and self-expression of hundreds of artists. These hearts and souls are threaded throughout humanity by the process of design and creation.

" As you get older, you get more chances to see who you are. "

Elizabeth Comas

Somalia

Busy with life

Fifteen years ago, Faduma Abdurahman lived in Mogadishu, Somalia's capital. The family home sat on a hill overlooking a stretch of white sandy beach, part of the longest coastline of any African country. Sometimes, Faduma dreams of going back to her homeland, where the sight, sound and scent of the Indian Ocean greeted her each day. The ocean seems to call to her from half a world away, trailing her to downtown Ottawa, where she spends mornings teaching English as a second language, and afternoons helping newcomers at the Catholic Immigration Centre.

But then, memories of sun and sea fade, subsumed by her busy life. Wife, mother, student, teacher, counsellor, community worker — the list is long. Daughter of an Italian father and a Somalian mother, Faduma speaks six languages: English, Somalian, Italian, French, Spanish and Arabic. After earning a degree in Italian-language studies at Ottawa's Carleton University, she taught for a brief time. Her dark eyes sparkle with amusement. "When I forget Spanish words," she says, "I just throw in a few Italian ones…and it works." Although her Italian heritage is important, she says: "I was born and raised in Somalia, so of course I feel more Somalian than Italian." Her father left when she was very young, and though their paths diverged, she maintains a connection to him, and to her Italian half-sister in Italy.

She continues to move forward down her own path. She funnels her relentless energy into numerous activities and organizations. Formerly president of the Horn of Africa Women's Organization for many years, she remains an active member. Faduma is one of only sixteen Muslims in all North America trained in pastoral services. Traditionally, Muslim family members and friends always visit those in hospital, she explains, "but there was nothing formally in place." These days she is working towards a Masters in Education.

One of the most culturally homogenous nations in Africa, with a predominantly rural and nomadic population, Somalia is renowned for its eloquent oral poetry and songs. Wit and humour are also highly prized. Watching Faduma interact with colleagues, one sees an enduring and invincible strength beneath her warm sense of humour.

Her choice of textile for the Somalia block is taken from a woman's body wrapping made from woven *alindi* cloth. Traditionally woven by teenage boys in southern Somalia, the blue and white colours symbolize independence and peace, the gold threads, pride and prosperity. Five cowrie shells, five points of the gold-work star, and five hanging strands represent the history of the five countries into which the Somali people were divided by colonial powers.

The best tool

The Inuit of Kitikmeot live in Nunavut, the territory newly created in 1999 as a result of the largest aboriginal land claim settlement in Canadian history. Nunavut, which translated means "our land," measures 1.9-million square kilometres, one-fifth of Canada. Known as the "Land of the Midnight Sun," it is so far north that long months of darkness, where the sun never rises, are followed by a season of a sun that never sets. The Kitikmeot, composed of three groups — the Igloolik, the Netsilik and the Copper Inuit — have lived here for thousands of years. The elders continue the time-honoured oral traditions, passing on not only the history of the people but also an intense pride in their Inuit heritage.

The Kitikmeot block was designed and created by the Inniutit Women's Group, in Taloyoak. Founded in 1947 as a new trading post for the Hudson's Bay Company, Taloyoak is Inuktitut for "large caribou blind," which refers to a stone pen once used to capture caribou. As the eye travels around the block, a story unfolds of the Kitikmeot people's distinct identity, past and present, and their hopes for the future.

Central to the block's narrative is the *iglu*, or igloo, the traditional home of the Kitikmeot and the heart of their society. It is depicted in bleached seal skin, outlined with sinew and cotton thread. Around the igloo, items vital to the survival of the Kitikmeot Inuit are shown. The warm glow of a soapstone oil lamp, or *qudliq*, reproduced in unbleached seal skin, lit their homes and kept the Arctic darkness at bay. A piece of *suputi*, a type of plant, acted as a wick. Seal oil or whale blubber kept the lamp burning. The *pana* knife, used to cut blocks of snow, is carved from caribou antler, while the curve-bladed *ulu* knife, the women's indispensable, multi-purpose tool, is carved from ivory. The *nauligaut*, or spear, is used to hunt caribou, seal, whale and other mammals. These hunts were often carried out from kayaks, unique one-man water vessels made by fitting seal skin snugly over a whalebone frame. The Inniutit Women's Group share their hopes for a better life for their community by attaching miniature tin, mining tools to the block, representing the great mining potential of Nunavut. A mortarboard and diploma at the top indicates the people's strong commitment to education as the path toward a bright future.

While the image of the igloo is still often associated with the Inuit, many now live in modern homes complete with central heating, electricity and access to media and communication. This settled life replaces a once nomadic existence. Once again, the Inuit's best survival tool has been adaptability.

Kitikmeot

Qitiqmeut

Around the iglu *the women have placed objects that have proven vital to the survival of the Kitikmeot.*

France

Margaret Milne took one full year to complete the petit point *at the centre of the block, a labour of love based on an original watercolour by Esther Bryan honouring French impressionists.*

Impressions of the past

At the centre of the France block, a village scene exquisitely executed in *petit point* boasts 1,600 ultra-fine stitches per square inch. Artisan extraordinaire Margaret Milne took one full year to complete this labour of love based on an original watercolour honouring French impressionists. In pictorial tapestry style, the piece depicts a quiet river flowing through a French country village at a time when waterways were important transportation corridors. The scene could just as easily be from a small town in Nouvelle France. The church, a dominant landmark and beacon found in even the tiniest villages, is reflected in the tranquil water.

In the mid-1600s, lace and embroidery were vital fashion accessories worn by both men and women in Europe. At that time, the most *recherché* quality came from Italy. Concerned about the survival of France's own trade, Cardinal Richelieu, the chief minister in the French government, levied a heavy tax on all lace imports. As a result, France became self-sustaining in this field and remained a world leader for several centuries. In 1665, King Louis XIV began sending young women of marriageable age to New France to help establish a permanent colony there. Known as Filles du Roi, they brought with them the embroidery techniques they had learned in the convents of France.

A single piece of Richelieu cutwork embroidery frames the block's oval *petit point*. Four symbolic *fleur-de-lis* appear in the intricate pattern worked on white linen. The embroidery is executed in a very fine buttonhole stitch worked over supporting threads; the negative space created is cut away, allowing the silky blue fabric to peek through. The *picots* adorning the floating bars are the distinct feature identifying this as "Richelieu."

The tradition of cutwork embroidery endures some 300 years after it crossed the Atlantic. Young girls and women continue to learn this craft in convents, church halls and stitching guilds. Lise Marvell learned Richelieu embroidery at the Académie St. Michel, a private girls' school in Cornwall, Ontario. "The Sacred Heart nuns took such pride in passing this gift on to us," declares Lise. While working on the block, Claudette Voët admits that she found the white-on-white stitching extremely challenging. "It brought me back to my school days," she says. "I remember fondly how *ma tante* Cécile [her aunt] took pity on me, kindly completing my weekend sewing assignments. This time it was Greta Le Corney who finished the bulk of my homework".

Deft workmanship and a harmonious marriage of centuries-old techniques make the France block truly striking. It honours a proud heritage and a people whose contributions to Canada began in its earliest days.

People of the books

Following a series of natural disasters in their homeland, Icelanders came to Canada in the late 1800s "looking for the perfect place," says Shirley-Ann Laxdal. That meant an area where they could farm and fish. Others might consider southeastern Saskatchewan or the shores of Lake Winnipeg too harsh, but to the hardy Icelanders, "it sounded like Eden." These Prairie settlers were not the first Icelanders to come to North America, however. Historians believe that in 986, Bjarni Herjolfsson made the first known European sighting of the northeast coast of Canada. Archaeological excavations at L'Anse aux Meadows in northern Newfoundland indicate the presence of a Norse settlement there.

The Icelandic settlers of the 19th century brought trunks and suitcases full of books. Icelanders have the highest literacy rate in the world, and publish more books, magazines and newspapers per capita than anyone else. Naturally, their new life in Canada included starting schools and libraries, along with choirs and churches. Shirley-Ann's grandparents, farmers from northeastern Iceland, were among those who settled along a 100-kilometre stretch in Saskatchewan that they dubbed Vatnabyggd or "Lakes Settlement." They grew hay for their cattle and sheep, and fished in the nearby Quill Lakes. With their countrymen they worked hard at keeping their traditions and language alive. Although she was born in Canada, Shirley-Ann only learned to speak English when she was four years old. When she visited Iceland, she says, "I felt like I was coming home."

With the passing years, new generations often lose their ethnic identity and the language of their ancestors. Yet, this is not the case for Icelandic descendants living on the prairies. Many, like Shirley-Ann, continue to cherish the Icelandic language and heritage. Icelandic clubs ensure strong ties with the homeland. Shirley-Ann is a member of the Vatnabyggd Club, formed in 1981 to maintain cultural traditions and honour the pioneers. The club organizes events like Thorrablott, the spring festival, and celebrates Iceland's independence from Denmark in 1944 on June 17.

In the tiny village of Elfros, Saskatchewan, a bronze statue of a young Icelandic couple honours the Vatnabyggd settlers. The woman is knitting — a renowned, centuries-old Icelandic skill — while her husband reads poetry to her. Shirley-Ann had these two important elements in mind when she created the Iceland block. She contacted her friend Yolanda Gislason, "the best knitter I know" and a distributor for Icelandic wool, to knit the border for the block. Appropriately, the centre is a three-dimensional book that cleverly incorporates cross-stitch representations of significant Icelandic symbols: a Viking ship, a cross for the one thousand years of Christianity, and a fish to represent the fishing industry.

The shores of Lake Winnipeg might be considered harsh by some, but to the hardy Icelanders "it sounded like Eden."

Belgium

People watching Hélène work the bobbins, making lace, often comment that she seems to be playing a musical instrument, for the movements of her hands are as graceful and delicate as the lace she weaves.

Oh, what webs we weave…

According to legend, a Belgian woman was inspired to invent bobbin lace after studying the complex weaving of a spider's web in a dark, dusty corner of an attic. Regardless of this tale's veracity, Belgium most certainly deserves to be called "the cradle of lace." Although the exact origin of the art is uncertain, records indicate that early lace-making developed in Belgium during the 15th century. Its longevity in that culture was assured once a royal decree required the intricate and difficult craft be taught in schools and convents.

Hélène Plouffe fell in love with the tradition of lace-making on her first visit to Belgium. In the beginning, she stood behind a lace-maker to follow the movements of dozens of bobbins, each wound with a different thread, crisscrossing to weave elaborate patterns. With years of study and much practise, she has become an expert who now teaches her passion to others. Hélène's avocation is the art of lace-making; her vocation is playing the pipe organ. This is very fitting. People watching Hélène work the bobbins, making lace, often comment that she seems to be playing a musical instrument, for the movements of her hands are as graceful and delicate as the lace she weaves. And indeed, the bobbins do make music. Hélène recounts, "Radio Canada once came and recorded the sound of my bobbins while I was working them. Different types of wood create different sounds as they touch during the complicated manoeuvres." Hélène worked over a year to make the lace for her block, with its particularly fine structure, while she continued to run her needlework supplies store and teach lace-making and embroidery.

Belgium itself has a complicated history and intertwined cultures shaped by its role as the meeting place of Western Europe. The two main ethnic groups, the French-speaking Walloons and Dutch-speaking Flemings, create a bilingual context similar to Canada's. Today, Brussels, along with Ottawa, is one of the world's few officially bilingual capitals. Belgians, who love celebrations, religious tradition, art, fine cuisine and folklore, adapt easily, quickly becoming deeply involved in Canadian life.

Hélène had a unique opportunity to transform her small-scale art form into life-size art. With metallic threads and huge bobbins, she wove ethereal, shimmering costumes for the acrobatic dancers and circus performers of the famous Cirque du Soleil. Today, Hélène's wonderful art — born in Belgium, grown in Québec — continues to weave its enchanting spell as her threads magically and musically intertwine to form delicate lace.

People of the snow

About half of the 1,525 members of the Haisla First Nation live in Kitamaat Village, located at the head of Douglas Channel on British Columbia's northwest coast. The place name, Kitamaat, was first given by a group of Tsimshian on a winter trip to the area. They spied a mass of heads that moved along the snow-covered shoreline. *"Git-a-maat,"* someone said, meaning, "there pass the people of the snow." In fact, Haisla men were only partially visible as they travelled along paths dug through deep snow, but the title stuck.

Artisan Peggy Ross, her husband, Russell, and their daughters, Crystal, Teresa and Delilah are among those who live in Kitamaat Village. Their bright, welcoming home perched high on a hill overflows with evidence of familial artistic talent. Peggy's beading, painting and button-blanket work decorate her home and family's clothing. She learned her traditional Haisla skills from her mother and grandmother, and beading at a summertime church event called Vacation Bible School. Russell's carved antlers depict legends handed down through the ages. One fine carving shows Raven transformed from human to raven form to illustrate the tale of "How the Raven Stole the Moon." The exceptional quality of their daughters' artwork throughout their home is a testament to the significant influence of their parents and their culture.

Together, Peggy and Russell attended art college in Alberta. After two years away, they returned to their roots and the home of their ancestors with certificates in hand. Their design for the Haisla block contains traditional beadwork on a base of white antelope hide and a painted pattern, the split U, on red Melton cloth. Such U-shapes, which often adorn dancing regalia, are basic building blocks of Pacific Northwest flat-form designs and can be used to delineate various parts of designs, such as claws, ears, arms, tails and wings.

Talent and interest in maintaining traditional ways give the Rosses a strength that unites and anchors them. Russell and Peggy have been together for twenty-two years, but Russell says, "We have been together for more than one lifetime spiritually." They share a strong belief in maintaining harmony with nature. An old Haisla adage says, "Mistreat not the frogs, toads, birds, fish, nor any small animal, for as you treat them, so shall you be treated."

Peggy and Russell's community has evolved to a point where diverse ethnic backgrounds are represented. Potluck dinners are opportunities to share foods from many cultures and other First Nations. The Ross family's hilltop view has inspired them to work towards opening their own business to promote their foods, arts, crafts and culture. Fittingly, it will be named: "My Point of View."

Artisan Peggy Ross, her husband, Russell, and their daughters, Crystal, Teresa and Delilah.

Haisla

Netherlands

Home is where the heart is

Executed in delicate cross-stitch, the house at the centre of the design looks like the cosiest place in the world. Home is so important to the Dutch that they even have a special word for it: *gezellig*, meaning "cosy, home environment." Well-thought-out details create a home. Leaning against the wrought-iron stair rail of the brick house is a bicycle, a popular mode of transportation in the Netherlands. Miniature silver clogs are reminders of the wooden shoes farmers donned to keep their feet dry and children wore for after-school play. Colourful flowers spill out of window boxes. Curtains of handmade lace hang perfectly at the windows.

The home, and everything and everyone in it, is the epicentre of the Dutch family. That's why Aleida Limbertie of the Netherlands Folklore Group chose this theme, bypassing the stereotypes of windmills and tulips. "Holland is very much a country that believes in home life," says Greta Le Corney who stitched the block. "That was the centre of your being." In her home, it was very important that everyone who played an important role be home when the children walked through the front door. Greta remembers arriving home in a rush for teatime and pestering her father about the where-abouts of her mother. In a deadpan voice, her father would say: "I haven't got her in my vest pocket, you know."

Throughout Greta's school years, needlework and other textile crafts were mandatory subjects she greatly enjoyed. During World War II, her fifth year was lost when the school was converted to military headquarters. In a time of rationing, needlework materials were "as scarce as hen's teeth," says Greta. Young and clever, Greta saw a way around this. Her father had a polishing ball made from the snipped coloured end-pieces of thread-looms. Every time she needed a strand, she'd snitch it from the ball. Her father, puzzled when the ball began shrinking faster than he was using it up, questioned everyone. "I had to own up," Greta laughs.

Another look at the block reveals the symmetry of windows with precisely placed night-blinds, balanced architectural features, and a sophisticated use of colour. Love of symmetry and precision "is a very Dutch trait," admits Greta. She illustrates this with an anecdote about her friend's meticulous gardening regime. Her husband strongly suspects that the woman "measures where she puts her flowers, because they are exactly so many inches apart." This affinity for exactitude appears to be part of Greta's nature too. Her basement workshop is an organized treasure trove of catalogued beads, patterns and imported threads. Creating this challenging block in miniature was a joy for Greta, who says, "To me, small is beautiful, home is beautiful."

> " Holland is very
> much a country
> that believes
> in home life. "
>
> *Greta Le Corney*

White as snow

Beautiful weaving and embroidery were part of Heljä Thomson's Finnish upbringing. Her mother and grandmother taught her to embroider and weave traditional patterns at an early age, at a time when a girl often gave the first handkerchief she embroidered to her grandmother.

Delicate monochromatic patterns woven in white and natural linen threads create elegant Scandinavian designs. A fine example of the "summer and winter" weaving, with its reversible pattern, is layered in the quilt block. The blue and white are popular Finnish colours, while the dark blue, red, yellow and green cording represents the Saami, the only indigenous people in the European Union. A wildflower-embroidered hankie is tucked into a miniature birchbark basket Heljä's cousin made for her during World War II.

Textiles are interwoven with Heljä's childhood memories of the war. She remembers that families gave many of their sheets and table linens to make snow-covers to camouflage the soldiers against the winter landscape. In turn, they had dresses made out of parachute silk. Heljä was only three-years-old the first time her family had to evacuate their home, during what the Finns called the Winter War. Aeroplanes suddenly appeared overhead and began shooting as the family hurried to the railway station. Her father pushed Heljä into a snowbank and lay on top of her. Heljä says quietly, "I can still hear the very bizarre thumping noise those bullets made when they hit the snow."

Things remained unsettled after the war. Unsure whether another conflict would involve Finland, Heljä's father decided to travel. He wanted his children to become "citizens of the world." The family planned to learn first French in Québec, followed by Spanish and Portuguese in South America, English in Australia, and then return to Finland. But after a few years in Canada, her father died, and the family decided to stay. Despite a difficult start, Heljä says, "Canada has been very good to us." Leaving Finland did not mean abandoning their traditions. They brought what was important, mostly items of sentimental value, such as photographs, some books and the treasured linens that remained. Linens are part of a Finnish family's pride and ongoing identity—who they were and who they are now. A table set with her linens is an important part of everyday life for Heljä.

Today, needlework brings Heljä relaxation and peace of mind. "It's been my Valium," she laughs, while noting that various pieces remind her of what was happening in her life at the time. People who receive her hand-stitched gifts know they have been given something special. Heljä's linens, made and carried through a lifetime, remind her of war and peace, joy and sorrow, transitions and roots. To this day they remain a significant part of her life.

Finland

During World War II, Heljä Thomson's father (right) and uncle wore "snow covers" made from bed and table linens.

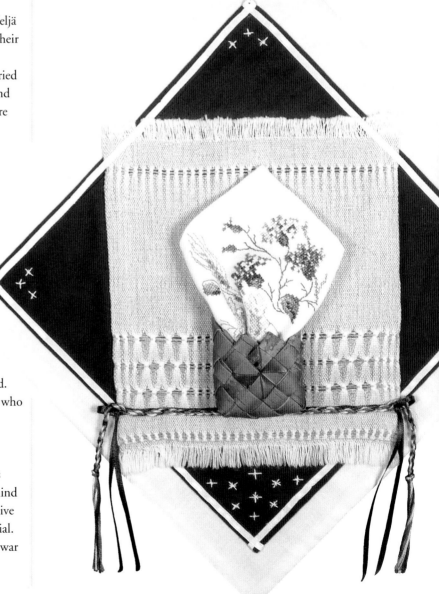

Singapore

The perfect puzzle

Ruth Loh Bauman was raised in Singapore, a small island off the tip of Malaysia and one of the most densely populated countries in the world. "We live in harmony, and there's a very strong racial and religious tolerance," Ruth explains. "We all live together and we are friends. Even our food is intertwined now. I could make a curry dish and if you were to ask me if it was Malay, Indian or Chinese, I'd say 'Singaporean,' because we have created an identity of our own." There are four official languages: Mandarin, English, Malay and Tamil. Individuals are encouraged to use their mother tongues to transfer cultural traditions and values, but as a people they must also work as a harmonious whole. "It's a society in which we are free to develop our own potential, but we all know we are part of a puzzle that can only be set a certain way."

The five points in the mane of the mythological Merlion, embroidered in the centre of Ruth's block, remind Singaporeans of their five cherished ideals: democracy, peace, progress, justice and equality. A large sculpture of the Merlion keeps watch at the entrance to the Singapore River, as legend claims that it once saved the island from a destructive storm.

Singaporean batik fabrics are renowned for their intricate, labour-intensive designs. The more finely executed the pattern, the more valuable the fabric. Ruth was meticulous in pleating symmetrical layers of batik for her block; even the dots are perfectly matched. Ruth says, "Orderliness is highly prized in my society."

Once in Canada, semantics required some adjustments for Ruth. Family is important for both Ruth and her husband, Doug. For Doug, this means that family members occasionally get together. For Ruth, it meant frequent gatherings of sixty-five or seventy people, all day, in her grandmother's three-bedroom apartment in Singapore. Ruth's Canadian home reflects her principles for the benefit of her family, especially her young son, Joshua Wei-Ming. "Everything in our home represents my husband's or my culture. My son knows 'this is Singaporean, this is Chinese, this is Canadian.'" She laughs, admitting it can be confusing to outsiders, but to her, once again, "It's a puzzle that makes sense."

The puzzle got rather complicated when, as a young bride-to-be who prided herself on always being well organized, she tried to bring order to her wedding plans. Ruth's fiancé was living in Ontario while she was still in Singapore, and as there was no practical middle ground, she planned two weddings, one in Singapore, and then a second one in Canada. But first, government red tape forced them to be married before they could hold their two weddings — so, she married Doug Bauman three times!

Brother caribou

The Naskapi of the Labrador plateau speak the Algonquian-based Innu-aimun and call themselves Iyuch, meaning "the people." For most of the year, the Naskapi roamed their homeland in small hunting bands, but they came together briefly during the summer in larger encampments along rivers to trade and socialize.

The nomadic lives of the Naskapi revolved around the caribou, which were key to their very survival. Traditional belief holds that every animal group has a master, and Papakashtshishku (or Papakassik) is the Caribou Master. He was once a man who dreamed he was a caribou, only to wake up with antlers on his head and a white spot marking his hindquarters. He became their leader and warned the herd to stay away from over-zealous hunters. A hunter's success depends on the respect he gives to the Caribou Master. The Naskapi show respect to the caribou by using every part of the animal.

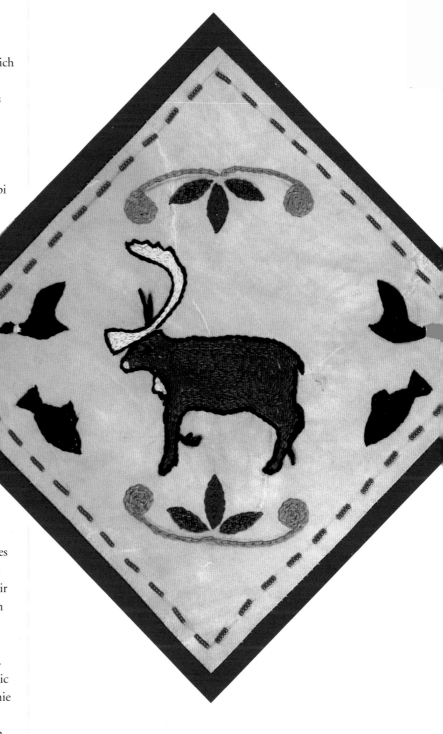

James Uniam, a trained Naskapi artist, learned the value of showing respect to animals as a youngster. His first caribou kill at age ten made him feel "like a man." He has been hunting ever since. During the winter he traps rabbits, martens and foxes, trading the furs. James is passing on the traditional ways of hunting to his own six-year-old son. He teaches by example how to skin and cut up the caribou and how to snare small game. He learned these ways from the elders. As a member of the Naskapi Hunter Support Program, James would like to help guide the community "back to the hunting ways."

James does not spend all his time hunting, however. His other passion is his art. At a very young age, James became inspired by his mother's beaded moccasin designs. Eventually, James managed to mesh his two loves by painting wildlife and hunting scenes. James recognizes a similar talent blooming in his seven-year-old daughter. With unwavering support, he encourages his children to follow their dreams, just as his mother gave him the freedom to explore his own talents.

James designed and his mother, Minnie, created the Naskapi block. This artistic mother-and-son team honoured the caribou as symbolic of their people. On a hand-tanned and smoked caribou hide, Minnie embroidered a caribou, front and centre, flanked on either side by fish and fowl, which are secondary food sources. The stitches are an example of traditional needlework used to decorate clothing made primarily from caribou skin. The double-curved symbols at the top and bottom represent the synergy in nature and, in this case, the unity of the hunter with his brother caribou.

Mexico

Martha Weber

Yolanda Corvese

Proud people

To know Mexico is to understand the deep sense of pride of its people. Mexico has the oldest continuous culture in the Americas, dating back to the Stone Age. As early as 1,500 B.C., the Olmecos were renowned for sculpture, science and philosophy. The Mayan civilization spanned a 3,000-year period ending in the 10th century. The sun-worshipping Aztecs carved the famous Sun Stone or "Eagle Bowl," a 12-foot stone calendar discovered in 1760 buried beneath the main square in Mexico City. Rich in natural resources, today Mexico is a world leader in silver and petroleum production. Silver and turquoise jewellery, woodcarvings, textiles, and pottery all attest to the creativity of Mexicans.

Yolanda Corvese and Martha Weber, two Mexican women living in Ontario, share a devotion to enlightening others about their native land. To represent Mexico on their block, Martha and Yolanda depicted two famous ancient symbols: the Mayan pyramid at Chichén Itzá, and the Aztec sun calendar. Their embroidery incorporates "as many different stitches as possible to represent the diversity of the land and people," Yolanda and Martha explain. Important, too, are the colours: gold thread for the richness of Mexico; brown for the land; and bright blue and yellow — popular colours in Mexico. The handwoven fabrics from the states of Michoacan and Oaxaca are dyed with pigment from flowers and cacti. The block's background fabric is typical of the type used for clothing, *serapes*, blankets and shoulder bags.

Mexicans are as devoted to family life as they are to their history. The second youngest of ten siblings, Yolanda remembers family meals with everyone gathered around a large table. Martha recalls, "My father often hired roving Mexican folk bands, called *mariachis*, to come and play at our home." Each woman raised her own family in a Canadian home suffused with Mexican warmth. Yolanda, an accounting graduate, met her Toronto-born husband while both were vacationing in Acapulco. She immigrated in 1964 and raised four daughters. "I was very impressed with the democratic system and the incredible opportunities for new Canadians," she recalls. Martha, an interior designer, came to Canada in 1979 to study English, planning to return to Mexico to open her own business. "In a turn of fate I met my husband, whose heritage is German, and got married a year later." Their two daughters were brought up in a tri-lingual home.

Both women remain active in Mexican organizations, taking joy in transmitting the cultural richness of their homeland. Throughout the centuries, Mexico's art and history have been preserved as the heritage of a proud nation. Buried treasure notwithstanding, Yolanda and Martha are proof that true wealth lies in the pride of the Mexican people themselves.

A treasure hunt

When the wife of the High Commissioner of Great Britain and Northern Ireland in Canada accepted the challenge of creating the block for the U.K. and Dependencies, she had no idea that her daily existence and night-time reveries would become consumed by the pursuit of obscure plants with delightful names like diddle-dee berry, wild banana orchid and Turk's head cactus. Yet, this is precisely what happened.

At the outset, Lady Veronica Goodenough assembled a creative team that included Esther Bryan, Rachel Bryan, Hazel Campbell, Helene Kelly, Rose Sisty, Christine Pearson, Christine Welsh and Annie Williams. They quickly reached consensus: The base fabric would be ivory-coloured wool since this sturdy, enduring fabric is suitable to the textile history of the UK. The pattern is a tasteful composition of nineteen embroidered flowers, one for each nation, carefully coordinated to ensure congruity of design and colour.

Then, following proper protocol, the High Commissioner's office contacted the dependencies and asked each one to provide details of its national flower. Several of the plants are quite rare and photos or drawings are not commonly available. Bureaucrats and botanists in every hemisphere scrambled to obtain photos of the loveliest specimens. The project took on all the excitement and intrigue of an international treasure hunt. Two flowers even had to duke it out to represent Bermuda. The shocking-pink oleander beat out the purple Bermudiana — by a nosegay. Antarctica presented a vexing problem since virtually nothing grows there; thus, a snowflake claimed the honour, by default.

Then, there was the perplexing case of the Pitcairn Islands, which had no official national flower. Not wishing to be excluded, the Governor convened a committee to select one. An artist created botanical line drawings of their choice — the regal, long-throated high white, with its delicate six large petals. Now it flourishes in embroidered splendour at the two o'clock position, just to the left of Montserrat's flaming helleconia. In recognition of its official status as national flower of the Pitcairn Islands, the high white will grace a new postage stamp.

The creamy square of English wool was passed from woman to woman. Each one stitched and embroidered to bring the floral emblems into bloom. Resplendent at the centre is a jewelled crown of gold purl created on royal purple velvet by Sue Leeson. It is encircled by embroidered leafy vines that swirl, separating and yet linking each of the widely dispersed nations represented. The end result is exquisite, harmonious and appropriately majestic. Diplomatic mission accomplished!

United Kingdom and Dependencies

Clockwise, from 12 o'clock: snowflake (British Antarctic Territory), oleander (Bermuda), high white (Pitcairn Islands), helleconia (Montserrat), white cedar (Anguilla & British Virgin Islands), Turk's head cactus (Turks & Caicos), pale maiden (Falkland Islands), Guernsey lily (Guernsey Islands), ragwort (Isle of Man), arum lily (St. Helena), diddle-dee berry (Tristan da Cunha), flower of the rose tree (British Indian Ocean Territory), ascension lily (Ascension Island), wild banana orchid (Cayman Islands), campion (Gibraltar).

Scotland

Quilts and kilts

Nancy Woollven's family can trace their ancestors to the late 1700s when the clans Gordon and Aird emigrated from Scotland to New Scotland. Highland games, kilts, tartans and scones on Sunday were part of their lives when they were growing up. There's never been any doubt — Nancy, her husband and their two children are definitely Scottish. They've lived in Ontario's Glengarry County for twenty-five years and try to observe Scottish traditions whenever possible.

Not many are prepared for the fervid Celtic traditions swirling about like mist across the "moors" of Glengarry County. Yet it's a fact supported by popular opinion: These United Empire Loyalist descendants are "more Scottish than the Scots." Life's milestones and most social gatherings are synonymous with tartans and bagpipes. The annual Robbie Burns supper is a good example. The celebration of the beloved poet's life begins with haggis, ceremoniously carried aloft to the accompaniment of bagpipe music. Made from minced sheep innards mixed with oatmeal and suet, this much-maligned traditional dish is a favourite at the Glengarry Highland Games held in the village of Maxville. Touted as the biggest in North America, the games draw crowds of over 20,000 people. The three-day gathering of the clans is all about music and competitions: highland dancing, caber tossing and massed pipe bands. And when the bands begin their opening number, whether you're Scottish or not, the hair will stand up on the back of your neck.

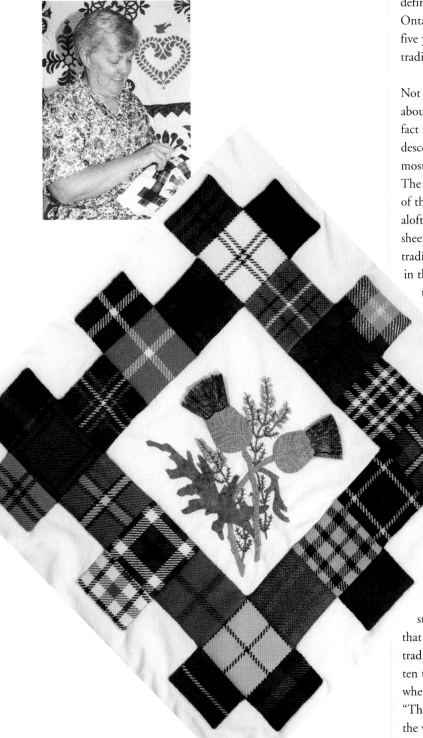

For some, hearing the wail of the pipes stirs strong emotions, but for Nancy, her real passion is quilting. A multiple award winner for this craft, she loves to create a world of vibrant colours and designs. Fittingly, her quilting embodies some of the more notable Scottish characteristics: love of poetry, economy and hard work, common sense and family devotion. Her embroidered heather and three-dimensional appliquéd thistle are as fanciful as any lyrical poem. Taken from a "whole stack of leftover squares," the clan tartans were placed in a pattern that echoes crenellated castle walls and is in keeping with quilting's tradition as a "thrift craft." Further, anyone who "takes things apart ten times to get it right" genuinely understands hard work. And when she designs quilts for the men in her life, common sense rules: "They have to be the sort where the dogs could get on the bed and the whole world wouldn't come to an end," she says. Most important of all, her quilts one day will become family heirlooms — a cultural legacy to loved ones.

Sharing the old with the new

The Mohawk are a proud and resourceful Woodlands people who strongly believe in keeping their culture and traditions alive. They do so even as they adapt to ever-changing times at Akwesasne, Kanesatake and Kahnawake, communities that border the St. Lawrence and Ottawa Rivers.

Barbara Little Bear uses her beadwork skills to express this heritage for the benefit of future generations. She wasn't allowed near the crowded beading tables as a young child, but listened intently and watched as her elders gathered to stitch and talk while their men were away doing dangerous high-steel construction work. Barbara's job became that of "threader," getting needles ready for her grandmother, great-aunt and their friends. Barbara was about seven when the ladies began to show her how to bead. She developed a distinctive style that uses "a lot of rope work, my favourite colours, and shiny beads." She has taught these skills to her own daughters and grandchildren — and even to a few men.

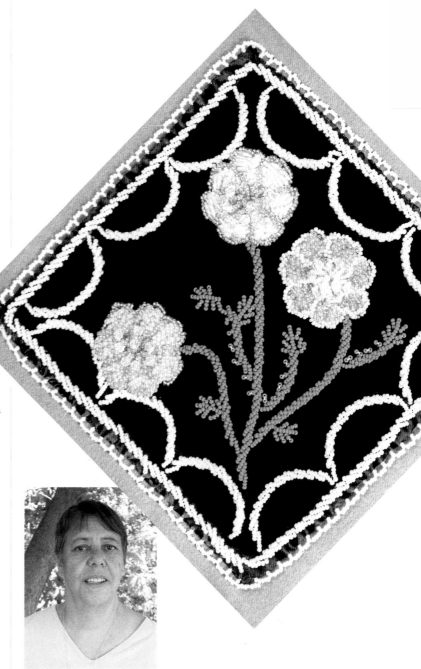

"The raised style of beadwork is very Mohawk," says Barbara. "It's distinctive to the Iroquoian people, raised without any padding … a technique we developed through time." She goes on to explain, "Our beadwork has a lot of meaning. Every part of the design represents something." The symbolism on her block starts simply: pink flowers for women, blue for men, with seven petals, one for each day of the week. The women are represented as leaves, the children as buds. Four sets of trinities appear as domes: Earth, Moon, Sun; the sacred Three Sisters: corn, beans, squash; the elements: fire, water, air; and the three tribal clans: Bear, Wolf, and Turtle. The total is twelve, for the months of the year. Surrounding this principal design, spiralling beaded rope and a delicate beadwork "fence" signify the men protecting the united community. Even Barbara's knots are done in threes, one for each of the Mohawk clans!

Barbara speaks passionately about the importance of preserving and practising longhouse traditions. She tells many of the old stories learned while threading, about the significance of corn, used to make cornbread, corn soup, corn fritters. She talks of honouring Mother Earth. "We drink strawberry juice; the fruit is shaped like Her heart, it is a very strong and powerful berry." Barbara emphasizes, "It is essential to teach the young anything that is traditional."

"You [the Invitation Project] have inspired us," she says, smiling warmly. "Twelve women are going to bead traditional pieces that we will join together to create a beadwork quilt. It will be a nice wall-hanging…and we're going to donate it to the community." Teaching and sharing with each generation in just this way brings Barbara Little Bear great satisfaction.

> " Anything that is traditional, it is essential to teach the young. "
>
> *Barbara Little Bear*

257

Japan

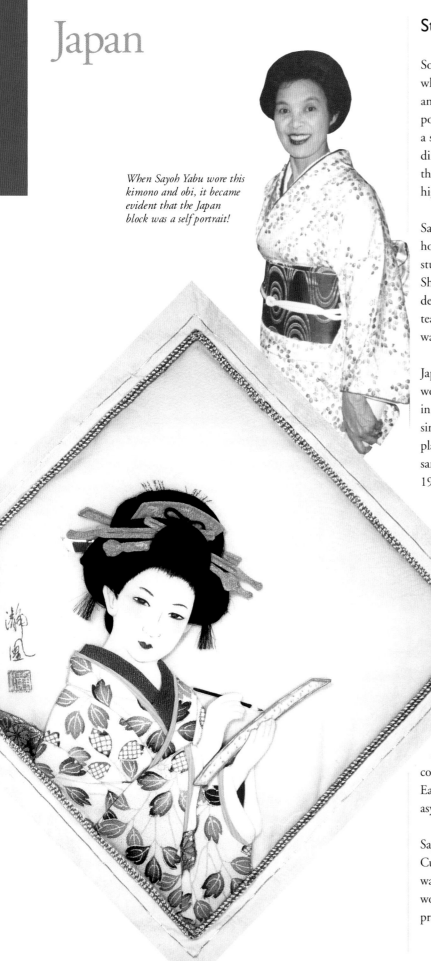

When Sayoh Yabu wore this kimono and obi, it became evident that the Japan block was a self portrait!

Stories in silk

Softly, shyly, Sayoh Yabu shows her visitor the collection of silks with which she shapes her stories. The Japanese technique she practises and teaches, called *oshie*, dates back to the 8th century and was popular from the 17th through the 19th centuries. Her art tells a story through a carefully drawn design rendered as a three-dimensional cloth relief. Each piece of fabric is cut, padded and then assembled. It exemplifies the Japanese love of beauty and the high artistic value attached to traditional handmade works.

Sayoh dyes her own silk, often bringing pigment and cloth from her homeland to achieve the delicate tones needed for her creations. She studied her craft for many years before coming to Canada in 1970. She spent two years just learning the art of painting the faces often depicted in this ancient art. After becoming a master of *oshie*, her teacher christened her Sayoh. This artist's name means "still water," water that remains quiet despite the movement around it.

Japanese gold-work frames the block, outlining the portrait of a woman dressed in a handpainted kimono, a calligraphy brush poised in mid-air as if deciding how to express a complicated matter in the simplest way. Even the woman's hair is made of silk, combed and placed strand by strand. When Sayoh wore a kimono and *obi* of the same fabrics to a reception held by Invitation on Parliament Hill in 1999, it became evident that the Japan block was a self-portrait.

Once used as daily wear, kimonos are now reserved for special occasions, such as weddings or celebrations. Modern Japanese women find it difficult to have their movement so restricted. Putting on a kimono, with all its layers, and correctly tying the *obi* is a complicated process, requiring much time. When Sayoh must clean one of her silk kimonos, she takes it apart by unstitching each seam, handwashes each layer, lays it flat to dry, and then re-sews the entire garment.

Japanese art takes many forms, including *ikebana*, the renowned art of flower-arranging; *haiku*, a 17-syllable poem; *bonsai*, the popular art of miniaturizing plants; delicate watercolours painted on rice paper; and the country's famous calligraphy. Each art achieves a significant impact with its minimalist asymmetrical, yet balanced forms.

Sayoh has taught and exhibited her art in Toronto at the Japanese Cultural Centre, but the best showcase is in her home. Here the walls form a continuous display of men and women captured at work or play, immortalized in silk, a testimony to this ancient art practised in modern times.

Turmoil, toil and trouble

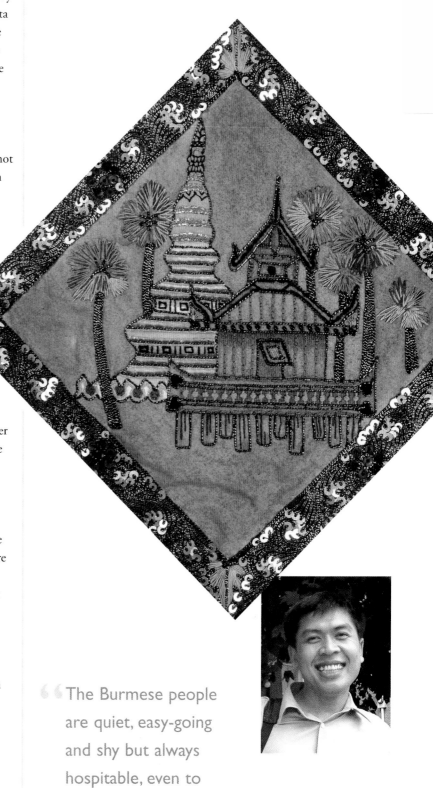

Myanmar

When Marco Polo visited Burma, in Southeast Asia, in the 13th century, he was fascinated by the shining golden temple towers and by the "vast jungle" teeming with elephants. Since 1988, a military junta has ruled. They reclaimed the traditional name of Myanmar because "Burma" implied cultural dominance of the Burmese, who make up sixty-five percent of the population. In 2004, dissent continues to be suppressed, political prisoners are many, and expressing an opinion can mean jail. Political candidates elected in 1990 have yet to form a government.

Toe Kyi fled his turbulent nation in 1996 to live in Ottawa. "I did not know anything about Canada," he confesses. Toe had been in prison in Bangkok for four years when Amnesty International helped free him. Toe, who speaks Burmese and English, longs to change his beloved country. "My memories are of a police state; it seemed normal for those of us growing up at the time," he says. "We were subjected to forced labour under the title of 'volunteers.' A lot of my classmates got shot while volunteering," he recalls.

When he and his friends began listening to BBC news reports, they realized things were not right in their country. On August 8, 1988, a small band of students grew 100,000-strong and staged a protest. The soldiers told them, "We don't have democracy; we have bullets." After two years as a resistance fighter hiding in the jungle, Toe fled. "I tried to work for democracy when I was a high-school student," he says. As a volunteer with the Canadian Friends of Burma, he still is trying. "The struggle sometimes seems hopeless and depressing," he admits, but he keeps doing that in which he believes.

"The Burmese people are quiet, easy-going and shy but always hospitable, even to strangers," Toe asserts. At their festivals, everyone receives food and clothes, whether friend or stranger. Most people are deeply religious, and though poor, they are generous to the monks who depend on food donations. Celebrations are an important facet of life; there is one about every month, Toe says. The people of Myanmar dress up in their best attire, and usually both men and women wear a long wraparound skirt of embroidered cotton or silk, folded across the front and gathered. Ladies' costumes are often accented with silver neck-rings and bracelets. The country is known also for its dance, drama, music, woodcarving, lacquerware, silk-weavings and embroidered wall-hangings.

A wonderful example of this weaving and embroidery appears in the block which was made and donated by U Kan Thein and Gerry Hainesrtm. The unique architecture of stupas and a monastery are highlighted, embroidered in lush silk threads. An intricately stitched border features small metal rings, which are commonly used as embellishments, adding glimmers of hope to Myanmar's tarnished image.

> " The Burmese people are quiet, easy-going and shy but always hospitable, even to strangers. "
>
> *Toe Kyi*

Nauru

New breath, new life

A baby took its first breath and a whole nation rejoiced. She was not royalty, but she symbolized triumph over hardship for the island nation of Nauru (pronounced *nah-oo'-roo*) in the South Pacific. Baby Eidegenegen Eidagaruwo, born October 26, 1932, was showered with gifts and honour. With her birth, tiny Nauru had reached a population of 1,500, recovering from a dip to just 1,068 people following the ravages of an influenza epidemic in the 1920s.

One of the smallest countries in the world, Nauru has been an independent republic since 1968. During the 1920s and 1930s, it was under the mandate of Australia, New Zealand and Britain. The Australian administrator, Brigadier-General Griffith, commented that if Naurans wanted to survive as a race they should maintain a population of at least 1,500. It was then declared that the day the population reached that number would become an annual holiday called Angam Day. In Nauru, *angam* has several meanings: jubilation, celebration, to triumph over all hardships, to reach a goal or coming home. All these definitions give the Nauru plenty of reasons to celebrate.

The population of Nauru fell below 1,500 a second time during World War II. Under Japanese occupation in 1942, 1,201 Naurans were evacuated to the Island of Truk (now Chuuk). Malnutrition and yaws plagued the evacuees, causing the death of 464 people, including the first Angam baby. Of the 600 people left on the island of Nauru, only 400 survived. Once again, the survival of the community was in question, and there was a pressing need to increase the population. On March 31 1949, the 1,500th Nauran, Bethel Enproe Adam, was born. Angam Day was celebrated once again and ever since (though the October 26 remained the official holiday).

Numbers are not a problem for the frigate bird. With its showy scarlet breast, it forms the central theme of the block, designed and crafted primarily by Linda Bitterman. This agile flyer has an impressive eight-foot wingspan and great manoeuvrability. For years the phosphate-rich droppings from frigate birds have been mined and sold to make fertilizer. This unusual export has made Nauru the richest island in the Pacific. However, environmentalists warn of dire ecological consequences because of excessive mining.

Today the population of Nauru numbers around 12,500. The people value each other as participants in a close-knit community, and their easy acceptance of others makes Nauru a friendly place. The people of Nauru are so hospitable that no visitor would be among strangers for very long.

The old ways

Mabel Pierre is a strong traditionalist. A Sekani from Prince George, she learned beading skills from her mother almost fifty years ago. Mabel now teaches Native culture and beadwork in the schools in her area, along with Elsie Pierre. She believes that it is very important for the younger generation to learn "the old ways."

Not only do the two women instruct in the traditional art of making moccasins, gloves, snowshoes and bags, but they teach students to dry meat, process hides, make bannock and hunt. These are critical skills that the students will need to survive, if circumstances demand it. Mabel and Elsie often take their fascinated students on field trips to study "bush medicine," instructing them in the use of native plants for healing and treating the ill, a practise still common today. Throughout their lands can be found many natural ingredients used for food or for medicine, including willow, devil's club, Labrador tea, cattails and mountain ash. Delicious treats are collected along the way as well, perhaps some blueberries or wild strawberries, lingonberries or gooseberries.

The Pierres' quilt patch depicts a typical Sekani landscape — a white tepee, trees, two rivers beaded in turquoise, and a campfire before a backdrop of lavender mountains. Sekani Tsay Kenneh means "people of the mountain." They used the Finlay and Ingenika Rivers as their principal "highways" where they also caught a wide variety of fish that included Kokanee salmon, trout and Dolly Varden (a type of char).

Their territory once covered the entire Finlay River basin, where they relied on the abundance of wildlife for their main food supplies: bear, moose, beaver, porcupine, rabbits, caribou, deer, sheep and, when plentiful, elk and buffalo. The Sekani made winter clothes from the furs of beaver, groundhog, fox and wolves, used groundhog (marmot) skins sewn together to make blankets and used moose hide for moccasins. Everything brought home from the hunt served a purpose and was put to good use.

For Mabel and Elsie, this small but exquisite scene represents a vast and magnificent land — and a way of life worth preserving.

Sekani

Tsay Keh Dene

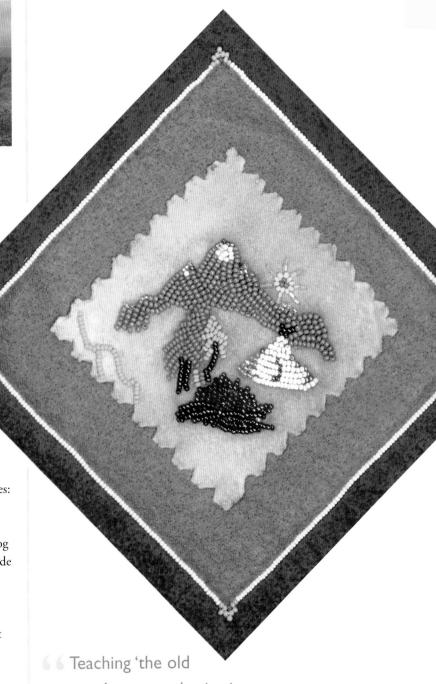

" Teaching 'the old ways' to an enthusiastic new generation is very rewarding. "

Mabel Pierre

Turkey

Turkish delight

Erten Uras' home contains all the riches found in a Turkish bazaar: striped cushions, hand-knotted rugs, beaded cloth birds, and handpainted ceramics — everywhere. One can easily imagine the exotic scents of a real *Çarsi*, or market: Turkish coffee, crushed mint leaves, pungent spices, apricots and figs in profusion. Vibrant silks and long-staple cottons, beaten copper implements and gleaming gold jewellery also come to mind.

When she was less than ten years old, Erten began making doll clothes for her baby sister. Later she went to a sewing institute where she crafted clothing and handmade lingerie. She now keeps busy stitching exquisite embroidery. One recurring motif in Erten's home, and in Turkish textiles and tile patterns, is the tulip. They adorn the ceramics she collects and are stitched on pillows and woven into fabrics. "Holland is famous for its tulips, but their first ones came from Turkey," she informs. "We introduced them to the Dutch in the 16th century. At home, they cover the mountainsides by the thousands." The Turks cultivated tulips as early as A.D. 1000.

Daphne Uras, Erten's daughter, incorporated tulips into the Turkey block design, honouring the flower's cultural and religious significance. Erten stitched stylized tulips sitting atop golden branches laden with buds and leaves. In two corners, special blue and white glass beads wink out. These *göz boncuk* or "evil-eye" beads are talismans found throughout Turkey in homes, cars, offices, and even pinned to the right back shoulder of a newborn's garment. They are meant to deflect evil and bring good luck. In Erten's home, *göz boncuk* keep watch from every nook and cranny.

Erten reluctantly accompanied her husband to Canada in 1965. "For the first eighteen years, I was homesick every summer. We could not afford for me to go back home to visit. As soon as we could, we sent the older girls to spend the summer with their grandparents, then later, our son." In 1983, three years after Erten was widowed, she took Canadian-born Daphne, then age fourteen, to meet the extended family. Erten rejoiced in the familiar culture, the weekly bazaars, the friendly people — and the sun. "I can't get enough of the sun in Canada," she laughs. Her homeland is a country rich in history, a bridge between Asia and Europe. Istanbul is the only city in the world situated in two continents. Some scholars believe that 5,165-metre-high Mount Agri (or Ararat), on the borders of Iran and Armenia, could be the final resting place of the biblical Noah's Ark.

Although she returns to Turkey every year, Canada is home for Erten, her children and grandchildren. Surrounded by her beloved tulips, she enjoys sewing, knitting, beading and dreaming of the next time she will feel the warmth of the Turkish sun.

> " We introduced tulips to the Dutch in the 16th century. At home they cover the mountainsides by the thousands. "
>
> *Erten Uras*

A light passed on

Anahid Jelderian and Arsho Zakarian's story of Armenia is beautifully evoked in contrasting delicate and bold stitches. The cross and gold-domed church with arched windows attest to a strong attachment to the church. Indeed, Armenia was the first nation in the world to formally accept Christianity in A.D. 301. Strategically located along east-west trade routes, between the Black and Caspian Seas, this culturally rich nation endured twenty-five centuries of war, persecution, massacres and large-scale dispersal. In 1988, a devastating earthquake claimed 25,000 lives and many cities and towns were reduced to rubble. Today, Armenia is barely one-tenth its original size and its people are scattered across the globe. Yet, despite the country's constant metamorphosis, Armenian courage and resiliency are like the gold-stitched infinity circles in the block: they never waver.

Arsho Zakarian and Anahid Jelderian

Although blockmakers Anahid Jelderian and Arsho Zakarian were born in Egypt and immigrated to Canada in the 1960s, their Armenian heritage remains central to their identity. Both women are well pleased that their children have embraced the Armenian culture by learning the language, the songs and the history of their people. Arsho's daughter, a theatre arts student, reviews Armenian music for a local television station and coordinates children's theatre workshops at the Armenian Cultural Centre in Toronto. Their other children also took part in the centre's many activities, and Anahid's son performed with a folk dance troupe.

Anahid's use of the *ourfa* stitch in the block brings to life colours most often found in liturgical garments and cloths: royal purple, gold and green. The overall design incorporates grapevines as a symbol of hospitality, agriculture and prosperity. The grape leaves are also an important element of Armenian cuisine, used in many recipes handed down from mother to daughter. According to Arsho, *derevi sarma* (an appetizer of grape leaves stuffed with rice) is so delicious, young people don't just eat it—they want to learn how to make it.

Through their arts, cuisine and worship, Armenians are able to tie the present to the past, like a light passed from one to another. Writer William Saroyan captured this enduring essence of the Armenian soul when he wrote, "I should like to see any power in the world destroy this race...send them into the desert without bread and water. Burn their homes and churches...then see if they will not laugh, sing and pray again. For when two of them meet anywhere in the world, see if they will not create a new Armenia."

Democratic Republic of Congo

> "Where there is suffering,
> joy also is present."
>
> *Congolese saying*

Asante sana!

The little voice on the telephone from Africa said it all: *Niko naenda Canada!* ("I am going to Canada!") Two-and-a-half year-old Deborah spoke in Swahili to the aunt she had never met. Too young to know where Canada was or to understand the violent circumstances that had brought about this momentous trip, she nevertheless expressed the hope of her family for a new life in a new place.

Her aunt, Mimi Kashira, was eager to welcome Maombi and her five children to Kingston, Ontario. The two sisters had not seen each other since 1998, when Maombi's husband died in the civil war that gripped the Democratic Republic of Congo, formerly Zaire. Maombi and the children endured several years of violence and hardship, and then escaped to Uganda, where they stayed two years. Mimi also lost her husband and had fled when it was no longer safe to stay. It was now June 15, 2004. Just the day before, Mimi and her two young sons had become Canadian citizens. It was thrilling for the brand-new Canadian to welcome her cherished sibling.

In Canada, Maombi and the children are learning a new life, free from fear and war and hunger. They feel fortunate to have joined family and a Congolese community of people who have made the journey before them — people like Mariette Lwesso. She arrived in Canada in 1996, before the civil war began to tear Congo apart. Mariette came to join her husband in Canada, but after her arrival her marriage broke up, crushing her hopes and compounding the sorrow of missing home and family. Mariette, along with Mimi and Maombi, found comfort in a circle of Congolese friends and relatives in Canada.

Mariette is now training for a new career in nursing in Montréal and continues to use the needlework skills she learned at her mother's side. In making the Congo block, she wanted to show the natural wonder and beauty of the country that has known so much trouble. The hand-embroidered lion, cheetah and elephants, and the colourful birds on the tree at the centre of the block, represent that beauty. She wants the world to give Congo a second chance, an opportunity to rebuild. This determination to focus on beauty and goodness is part of what sustains the Congolese and reflects a familiar saying: "Where there is suffering, joy also is present." Maombi expresses that joy and gratitude to the supportive community and all those who made it possible for her and her children to live in safety and security. "*Asante sana! Asante, asante!*" ("Thank you very much! Thank you, thank you!")

A true Arctic rose

In many ways, creating the block to represent the Hare First Nation was a labour of love for Dora McNeely. The design is a legacy from her late mother and pays homage to the special love that exists between a mother and a daughter. The Arctic Rose inspires Hare women because it is one of the few flowers that survives in the cold climate of the Northwest Territories. Dora used translucent soft pink and burgundy *rocaille* beads to bring to life the large rose balanced by two delicate buds, worked on a background of tanned moose hide.

For Dora, the process of putting the block together was, in a sense, a conversation with her mother. Dora's memory of her mother teaching her how to sew guided her hands as she beaded. Dora feels her mother's presence constantly, but at no time more poignantly than when she is seated at her sewing machine making the same types of items for her family that her mother used to make. As a child, Dora was never cold in the parkas, mukluks, gloves and slippers that her mother's loving hands created.

"The Arctic Rose decorated many of my mother's pieces," Dora recalls. The tenacious and steadfast nature of the rose reminds Dora of her mother. Energetic and courageous, she worked hard to provide for her family, earning the respect of her children. Not even years of fighting against the ravages of tuberculosis and frequent hospital stays could slow her down. She had a quiet confidence, evidenced by her sewing and design abilities. One time, her mother was honoured by the government of the Northwest Territories and was given a beaded purse. Her mother did not really like the design, "so she took it home, took it apart and fixed it the way she liked it," chuckles Dora.

Dora misses the close relationship she shared with her mother despite the physical distance that separated them. Even though Dora brought her mother's body home to Fort Good Hope from Yellowknife in 2000 for burial, Dora still sometimes catches herself reaching for the phone to call her. On the Hare block, a fraction of that love and devotion is captured in the glowing depths of Dora's tribute to her mother.

Malaysia

" Mathematics
comes in handy
when quilting. "
Gillian Lee

Flying high

World-class quilt artist Gillian Lee discovered the art when she was a student at McGill University. A summer job at a quilting supplies shop caused Gillian's passion to blossom. Gillian had emigrated from Malaysia to Montréal with her family in 1984, when she was thirteen. Malaysia was formed in 1963 through a federation of the former British colonies of Malaya and Singapore (which seceded in 1965). In her homeland, elementary school students are taught knitting, sewing and cross-stitch as part of the curriculum.

Gillian later acquired a master's degree in one of her other passions, marine biology. She finds no incongruity in being both a scientist and an artist. "Mathematics comes in handy when quilting," says Gillian. In creating her textile masterpieces, she loves to take traditional techniques and put them into non-traditional settings. Gillian sometimes combines both her loves in her work, such as the CQA-award-winning *Turtle Pond*, and her recent showpiece, *Oceania*, which features fishes and seahorses.

Digging deep into her stash of fabric, Gillian chose some batik sarongs that had belonged to her grandmother. Malaysia's rich textile history is dominated by batik, a dyeing technique in which wax is used to seal different areas as the fabric is dyed over and over again. She appliquéd seven layers of fabric to create the image on the block; it is the instantly recognizable *wau*, the Malay word for kite. They are so-named because the shape of their wings is similar to an Arabic letter that is pronounced *wow*. "Malaysians are major kite-makers and hold yearly kite-flying contests along the east coast. Some entries are as tall as a man," she explains. Stemming from a post-harvest activity, *wau* festivals now attract participants from around the world.

Besides teaching quilting and creating several of her own works of art each year, Gillian runs a bed-and-breakfast that caters to quilters in the Laurentian foothills north of Montréal. She adeptly prepares all the culinary delights for her lucky guests, treating them to luscious delicacies she perfected while attending l'Institut de l'Hôtellerie, where she became a proficient pastry chef.

There is an undeniable parallel between the *wau* and the multi-talented Gillian Lee. The colourful kite darts through the sky, flying high, yet limited by the string that binds it. Gillian is grounded, but energetic, free-spirited and full of new ideas, eager to take each to a new height. The sky may be the limit for the *wau*, but for Gillian it's just the beginning.

A mother's gift

Danutè Staškevičius came to Canada in 1948 with her sister and her mother, a seamstress. "You could say that I grew up 'under and over' a sewing machine," she jests. "When I began to do needlework, it was as if I just naturally knew how." Danutè immersed herself in Montréal's close-knit Lithuanian community and attended St. Casimir Church, where she met her husband.

Kristina Bendžius-Makauskas is a childhood friend of Danutè's daughter, Alma. In 1948, Kristina's father came to Canada alone from Lithuania, temporarily leaving behind his wife and two little ones. They joined him one year later. Kristina was the first of their five daughters to be born in Canada. When Kristina was only six years old, her mom showed her how to design pretty clothes for her dolls. Her love of crafts led her to a Fine Arts diploma and a career in textile design.

Together, Danutè and Kristina worked to design and create the block. One thing was certain: The *juosta* (pronounced "yosta") had to represent the country's rich tradition of weaving. Danutè recounts, "In my grandmother's youth, girls tending cows in the field wrapped strands of multicoloured wool around their waists and then hooked them around a big toe so that they could move about, herding and weaving at the same time." The *juosta* is a colourful woven sash commonly worn at the waist with the national costume, by both men and women. Narrower versions are worn as neckties or plaited hair crowns. "Any girl, to be considered worthwhile, had a stockpile of sashes she had made," says Danutè. "As well as being beautiful, the *juostas* had many practical uses and would be given as gifts on a bride's wedding day."

The women chose tone-on-tone jacquard linen for the block base, while the border is a plain weave. Danutè is the consummate weaver and master craftswoman who created the *juostas*. She has a vast collection of her own weaving, much of it reproduced from complex examples in books. She chose different patterns in complementary shades of burgundy and green. "The beauty of the sashes stands out on the plain base," explains Kristina, who assembled all the components and stitched them together.

Yet, a finishing touch was missing. Kristina recalled a Lithuanian metalwork brooch her mother had received as a gift years earlier. With her permission, they removed one of many small pieces of amber (known as "Lithuania's gold") hanging from it. Ninety percent of the world's amber — a semi-precious stone resulting from the fossilization of tree resins — come from Lithuania. The droplet now dangles proudly, but modestly, at the top of the block. Through their friendship and collaboration, women from two generations honoured their creative mothers and immortalized their Lithuanian heritage.

Lithuania

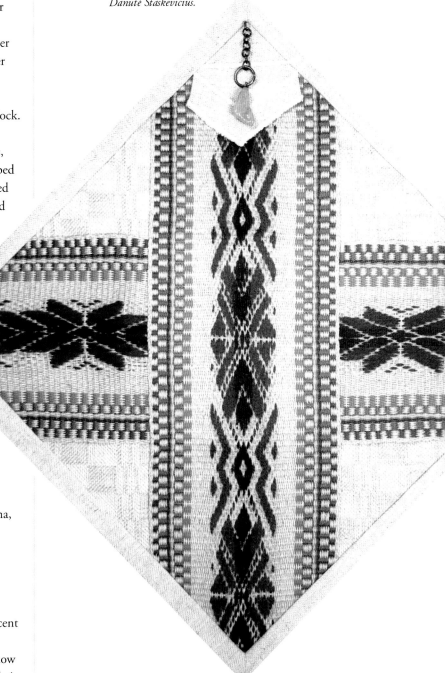

" The *juostas* had many practical uses and would be given as gifts on a bride's wedding day. "

Danutè Staškevičius.

267

Peru

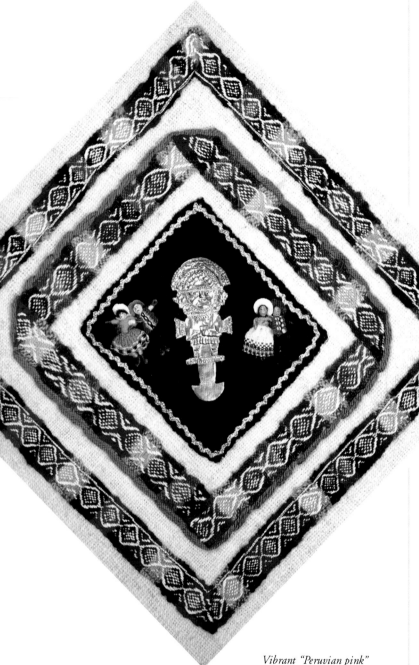

Vibrant "Peruvian pink" symbolizes the joy of life as well as the kindness and hospitality so inherent in the people.

Los patronato

Peru is a country filled with historical mystery. The Incan ruins of Machu Picchu are an architectural wonder with their precisely chiselled interlocking stones. Other marvels include the Nazca Lines, land drawings so enormous they're only discernible from the air. Irrefutable proof of Incan mastery over architecture, road building, and astronomy testifies to ancient Peru's rich and complex cultural life long before the Spanish conquistadors arrived.

In 1989, Rosa Maria Luza founded the Patron of Peruvian Arts, a private, non-profit organization dedicated to promoting Peru through the arts. She has entrusted her own extensive art collection to this group to ensure its preservation and a flourishing Peruvian legacy in Canada. Her vast and varied pieces, many inherited through four generations, include furniture, paintings and ceramics. She proudly displays an ancient Andean textile remnant. Handed down from a great-great aunt, she says the fabric is a thousand years old. The colours are faded but still evident. The figure depicted on it wears a crown indicating the role of shaman or high priest. One hand clutches a *tumi*, a ceremonial knife used in ancient rituals. This family heirloom is pre-Incan, says Rosa, possibly from the Paracas culture, known for its magnificent embroidered textiles featuring motifs of birds, fish and mythical creatures.

"The *tumi* is now an established Peruvian icon, a symbol of wisdom, strength and beauty," explains Rosa. On the block, one is centred between a pair of miniature three-dimensional dancers wearing colourful traditional costumes. The background is made of handwoven, naturally dyed llama's wool. Vibrant "Peruvian pink" symbolizes the joy of life as well as the kindness and hospitality so inherent in the people, and so apparent in Rosa.

A reverence for textile art suffuses her face and voice as Rosa presents yet another jewel. The contemporary fabric hung with chunks of ancient turquoise stone was a gift from an artist in Managua. Rosa sees it as "a meaningful contrast," an indelible link to her heritage. The stones are from an archaeological site in Peru. Today, it's a tourist destination, but once it was a place where indigenous people gathered to process vivid dyes and to create exquisite jewellery and crafts.

Faced with political turmoil in Peru, Rosa explains, "We were looking for a better future for our family." Since coming to Canada fourteen years ago, she has found a good life but has not forgotten what it was like to start over. She organizes many cultural events so people can learn about Peru and its treasures. "I want everybody to know about what we have — tell everybody to come see!" she declares enthusiastically.

A designing woman

Vickie Okpik loves to design and make clothes. Even as a child, she helped her mother make the family's winter clothes, consisting of parkas, *kamiks* (sealskin boots), and mittens. She explains that these enduring items continue to be handmade from natural skins in Inuit communities today. They are unsurpassed for comfort and quality, and are crucial for survival in the Arctic. Factory-made look-alikes in synthetic compounds simply are not warm enough and tend to crack in the bitter cold.

Making clothes has developed into a serious pursuit for Vickie. Since 1998 she has worked on a special project with Makivik Corporation to create employment opportunities for her people, particularly women. Permanent communities in Nunavik, once called Ungava, began to emerge only in the 1950s, when the formerly nomadic people were encouraged to settle in one place. Villages are small and isolated, often accessible only by airplane, making transportation costs very high. Major lifestyle changes and the tremendous challenges of living in the Far North are sometimes difficult to overcome, and a high suicide rate is a sad reality. She is determined to use her talents to help her community build a better future.

Vickie was raised in Quaqtaq, a village of 300 people, but had to go to Inukjuak for high-school. The school board sends young people "to the South" for post-secondary education. Prolonged separations from their family and tightly knit communities are too difficult for many Inuit; consequently, they often choose to return home to familiar surroundings. The extended family is the principal social unit of the community, which frequently involves members outside the nuclear family, such as adopted adults and children, namesakes, in-laws and co-residents.

Vickie studied in Montréal, first taking social sciences at Dawson College and then political science at Concordia University before pursuing her real love, fashion design, at LaSalle College. Her goal is to design clothing that can be made in small sewing centres in Nunavik villages, such as the one in Kuujjuaq, and sell them to a wider market. For several years, Vickie designed and made the uniforms for the Nunavik team participating in the Arctic Winter Games. Her designs were so popular that other athletes bartered to obtain her coats for themselves.

Vickie travels to her home in Nunavik as often as she can, but she lives in her second home on the West Island of Montréal. She makes frequent telephone calls to her family up north, and she seeks other solutions to combat homesickness. Her "safety net" is a freezer well stocked with caribou meat, arctic char and beluga whale. She eats this diet on a regular basis to remain healthy and to stay connected to home while pursuing her dream of seeing her people become self-sufficient.

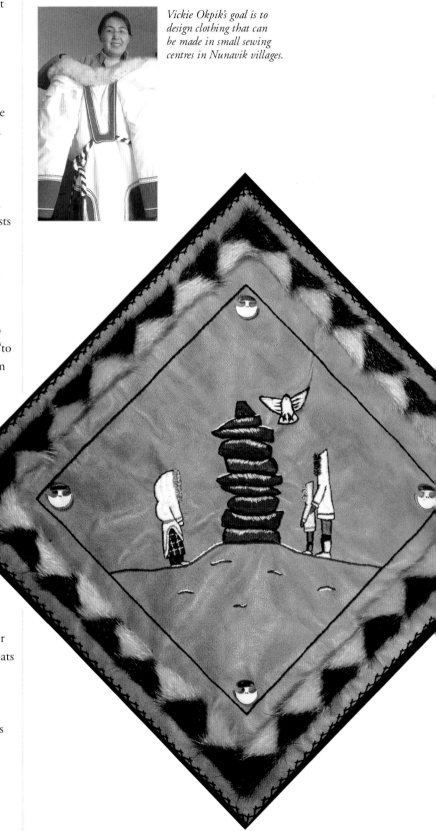

Vickie Okpik's goal is to design clothing that can be made in small sewing centres in Nunavik villages.

Trinidad and Tobago

Heart and soul

Fabrics have been a big part of Badoora Rambaran's life for as long she can remember. Her mother, a dressmaker, ran a shop from their home and, as Badoora recalls, "that was all I ever knew…I would help my mom when I was nine or ten…it was always fabrics, always dressmaking." In her native Trinidad and Tobago, Badoora says fabrics play a significant role outside the family as well. "The biggest use of fabric is for Carnival," she says referring to the world-famous annual two-day festival in which people come together through music, song and dance. The lively, fanciful decorated costumes celebrate people, freedom and life. "The reason fabric is so important to the island is that people make their own clothes. To learn to sew was a big thing for young ladies." Sewing includes making costumes for Carnival, and as soon as one finishes, work begins right away for the next one.

Badoora's Caribbean homeland is an island that resounds with the rhythmic beat of calypso music and the cadence of steel drums. Its people, much like Badoora herself, have a reputation for enjoying life and having a great sense of vitality, creativity and communal life. In creating her block, Badoora knew this was the spirit she wanted to convey, and what better way to accomplish this than by depicting Carnival. Her dynamic tribute features colourful satin petals. Satin is "a popular fabric for Carnival because that's what it's all about — all shine and glitter and colour." Badoora's undulating pattern brings to mind vivacious swaying dancers. Hand-stitched beads and sequins help capture not only the glittery essence of the festivities, but the island itself. In the centre, a steel drum (or pan) is "very representative of Trinidad and Tobago because it originated there," Badoora explains.

Badoora says that since coming to Canada at age twenty-one "the only sewing I ever did was for my own family or myself." But in creating this block, she sewed for others as well as for herself. She invested her whole being into it because she really wanted it to be perfect. Her vibrant finished work reflects Badoora's heart and soul. It is clear to see she still resonates with the rhythmic pulse of her island home.

Badoora Rambaran with her father.

> " Satin is a popular fabric for Carnival because that's what it's all about — all shine and glitter and colour. "
>
> *Badoora Rambaran*

On Laos Street

The path to Madame Khampiene Phimmasone's compact apartment in Montréal is through a wide gateway into an enclosed courtyard lush with gardens. She graciously receives visitors in her home, located two flights up an exterior staircase in a building complex inhabited solely by Laotians. Close to 35,000 immigrants from this former French colony, a mountainous and landlocked country, came to Canada in the late 20th century as refugees from the turbulence of war in their homeland. Many of them chose to establish themselves in Montréal because French is spoken there. In these vibrant new Laotian communities, Buddhism, cultural traditions, language and values are taught to each new generation.

Madame Phimmasone, called Gnamai (meaning mother) out of respect for her age, acts as community advisor. She instructs young Laotians in the traditional ways, such as the important virtues of politeness, gracious hospitality and respect for one's elders and family ties. She often acts as an interpreter for new Laotians, as well.

Throughout her home, lengths of colourful handwoven Laotian textiles are draped over furnishings or used for cushions and throws. Elegantly attired in a long skirt and sash made of similar brightly woven cloth, Madame Phimmasone explains that for Laotians, these fabrics are a matter of intense national pride. The colours are rich and varied, with gold and silver threads added to the expensive, luxurious versions used for special occasions. Master weavers spend years learning the intricacies of "discontinuous supplementary weft weaving," a technique that involves working in small amounts of colour in selected areas as in tapestry weaving. These beautifully patterned silk or cotton fabrics have become a cultural symbol for Laotians, an indication of their skilled craftsmanship and rich heritage. The Laos block is a fine example of this technique and incorporates stylized dragons and flowers within its geometric forms. Earthy tones of orange and green, along with white and magenta, are interlaced by hand under the weft threads to create complex designs.

Laos is also renowned for geometric reverse appliqué work made by members of the Hmong tribe, who create stitches so miniscule that they are barely visible to the naked eye. Madame Phimmasone's apartment houses many forms of Laotian craftsmanship. Incredibly delicate, lacy, carved wooden pieces vie for attention with the extensive assortment of finely worked silver. Plates, urns, bowls, vases, all wait to be polished anew for community celebrations. Madame Phimmasone explains Laotians are extremely sociable people who love to get together in groups. They celebrate the lunar New Year, Fête de Buddha, Fête de Fusé, Fête de Piroque, and many more occasions. "In Canada," she laughs wholeheartedly, "we even observe Thatluanj, the rice harvest celebration, even though there is no rice harvest!"

Bolivia

> " We laugh a lot, and we support each other through the difficulties. "
>
> *Les Femmes de Bolivie*

Supporting, caring, nurturing

In Bolivian culture, family relationships are paramount. Often many generations live and work together. The tradition of *copadrazgo*, or godparents, also creates strong bonds between different families. For Norma Greenhouse and Les femmes de Bolivie (The Women of Bolivia), who created the Bolivian block together, *copadrazgo* extends to include all Bolivians living in Canada.

A deep sense of caring, felt even by newcomers, is palpable among the group that has been meeting in Montréal for over a decade. When they gather, they speak in their native Spanish, enjoy the art of weaving, traditional music and dances, and are "family" to one another. The group is precious to the women because they feel it helps them recover a part of themselves that was lost in the immigration process. Their monthly gatherings are also an important way to reinforce their culture and to help their children come to terms with their mixed identity as Bolivian–Canadians. All the members of the group concur, "We laugh a lot, and we support each other through the difficulties."

Bolivia was named after the independence-fighter Simón Bolívar, but has earned the nickname "Tibet of the Americas." This is partly owing to its physical isolation and elevation, but also because the population has remained largely indigenous. Over half the people in this landlocked South American nation maintain traditional lifestyles, beliefs and language. In the more isolated communities on the *altiplano* (high plain), ancestral ways of life have changed little.

For Les Femmes de Bolivie, the experience of isolation has been social rather than geographical. Each member of the group agrees that language barriers made early life in Canada difficult, fostering nostalgia and homesickness. But Bolivians are strong and open-minded by nature, which helps them integrate into new societies. They also believe in living by an early Incan saying, a kind of "golden rule": *Don't steal, don't lie and don't be lazy.* Like the condor depicted in the centre of the block, the Bolivian women possess an inner strength that embraces freedom and self-determination.

Bolivian textile traditions keep alive the skills of the ancient Inca civilization. The natural-dyed colours of sheep's wool and the styles of weaving represent different regions of the country. Fulfilling primarily a personal rather than a commercial purpose, weaving is a sign of important relationships. Woven items, given to friends or family members to mark occasions, are made to last a lifetime. This small gift of weaving from Les Femmes de Bolivie is a physical symbol of intertwined lives and relationships — a warm and wonderful expression of friendship and unity with all of Canada.

A breath of spring

At the end of the long winter, when days begin to lengthen perceptibly, the appearance of the buds on the wild northern rose is a welcome sight in sub-Arctic regions. Flora Lefoin, of the Deh Gah Gotie First Nation, selected this harbinger of spring as the central focus of the block she created to represent the South Slavey people. Flora continues to live in Fort Providence (Zhahti Koe, formerly Mission House) in the Northwest Territories, a hamlet of about 850 residents. It is where she was born, married Oscar Lefoin, and now raises their three children.

The South Slavey are located in the Deh Cho region, along the Mackenzie River to the west of Great Slave Lake. Their neighbours in the larger area known as Denendeh, meaning "the Creator's spirit flows through this land," include four other Dene peoples: North Slavey, Gwich'in, Chipewyan and Dogrib. Their respect and knowledge of this land has ensured their survival in one of the most demanding environments on Earth. Flora says she "likes being out on the land," where she prepares traditional foods such as dried fish and meat.

In the culture and beliefs of the South Slavey, the land is a living thing inhabited by entities or powers both benevolent and malevolent. The effects of personal actions are constantly weighed and entities are appeased with offerings (matches, ammunition, tobacco), and by the following of strict behavioural rules. Slavey lore is passed from generation to generation orally. Efforts have been made to preserve in print the legends and stories of the elders, as well as their distinct South Slavey language. Part of the Athapaskan linguistic family, it is used by about 2,600 people as a mother tongue, but there is concern about attrition among younger band members. Most of the stories have an implied message of warning or wisdom for the younger generation.

Flora's skills as a needleworker are in high demand locally, where members of the RCMP detachment and community nurses are eager customers. She believes strongly in carrying on moose-hair tufting and porcupine-quill art, which she has started to teach to her twelve-year-old daughter. In creating the South Slavey block, Flora used natural materials such as the smoke-tanned moose hide for the background. Vividly coloured and tightly twisted moose hair is used to create the scalloped border and to outline the flowers. The interior portion of the petals is embellished with flattened, dyed porcupine quills. Flora's South Slavey block is a tribute to a proud people who value the recognition of their distinct heritage.

Flora (Minoza) Lefoin believes strongly in carrying on moose-hair tufting and porcupine-quill art, which she has started to teach to her twelve-year-old daughter.

273

Bulgaria

One of Marina Fedchenko's treasures is a large ostrich egg decorated with handpainted roses.

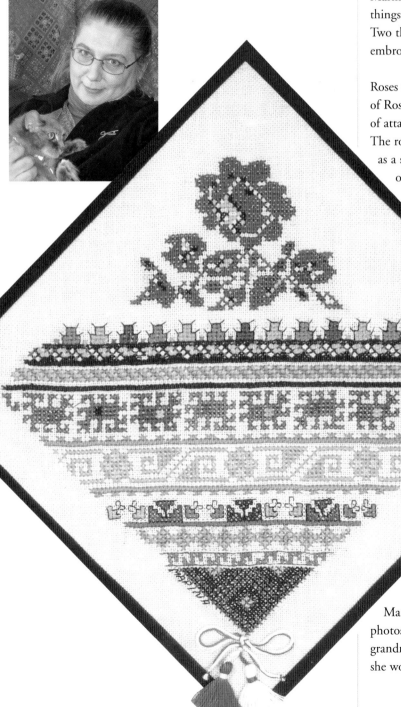

A love of roses

Marina Fedchenko was named after her paternal grandmother, a Bulgarian woman she never met but with whom she developed a sense of kinship and of connectedness over the years. Marina would receive gifts of embroidery by mail from her grandmother and she inherited her passion for colour, design and life expressed in thread and linens. Both her grandmothers were born in the Victorian era, a time when needlework skills were highly valued. Her maternal grandmother, who lived nearby and was very present in her life, taught her many things, including sewing and crochet. Marina feels she is carrying on the female lineage because the things she loves most have come through the women in her family. Two themes recur consistently, both Bulgarian passions: embroidery and roses.

Roses are central to Bulgarian culture and industry. The "Valley of Roses" in the Balkan foothills produces most of the world's supply of attar of roses (rose oil), an essential ingredient in most perfumes. The rose is also the national flower and is often presented to guests as a sign of friendship. Marina collects objects with roses, and one of her treasured family keepsakes is a large ostrich egg decorated with handpainted roses. It is natural, therefore, for the rose to be a favourite design in her stitching, as well as the focal point of her block.

Bulgarian women are passionate about embroidery, especially on their elaborately decorated folk costumes and on their household linens. Each district, village and household can be identified by its embroidery style. To represent her heritage, Marina has created a sampler of Bulgarian patterns, finishing the block with a red and white tassel. These tassels are traditionally worn by Bulgarians during March to mark their Independence Day and signal the end of winter. They are said to bring luck, health and fertility. Every spring, her family would receive a card containing a red and white tassel from Grandmother Marina.

Marina has carefully collected the tassels, embroidery, letters, photos and stories that form the threads connecting her to a grandmother she resembles in so many ways — and to someone she would dearly have loved to know in person.

The land within me

"I can wake up at four in the morning and sit and relax, and be doing this for two or three hours without feeling tired," says Violet Seikaly Srigley, referring to the complex and lavish embroidery of the type she created for the Palestinian block. With her soft-spoken voice and elegant nature, it is evident that many of Violet's inner qualities are expressed in the richness of her work.

The densely embroidered costume folk-art evolved from functional stitching and patchwork done to mend daily work clothes. The cross-stitch is called *fallahi*, from *fallaha*, meaning "farmwoman." Now elaborate festive garments, covered almost entirely with embroidery provide a striking contrast to the humble farm clothing. Such skills were usually passed down from previous generations, but not in Violet's case. "My mother didn't embroider, nor my grandmother," she says. "Nobody showed me how to start, nobody told me how to end. I just fell in love with it…it must be in my genes." Indeed, Violet possesses an innate sense of how to combine colour and shapes, which is so vital in *fallahi*.

Traditionally, each region of Palestine has its own colours and patterns (generally geometric) as a sign of group identity. For this piece, however, Violet wanted to represent the nation as a whole, so she masterfully incorporated several symbols and motifs from different regions. They include the cypress tree, or *saru*, which stands for death and rebirth, the Holy Mount of Olives, candlesticks, and motifs representing the popular feathered pattern known as *reesh*. Violet framed the piece with a colourful border-moon pattern.

Costumes embellished with *fallahi* are usually worn on important religious holidays and formal visits, with the brightest and most dramatically coloured ones saved for wedding ceremonies. Traditionally, design or style of the embroidery was more important than what it represented. However, Violet remarks that recent designs have become increasingly nationalistic, incorporating the colours of the Palestinian flag. In the context of a dispersed and fragmented society, *fallahi* has, for some, become a symbol of national identity, aspirations and solidarity.

Although Violet fled Palestine as a young girl during the conflict of 1948, she feels a strong kinship with the people and land. "Now, it is the land within me," she says. Violet reflects on her childhood in Palestine, "Sometimes we couldn't sleep at night because of the bombings and shelling. But we were fortunate enough to be able to support ourselves, to go to school. Now there are kids who don't know what a normal childhood is. It is very sad." Violet teaches her own children and grandchildren here in Canada the skills she taught herself. Steadily, she stitches beautiful designs for them, expressing her feelings and history, passing on the legacy of their Palestinian heritage.

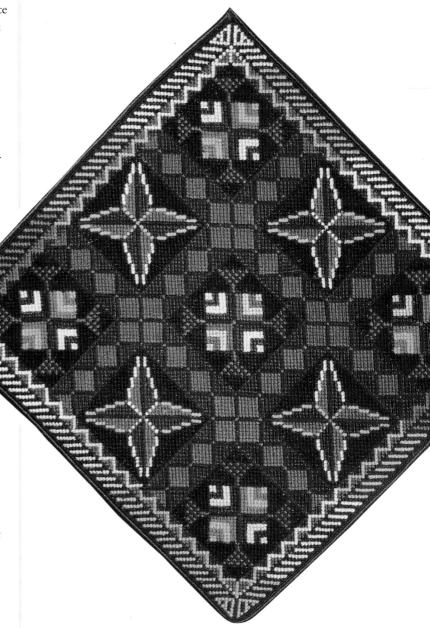

> My mother didn't embroider, nor my grandmother. I just fell in love with it… it must be in my genes.
>
> *Violet Seikaly Srigley*

Macedonia

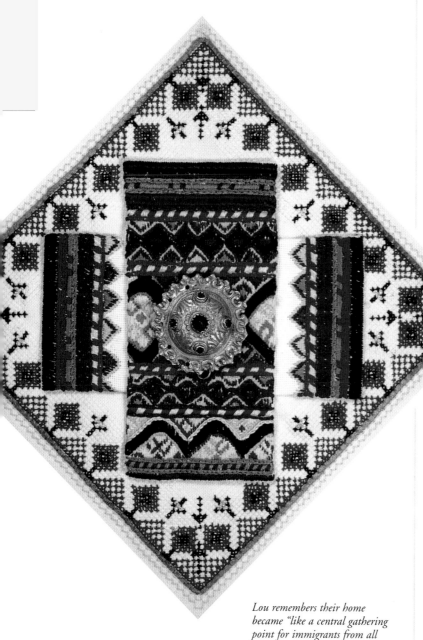

Lou remembers their home became "like a central gathering point for immigrants from all over the world."

Under the Macedonian sun

Since biblical times, the Macedonian sun symbol has appeared on coins, in icons, church frescoes, jewellery and art, exemplifying cultural traditions sustained over thirty centuries. Lou Sekulovski supplied the antique silver *toka* that mimics the sunburst in the centre of the block. Passionate about his heritage, Lou often visits Macedonia, where he collects remnants of a rich cultural and historical legacy. He found and brought back the handmade clothing his mother had worn as a young bride. She would have worn a *toka* then, suspended from a waistband with money clipped to it by wedding guests.

Lou took his job as consultant and co-blockmaker very seriously. He gathered authentic materials and researched patterns that his sister Milka and Dragica Bogdanovic executed on the layers of densely embroidered linens, typical of national costumes. Milka struggled through the complicated stitching for the sake of her brother and to honour their heritage. "I'm not so interested in stitching; cooking is my passion," she admits.

Equally complex is the ethnic makeup of the Republic of Macedonia. The people have experienced great upheavals and frequent political and societal uncertainty. Driven by a search for freedom and a better socio-economic life, Macedonians have emigrated in large numbers. Lou and Milka's father, Risto Sekulovski, was among them. He spent three years in a refugee camp in Greece after fleeing his homeland in 1959. In Canada, he was given $20 and a one-way ticket from his entry point at Halifax's famous Pier 21 to London, Ontario. Like many others, he had left his young wife and two small children behind. The family was finally reunited five years later, in 1964.

In later years, the family moved to Toronto. The city claims the largest Macedonian settlement outside the Balkans, in excess of 150,000 people. While still living in London, Lou remembers their home became "like a central gathering point for immigrants from all over the world." Milka lives with her aging parents now, to help them in their declining years. She remarks, "The company still never ends."

Lou has been a tireless volunteer with various Macedonian organizations and the Canadian Ethnocultural Council. He remembers the challenges faced by his own family and those they welcomed. Now a business entrepreneur and self-confessed perpetual student, he is devoted to helping others find their niche. "People come because of hardships, but we don't want the negative impact of their Old World politics here," he cautions. "My effort is to assist people in maintaining their identity while enriching a new Canadian one." Lou, short for Lubomir, still lives under the influence of the Macedonian sun, living up to his name, which means "love of the world."

A wealth of woven dreams

In Salish communities, beautifully woven blankets were once symbols of prestige and wealth. Myrna Crossley, a weaver from Saanich, on Vancouver Island, says this tradition is still evident at wedding ceremonies, where the bride is obliged to stand on the blankets she receives as gifts. "The higher the pile, the more you're thought of in the community," says Myrna.

The ancient craft of Salish weaving gives Myrna "a strong sense of bonding" with her Songhee and Esquimalt ancestors, who were also weavers. She was introduced to the art ten years ago by master weaver Rita Lewis, one of the first women of the Saanich Peninsula to study and revive the art form, helping to pull it back from the brink of extinction. Myrna, who's been weaving since then, is one of about twenty weavers on the peninsula. In 1999, she received the Vancouver Arts Award for her work.

Myrna spins and dyes her own wool, using natural materials such as onionskin, bark, copper or maple leaves. "The raspberry colour is actually made from tiny little Mexican bugs," she says, referring to one of the shades in the quilt block. The design she created features a smaller version of a large woven blanket, worked in a diamond pattern, using full-sized materials. Myrna says Salish blankets were originally made from the wools of mountain goats and small white dogs bred for that purpose. The Salish dog is now extinct, and women no longer gather goat hair, but Myrna has faith in the weaving revival that continues to gather momentum. "Children in our local Lau Welnew tribe are now being taught weaving along with other traditions." Myrna's husband, a woodcarver, is co-founder and curator of the Annual Coast Art Show, a venue that showcases new and established artists. Myrna is active in numerous fund-raising events for children and says proceeds from the annual art show go towards traditional art education for students. For her part, she's happy to participate in the weaving revival and particularly delighted to share her knowledge with her eight-year-old daughter.

Once people discover you're a weaver, wool begins to magically appear, she says. "From farmers, particularly," she smiles, indicating three full bags that recently materialized. She prefers to process the wool by hand. "I have a small roller that I use," she explains, "but I would like to start adding nettles and bark … incorporating them into the blanket." Myrna plans to expand her knowledge of dyes and learn to weave traditional clothing, though she prefers a "contemporary style with lots of colour and lots of design." One might think ten years is a good distance in an artist's journey, but for Myrna, head spinning with exciting dreams and goals, it is only the beginning.

Coast Salish

“Once people discover you're a weaver, wool begins to magically appear.”

Myrna Crossley

Azerbaijan

The filling stitches

Neliya Huseynova's widowed mother had no time to teach her young daughter to embroider because her days were full caring for her five children. So finally Neliya taught herself the techniques at the age of sixteen. What Neliya really wanted to do, however, was learn to make the renowned silk and wool Azeri carpets. She was fascinated by this ancient art. She loved the inexhaustible richness of colours and the complex geometric designs. Traditionally women work the patterns from memory, passing the symbolism of the motifs to the next generation through storytelling.

Neliya never did make a carpet. As an adult she was busy raising her own family and working as a civil engineer — too busy to continue her much-loved needlework. However, she did purchase several of the precious carpets she so admired, hence adding warmth, beauty and prestige to her home.

Then, everything changed when war erupted in her region. Neliya lost her job, her home and her way of life. Forced into hiding, her days became filled with worry. During this fearful time, she took up the embroidery of her youth to quell her anxiety. She was able to produce beautiful needlework despite a scarcity of materials in this war-torn, oil-rich country where natural gas seeping from the ground burns endlessly.

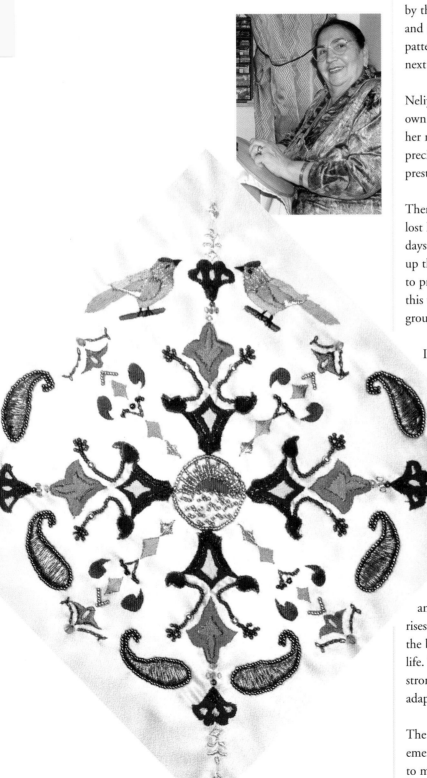

In 2000, Neliya left Baku, the capital city of the Republic of Azerbaijan, to follow her two sons to Canada because she did not want to remain alone and desolate. Since her arrival, she faces a different type of isolation. Now she struggles to survive in a country where she does not understand the language, though she is trying to learn. She cannot remotely afford the comfort of owning one of her beloved carpets again. Once more, she finds solace in the visual language of her needlework. Her small surroundings overflow with the pieces she spends the better part of each day stitching.

The block she made to represent Azerbaijan is rich with colour and a dazzling variety of patterns. In the beaded centre, the sun rises over the Caspian Sea, representing not only her country, but also the beginning of a new day and, for Neliya, the beginning of a new life. The silk-thread embroidery is bold and confident, belying her strong feelings of insecurity and her fear that she will be unable to adapt to a new land at her age.

The Azerbaijani community in Canada is still very small and emerging; a strong support network is not yet in place. Neliya longs to meet other needleworkers who speak Azeri, or perhaps Russian. All the while, she patiently adds stitches, row upon row, filling the cloth, filling the long and lonely days with beauty.

All wrapped up

Love and marriage brought Adriana Molder from Argentina to Canada. "We met on a beach in Acapulco," she explains. "He was on holiday from studying at university in Ottawa, and I was on a student exchange. We had only three days together, but then we wrote letters for three years. He proposed though the mail, because it was very difficult to get a telephone connection in those days. He came to Argentina, we were married and then we moved to Canada." With a smile she adds, "And the rest is history."

Her romantic courtship might well have been the storyline for a song played by the *gaucho* featured in Adriana's block. An epic poem from 1872 entitled *Martin Fierro*, written by José Hernandez, provided Adriana with the inspiration for the centrepiece. Part of the national psyche, this poem illustrates the passion for freedom and individualism of the Argentine people embodied by the nomadic horsemen and cattle herdsmen who roam the vast *pampas*, the grass plains that stretch from the country's tropical rainforests to the snowcapped peaks of the Andes. While traditional *gauchos* still exist, they are on the verge of becoming a romantic myth as Argentina becomes an increasingly modernized country.

For her block, Adriana framed a richly textured, embroidered *gaucho* in the neck opening of a *poncho* woven from deep-red wool, trimmed with black braid and typical decorative bow ties. *Ponchos* can substitute for blankets and feature a centre hole for the head so they can be worn like a cape. Adriana says, "We have a big, big land, and it seems to be all sky, because you can see the sky forever," and everywhere under that sky, people wrap themselves in *ponchos*. For Adriana, *ponchos* are the quintessential Argentine garment, representing both physical and psychological warmth, as well as a connection to her native land.

The *gaucho* has a handwoven *faja* tied around his waist, similar to the miniature sash in the blue and white colours of Argentina that defines the inner border of the block. Tucked into open-toed leather foot protectors, the baggy *bombachas* he wears are characteristic of the practical clothing that evolved to meet the demands of the horsemen's work. Easy-to-remove clothing, such as the *poncho*, allows the *gauchos* to throw their weighted, triple-thonged leather *boleadoras*, used to bring down animals (including ostriches!).

Adriana muses about societal change and her own personal growth. "When I came to Canada thirty-two years ago, people were very serious, not much fun. I had the feeling they didn't like the way I did things." But Canada has changed, declares Adriana, "and I have changed. I have brought this individualism into my community and, after so many years, I feel more Canadian than Argentine."

> " We have a big, big land, and it seems to be all sky, because you can see the sky forever. "
>
> *Adriana Molder*

Romania

Little Paris of the East

Romanian weaving dates back to the Neolithic and Bronze ages. Over time, styles and techniques that used cotton, natural silk, flax and wool became distinguishable by geography. Folk traditions that included woven carpets, needlework and textile decorations have remained unchanged throughout the country's long history. Toronto visual artist Doina Serban, of the Romanian Heritage Group, wanted to highlight this rich textile history in the Romania block. She chose to use heirloom fabrics to create her montage. The background is a piece of antique linen made from homespun flax surrounded by handwoven fabric taken from a vintage Romanian skirt. The cross-stitched, stylized plant prepared with hand-dyed embroidery thread represents the tradition of Romanian folk art. A geometric design frames the work, incorporating the colours most favoured by different regions.

Ethnic Romanians comprise the greater part of the population, with an estimated two million Romany gypsies creating the minority. Their culture is largely derived from the Romans, with strains of Slavic, Hungarian, Greek and Turkish influences. Massive fortified churches and ornate medieval castles are found throughout the country, along with the first painted monasteries in the world to be adorned with frescoes on external walls.

Under control of foreign power for much of its history, Romania has long been one of Europe's poorest and least-developed nations. As a result, it has suffered great economic hardship and restriction of freedom. In 1989 Romanians rose up to overcome the tyranny of a dictatorship, yet economic woes still plague the country while it struggles to make the transition to a market economy. Hope lies in their rich stores of natural resources. One of the largest countries in Europe, it has been called "Little Canada" because of its abundant grain, timber and minerals. With thirteen national parks and 500 protected areas, the Carpathian Mountains have the least spoilt forests in Europe. Healthy numbers of wolves, lynx and other wildlife, including sixty percent of Europe's bears inhabit these woods.

Romania features beautiful cities such as Bucharest, whose world-class opera houses, concert halls, art galleries, and museums have earned it the name "Little Paris of the East." The country is famous, too, for its icon paintings, woodcarving, pottery and blown glass. Beyond creating exquisite art, this nation is renowned for its extraordinary hospitality and friendliness. Often, in keeping with this Old World charm, glassblowers will collect leftover glass at the end of their shifts. These bits and pieces are transformed into little hearts or animals, blown carefully into token gifts of friendship and good luck.

Rebirth

Dawn breaks in the small village of Alert Bay, nestled along Vancouver Island's northeast coast. As the sun burns through fog patches moving across Johnston Strait, it washes everything in a peaceful, transparent light. Eagles ride the air thermals, searching for breakfast. Head swiveling sharply, one sits atop a totem pole in front of the village's traditional Big House. Contentedly watching from next door, Kwakiutl artist Diane Bell sips her coffee and plans her day. "It's very quiet," says this grandmother of three. "No one else wakes up this early."

After years of city life, she treasures such mornings. Despite the obstacles in her way, Diane decided to become an artist years ago when she was a single mother raising three children. She felt propelled by a strong natural desire stemming from an artistic family legacy. "I had very little self-esteem, little faith in myself," she explains. It was her artist-uncle, Eugene Hunt, who helped her. Each time she embroidered a doll's face, created a tiny, woven cedar headpiece, a calico dress, an apron or a button blanket, her confidence blossomed when he said, "That's great!"

Her art has become "all encompassing." Diane has worked in Japan as an on-site artist and participates as a traditional storyteller at different venues, including the First People's Festival in Victoria. One of her *Dancing Aprons* hangs in the Canadian Museum of Civilization; another was presented to a Maori queen in New Zealand. It's all very special, she admits. Yet she's equally proud when her dolls become beloved playmates to small children. She sees teaching art and culture to Native and non-Native children as a rewarding challenge akin to "bridge-building."

Cultural traditions are important, she feels, "connecting us to who we are and where we're from." The block she created in the Frog design symbolizes rebirth. It is based on the collection of stories and family lore known as the "Box of Treasures" belonging to her grandfather, Chief Thomas Hunt. He was a third-generation descendant of Anasliga, a renowned Chilkat weaver. Highlighted with beads and pearl buttons, the red melton cloth is appliquéd on black in the traditional style of button blankets, which are considered the Robes of Power in Kwakiutl culture. Diane dedicates the block to her late uncle Eugene. She wants to honour him: "He is why I'm an artist."

Still known as "the Salmon People," the Kwakiutl are masters of stagecraft and dramatic art. Diane is excited by the idea of expanding her art, and she is considering writing a book or a play. But as she learned from her mentor, it is not enough to create art for art's sake. She says, "You need to go out there and share it."

Kwakiutl

Kwak̲wak̲a'wakw

> " You need to go out there and share your art. "
> *Diane Bell*

Tsilhqot'in

Chilcotin

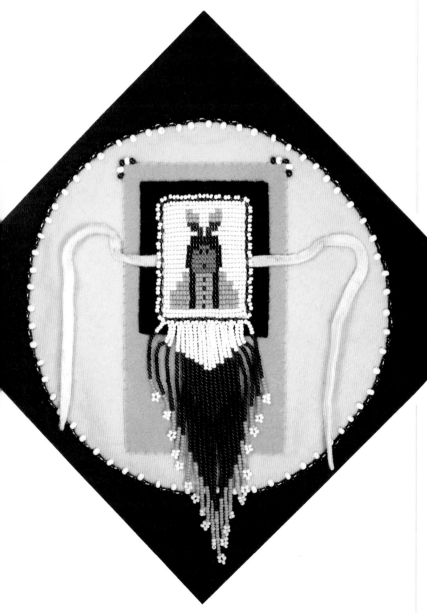

Masters of their own destiny

The emblem of the Tsilhqot'in national government speaks volumes of the nature of the people. The picture presents a warrior on a horse silhouetted by the moon, arms raised to the sky in honour of the earth. Clouds waft around the moon, settling into a shadowy shape of an eagle and mountainous terrain. It is a splendid, powerful image. The independent "never say die" spirit of the Tsilhqot'in emanates through every flowing line. When speaking with Don Wise, issues co-ordinator for the Tsilhqot'in national government, it is impossible to miss, in his tone of voice and choice of words, the fervent pride in his heritage.

This proud spirit was never more apparent than during the Tsilhqot'in War of 1864. In 1858 the cry of "Gold!" reverberated through the mountains on either side of Williams Creek in the Chilcoltin-Cariboo plateau region. To Tsilhqot'in ears it resonated with foreboding. Soon their lifestyle and homeland would be forever altered by an influx of outsiders who had little regard for Tsilhqot'in land title. Few could resist the romantic allure of the region's untamed beauty and the promise of untold wealth despite the difficulties of reaching the remote area. By 1864 plans were being carried out to build a road to transport supplies inland from the coast.

In that fateful year a number of Tsilhqot'in warriors fought to protect their homeland against an invasion by British colonial militia. It was a cataclysmic, defining moment for the nation. Six warriors, including war chief Lhats'as?in (whose name means "we do not know who he is") were captured, found guilty of murder and hung. The Tsilhqot'in saw their actions as an act of war, not murder, and the court's decision intensified their defiance. October 26 marks the annual Lhats'as?in (Klatsassin) Memorial Day which celebrates the lives of those warriors and reminds the people that they are masters of their own destiny.

The Tsilhqot'in, with a population of 6,000, still live off the land much as their ancestors did, nestled between the west bank of the mighty Fraser River and the towering Rocky Mountains. The women make gloves, jackets and moccasins from hide they tan and smoke. The portion of the block donated by Don is a square-shaped, beaded decoration depicting the image of a warrior, used to tie off the end of a braid.

Don is a contributor to *Wolf Howls: The Tsilhqot'in Nation Journal*, which lends its voice in support of the ongoing struggle for Tsilhqot'in land rights on the basis of the 1997 Delgamuukw decision made by Canada's Supreme Court that Aboriginal land title existed. The journal gives him the opportunity to celebrate the independent spirit of the Tsilhqot'in every day through the power of words.

The medicine wheel, symbol of life

Aboriginal nations across Canada may not share the same cultural traditions or religious beliefs, but there are certain things they do have in common. They were the first peoples to call Turtle Island (North America) home. They share a close relationship with the land, respect for the natural environment, and a unique understanding of the circle of life. It is not surprising that a symbolic representation of the circle of life, the medicine wheel, or sacred hoop, so often appears in varying forms and interpretations. While it is not a symbol used by all Aboriginal peoples, the medicine wheel on the quilt, designed and created by Sue Towndrow, is meant to provide representation for all Canada's First Nations.

The medicine wheel, in whatever form it appears, is charged with meaning and wisdom. It is the foundation of the Aboriginal world view, a discourse of life's very essence. Simple in design, the medicine wheel embodies a holistic and earth-centred approach to life, relating to both the physical and metaphysical realms. The concepts that permeate this ancient symbol are richly layered. The circle is usually divided into four quadrants by blue or purple lines and is encircled by green, representing the spirit world and Earth.

Together the four quadrants illustrate the balance of life and equality. The number four is central to the wheel. The colours of the four quadrants begin in the east with yellow and move clockwise to the south (red), west (black) and north (white). The medicine wheel implies many concepts all of which are superimposed and interconnected. At the core is the concept of self, as the self is the centre of the universe. Building upon the self are the concepts of the four personalities, the four stages of life, the four aspects of nature, the four directions, the four seasons, the four elements, the four teachings learned by observing nature, the four visionary personality traits and the four races. Working with the strengths of each and learning from one another, the four races could live in greater peace and harmony and be better stewards of the earth.

The medicine wheel provides a map for one's path through life so long as one is willing to walk the true path. This means being open to new experiences and life lessons that are learned by standing at each spoke of the wheel many times during the circle of life. Each person walks his or her own path, absorbing knowledge wisdom and understanding. It is impossible to fully understand another until one stands at each spoke, honouring each direction. A well-known Native American prayer reads, "Great Spirit, let me not criticize another until I have walked a mile in his moccasins."

Founding Nations

❝ Great Spirit, let me not criticize another until I have walked a mile in his moccasins. ❞

Native American prayer

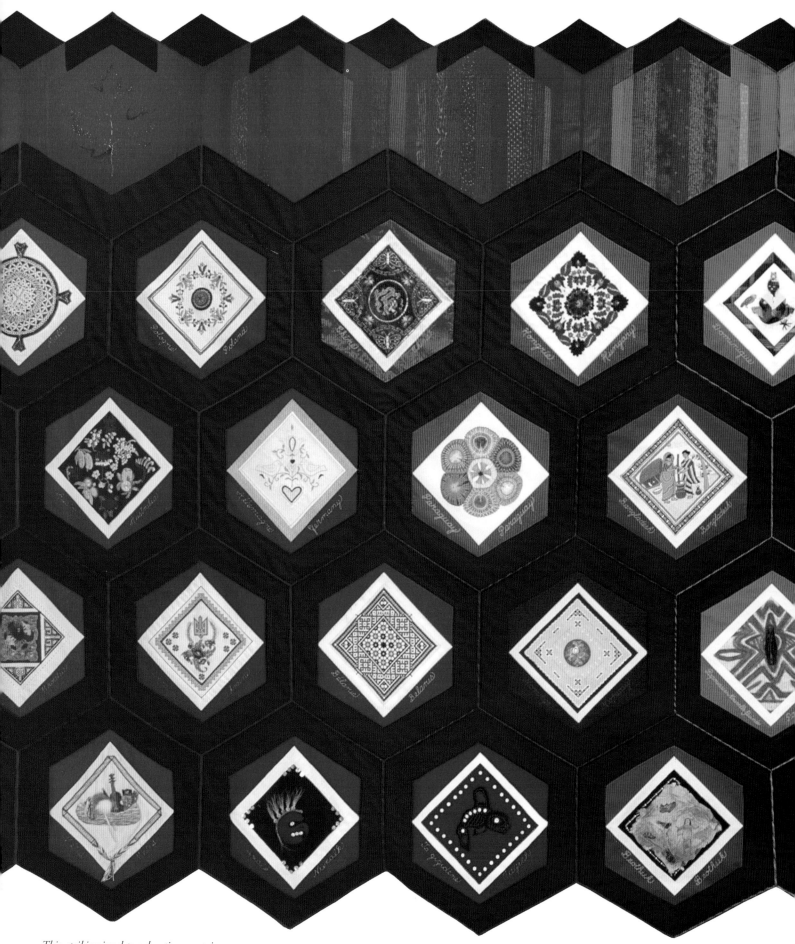

This striking jewel-toned section comprises one-eighth of the 120-foot quilt.

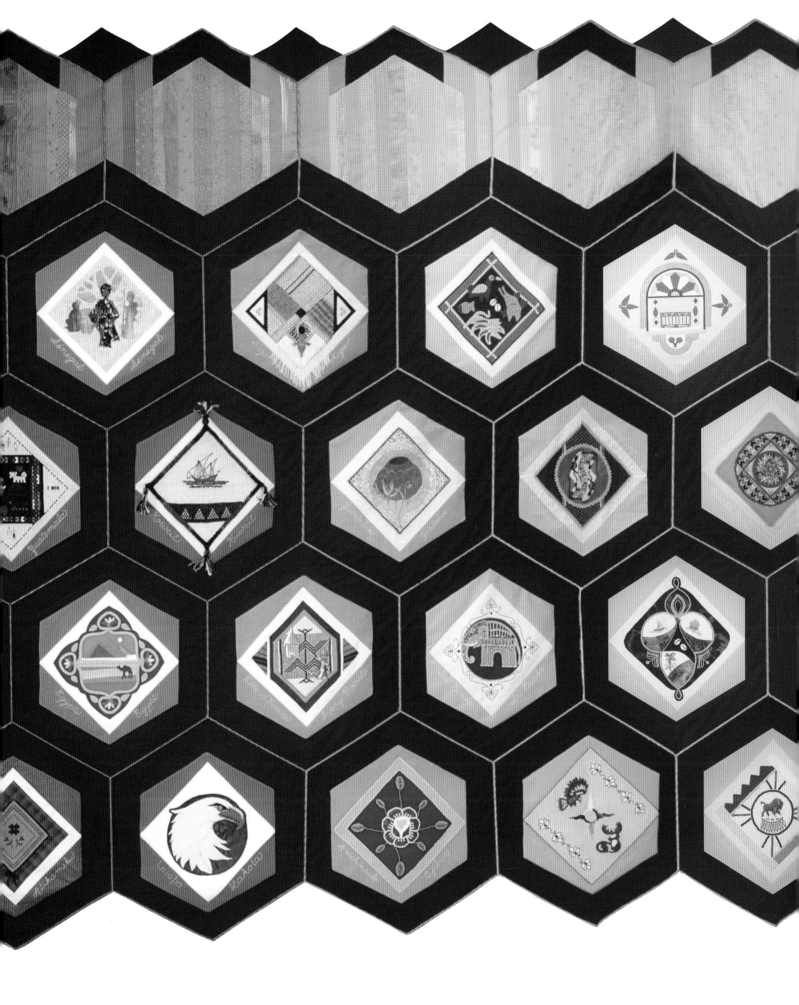

Marilyn Vance

Ulla Kuhlmann

Nancy Baker

Kathleen Alguire

Rachel Bryan

Nancy Douglas

Sabina de Stecher

286

Acknowledgments

This book has become a reality because of the commitment, love and faithful support of hundreds of people who have believed in the vision of *Invitation: The Quilt of Belonging*. It is the generous spirit of the volunteers, staff, and sponsors that has brought this dream to fruition. Each has willingly given the gifts of talents, time and resources through the long journey. Working together, we have helped one another through the tough times and good times of the project, and shared our lives with one another. This textile work of art and these stories are the result of the collective effort of many who believe that the world can be changed for the better by the courage and commitment of ordinary people.

We would like to thank the Board of Directors for their wisdom, encouragement and guidance in the inspirational, professional and practical aspects of this enormous project spanning almost six years to date. Vera Arajs has chaired the board since the beginning, assisted by current board members George Baker, Carol Campbell, Claudette Voët, Maynard Gertler, Peggy McDonald, Linda Halliday, Sue Harrington, Jane Rietze and John Towndrow. Past members were Alan Sullivan, Pam Maloney, Nancy Warwick, Jane Foster and Dianne Crutcher.

We are grateful for the unfailing efforts of those involved in research, tracking down contacts in the most remote parts of the country, and organizing vast amounts of information. Daphne Howells has worked tirelessly through the years as research team leader and her knowledge and skills have been a great asset. We thank Ryne Veldhoen, Nelson Wells, Johanna and George Feilotter, Allison Bishop, Gerty Brabant and the many others who worked with her. A special thanks goes to Rachel Bryan, who did the early and challenging work on the Aboriginal groups, and to Meredith Royds, who continued this along with her many other tasks as communications officer. We thank the Canadian Ethnocultural Council, the Department of Indian Affairs, the Inuit Tapiriit Kanatami, the Canadian Museum of Civilization, Heritage Canada, the Departments of Immigration and Foreign Affairs, the embassies and band councils of many nations, and numerous other organizations that contributed their knowledge and contacts.

The determination and skill of those involved in office management juggling a multitude of people, carrying out hundreds of thankless but necessary tasks and creatively stretching the limited resources were critical to our success. We heartily thank devoted Heljä Thomson and Claudette Voët, and many others, including RéJeanne DesRosiers, Marie-Ange Brisson, Danielle Butt, Karen Cooper-Douglas and Ronaye Gabriel-Cooper, Lucie L'Écuyer, Charlotte Fielding, Marylyn Baker, Dorothea Kubli, Christy Paradis, Laura Meyer, Rachel Bryan, Pat Cloutier, Georgina Mitchell and Karla Major and Vivianne Panizzon. We thank George Bigalow who kept us all connected with his computer magic. Elena Mirga-Cincik archived all the photos and articles that marked our progress.

We extend our heartfelt appreciation to the sewing and design teams for their faithfulness, willingness to learn, to teach, and to innovate. Many blocks arrived complete and ready for framing. For others, though, the assistance of capable hands and partnerships with caring volunteers were needed. As leader of the design team Susan Towndrow gave countless hours of work, together with Esther Bryan, Linda Barry, Denise Dompierre and Theres Speck. Embroiderers and needleworkers with a wide range of specialities shared their skills to help others bring their ideas to life. They included Greta Le Courney, Reina Cross, Ruth Lewis, Elfriede Petric, Kathleen Alguire, Karen Paavila, Olga Fortin, Chloe Fox, Nancy Baker, Ruby Andrews, Bernice Michaud, Jeannette Schaak, Sarah and Elizabeth Krol, Kay Amell, Bridget Grice, Elspeth Greer, Barbara Gale, Mary Morber, Mona Norman, Amber and Whitney Hoekstra and many others. Ulla Kuhlmann embroidered many of the block names, while Susan Robertson hand-quilted almost the entire quilt herself. Elizabeth Ferguson spent long hours at the sewing machine putting the body of the quilt together, assisted by RéJeanne Des Rosiers, and Monique Saucier. Christine Allan, Sabina de Stecher, Nancy Douglas, Mary Barkway, Amelia and Colleen Brown framed and pillowcased blocks. Marilyn Vance sewed the 120-foot-long border together. The Kingston Heirloom Quilters, ably led by Dianne Berry, helped finish the last stages of assembly. We thank each one for their patience, their willingness, where necessary, to rip out and re-sew, and for their sense of humour.

Raising funds for all the materials and activities of this mammoth undertaking was not a task for the faint of heart. We are grateful for each donation, whether it was the dollar dropped into the donation box, the sponsorship of a block or the larger gift of a corporate

sponsor. We thank the fundraisers like Claudette Voët, Ariella Hostetter, Virginia Winn, Pat Kempffer and Pat McKenna, who boldly approached sponsors, organized events, and found sources of money in dozens of ways. Thanks especially to those who worked so hard on the three gala fundraisers that helped sustain us through the years: Heljä Thomson, Bev Schaeffer, Jean Fraser, Marjorie Quenneville, Kevin Kehoe, Maureen Stephens, Del Roulston, Liz Nurse and Denis Brunet. We also are grateful to auctioneers Flora Dumouchel and Theresa Taylor and those who donated items and food to the event.

We thank artists Alan Bain, Audrey Bain, Esther Bryan, Peggy MacDonald, Linda Gareau and Renée Levesque for their gift of a signatory book which has delighted all the visitors and participants.

We have been blessed with gifted writers, editors, photographers and a graphic designer who have captured the spirit of this project in words and images. We especially thank Linda Norton for her beautiful design and direction in putting together such a complex book, and Ken McLaren, who spent a full year shooting thousands of photos and meticulously preparing them to produce the fine images that bring the text and the quilt to life. Brian Greer and Sherri Smelko also contributed photography. We thank each writer who interviewed contributors and wrote their stories: Isabella Carello, Andrea Veerman, Debra Fieguth, Chelsea Stelmach, Helen Sloan, Vera Arajs, Lori Andrews-Christiansen, Nancy Douglas and Lorri Benedict. We thank Meredith Royds and Ginette Cotnoir for skillfully doing the lengthy editing process, and Daphne Uras, Daphne Howells and John Voët for transcribing interviews. Our publisher, Boston Mills Press, and distributor, Firefly Books, have provided direction and we are grateful for their belief in the value to other Canadians of the story told within these pages.

For their professional and technical expertise in the preparation of this project for exhibition and travel, we give special thanks to the Canadian Museum of Civilization, as well as Martin Gaudet, and to Paul Ahad of Media-fX, C-Tech Ltd., and to our own colleagues Carol White and Bradley Nuttley, who have worked on the tour and event planning.

We also heartily thank Human Resources Development Canada for allowing us to be a partner in their Job Creation Program. Through this special program we were able to have specialized staff to complete work that would have been beyond the scope, expertise and time of volunteers and that included a significant portion of the production of this book.

We thank also the many organizations that have helped to spread the word of this project across the country and abroad. Our beautiful website was designed by WEBtech and written by Lori Andrews-Christiansen and Andrea Veerman. *Canadian Living*, Cathy Donovan at Regional Contact CJOH, *Canadian Geographic*, CBC, City TV, the Canadian Quilters Association, the Toronto Stitchery and Needlework Festival, the Kitchener-Waterloo Quilt Festival, the South Shore Quilters Guild, other guilds and many others made significant contributions. To the local community, especially the Township of South Glengarry, who gave their support through the years, we also extend our warmest thanks.

We appreciate Lydia Bryan for her morning hugs and for doing so many of the necessary but thankless tasks.

We are grateful to Esther Bryan, who seemed to move heaven and earth in her efforts to not only bring this project to completion but to make it meaningful along the way, and to the many like Susan Stelmach, Nancy Warwick and Peter Hincke, who quietly supported her and the project in prayer.

We extend our gratitude to many others whom we do not mention individually by name but who have given of themselves in so many ways. Your gifts are not forgotten.

Lastly but most importantly, we want to thank our spouses and families for their patience, understanding and willingness to pick up the tasks left undone by those of us who have been so deeply immersed in this project.

Friends of Invitation: The Quilt of Belonging
November 2004, Williamstown, Ontario

SPONSORS

ABENAKI
Lafarge Canada Inc., Montreal

AFGHANISTAN
Kathleen Warden

ALBANIA
Albanian Muslim Women's Association

ALGERIA
Knights of Columbus, St. Mary's Parish, Williamstown

ALGONQUIN
Alison Wilson

ANDORRA
Permanent Mission of the Principality of Andorra to the United Nations

ANGOLA
Alan Sullivan

ANTIGUA AND BARBUDA
Knights of Columbus, St. Lawrence Council #5068

ARGENTINA
Bainsville Women's Institute

ARMENIA
Karla and Bruno Major

ATIKAMEKW
Anonymous

AUSTRALIA
High Commission for Australia

AUSTRIA
Austrian-Canadian Council

AZERBAIJAN
St. Andrew's & St. Mark's UCW, Long Sault, in memoriam Katherine Klassen

BAHAMAS
Joyce M. Jones, in memoriam E. Donald Jones

BAHRAIN
Martha Weber, in memoriam of her sister Ruth on the anniversary of her death

BANGLADESH
Mary Anderson Marouf and Kazi Marouf

BARBADOS
Hazel and Ryan Seale

BEAVER
Adaire Chown Schlatter

BELARUS
Belarusian Canadian Co-ordinating Committee

BELGIUM
Richmond Area Quilt Guild

BELIZE
Heenan Blaikie, LLP

BENIN
Adult Centre Town of Mount Royal

BEOTHUK
Joyce and Jack McGaughey

BHUTAN
Dr. Catherine Lamarche

BLACKFOOT
Barrington and Ronaye Cooper, Rick and Linda Lussier and their family, in memoriam Florence Lussier Tremblay, their mother

BOLIVIA
Gary Bryan, in memoriam Audrie Bryan

BOSNIA-HERCEGOVINA
Richard and Lorraine Lapointe

BOTSWANA
The MacDougall family

BRAZIL
Norman and Jeannette Schaak

BRUNEI DARUSSALAM
Jay and Nancy Woollven

BULGARIA
Bruce Burgess

BURKINA FASO
Martintown Women's Institute

BURUNDI
Lancaster Optimist Club

CAMBODIA
Nancy Warwick

CAMEROON
Anonymous

CANADA
CEC (Canadian Ethnocultural Council) Maynard and Ann Gertler

CAPE VERDE
Paul A. Smith

CARRIER
Kinette Club of Cornwall

CAYUGA
The Sunshine Gang & The Fairweather Group

CENTRAL AFRICAN REPUBLIC
Famille Galley

CHAD
The Dagenais family

CHILE
Ron Kubelka, in memoriam Miss Marie Patterson

CHINA
Central Ontario Chinese Cultural Centre

CHIPPEWAYAN
Joyce and Jack McGaughey

COAST SALISH
Joyce and Jack McGaughey

COLOMBIA
Aida Ramirez-Mesa

COMOROS
Mrs. Lydia Kukuchka Matusky, in memoriam John and Anna Kukuchka

CONGO BRAZZAVILLE
Elizabeth Ferguson

COSTA RICA
Jennifer and J. Wayne Mitchell

CÔTE D'IVOIRE
Norman Laflamme

CREE CENTRAL
O-Pipon-Na Piwin Cree Nation

CROATIA
Lanark County Quilters Guild

CUBA
Patricia and Rose Sisty

CYPRUS
Thousand Island Quilters, Brockville

CZECH REPUBLIC
Masaryk Memorial Institute

DAKOTA
Norman Rietze

DELAWARE
Pam and Paul Lamarche

DEMOCRATIC REPUBLIC OF CONGO
André et Monique Vigeant et famille

DENMARK
Danish Canadian Society of Montreal Inc. Danish Club of Montreal, Royal Danish Embassy

DJIBOUTI
John and Susan Towndrow

DOGRIB
Dogrib Rae Band

DOMINICA
Sisserou Cultural Club

DOMINICAN REPUBLIC
Knowledge Flow Corp.

EASTERN CREE
Forrest and Jane Rietze

ECUADOR
Bill and Anne Harker, in honour of Mary Harker

EGYPT
Patrick and Irene MacPhee, in memoriam Esther Van de Walle-Willems

EL SALVADOR
Cornwall Quilters Guild

ENGLAND
John and Susan Towndrow, in memoriam Pearl Irene Unwin

EQUATORIAL GUINEA
Helen Carroll, in honour of Joy and Martin Carroll

ERITREA
IGS (Information Gateway Services)

ESTONIA
Estonian Ethnographic Society in Canada

ETHIOPIA
Elizabeth and Chris Nurse

FIJI
Del and John Roulston

FINLAND
Canadian Suomi Foundation; Karen Paavila, in memoriam Kaino Paavila and Mabel Fishlock

FOUNDING NATIONS
Ulla Kuhlmann

FRANCE
Conseil de Vie Française, Cornwall Mario, Paolo and Vivianne Panizzon

GABON
Canadian Federation of University Women, Cornwall and area

GAMBIA, THE
In memoriam Pat MacKenna, from the Invitation Project volunteers

GEORGIA
Catholic Ladies Guild, St. Mary's, Williamstown

GERMANY
Christine Allan and Ruth Friedrich

GHANA
Elizabeth Ferguson

GIBRALTAR
Nellie I. Wells, from her family on her 92nd birthday

GITXSAN
Andrew Thomson, in memoriam Margaret and Andrew Thomson

GREECE
Hellenic Canadian Congress

GRENADA
Roslyn, Julien and Johnny Bullen and Cedmo Clyne

GUATEMALA
Irene Tobias

GUINEA
Rotary Club of Cornwall

GUINEA-BISSAU
Lydia Bryan

GUYANA
Audrey Bain and Elaine Murdoch, in memoriam Vivian and Samuel Murdoch

GWICH'IN
Gwich'in Teaching and Learning Centre Irene Poirier, in memoriam, from her children

HAIDA
Council of the Haida Nation

HAISLA
Agnes Cooper

HAITI
Glen Walter and Area Chamber of Commerce

HARE
Marilyn and George Vance, in memoriam Grenetta Jackson

HEILTSUK
Heiltsuk Women's Council

HONDURAS
Williamstown Green Thumb Horticultural Society

HUNGARY
Canadian Hungarian Folklore Association Bela A. & Ilona Rieger

ICELAND
Vatnabyggd Icelandic Club of Saskatchewan Inc.

INDIA
The Bryan family, Reina and Bill Cross

INDONESIA
Heidi and Michael Krol

INUVIALUIT
Inuvialuit Regional Corp.

IRAN
The Honarvar family

IRAQ
Ulla Kuhlmann

IRELAND
Mona Kerr Street

ISRAEL
Judith Jolly, in memoriam Larry Schwartz

ITALY
Somerset West Community Centre, Gruppa Anziani

SPONSORS

JAMAICA
Royal Canadian Legion, Branch 297, Cornwall

JAPAN
Embassy of Japan

JORDAN
Hugh and Bridget Grice

KAINAI
Kainaiwa Band Administration

KASKA DENE
Margaret Zerter, in memoriam Wilhelm Zerter

KAZAKHSTAN
Martintown Animal Hospital

KENYA
Sunrise Rotary Club, Cornwall

KIRIBATI
Travels With Charlie

KITIKMOET
Ruth and Harold Fourney

KIVALLIQ
Kivalliq Inuit Association

KOREA
Nancy Warwick

KTUNAXA
Janette Abbey & family, in memoriam
Dr. H.K. Abbey, DVM

KUWAIT
Embassy of the State of Kuwait

KWAKIUTL
U'Mista Cultural Centre

KYRGYZSTAN
Peggy McDonald

LABRADOR INUIT
C-Tech Ltd., Cornwall

LAKOTA
St. Andrew's United Church
Ecumenical Service at Williamstown Fair

LAOS
Jim and Charita Warwick

LATVIA
George and Vera Arajs, Diana, Julie and Eric
Latvian National Federation in Canada

LEBANON
Ken MacLennan

LESOTHO
Sue and David Harrington

LIBERIA
The Booth family, in memoriam Michael David Booth

LIBYA
Georgina and Roy Yorke

LIECHTENSTEIN
In memoriam John and Linda Jekel, from their family

LITHUANIA
Lithuanian Folk Art Group, Montreal

LUXEMBOURG
Brian and Elspeth Greer

MACEDONIA
United Macedonian Organizations of Canada

MADAGASCAR
Fabricville, Montreal

MALAWI
Nancy Warwick,
in memoriam Helen and Clinden Warwick

MALAYSIA
Picnic Grove Women's Institute

MALDIVES
Margaret Richards

MALI
Bela A. & Ilona Rieger

MALISEET
George E. Davis, in honour of his grandparents,
Margaret E. and Leslie F. Jiles

MALTA
Alan and Audrey Bain,
in memoriam Anne and James Bain

MAURITANIA
Linda Halliday and Bob Copeland

MAURITIUS
Elizabeth and Chris Nurse, in memoriam Wanda Nurse

MÉTIS
RéJeanne Saumure DesRosiers,
in memoriam Jean-Paul Saumure

MEXICO
Yolanda Corvese and Martha Weber

MI'GMAQ
Listuguj Mi'gmaq First Nation Council

MOHAWK
The Fraser family, in memoriam Mary Ann
(MacDonald) and Eugene Archibald Fraser

MOLDOVA
In memoriam Marion Brazier, from her friends at
Trillium Health Centre, Mississauga

MONACO
Daphne Howells, in memoriam Jock Howells

MONGOLIA
Joy Clinton, in memoriam Joan and Tom Lock

MONTAGNAIS
Bernardine Greffe, in memoriam Célina and
Cyprien Cousineau, her parents

MOROCCO
The Urquhart family,
in memoriam Kenny John & Mina Urquhart

MOZAMBIQUE
Cornwall Honda

MYANMAR
Cornwall New Comers Club in honour of Ilana
McGrath, past president

NAKOTA
Norman Rietze

NAMIBIA
Margaret Wallach, in memoriam Terry Wallach

NASKAPI
Naskapi Development Corp.

NAURU
South Shore Quilters Guild (PQ)

NEPAL
Ralph and Monica Hainer, Geoffrey, Kirstin,
Sarah and Anne

NETHERLANDS
Netherlands Folklore Group

NEW ZEALAND
Pins and Patches Quilt Group

NICARAGUA
Rev. Andrea Harrison

NIGER
Sandra Matthews

NIGERIA
The Dedeke family

NISGA'A
Mary Ellen McIntosh, from Stuart McIntosh

NORTHERN IRELAND
Julia (Crawford) Coulter and Rachel (Coulter) Bryan

NORWAY
Kirkeringen Women's Auxiliary, Norwegian Church
of Montréal & Norske Klubben, Norwegian Club
of Montréal, Greta Grzegorek,
Øivind and Ragnhild Sveistrup

NUNAVIK
Makivik Corp., Lachine

NUU'CHAH'NULTH
Dr. Betty Martin, May Winslow and Bill Martin,
in memoriam Jane Maria Houston-Carson,
their grandmother

NUXALK
Inge U. and Dieter Scholz

ODAWA
David and Erna Witherspoon,
in memoriam Nancy and Dean Richard

OJIBWE
Adam Beach and Tara Mason Beach

OKANAGAN
Sunshine Women's Institute

OMAN
Melody Music Centre, Cornwall

ONEIDA
Elena Cincik-Mirga and Vojtech Mirga

ONONDAGA
Navan Women's Institute

OWEEKENO
Mr. and Mrs. Norman Rietze

PAKISTAN
The Winn family, in memoriam Helen McMillan,
Bruce McCuaig, Roger McNeal

PALESTINE
Carol Campbell

PANAMA
Kathleen Irwin, Helen Irwin & Margaret MacLachlan

PAPUA NEW GUINEA
Rotary Club of Cornwall

PARAGUAY
St. John's Women of the Church, Cornwall

PASSAMAQUODDY
Linda Norton, in memoriam Margaret Leblanc

PEIGAN
Walter and Mary Cartwright,
in memoriam Dorothy and Bernard Broadhead

PERU
Rita and George St. Pierre

PHILIPPINES
Cornwall Township Lions Club

PLAINS CREE
Adam and Benjamin Magana

POLAND
Canadian Polish Congress

PORTUGAL
Shirley and Victor Santos-Pedro, in honour of our
mothers Armanda Santos-Pedro and Florence E. Nelson

POTAWATOMI
Dianne Crutcher

QATAR
Kingston Heirloom Quilters

QIKIQTANI
Robert J. and Janice McGillis

ROMANIA
The Barker, J. Gazdik, P. Gazdik,
Pyne and Walborn families

RUSSIA
Coleman and Joan P. MacDonald

RWANDA
Carol and Jasmin Paschek

SAINT KITTS AND NEVIS
The Lee family

SAINT LUCIA
Sarah and Elizabeth Krol

SAINT VINCENT AND THE GRENADINES
Russell Village Women's Institute

SAMOA
Canadian Slovak Butterflies, 55+, Montreal

SAN MARINO
Staff of St. Monica's House, St. Joseph's Secondary
School, Cornwall. Stitched by the Meyer and McLeod
families and friends in memoriam for Sarah Meyer

SÃO TOMÉ E PRÍNCIPE
Valade and Bougie families,
in memoriam Jennifer Valade

SARCEE
Marcelle Clark, Irene H. Rachuk and Edgar A. Emond,
in memoriam Bertha H. Emond, their mother

SAUDI ARABIA
Sheldon and Rosann Carr

SCOTLAND
Glengarry Historical Society

SEKANI
Kathleen Alguire

SENECA
Arthur and Shirley Charbonneau

SENEGAL
Gary Bryan, in memoriam Kenneth Bryan

SERBIA AND MONTENEGRO
Serbian National Shield Society of Canada

SEYCHELLES
Ulla Kuhlmann

SHUSWAP
The Robertson McKenzie family

CORPORATE SPONSORS

SIERRA LEONE
Irma R. Long

SINGAPORE
Louise E. Lavictoire

SLOVAKIA
Ann Adams, la Maison Slovaque Inc., Montréal
Mrs. Lydia Matusky, in memoriam John S. Matusky
Slovak Canadian National Council, Toronto

SLOVENIA
Annie Kramar Richard

SOLOMON ISLANDS
Caitlyn Bowser and Meredith Royds

SOMALIA
Susan and Malcom Robertson

SONGISH
Twistle Guild

SOUTH AFRICA
High Commission for South Africa

SOUTH SLAVEY
Carmen and Jack Hunting
Eleanor Sides, in memoriam Mary Higginson

SPAIN
Far and Near Gourmet Club

SRI LANKA
Faith Burgess,
Pauline Siva, in memoriam Michael Siva

ST'ÁT'IMC
Elizabeth and Gordon Ferguson

SUDAN
The Foster family

SURINAME
Sean Adams

SWAZILAND
Dot Taylor

SWEDEN
Swedish Club of Montreal

SWITZERLAND
Embassy of Switzerland
Swiss Needleworkers of Eastern Ontario & West Quebec

SYRIA
Anne Arajs

TADJIKISTAN
A.L. MacDonald Grocery Ltd.

TAGISH
Skookum Jim Friendship Centre

TAHLTAN
Tahltan Band Council

TAIWAN
Reginald and Keitha Melrose

TANZANIA
The Snowbee family

THAILAND
The Helle family

THOMPSON
Nicola Tribal Association

TLINGIT
The Feilotter family

TOGO
Anne Joyce Bayly

TONGA
Julie Clingman

TRINIDAD AND TOBAGO
National Council of Trinidad & Tobago
Organizations in Canada

TSILHQOT'IN
Carol White and her daughters Jana & Cheryl Comeau

TSIMSHIAN
Plantagenet Women's Institute

TUNISIA
Marilyn Parisien

TURKEY
Wendy and Les Wert

TURKMENISTAN
Pat and John Brittain

TUSCARORA
Douglas and Ursula Quantz,
in memoriam Ida Quantz

TUTCHONE
Stardale Women's Institute

TUVALU
Ethel MacLaurin

UGANDA
In memoriam David Barkway,
from the Invitation Project volunteers

UKRAINE
Ukrainian Canadian Congress, St. Catharine's Branch

UNITED ARAB EMIRATES
Alicia Page Cassidy

UNITED KINGDOM AND DEPENDENCIES
High Commission for the United Kingdom of Great
Britain and Northern Ireland

UNITED STATES OF AMERICA
Jan and Alice Gazdik, the Hoekstra family

URUGUAY
Mary Fraser-Earl

UZBEKISTAN
Dr. Theo and Mrs. Diane Jaggassar

VANUATU
The Barkway family

VENEZUELA
Maryelle Tétreault,
in memoriam Pierrette et Renée Tétreault

VIÊT NAM
Ruby Major Andrews,
in memoriam Vince Major

WALES
Daphne Howells,
with Bonnie, Happy and Robb and their families

WENDAT
Martintown Goodtimers

YELLOWKNIVES
Charles and Bernardine Greffe, for Gordon, Pauline
and Gérard

YEMEN
Wes and Carol Libbey

ZAMBIA
Brenda Watts, in honour of Donald Banda

ZIMBABWE
Gary and Eliane Broda

Air Inuit Ltd
Canadian Ethnocultural Council
Consoltex Inc.
C-Tech Ltd
Hydro One
Inuit Tapiriit Kanatami
NAV Canada
Sears Canada Inc.
Seaway Arts Council
The Robert Campeau Family Foundation

Bernina®
Hunt Insurance Brokers Ltd.
Luna Design
New World Timberframes
Northcott Silks Inc.
Sign It
Sodexho Canada Inc.
WEBtech

Bibliography

Allane, Lee. *Tribal Rug: A Buyer's Guide.* London: Thames and Hudson Ltd., 1996.

Anchor Manual of Needlework. Colorado: Interweave Press, Inc., 1990.

Apinis-Herman, Anita. *Latvian Weaving Techniques.* Kenthurst, NSW, Australia: Kangaroo Press, 1993.

Ayo, Yvonne. *Africa.* New York: Knopf, 1995.

Barnard, Nicholas. *Living with Decorative Textiles.* London: Thames and Hudson Ltd., 1989.

Beautement, Margaret. *Patterns from Peasant Embroidery.* London: B.T. Batsford Ltd., 1968.

Beck, Thomasina. *The Embroiderer's Flowers.* Devon: David & Charles Ltd., 1997.

Bird, Michael S. *Ontario Fraktur: A Pennsylvania-German Folk Tradition in Early Canada.* Toronto: M.F. Feheley Publishers, 1977.

Bishop, Robert . Karey P. Bresenham and Bonnie Leman. *Hands all Around.* New York: E.P. Dutton, 1987.

Black, Mary E. *New Key to Weaving.* New York: Macmillan Publishing Co., Inc., 1957.

Brudner, Nettie Yanoff. *Painting With a Needle.* New York: Doubleday, 1972.

Bullard, Lacy Folmar and Betty Jo Shiell. *Chintz Quilts: Unfading Glory.* Florida: Serendipity Publishers, 1983.

Campbell-Harding, Valerie and Pamela Watts. *Machine Embroidery.* London: B.T. Batsford Ltd., 1989.

Campbell-Harding, Valerie. *Textile Artistry.* London: B.T. Batsford Ltd., 1996.

Canada's Ethnic Groups Series. Ottawa: Canadian Historical Association, 1982-.

Caraway, Caren. *Southeast Asian Textile Designs.* Owings Mills, Maryland: Stemmer House Publishers, 1983.Chase, Pattie with Mimi Dolbier. *The Contemporary Quilt.* New York: E.P. Dutton, 1978.

Cirker, Blanche, ed. *Needlework Alphabets & Designs.* New York: Dover Publications, 1975.

Clabburn, Pamela. *The Needleworker's Dictionary.* New York: William Morrow & Co. Inc., 1976.

Clarke, Duncan. *Art of African Textiles.* California: Thunder Bay Press, 1997.

Collier, Ann. *The Art of Lacemaking.* North Pomfret, Vt.: David & Charles, 1986.

Contemporary Quilts. Quilt National. Asheville, NC: Lark Books, 1997.

Cross Stitch Embroidery. Edison, NJ: Chartwell Books, Inc., 1993.

Dickason, Olive Patricia and Rudi Haas. *Indian Arts in Canada.* Ottawa: Department of Indian Affairs and Northern Development, 1972.

Dillmont, Thérèse de. *Complete Encyclopedia of Needlework.* Philadelphia, Pennsylvania: Courage Books, 1972.

The DK Geography of the World. New York: Dorling Kindersley Publishing, Inc., 1996.

Dorling Kindersley Animal Encyclopedia. New York: Dorling Kindersley Publishing, Inc., 2000.

Earnshaw, Pat. *The Identification of Lace.* Aylesbury, Bucks, UK: Shire Publications, 1984.

Eaton, Jan. *Around the World in Cross Stitch.* U.K. : New Holland, 1992.

Encyclopedia Britannica. Volumes 1-24, Chicago: Encyclopedia Britannica, 1959.

England, Kaye & Mary Elizabeth Johnson. *Quilt Inspirations from Africa.* Lincolnwood, Ill.: Quilt Digest Press, 2000.

Ericson, Lois and Diane Ericson. *Ethnic Costume.* New York: Van Nostrand Reinhold Co., 1979.

Farkas, Claudia al-Rashoud. *Kuwait Kaleidoscope.* Kuwait: Al Alfain Printing and Publishing Co., 1995.

Felcher, Cecelia. *The Needlepoint Workbook of Traditional Designs.* New York: Hawthorn Books, 1973.

Ferrero, Pat. *Hearts and Hands.* San Francisco: The Quilt Digest Press, 1987.

Gillow, John and Bryan Sentance. *World Textiles: A Visual Guide to Traditional Techniques.* Boston: Little, Brown and Co., 1999.

Gostelow, Mary. *A World of Embroidery.* New York: Scribner, 1975.

Gostelow, Mary. *Embroidery.* New York: Scribner, 1977.

Greeen, Sylvia. *Patchwork for Beginners.* London: Studio Vista, 1971.

Greenoff, Jane and Sue Hawkins. *55 Flower Designs.* Devon: David &Charles Ltd., 1995.

Gulvin, Clifford. *The Tweedmakers; A History of the Scottish Fancy Woollen Industry 1600-1914.* New York: Barnes & Noble, 1973.

Haberland, Wolfgang. *Art of the World.* New York: Greystone Press, 1966.

Harrold, Robert. *Folk Costumes of the World in Colour.* Poole: Blandford Press, 1978.

Herald, Jacqueline. *World Crafts: A Celebration of Designs and Skills.* Asheville, NC: Lark Books, 1993.

Holm, Bill. *Northwest Coast Indian Art.* Vancouver: J.J. Douglas Ltd., 1965.

Hunt, Gail P. *Quiltworks Across Canada.* North Vancouver, BC: Pacific Quiltworks, Ltd., 1996

Inuit Kanatami. Ottawa: Inuit Tapiriit Kanatami, 2003.

Inuvialuit Pitqusiit: The Culture of the Inuvialuit. Northwest Territories Education, 1991.

Ireys, Katharine. *Canvas Embroidery Stitch Patterns.* New York: Thomas Y. Crowell Company, 1972.

Issenman, Betty Kobayashi. *Sinews of Survival: The Living Legacy of Inuit Clothing.* Vancouver: UBC Press, 1997.

Jefferson, Louise E. *The Decorative Arts of Africa.* New York: Viking Press, 1973.

Kennett, Frances and Caroline MacDonald-Haig. *Ethnic Dress*. New York: Facts on File, 1995.

Kerimov, Lyatif. *Folk Designs from the Caucasus*. New York: Dover Publications, 1974.

Keywan, Zonia. Greater than kings: *Ukrainian Pioneer Settlement in Canada*. Montreal: Harvest House, 1977.

Kiracofe, Roderick. *Cloth & Comfort : Pieces of Women's Lives from Their Quilts and Diaries*. 1st ed. New York: Clarkson Potter, 1994.

Kmit, Ann, Johanna Luciow and Loretta Luciow. *Ukrainian Embroidery*. New York: Van Nostrand Reinhold Co., 1978.

Krody, Sumru Belger. *Flowers of Silk and Gold*. Washington, D.C.: Merrell Publishers Limited, 2000.

Lace. Paris Bookking Int., 1995.

Lands and Peoples. Dansbury, Conn.: Grolier Educational, 2001.

Lane, Rose, Wilder. *Woman's Day Book of American Needlework*. New York: Simon and Schuster, 1963.

Lind, Vibeke. *Knitting in the Nordic Tradition*. English translation by Annette Allen Jensen. Asheville, N. C.: Lark Books, 1984.

MacDowell, Marsha L. and C. Kurt Dewhurst, eds. *To Honor and Comfort : Native Quilting Traditions*. Santa Fe, N.M.: Museum of New Mexico Press, 1997.

Magocsi, Paul R. ed. *Encyclopedia of Canada's Peoples*. Toronto: University of Toronto Press, 1999.

Mathews, Kate, ed. *Fiberarts Design: Book Three*. Asheville, N.C.: Lark Books, 1987.

McCall's Needlework Treasury. New York: Random House, 1964.

Meech, Sandra. *Contemporary Quilts: Design Surface and Stitch*. London: B.T. Batsford Ltd., 2003.

Meilach, Dona Z. *Contemporary Batik and Tie-dye*. New York: Crown Publishers, Inc., 1973.

Messent, Jan. *Designing for Embroidery*. London: Studio Vista, 1976.

Morrison, R. Bruce and C. Roderick Wilson, eds. *Native Peoples: The Canadian Experience*. Toronto: McClelland and Stewart, 1986.

Mosey, Caron L. *America's Pictorial Quilts*. Paducah, KY: American Quilter's Society, 1985.

Nasby, Judith. *Irene Avaalaaqiaq: Myth and Reality*. McGill-Queen's University Press, 2002.

Noble, Mary and Janet Mehigan. *The Calligrapher's Companion*. London: Quarto Publishing, 1997.

The Native Peoples of Québec. Québec: Les Éditions Sylvain Harvey, 1997.

Ohms, Margaret. *Ethnic Embroidery*. London: B.T. Batsford Ltd., 1989.

Paine, Sheila. *Embroidered Textiles*. New York: Thames and Hudson, 1997.

Pan Am's World Guide: The Encyclopedia of Travel. 26th ed. New York: McGraw-Hill, 1982.

Parker, Mary S. *The folkwear Book of Ethnic Clothing*. New York: Lark Books, 2002.

Pastore, Ralph T. *Shanawdithit's People*. St, John's NFLD: Atlantic Archeology Ltd., 1992.

Patera, Charlotte. *Mola Techniques for Today's Quilters*. Paducah, KY: American Quilter's Society, 1995.

Peoples of the Earth. Connecticut., Danbury Press, 1972-.

Phillips, Barty. *Carpet Style*. Secaucus, N.J.: Chartwell Books, Inc., Inc. 1997.

Pocket Encyclopedia of the World, published by Geddes & Grosset Ltd., 1997.

Reichek, Elaine. *When This You See…* New York: George Braziller, Inc., 2000.

Robinson, Charlotte, ed. *The Artist and the Quilt*. New York: Knopf, 1983.

Rogers, Janet, ed. *Vision: quilt art*. San Diego: C&T Publishing, 1996.

Saunders, Sally. *Royal School of Needlework: Embroidery Techniques*. London: B.T. Batsford Ltd., 1998.

Springer, Jo. *Crewel*. New York: Golden Press.

Smith, Paul J. and Akiko Busch. *Objects for Use: Handmade by Design*. New York: H.N. Abrams, 2001.

Snook, Barbara. *The Creative Art of Embroidery*. London: Hamlyn Publishing Group Ltd., 1972.

Sparey, Jóna. *Icelandic Patterns in Needlepoint*. Devon: David & Charles Ltd., 1993.

Staniland, Kay. *Embroiderers – Medieval Craftsmen*. Toronto; University of Toronto Press, 1991.

Stitching Women's Lives. Toronto: The Museum for Textiles, 2000.

The Statesman's Year-book, 1999-2000. London: Macmillan, 1999.

Swim, Laurie. *World of Crafts: Quilting*. New York: Michael Friedman Publishing Group, Inc., 1991.

Tremblay, Hélène. *Families of the World*. New York: Farrar, Straus and Giroux, 1988.

Tully, Kate. *Needlepoint*. New York: Crescent Books, 1992.

Von Finckensten, Maria ed. *Nuvisavik, the Place Where We Weave*. Montreal: McGill-Queen's University Press, 2002.

Waldrep, Mary Carolyn. *Irish Crochet Designs and Projects*. New York: Dover Publications, 1988.

Wilson, David A. *The Irish in Canada*. Ottawa: Canadian Historical Association, 1989.

Wolfrom, Joen. *Patchwork Persuasion*. Lafayette, Calif.: C & T Pub., 1997.

Wood, Dorothy. *Kilim Designs in Needlepoint*. London: Ward Lock, 1998.

Zeiman, Nancy and Natalie Sewell. *Landscape Quilts*. Birmingham, AL: Oxmoor House, 2001.

Electronic Resources

Aboriginal Canada Portal. Government of Canada. URL: www.aboriginalcanada.gc.ca/.

The Africa Guide. URL: www.africaguide.com/.

Affaires autochtones.com, le réseau autochtone. URL: www.affairesautochtones.com.

ArabNet. Arab Net Technology. URL: www.arab.net.

Bartleby, Great Books Online. Accessed 2004-11-09. URL: bartleby.com.

British Columbia First Nations. Peigan Design. URL: www.bcfn.org.

Canada Heirloom Series. Volumes I-VII. Canada's Digital Collections. URL: collections.ic.gc.ca/heirloom_series/.

The Canada-Mauritius Cultural Association of Ottawa. URL: www.mauritiusottawa.org/.

The Canadian Encyclopedia. © 2004 Historica Foundation of Canada. URL: canadianencyclopedia.ca/.

The World Factbook. Central Intelligence Agency (CIA) Publications. URL: www.cia.gov/cia/publications/factbook/index.html.

Civilization.ca. Canadian Museum of Civilization Corporation. URL: www.civilization.ca.

Cultural profiles. University of Toronto: Anti-Racism, Multiculturalism and Native Issues (AMNI) Centre, 1997-2002. Available online in pdf at: http://www.settlement.org/cp/.

Department of Citizenship and Immigration. Government of Canada Internet Portal. URL: http://www.cic.gc.ca/.

Departments of Foreign Affairs Canada and International Trade Canada. Government of Canada Internet Portal. URL: www.dfait-maeci.gc.ca.

Department of Indian and Northern Affairs Canada. Government of Canada Internet Portal. URL: www.ainc-inac.gc.ca.

Encylopædia Britannica. Encylopædia Britannica, Inc, ©2004. URL: www.britannica.com.

Estonian Institute. URL: www.einst.ee.

Geographia. Interknowledge Corp. ©1997-2003. URL: www.geographia.com.

Gitxsan Chiefs' Office. BC Web. URL: www.gitxsan.com/html/who.htm.

Government of Belize. ©2001. URL: www.belize.gov.bz.

Haisla totem pole repatriation project. Raised Eyebrow Web Studio. URL: www.haislatotem.org.

Hungary National Tourist Office. GM Studio. URL: www.gotohungary.com.

Indigenous Art from Panama ©2003. URL: www.panart.com.

Infoplease. © 2000–2004 Pearson Education. URL: http://www.infoplease.com.

Innu Nation/Mamit Innuat. URL: www.innu.ca/.

Jamaica National Heritage Trust ©2002. URL: www.jnht.com.

The Knitting Universe. Copyright © 2004 — XRX, Inc — Home of Knitter's Magazine URL: www.knittinguniverse.com.

Korean Cultural Service, New York. ©2004. URL: www.koreanculture.org.

Lonely Planet Destinations. ©2003 Lonely Planet Publications. URL: www.lonelyplanet.com/destinations/.

MapZones, World Information. 1995-2002. ©1995-2002 Panalink Technologies. URL: www.mapzones.com.

Métis Nation. ©2004 Métis National Council. URL: www.metisnation.ca.

Microsoft Encarta Online Encyclopedia. © 1997-2003 Microsoft Corporation. URL: encarta.msn.com.

Native Languages of the Americas. URL: www.native-languages.org.

Native North America.©2003 Minnesota State University EMuseum. URL: www.mnsu.edu/emuseum/cultural/northamerica/.

Nisga'a Lisims Government Information. ©2001. URL: www.nisgaalisims.ca.

Newfoundland and Labrador Heritage, Aboriginal Peoples. ©1997, Memorial University of Newfoundland and the C.R.B. Foundation. URL: www.heritage.nf.ca/aboriginal/default.html.

Okanagan Indian Band. URL: www.okanagan.org.

Peace 4 Turtle Island. ©2002 Kanatiiosh. URL: www.peace4turtleisland.org.

Secrétariat aux affaires autochtones. ©2004 Gouvernement du Québec. URL: www.autochtones.gouv.qc.ca.

The Secwepemc Cultural and Education Society. URL: www.secwepemc.org.

Songhees Nation. URL: www.songheesnation.com.

Sultzman, Lee. First Nations Histories. URL: www.tolatsga.org/Compacts.html.

Statistics Canada. Government of Canada Internet Portal. URL: www.statcan.ca/.

Turkish Cultural Foundation. ©2004. URL: www.turkishculture.org.

United Nations Educational, Scientific and Cultural Organization. URL: www.unesco.org.

Wikipedia, the free encyclopedia. Wikimedia Foundation. URL: www.wikipedia.com/.

The World Travel Guide. © 2004 Highbury Columbus Travel Publishing Ltd. URL: www.travel-guide.com.

The Yinka Déné Language Institute. ©2004. URL: www.ydli.org.

We have done our utmost to include every reference source we used to research this book; we apologize if we have inadvertently missed any and thank everyone for their input.

Index